Real Answers to Real Questions asked by Lightroom Users

Victoria Bampton

Lightroom Queen Publishing

Adobe Lightroom - The Missing FAQ - Version 3.0

Copyright © 2010 Victoria Bampton. All rights reserved.

Published by The Lightroom Queen

ISBN - 978-0-9560030-3-4 (PDF Format) ISBN - 978-0-9560030-4-1 (Paperback)

No part of this publication may be reproduced in any form without prior written permission of the publisher, with the exception that a single copy may be printed for personal use. Permissions may be sought by email to victoria@victoriabampton.com or via the website http://www.lightroomqueen.com/

The publisher/author assumes no responsibility or liability for any errors or inaccuracies that may appear in the informational content contained in this guide.

Adobe, the Adobe logo, Flash, Lightroom, and Photoshop are either registered trademarks or trademarks of Adobe Systems Incorporated in the United States and/or other countries.

Microsoft and Windows are either registered trademarks or trademarks of Microsoft Corporation in the United States and/or other countries.

Apple, Mac, and Macintosh are trademarks of Apple Inc. registered in the U.S. and/or other countries.

All other trademarks are the property of their respective owners.

Table of Contents

Introduction	51
Quick Start Essentials	55
Import	61
Shooting Raw, sRAW or JPEG	61
The Import Dialog	65
Selecting Folders & Files for Import	67
Import Options	74
Renaming	77
Destination Folders	82
Import Presets	90
Proprietary Raw vs. DNG	91
Other Import Questions	102
Tethered Shooting & Watched Folders	111

117
117
126
131
133
136
138
139
143
147
147
154
158
160
166
170
173
182
186
187
196
198
200

Working with Catalogs	205
Managing Catalogs	205
Catalog Corruption	212
Single or Multiple Catalogs	215
Backup	221
Restoring Backups	227
Moving Lightroom on the Same Computer	229
Moving Lightroom to a New Computer	232
Working with Multiple Machines	234
XMP	241
Networking	247
Offline Archives	251
Previews & Speed	253
Previews	253
Preview Problems	257
Speed Tips	263
Develop Module	271
Raw File Rendering	271
Process Versions	274
White Balance	276
Basic Adjustments	279
Working with Sliders & Targeted Adjustment Tool	283

	Tone Curves	287
	HSL, Color, B&W & Split Toning	288
	Adjusting Multiple Photos	291
	Before / After Views	295
	Histogram & RGB Values	296
	Presets	300
	Defaults	306
	Snapshots & Virtual Copies	308
	History & Reset	312
	Detail—Sharpening & Noise Reduction	314
	Lens Corrections	319
	Effects—Post-Crop Vignette & Grain	327
	Calibration Profiles & Styles	329
	DNG Profile Editor	330
	Cropping	336
	Spot Removal—Clone & Heal Tools	340
	Red Eye Reduction Tool	342
	Local Adjustments—Graduated Filter & Adjustment Brush	343
Edi	ting in Other Programs	353
	Editing in Other Programs	353
	Adobe Camera Raw Compatibility for Photoshop	359

Ex	port	367
	Export Locations & File Naming	367
	File Settings	370
	Color Space	375
	Sizing & Resolution	381
	Output Sharpening	388
	Copyright & Watermarking	389
	Post-Processing Actions & Droplets	394
	Plug-ins	399
	Other Export Questions & Troubleshooting	403
Pul	blish Services	407
	Setting Up Your Publish Services	407
	Creating Collections & Photosets	412
	Synchronizing Changes	413
	Flickr Account Questions	415
	Publish Services Troubleshooting	417
Slic	deshow Module	419
	Styles & Settings	419
	Music	425
	Saving & Exporting Slideshows	426
	Errors	430

Print Module	431
Laying Out Your Photos	431
Styles & Settings	437
Printing	441
Web Module	447
Styles & Settings	447
Additional Galleries	451
Exporting & Uploading	453
Troubleshooting & Useful Information	457
Troubleshooting Steps	457
Preferences & Settings	461
Default File Locations	461
64-bit	465
Initial Installation	467
Upgrading from Lightroom 1, 2, or version 3 beta	468
Installing, Updating & Downgrading	472
Languages	474
Licensing Information	476
Final Words	478
Keyboard Shortcuts	479
Index	489

Table of Contents... in Detail

Table of Contents	3
Table of Contents in Detail	9
Acknowledgements	49
Introduction	51
The Book Format	52
Windows or Mac?	52
Paperbacks and FREE digital formats	53
Updates	53
Talk to me!	54
Quick Start Essentials	55
The Basics	55
Basic Workflow	57

	The Top 10 Gotchas	59
	Remember Lightroom's Rule Number 5	60
lmp	ort	61
SH	OOTING RAW, SRAW OR JPEG	61
	Can I use Lightroom on JPEG files as well as raw files?	62
	If I can use all of Lightroom's controls on JPEG files, why would I want to shoot in my camera's raw file format?	62
	If I shoot raw, can Lightroom understand the camera settings?	63
	If I shoot sRAW format, can Lightroom apply all the usual adjustments?	64
TH	E IMPORT DIALOG	65
	What's the difference between the compact Import dialog and the expanded Import dialog and how do I switch?	66
	What's the difference between 'Add,' 'Copy,' 'Move,' and 'Copy as DNG'?	66
SE	LECTING FOLDERS & FILES FOR IMPORT	67
	How do I import multiple folders in one go?	67
	Is it possible to import from multiple card readers at the same time?	68
	Why do the folders keep jumping around and what is Docking?	68
	Can I use the operating system dialog to navigate to a folder instead of using Lightroom's Source panel?	69
	Can I save favorite folders?	69
	How do I select only certain photos to import?	69
	How do I select photos from a specific date?	70
	How do I select specific file types to import?	71

	Why are some photos unavailable or dimmed in the Import dialog?	72
	Can I see larger previews of the files before importing?	73
IMPORT OPTIONS		
	Why do I have to create previews? Why can't I just look at the photos?	74
	What does 'Don't Import Suspected Duplicates' do?	74
	What does the 'Make a Second Copy' option do?	75
	What Develop settings, metadata and keywords should I apply in the Import dialog?	75
	How do I apply different settings to different photos while importing?	77
R	ENAMING	77
	How do I rename the files while importing?	77
	What's the difference between Import#, Image#, Sequence# and Total#?	79
	Can Lightroom continue my number sequence from my previous import?	80
	How do I pad the numbers to get Img001.jpg instead of Img1.jpg?	80
	Can I have more than 5 digit numbers?	81
D	ESTINATION FOLDERS	82
	I've chosen 'Copy' or 'Move'—how do I organize the photos into a folder structure that will suit me?	82
	Why are some of the Destination folders in italics?	83
	How should I organize my photos on my hard drive?	84
	Can I create a different dated folder structure automatically?	87
	Can I leave Lightroom to manage my photos like iTunes moves my music files?	90
IN	MPORT PRESETS	90
	How do I create Import presets, and what do they include?	90

PΙ	ROPRIETARY RAW VS. DNG	91
	Should I convert to DNG?	91
	Do I lose quality when converting to DNG?	94
	If I convert to DNG, can I convert back to the proprietary raw file format again?	95
	Which preferences should I choose when converting to DNG?	95
	How do I convert to DNG?	97
	Should I convert other formats like JPEG or TIFF to DNG?	100
	How do I update my embedded preview?	100
	How do I change my embedded preview size?	100
	Why do some files get bigger when converting to DNG?	101
	I embedded the proprietary raw file—how do I extract it to use it?	101
	I embedded the proprietary raw file—is there any way to remove it?	101
OTHER IMPORT QUESTIONS 10		102
	How do I import my existing photos into Lightroom?	102
	Why does Lightroom load or open the Import dialog every time I insert a memory card or device?	103
	I can't see thumbnails in the Import dialog, I just see grey squares. How do I fix it?	103
	Can I set Lightroom to delete the photos from the memory card once they've uploaded?	104
	What happens to the other files on a memory card, such as sound or video files?	105
	Can I import CMYK photos into Lightroom?	105
	It says: 'Some import operations were not performed. Could not copy a file to the requested location.'	105
	It says: 'Some import operations were not performed. The file is too big'	106

It says: 'Some import operations were not performed. The file is from a camera which isn't recognized by the raw format support in Lightroom.'	106
It says: 'Some import operations were not performed. The files use an unsupported color mode.'	107
It says: 'Some import operations were not performed. The files could not be read. Please reopen the file and save with 'Maximize Compatibility' preference enabled.'	107
It says: 'Some import operations were not performed. The file appears to be unsupported or damaged.'	108
Lightroom appears to be corrupting my photos—how do I stop it?	108
Why is Lightroom changing the colors of my photos?	109
I shot Raw+JPEG in camera—why have the JPEGs not imported?	110
TETHERED SHOOTING & WATCHED FOLDERS	111
Which cameras are supported by the built-in Tethered Capture?	111
How do I set Lightroom up to use Tethered Capture?	112
Crops can't be saved in presets, so how do I get it to apply a crop to my Tethered photos?	114
Can I convert to DNG while tethering?	114
How do I set Lightroom up to use a watched folder?	115
Workspace	117
THE MAIN WORKSPACE	117
Menu bar, Title bar and screen modes	118
Module Picker	118
Identity Plate / Activity Viewer	118
Panel Groups & Panels	120

Panel Auto Hide & Show	121	
Filmstrip	122	
Preview Area	123	
Toolbar	123	
Grid View & Filter Bar	124	
Loupe View, Info Overlay & Status Overlay	124	
Zooming using the Navigator panel	125	
THUMBNAILS	126	
Thumbnail (1)	128	
Cell Border (2)	128	
Index Number (3)	128	
Top Label (4)	128	
Flag (5)	128	
Metadata Status Icon (6)	129	
Quick Collection Marker (7)	130	
Badges (8)	130	
Video Icon (9)	130	
Rotation (10)	130	
Bottom Label (11)	131	
SELECTIONS 13		
What's the difference between the selection shades of grey?	131	
Why don't the rest of my photos deselect when I click on a single photo?	132	
How do I select multiple photos?	132	

	I've got multiple photos selected—why is my action only applying to a single photo?	132
٧	IEWING & COMPARING PHOTOS	133
	Grid View	133
	Compare View	134
	Survey View	135
	Loupe View	135
	Lights Out	135
W	ORKING WITH SLIDERS & PANEL ICONS	136
	Moving Sliders	136
	Resetting Sliders	137
	Disclosure Triangles	137
	Panel Switches	137
W	WORKING WITH DIALOGS	
	Saving Presets in Pop-Up Menus	138
	Renaming, Updating and Deleting Presets in Pop-Up Menus	138
	Using Tokens in Dialogs	139
SE	ECONDARY DISPLAY	139
	Which views are available on the Secondary Display? How are they useful?	140
	Why do shortcuts and menu commands only apply to a single photo even though I have multiple photos selected on the Secondary Display Grid?	141
	Why does the Secondary Display switch from Grid to Loupe when I change the Main Screen to Grid?	142
	What does 'Show Second Monitor Preview' do?	142

How do I move the Library Filter bar to the Secondary Display?	142
FREQUENT WORKSPACE QUESTIONS	143
My toolbar's disappeared—where's it gone?	143
How do I stop the panels opening every time I float near the edge of the screen?	143
Where have my panels gone?	143
Can I detach the panels and rearrange them?	143
Where have the Minimize, Maximize and Close Window buttons gone?	144
It's all gone black! How do I change the view back to normal?	144
I can see Badges in Grid view, but not in my Filmstrip. Where have they gone?	144
How do I turn off the overlay which says 'Loading'?	144
Is it possible to see camera setting information while in Develop module, rather than constantly switching back to the Metadata panel?	145
Why is there an exclamation mark near the preview in the Develop Module?	145
How do I bring back the warning dialogs I've hidden?	146
Why won't Lightroom show a dialog, such as the Export dialog?	146
Library Module	147
FOLDERS	147
Can I change the way the folders are displayed?	148
When I look at a parent folder in Grid view, I see the photos in the subfolders as well. Can I turn it off so I can only see the contents of the selected folder?	149
I have a long list of folders—can I change it to show the folder hierarchy?	149
Why aren't 'Add Parent Folder' and 'Promote Subfolders' showing in my context-sensitive menu?	151

	How do I expand or collapse all of a folder's subfolders in one go?	151
	How do I find out where a photo is stored on my hard drive?	152
	I've added new photos to one of Lightroom's folders—why don't they show in my catalog?	152
	How does the Synchronize Folder command work?	152
C	OLLECTIONS	154
	How are Collections different from Folders?	154
	How do I organize my collections into collection sets?	155
	How do I add photos to a collection?	156
	What are the Quick Collection and Target Collection?	156
	How do I see which collections a photo belongs to?	157
S.	TACKING	158
	How do I stack photos?	158
	Why are the stacking menu options disabled?	158
	How do I move a photo to the top of the stack?	158
	How do I apply metadata to multiple photos in a stack?	159
	I've placed retouched derivatives into the same folder as the originals and I'd like them stacked in pairs. Can I do it automatically?	159
	When I create a virtual copy, it should automatically stack them, but it hasn't—why not?	160
R	ATING & LABELING	160
	Which rating or labeling system should I use?	161
	How do I apply ratings and labels quickly?	162
	How do I use the Painter tool to quickly add metadata?	163

	Is it possible to view flag/rating/color labels status when in other modules?	163
	I've flagged my photos, but the flags disappear when I view these photos in another folder or collection—why?	164
	I gave my photos stars or color labels in Lightroom—why can't I see them in Bridge?	164
	I gave my photos different color labels in Lightroom—why are they all white in Bridge Or I labeled my photos in Bridge—why isn't Lightroom showing my color labels?	e? 164
	Lightroom's not quick enough to sort through a large shoot—is there anything I can do to speed it up?	165
R	ENAMING, MOVING & DELETING	166
	How do I rename one or more photos?	166
	How do I move or copy photos between folders?	167
	When I delete photos, am I deleting them only from Lightroom, or from the hard drive too?	e 168
	Why can't I delete photos from the hard drive when I'm viewing a collection?	168
	I'm deleting photos in Lightroom, set to send to Recycle Bin/Trash, so why isn't it deleting them?	169
	I accidentally deleted my photos from my hard drive and I don't have backups! Can I create JPEGs from Lightroom's previews?	169
VI	IEWING & EDITING METADATA	170
	How do I add metadata to multiple photos at once?	170
	How do I create a Metadata preset?	171
	How do I select which metadata to view in the Metadata panel?	172
	Can I import and listen to my camera's audio annotations?	172
	Why do some files say CR2+JPEG and some just say CR2?	173
	Some of my lenses are listed twice in the Metadata filters, for example 24.0-105.0 mm and also as EF24-105 IS USM. Why?	173

K	KEYWORDING	
	How should I keyword my photos?	173
	How do I change my long list of keywords into a hierarchy? Or change the existing hierarchy?	175
	How many keywords can I have?	176
	How can I keep certain keywords at the top of the list?	176
	Is there a quick way of finding a particular keyword in my long list?	176
	What do the symbols in the Keyword panels mean?	177
	Is there an easier way to apply lots of keywords in one go, other than typing or dragging them all?	178
	Why are there only 9 keywords in the Keywords panel?	179
	I mistyped a keyword and now Lightroom keeps suggesting it—how do I clear the autofill?	179
	Is it possible to display all of the photos in a catalog that aren't already keyworded?	180
	I use multiple catalogs, but I'd like to keep my keyword list identical and current across all of the catalogs—is there an easy way?	180
	How do I import my keywords from Bridge?	181
	If I can import keywords from Bridge using a text file, does that mean I can create my keywords manually using a text file and then import them into Lightroom?	182
ΕC	DITING THE CAPTURE TIME	182
	What do the different options in the Edit Capture Time dialog do?	183
	The time on my camera was incorrect—how do I change it?	183
	How do I sync the times on two or more cameras?	185
M	MANAGING VIDEOS 1	
	What can I do with my imported videos?	186

	How I do change which program opens my videos?	186
S	ORTING, FILTERING & FINDING PHOTOS	187
	How do I change my sort order?	187
	Can I set a default sort order regardless of folder?	187
	How do I sort my entire catalog from earliest to latest, regardless of their folders?	187
	Why can't I drag and drop into a custom sort order or User Order?	188
	Why does Lightroom add new photos to the end of the sort order when editing in Photoshop?	188
	Why does my filter disappear when I switch folders?	189
	What does the Filter Lock icon in the Filter bar do?	189
	How do I filter my photos to show photos fitting certain criteria?	189
	Can I save the filters I use regularly as presets?	191
	How can I view all of the photos tagged with a specific keyword or keyword combination?	191
	How do I filter my photos to show just one flag/color label/rating?	191
	Can I select all photos with a specific flag, color label or rating without changing the filtering?	192
	How can I use the Text filters to do AND or OR filters?	192
	How do I change the Metadata filter columns?	194
	How do I select multiple options within the Metadata filter columns?	194
	Can I combine Text filters, Attribute filters, and Metadata filters?	195
	How do I search for a specific filename?	196
SI	MART COLLECTIONS	196
	Why would I use smart collections instead of standard collections or filters?	196

	How do I create smart collections?	197
	How do I transfer smart collection criteria between catalogs?	198
Ql	JICK DEVELOP	198
	Why is the Quick Develop panel so useful?	199
	Why am I missing some Quick Develop buttons?	199
	Can I adjust any other sliders using Quick Develop?	200
МІ	ISSING FILES	200
	Lightroom thinks my photos are missing—how do I fix it?	200
	How do I prevent missing files?	201
	Why does Lightroom keep changing my drive letters and losing my files?	202
	Where has the Missing Files collection gone? How do I find all of the missing files in my catalog now?	202
	I've renamed the files outside of Lightroom and now Lightroom thinks the photos are missing. Is it possible to recover them?	203
	I've deleted some renamed photos. I do have backups but they have the original filenames, so Lightroom won't recognize them. Is it possible to relink them?	203
or	king with Catalogs	205
MA	ANAGING CATALOGS	205
	How do I create a new catalog and switch between catalogs?	206
	Why do I have a few different files for my catalog?	207
	What does the catalog contain?	207
	Is there a maximum number of photos that Lightroom can hold?	208

Is there a maximum number of photos before Lightroom's performance starts to degrade?	208
Is there a maximum image size that Lightroom can import?	209
Can I move or rename my catalog?	209
How do I set or change my default catalog?	209
How can I remove everything I've done and start again?	210
What general maintenance will keep my catalogs in good shape?	210
Why can't I open my catalog?	211
CATALOG CORRUPTION	212
How do catalogs become corrupted?	212
How can I keep my catalogs healthy and prevent corruption?	212
Lightroom says that my catalog is corrupted—can I fix it?	213
SINGLE OR MULTIPLE CATALOGS	215
Should I use one big catalog, or multiple smaller catalogs?	215
Can I search across multiple catalogs?	217
How do I set default Catalog Settings to use for all new catalogs?	217
I seem to have 2 catalogs. I only use 1, so can I delete the other?	218
Taccin to have 2 catalogs. Formy ase 1,500 carried and outside	210
How do I split my catalog into multiple smaller catalogs?	218
How do I split my catalog into multiple smaller catalogs?	218
How do I split my catalog into multiple smaller catalogs? How do I merge multiple catalogs into one larger catalog?	218 219
How do I split my catalog into multiple smaller catalogs? How do I merge multiple catalogs into one larger catalog? How do I transfer photos between catalogs?	218 219 219

	Does Lightroom back up the photos as well as the catalog?	222
	How do I back up Lightroom?	222
	I back up photos using the Import dialog—isn't that enough?	223
	How often should I back up my catalog?	224
	Where does Lightroom save the backups?	224
	How do I change the backup location?	225
	Should I turn on 'Test integrity' and 'Optimize catalog' each time I back up?	225
	Can I delete the oldest backups?	225
	Is it safe to have Time Machine back up the catalog?	226
	I'm worried about keeping all changes in one catalog—are there any other options?	226
	I haven't got time to back up now—can I postpone the backup?	226
	Why does Lightroom say it's 'unable to backup'?	227
	my does right oom say it's anable to backup:	221
RE	ESTORING BACKUPS	227
RE		
RE	ESTORING BACKUPS	227
RE	How do I restore a catalog backup?	227 228
	How do I restore a catalog backup? How do I restore everything from backups?	227 228 228
	How do I restore a catalog backup? How do I restore everything from backups? If I'm restoring from backups, does the catalog or the XMP data take priority?	227228228229
	How do I restore a catalog backup? How do I restore everything from backups? If I'm restoring from backups, does the catalog or the XMP data take priority? OVING LIGHTROOM ON THE SAME COMPUTER How do I move only my catalog to another hard drive, leaving the photos where	227228228229229
	How do I restore a catalog backup? How do I restore everything from backups? If I'm restoring from backups, does the catalog or the XMP data take priority? OVING LIGHTROOM ON THE SAME COMPUTER How do I move only my catalog to another hard drive, leaving the photos where they are? How do I move only my photos to another hard drive, leaving the catalog where	227228228229229230
м	How do I restore a catalog backup? How do I restore everything from backups? If I'm restoring from backups, does the catalog or the XMP data take priority? OVING LIGHTROOM ON THE SAME COMPUTER How do I move only my catalog to another hard drive, leaving the photos where they are? How do I move only my photos to another hard drive, leaving the catalog where it is?	227228229229230230

	How do I move my catalog & photos from Windows to Mac or vice versa?	234
W	ORKING WITH MULTIPLE MACHINES	234
	How does Export as Catalog work?	234
	What are the limitations of offline files?	235
	How does Import from Catalog work?	236
	I need to work on my photos on my desktop and my laptop—what are my options?	237
	How do I use a portable catalog with originals, for example, the whole catalog on an external drive with the photos?	238
	How do I use a portable catalog without originals, for example, the whole catalog copied without the photos?	238
	How do I upload and start editing on my laptop, and then transfer that back to the main catalog?	239
	How do I export part of my catalog to another computer and then merge the changes back later?	239
	How can I use my presets on both computers?	240
	Can I synchronize two computers?	241
ΧI	МР	241
	Why would I want settings written to XMP?	242
	Which of Lightroom's data isn't stored in XMP?	242
	Where are the XMP files for my JPEG/TIFF/PSD/DNG files?	242
	How do I write settings to XMP?	243
	Should I turn on 'Automatically write changes into XMP'?	243
	What's the difference between 'Write Metadata to Files' and 'Update DNG Preview & Metadata'?	244
	Should I check or uncheck 'Include Develop settings in metadata inside JPEG, TIFF, and PSD files'?	244

	How do XMP files relate to the catalog?	245
	Can I view the content of my XMP sidecar files?	245
	XMP has been updated on another program or computer. Why don't the changes show in Lightroom?	246
	Lightroom says it can't write to XMP—how do I fix it?	246
	NETWORKING	247
	Can I share my catalog with multiple users on the same machine?	247
	Can one catalog be opened simultaneously by several workstations across a network?	247
	Is it possible to have the catalog stored on a Network Accessible Storage unit (NAS) but open it on a single machine?	248
	Is it possible to use XMP files to allow some degree of sharing across the network?	248
	OFFLINE ARCHIVES	251
	How do I archive photos to offline hard drives?	251
	How do I archive photos to CD/DVD/Blu-Ray?	252
Pr	eviews & Speed	253
	PREVIEWS	253
	What's the difference between Minimal, Embedded & Sidecar, Standard and 1:1 previews?	253
	What size and quality should I set for Standard-Sized Previews?	255
	When I choose Render 1:1 Previews from the Library menu, does it apply to the entire catalog or just the selected photos?	255
	The previews folder is huge—can I delete it?	256
	If I delete a photo, is the preview deleted too?	256

	I've discarded 1:1 previews—why hasn't the file/folder size shrunk?	256
	Can I move the previews onto another drive?	257
PF	REVIEW PROBLEMS	257
	Why do I just get grey boxes instead of previews?	257
	Everything in Lightroom is a funny color, but the original photos look perfect in other programs, and the exported photos don't look like they do in Lightroom either. What could be wrong?	258
	How do I change my monitor profile to check whether it's corrupted?	259
	How should I calibrate my monitor?	260
	The previews are slightly different between Library and Develop and Fit and 1:1 views—why is that?	260
	My photos have imported incorrectly rotated and distorted—how do I fix it?	262
SF	PEED TIPS	263
	How can I get Lightroom to import faster?	263
	How can I speed up browsing in Library module?	263
	How can I speed up moving files between folders?	264
	It's taking forever to delete photos—should it really take this long?	265
	How can I speed up browsing in Develop module? And what are these Cache*.dat files?	265
	Are there any other Lightroom tweaks to make it run faster?	268
	Are there any hardware or operating system tweaks to make Lightroom faster?	268

Develop Module	
RAW FILE RENDERING	271
Why do my raw photos change color? When the first preview appears, it looks just like it did on the camera—how do I stop it changing?	272
I set my camera to black & white. Why is Lightroom changing them back to color?	273
How do other programs like iView, PhotoMechanic, Apple's Preview, Windows Explorer, Breezebrowser, etc., get it right?	273
There are some hot pixels on my sensor in other programs, but I can't see them in Lightroom. Where have they gone?	274
PROCESS VERSIONS	274
Which settings are affected by the Process Version?	275
Which Process Version should I use?	275
How do I switch between PV2003 and PV2010?	275
Why are my new imports set to Process Version 2003?	276
WHITE BALANCE	276
Where should I be clicking with the White Balance Eyedropper?	277
The White Balance Eyedropper disappears every time I click anything—how do I keep it turned on?	277
Why don't the Temp and Tint sliders have the proper white balance scale when I'm working on JPEGs?	278
Where have the other White Balance presets gone, such as Cloudy and Flash?	278
Why is Lightroom showing different Kelvin values than I set in my camera custom white balance?	278
Can I change the eyedropper averaging?	279
How do I adjust for an extreme white balance, under 2000k or over 50000k?	279

BASIC ADJUSTMENTS	279
What's the difference between Exposure and Brightness?	280
Why does the Recovery slider add a colored tint?	281
Fill Light creates halos and drops the contrast too far—is there an easy solution	n? 281
What does the Clarity slider do?	282
What's the difference between Vibrance and Saturation?	283
WORKING WITH SLIDERS & TARGETED ADJUSTMENT TOOL	283
The slider movements are too coarse—how can I adjust them?	283
How do I apply Auto settings to individual sliders?	284
Does it matter in which order I apply sliders?	286
How do I use the TAT, or Targeted Adjustment tool?	286
TONE CURVES	287
How do I use the standard Parametric Tone Curve?	287
What do the three triangular sliders docked at the base of the Tone Curve do?	287
How do I use the Point Curve?	288
Where have the Tone Curve sliders gone?	288
HSL, COLOR, B&W & SPLIT TONING	288
What is the HSL panel used for?	289
What's the difference between the HSL and Color panels?	290
How do I create a Black & White photo?	290
How do I use the Split Tone panel?	290
How do I create a Sepia photo?	291

A	DJUSTING MULTIPLE PHOTOS	291
	How do I copy or synchronize my settings with other photos?	291
	Why won't my white balance sync?	294
	What does 'Match Total Exposure' in the Settings menu do?	294
	Can I make relative adjustments, for example, brighten all selected photos by 1 stop?	295
ВІ	EFORE / AFTER VIEWS	295
	Can I see a Before / After preview?	295
	Can I change the 'Before' state to something other than the Import state?	295
	Can I turn off the effect of a whole panel's settings, to see the preview with and without those settings?	296
н	ISTOGRAM & RGB VALUES	296
	Is it possible to see clipping warnings? Or, why are there red and blue areas on my photos?	298
	Why does the Histogram look different when I open the exported sRGB photo in Photoshop? Why are my highlights clipping in Photoshop but not in Lightroom?	298
	Can I view RGB values using a normal 0-255 scale?	300
PF	RESETS	300
	Where can I download Develop presets?	300
	How do I install Develop presets?	301
	How do I preview and apply presets to my photos?	301
	How do I create my own Develop Presets?	302
	How can I organize my presets into folders or groups?	303
	How do I rename Develop presets?	303
	How do I remove the default Develop presets?	303

	How do I uninstall Develop presets?	304
	Where have my presets gone?	304
	Can I apply multiple presets to the same photo, layering the effects?	305
	I have some Develop presets that I use in ACR in CS4—can I use them in Lightroom?	305
	Why do my presets look wrong when used on JPEG/TIFF/PSD files, even though they work on raw files?	305
	Is there a way to add a keyboard shortcut to a preset?	306
D	EFAULTS	306
	Why would I change the default settings instead of using a preset?	306
	How do I change the default settings?	307
	Why would I want different defaults for each ISO and serial number combination?	308
	Why don't all of the sliders default to 0?	308
	What settings should I use as the defaults?	308
SI	NAPSHOTS & VIRTUAL COPIES	308
	Why would I want to use virtual copies?	309
	When would I use a snapshot instead of a virtual copy?	310
	Can I rename virtual copies?	310
	Can I turn virtual copies into snapshots and vice versa?	311
	Can I swap virtual copies for masters and vice versa?	311
	What do Sync Copies and Sync Snapshots do?	312
Н	ISTORY & RESET	312
	How do I reset a single slider or panel section to its default setting?	312
	How do I reset photos back to their default settings?	313

	If I don't like the last adjustment I made, can I just undo that step, rather than resetting everything?	313
	How long do the adjustments stay in the History panel?	314
D	ETAIL—SHARPENING & NOISE REDUCTION	314
	Why are my pictures softer and noisier than other programs?	314
	What is multiple pass sharpening?	314
	How do the sharpening sliders interact?	315
	Can I apply or remove sharpening selectively?	316
	How do I use the different Noise Reduction sliders?	317
	I've turned sharpening and noise reduction right up to the maximum, but it doesn't seem to be doing anything—why not?	318
	Why is the Noise Reduction sometimes visible in Fit View and other times only visible in 1:1?	318
		310
LI	ENS CORRECTIONS	319
LI		
LI	ENS CORRECTIONS	319
LI	ENS CORRECTIONS How do I apply lens corrections to my photo?	319
LI	ENS CORRECTIONS How do I apply lens corrections to my photo? Why is the lens profile not selected automatically?	319 319
LI	ENS CORRECTIONS How do I apply lens corrections to my photo? Why is the lens profile not selected automatically? How do I set a default lens profile?	319 319 319 320
LI	How do I apply lens corrections to my photo? Why is the lens profile not selected automatically? How do I set a default lens profile? In the Setup pop-up menu, what's the difference between Default, Auto & Custom?	319 319 319 320 320
LI	How do I apply lens corrections to my photo? Why is the lens profile not selected automatically? How do I set a default lens profile? In the Setup pop-up menu, what's the difference between Default, Auto & Custom? How do the Amount sliders interact with the profile? Can I use the profiled lens corrections to correct the chromatic aberrations without	319 319 320 320 321
LI	How do I apply lens corrections to my photo? Why is the lens profile not selected automatically? How do I set a default lens profile? In the Setup pop-up menu, what's the difference between Default, Auto & Custom? How do the Amount sliders interact with the profile? Can I use the profiled lens corrections to correct the chromatic aberrations without removing the distortion? Why have the lens corrections created new chromatic aberration and vignetting	319 319 320 320 321

	What are my options if my lens profile isn't available?	322
	What do the Manual Lens Corrections sliders do?	322
	How is the Rotate slider different from Straighten in the Crop options?	323
	How is the Scale slider different to cropping?	324
	What does the 'Constrain Crop' checkbox do?	324
	Why doesn't the Lens Correction Vignette adjust to the Crop boundaries?	324
	How do I fix Chromatic Aberration?	325
	Can I save Manual lens corrections as defaults for lenses?	325
	When in my workflow should I apply lens corrections?	325
	How do I turn off the grid overlay?	326
	How do I create a Lens Profile using the Lens Profile Creator?	326
	Does it matter which camera body is used when creating a lens profile?	326
EI	FFECTS—POST-CROP VIGNETTE & GRAIN	327
	What's the difference between Highlight Priority, Color Priority and Paint Overlay?	327
	How do the Post-Crop Vignette sliders interact?	328
	How do the Grain sliders interact?	328
	Why does my grain not always look exactly the same in the exported file as in the Develop preview?	328
C	ALIBRATION PROFILES & STYLES	329
	How do I install and use the profiles?	329
	Which are the profiles for my camera?	329
	Why does my Nikon D300 have D2X profiles?	330
	Why does the profile pop-up menu just say 'Embedded'?	330

	Why do I only have Matrix listed?	330
	The ACR version number in the Calibration section is an old version—how do I update it?	330
D	NG PROFILE EDITOR	330
	Why is the DNG Profile Editor better than the Calibration sliders?	331
	Can I use the profiles on proprietary raw files, not just DNG?	331
	Why doesn't it use ICC profiles?	331
	Where do I download the DNG Profile Editor?	333
	How do I use the DNG Profile Editor? It looks complicated!	333
	Is there a simpler way of creating a DNG Profile for my camera?	335
CROPPING 3:		336
	Why does the crop go in the wrong direction when I try and move the grid around?	336
	How do I crop a vertical portion from a horizontal photo?	337
	Can I zoom while cropping?	337
	How can I change the default crop ratio?	337
	How do I set a custom crop aspect ratio?	338
	How do I delete a custom crop aspect ratio?	338
	How do I set my crop grid back to thirds or bring the Crop Overlay back when it goes missing?	338
	Is it possible to change the Crop Overlay color?	338
	How do I straighten or rotate a photo?	339
	Can a crop be saved in a preset?	340
	Is there a way to see what the new pixel dimensions will be without interpolation?	340

S	POT REMOVAL—CLONE & HEAL TOOLS	340
	How do I retouch a spot?	341
	How do I adjust the brush size or the size of an existing spot?	341
	How do I adjust the opacity of an existing spot?	342
	How do I move or delete an existing spot?	342
	Can I copy or synchronize the clone/heal spots?	342
R	ED EYE REDUCTION TOOL	342
	How do I work the Red Eye Reduction tool?	343
	Lightroom's Red Eye Reduction tool can't lock on to the red eye—is there anything I can do to help it?	343
	Why doesn't the Red Eye Reduction tool work properly on my dog's red eye?	343
L	OCAL ADJUSTMENTS—GRADUATED FILTER & ADJUSTMENT BRUSH	343
	Why would I use the Graduated Filter & Adjustment Brush rather than editing a photo in Photoshop?	344
	How do I create a new brush mask?	345
	What do Size and Feather do?	345
	What's the difference between Flow & Density?	346
	Is the Adjustment Brush pressure sensitive when used with a graphics pen tablet?	347
	What does Auto Mask do?	347
	Why are there speckles in the brushed area?	347
	How can I tell if I'm applying a color tint when using the Adjustment Brush?	347
	Can I select a color tint from the photo itself?	347
	Can I brush on a lens blur effect?	348

	Detail and Masking?	348
	Where have my mask pins gone?	349
	How can I tell whether I'm creating a new mask or editing an existing mask?	349
	How do I reselect and edit an existing mask?	349
	How do I create a new gradient mask?	350
	How do I adjust an existing gradient?	350
	How do I show the mask I've created?	350
	Can I change the color of the mask overlay?	351
	How do I fade the effect of an existing mask?	351
	Can I layer the effect of multiple masks?	351
	Can I invert the mask?	352
	Can I synchronize my settings with other photos?	352
	Can I save my Adjustment Brush strokes in a preset?	352
Edi	ting in Other Programs	353
EI	DITING IN OTHER PROGRAMS	353
	How do I change my Edit in file settings?	353
	In the Edit in options, should I choose TIFF or PSD?	354
	Can I have more than two External Editors?	354
	How do I get Lightroom to use a different version of Photoshop?	355
	Lightroom can't find Photoshop to use Edit in Photoshop—how do I fix it?	356
	Can I open the raw file into another raw processor?	356

Why isn't Lightroom creating a TIFF or PSD file according to my preferences?	357	
How do I open my layered file back into Photoshop without flattening it?	357	
What's the difference between 'Edit Original,' 'Edit a Copy,' or 'Edit a Copy with Lightroom Adjustments'?	358	
What do the other options in the Edit in menu do?	358	
ADOBE CAMERA RAW COMPATIBILITY FOR PHOTOSHOP	359	
How do I check which Lightroom and ACR versions I have installed?	360	
Which ACR version do I need for the settings to be fully compatible?	360	
What happens if I'm still using an older version of ACR and Photoshop?	361	
What's the difference between 'Render Using Lightroom' and 'Open Anyway' in the ACR mismatch dialog?	362	
Can I open a raw file directly into the ACR dialog?	363	
Rendered Files (JPEG/TIFF/PSD)	364	
Raw Files	365	
If I use ACR to convert, having created XMP files, will the result be identical to Lightroom?	366	
I'd prefer to let Bridge run the conversion to JPEG using Image Processor to run an action. Is it possible?	366	
Why is Bridge not seeing the raw adjustments I've made in Lightroom?	366	
Export	367	
EXPORT LOCATIONS & FILE NAMING	367	
Can I set Lightroom to automatically export back to the same folder as the original?	367	
Can I set Lightroom to automatically re-import the exported files?	368	
Why is the 'Add to Stack' checkbox unavailable?	369	
	Can I set Lightroom to overwrite the original when exporting?	369
-------------	---	-----
	Can I stop Lightroom asking me what to do when it finds an existing file with the same name?	369
	How do I burn the exported files to CD or DVD?	369
	How do I change the filename while exporting?	370
FI	LE SETTINGS	370
	What's the equivalent of JPEG quality?	371
	How do I set Lightroom to a JPEG level 0-12 so that Photoshop doesn't ask me every time I save?	371
	If a photo is imported as a JPEG, and it's not edited it any way, is what I am exporting identical to what I imported?	371
	Why won't Photoshop allow me to save my Lightroom file as a JPEG?	372
	Should I choose 8-bit or 16-bit?	372
	I am a high volume photographer (weddings, etc.)—do I have to convert to PSD or TIFF for light retouching, or can I use JPEG?	374
COLOR SPACE		375
	Which color space should I use?	376
	Why do my photos look different in Photoshop?	377
	Why do my photographs look different in Windows Explorer or on the Web?	380
	Can I export with a custom ICC profile?	381
SI	ZING & RESOLUTION	381
	What's the difference between Width & Height, Dimensions, Longest Edge & Shortest Edge?	382
	When I enter 4x6 as my output size, why do the vertical photos become 4x6 but the horizontal photos become 2.5x4?	383
	What does the 'Don't Enlarge' checkbox do?	384

	What PPI setting should I enter in the Export dialog?	384
	I set the export PPI to 300—why is it 72ppi when I open it in Photoshop?	386
	When I crop to 8x10 in Lightroom and then open in Photoshop, why is it not 8"x10"?	386
	Is it better to upsize in Lightroom or in Photoshop?	387
	Can I export to a specific file size?	387
0	UTPUT SHARPENING	388
	Why does the Export Sharpening only have a few options? How can I control it?	388
	Which Export Sharpening setting applies more sharpening—screen, matte or glossy?	388
C	OPYRIGHT & WATERMARKING	389
	How do I create a basic watermark?	389
	Are the watermarks intelligent for vertical and horizontal images?	390
	Which file formats can I use for the graphical watermark?	391
	Can I overwrite an existing watermark?	392
	What is 'Simple Copyright Watermark' in the watermark menu?	392
	Where can I use my watermarks?	393
	How do I change the watermark placement for each photo?	393
	Can I create more complex watermarks, such as text and a graphic?	393
P	OST-PROCESSING ACTIONS & DROPLETS	394
	How do I get Lightroom to attach the exported files to an email?	394
	Can I run a Photoshop action from Lightroom?	395
	The droplet runs, but it doesn't save—what have I done wrong?	397
	The droplet runs, but it keeps asking what JPEG compression to use—what have I done wrong?	397

Why is Flickr the only website? Where's my favorite photo sharing website?	407
SETTING UP YOUR PUBLISH SERVICES	407
Publish Services	407
The files appear in the export folder and then disappear again. Why is Lightroom deleting them?	406
It gives an error message—'Some export operations were not performed. The file could not be written.' or 'The file could not be found.' What went wrong?	406
Why can't CS2 save as JPEG when I've used Local Adjustments on the photo?	404
Can I strip the metadata from my files, like Save for Web in Photoshop?	404
Do I have to use the Export dialog every time I export?	404
Can I save my Export settings as a preset?	403
OTHER EXPORT QUESTIONS & TROUBLESHOOTING	403
Can I export directly to an FTP server?	403
How do I use Export plug-ins?	402
Why can't I remove this Export plug-in?	401
Where should I store my plug-ins?	401
How do I install Export plug-ins?	400
What plug-ins are currently available?	399
PLUG-INS	399
In my droplet I used a 'Save for Web' instead of a standard 'Save As'—why won't it overwrite the original file?	398
The droplet only works on some of the photos and then stops—what's wrong?	398
The droplet doesn't run at all—why not?	397

	What can I use the Hard Drive option for?	408
	How do I set up my Publish Services accounts?	408
	Can I choose the size of the photos to upload?	410
	How do I prevent it uploading a particular version of a photo?	411
	How do I control which keywords are visible on my published photos?	411
	Which settings should I use for Privacy & Safety?	411
C	REATING COLLECTIONS & PHOTOSETS	412
	Can I divide my photos into different sets?	412
	How do I add photos into a photoset that already exists on Flickr?	412
	I didn't mean to remove a photo from a photoset—how do I restore it?	413
S	YNCHRONIZING CHANGES	413
	How do I publish to Flickr or my hard drive?	413
	Does it automatically publish changes I make to my photos?	413
	How do I update Flickr or my hard drive with the changes I've made to my photos?	414
	How do I remove photos from my Lightroom catalog without removing them from Flickr?	414
	I deleted a photo on the Flickr web interface—how do I upload it again?	415
	What happens if I rename a photo and then republish it?	415
	Can I use Export as Catalog to transfer my Publish collections between catalogs?	415
F	LICKR ACCOUNT QUESTIONS	415
	What are the limitations of the Free vs. Pro Flickr accounts?	415
	How do I upgrade Lightroom to a Pro account?	416
	Can I have more than one Flickr account connected to my catalog?	416

Can I have the same Flickr account connected to multiple catalogs?	416
How do I disconnect Lightroom from my Flickr account?	417
I accidentally revoked the authorization on Flickr's website—how do I fix it?	417
PUBLISH SERVICES TROUBLESHOOTING	417
Why is the new Comments panel unavailable?	417
Why is there a question mark on my Flickr service?	418
What does 'Flickr API returned an error message (function upload, message Not a Pro Account)' mean?	418
Slideshow Module	419
STYLES & SETTINGS	419
How do I create my first slideshow?	419
How do I add my Identity Plate to my slideshow?	420
How do I adjust the anchor point?	421
How do I add captions to the slides?	421
How do I change the font on my text overlays?	422
How do I remove the quotation marks when a caption is blank?	422
How do I change the background?	423
What does 'Zoom to Fill Frame' do?	423
Can I add Intro and Ending slides?	424
Can I advance the slides manually, but still have them fade from one to the next?	424
Can I rate photos while a slideshow is running?	424
How do I make the slideshow display on my second screen?	425

M	IUSIC	425
	How do I select or change the music track?	425
	Which music formats can Lightroom play?	425
	How do I adjust the slide timings to fit the length of the music track?	425
	Why can't Lightroom find my iTunes playlists?	426
	How do I play multiple different music tracks during my slideshow?	426
S	AVING & EXPORTING SLIDESHOWS	426
	Can I save my settings for a specific slideshow?	427
	How do I save my settings as a template for use on other photos?	427
	Can I export my slideshow to run in a DVD player?	428
	Can I export my slideshow for viewing on the web?	428
	Can I export the slideshow with the music?	428
	Where has the 'Export to JPEG' option gone?	428
	I exported to PDF, but it doesn't automatically start the slideshow when I open the PDF. Why not?	429
	Which movie size option should I choose?	429
EI	RRORS	430
	Why does it stall part way through the slideshow or go much slower than the times I'd chosen?	430
	Everything appears to be running correctly, then the screen just goes plain grey or black when I try to running the slideshow. Why?	430
	Why is my noise reduction and sharpening not applied to my slideshow?	430

rint Module	
LAYING OUT YOUR PHOTOS	431
How do I set up a single borderless print, for example, a 4x6 snapshot?	431
How do I change the page size?	432
How do I create a contact sheet?	432
How can I change the order of contact sheet photos?	433
How do I use Picture Package?	433
What does the exclamation mark in the top right corner mean?	434
How do I create a Custom Package?	434
What's a pinned or anchored cell?	434
How do I replace a photo in an existing cell?	434
How do I see the cell size?	435
How can I stop the photos being cropped by the cells?	435
How do I rotate a photo within a cell?	435
How do I move a photo within a cell?	435
How do I scroll through custom package pages?	436
Can I use the Print module to design albums and books?	436
STYLES & SETTINGS	437
How do I add the filename and watermark to my contact sheet?	437
Is it possible to personalize my print by changing the background color?	438
How can I overlay a graphic such as a border onto my print?	438
With 1 photo on a sheet, I can place the Identity Plate anywhere on the photo. Is that possible for multiple photos?	439

	see them?	440
	How can I save my Print settings for later?	440
PI	RINTING	441
	Why do Page Setup, Print Settings and Print buttons show the same dialog?	441
	Which Print Sharpening option do I choose?	441
	When should I turn on 16-bit printing?	442
	What is 'Draft Mode Printing'?	442
	How do I set up my printer to match the preview I see on screen?	442
	Why do Lightroom's prints not match the preview on screen?	444
	How do I print to a file such as a JPEG to send to my lab?	444
	How do I get Lightroom to see my custom printer profile?	445
	Why does my custom ICC printer profile not show in Lightroom's list of profiles?	446
/e	b Module	447
	tyles & Settings	447
	TYLES & SETTINGS	447
	TYLES & SETTINGS How do I create my first web gallery?	447
	TYLES & SETTINGS How do I create my first web gallery? How can I change a web gallery I've already created?	447 447
	TYLES & SETTINGS How do I create my first web gallery? How can I change a web gallery I've already created? How do I save my settings as a template for use on other photos? The default flash gallery appears to be capped at 500 photos—how do I increase	447 447 448 449

ADDITIONAL GALLERIES	451
Where can I download additional web galleries?	451
Are there any web galleries with download links or an integrated shopping cart such as PayPal?	452
How do I install new web galleries?	452
When using some third party galleries, the panels are clipped—can they be resized?	? 453
EXPORTING & UPLOADING	453
How do I upload my gallery?	453
Why doesn't the FTP upload work—it says 'Remote Disc Error'?	455
Why are my FTP settings not saved in the templates?	455
Can I have multiple galleries on my website?	455
Is it possible to embed a web gallery into an existing website or webpage?	456
I changed an existing gallery—why hasn't it changed on the website?	456
Troubleshooting & Useful Information	457
TROUBLESHOOTING STEPS	457
I have a problem with Lightroom—are there any troubleshooting steps I can try?	457
How do I delete the Preferences file?	459
What is deleted when I delete my Preferences file?	459
I installed Lightroom, but it says 'An error occurred while attempting to change modules'. How do I fix it?	459
It says 'There was an error working with the photo' or there's an exclamation mark in the corner of the thumbnail and a small fuzzy preview. What's wrong?	460

PREFERENCES & SETTINGS	461
Lightroom Preferences & Catalog Settings are	461
Photoshop Preferences are	461
Photoshop Color Settings are	461
DEFAULT FILE LOCATIONS	461
The default location of the Lightroom catalog is	462
The default location of the Preferences is	462
The default location of the Presets is	463
The default location of the Camera Raw Cache is	464
The default locations of the Adobe Camera Raw & Lens Profiles are	464
Your custom Camera Raw & Lens Profiles can also be installed to the User folders	464
64-BIT	465
How do I install the 64-bit version?	465
Lightroom isn't certified for XP x64—does that meant it won't run?	466
My Mac version doesn't have an 'Open as 32-bit' checkbox. Why not?	466
How can I check whether I'm running the 32-bit or 64-bit version?	466
INITIAL INSTALLATION	467
Should I buy the download or the boxed version?	467
Do I have to install the 3.0 version from my CD before installing updates?	467
Why won't Lightroom 3 install on my Mac?	467
UPGRADING FROM LIGHTROOM 1, 2, OR VERSION 3 BETA	468

	Do I have to install Lightroom 1 or 2 if I purchased an upgrade version?	468
	If I install Lightroom 3, will it overwrite my current 1.x or 2.x version?	468
	Which catalog versions will upgrade to 3.0?	468
	How do I upgrade my catalog from version 2 to version 3?	469
	If I upgrade, can I go back to version 2?	470
	Do I have to upgrade a catalog before I can import it into version 3 using Import from Catalog?	470
	What happens if I try to upgrade a catalog that I've already upgraded?	471
	Can I delete my previous installations?	472
IN	NSTALLING, UPDATING & DOWNGRADING	472
	How do I check which update I'm currently running?	472
	How do I find out whether my new camera is supported yet?	473
	How do I update Lightroom with the latest version of ACR?	473
	How do I update to a newer Lightroom dot release?	473
	How do I downgrade to an earlier Lightroom dot release in the case of problems?	473
L	ANGUAGES	474
	How do I switch language?	474
	Some of the shortcuts don't work with my language version or non-English keyboard—can I fix it?	475
LI	CENSING INFORMATION	476
	I'm switching from PC to Mac—how do I switch my Lightroom license?	476
	How many machines can I install Lightroom on?	477
	How do I deactivate Lightroom to move it to another machine?	477

FINAL WORDS	478
Where else can I go to find solutions to my problems that aren't covered here?	478
I've got a great idea, or I've found a repeatable bug—how do I tell Adobe?	478
Keyboard Shortcuts	479
Keyboard Shortcuts	479
Standard Modifier Keys	488
Index	489

Acknowledgements

It's funny, I still stare at my Missing FAQ books on the shelf and wonder whether I really wrote them. I did, honestly—I have the grey hairs to prove it!

But I've had a lot of help along the way, for which I'm very grateful.

I'd never have started this project if Lightroom users on various forums hadn't given me so much encouragement, so I have to start by thanking the members of Digital Wedding Forum and Lightroom Forums for constantly challenging me with questions, problems to solve, and giving me the idea for this book.

I couldn't go without thanking the Lightroom engineering and QE teams who created our favorite program, especially Tom Hogarty, Mark Hamburg, Troy & Melissa Gaul, Dan Tull, Eric Chan, Eric Scouten, Julie Kmoch and Becky Sowada who have willingly answered my endless questions.

Thanks are also due to the team of Lightroom Gurus, who are always happy to discuss, debate and share their experience, especially Jeff Schewe, Andrew Rodney, Peter Krogh, Ian Lyons, Jeffrey Friedl, Sean McCormack, John Beardsworth, Mark Sirota, Lee Jay Fingersh, Brad Snyder, Don Ricklin, Gene McCullagh, Gilles Theophile, John Hollenberg and the rest of the crew!

Of course, then there are those who have helped put this book together. Many thanks go to Paul McFarlane, who did a great job of proof-reading and untangling my scribbles, cheered me up when I was shredding drafts that weren't quite working, and most importantly provided the HobNobs™ biscuits that fueled this project! Also Petra Hall, who stepped in to assist with the design at short notice, Erik Bernskiold who designed the cover, and Denis Pagé who has the most incredible eye for detail.

And finally I have to thank you, the Reader. This book has been completely rewritten since the Lightroom 3 beta 2 release, based entirely on the suggestions and questions that you've sent in. The lovely emails I've received make all the late nights and early mornings worthwhile—so thank you.

Adobe Lightroom 3 - The Missing FAQ			
	*		

Introduction

Adobe® Photoshop® Lightroom™ 1.0 was released on February 19th 2007, after a long public beta period, and it rapidly became a hit. Thousands of users flooded the forums looking for answers to their questions. In the 3½ years that have followed, Lightroom has continued to gain popularity, becoming the program of choice for amateur and professional photographers alike.

When you have a question or you get stuck with one of Lightroom's less intuitive features, where do you look? Do you trawl through thousands of web pages looking for the information you need? Perhaps post on a forum and wait hours for anyone to reply? Maybe you try to figure out the Help files? From now on, you look right here! *Adobe Lightroom 3 - The Missing FAQ* is a compilation of the questions most frequently asked by real users on forums all over the web.

This book isn't intended to be a basic step-by-step introduction to Lightroom. There are already books to fill that need and some things are far too obvious to need a book anyway. But there is one big gap—troubleshooting and reference material. I know you're intelligent (after all, you chose to buy this book!), and I'll assume you already have some understanding of computers and digital photography. You'll find a quick introduction at the beginning of each section, to give you an overview if you're a new user, but unlike those step-by-step books, I'm not going to tell you what you 'must' do—I'm going to give you the information you

need to make an informed decision about your own workflow so you can get the best out of Lightroom.

The Book Format

As you glance through the pages of this book, you'll notice it's designed primarily as a reference book, so similar topics and questions are grouped together. I've tried to keep things in a logical order for newer users who may decide to read the book cover-to-cover, but feel free to skip around to find the answers to your questions.

In the front you'll find a list of all of the questions covered in this book and, of course, no book would be complete without an index in the back. In the eBook format you can use the search facility or bookmarks to find the specific information you need, and better still, you can use your eReader software to add your own bookmarks and notes too.

As you read on, you'll also notice clickable sidebar links to other related topics marked with a pin, which are particularly useful if you're searching for the answer to a specific issue, or want to find out a little more about the current topic. Those cross-references usually refer to questions outside of the current section, rather than the question on the previous page. If you follow one of those cross-references, most eReader software includes a Back button to take you back to your previous page.

The final chapters list other useful information, including default file locations for preferences, presets and catalogs for each operating system, and a list of all of the known keyboard shortcuts.

Windows or Mac?

It doesn't matter whether you're using the Windows or Mac platform, or even both. Lightroom is cross-platform, and therefore this book will follow the same pattern. The screenshots are mainly of the Mac version because I'm writing on a Mac, but the Windows version is

Sidebar links are clickable - and then you can use your software's back button to return almost identical in functionality, and any significant differences will be explained and illustrated.

Where keyboard shortcuts or other commands differ by platform, both are included. The one exception will be the shortcut to view a context-sensitive menu, which is right-click on Windows or Ctrl-click on Mac. I'll keep that simple and just refer to right-clicking, as many Mac users today use 2-button mice, however if you're a Mac user with a one-button mouse, just remember that right-click is the same as Ctrl-click.

Paperbacks and FREE digital formats

As this book is primarily designed for the PDF format, with easy search and clickable links, anyone purchasing the paperback version can also request the color PDF or other digital format ABSOLUTELY FREE!

To claim your free eBook copy, all you need to do is email me at victoria@victoriabampton.com with a copy of your purchase receipt and this code:

10W07P21S

If you've bought a digital version, decided it's wonderful, and would now like a paperback copy (black & white print), visit http://www.lightroomqueen.com/shoppingcart.php for a discounted upgrade price on the paperback, which just covers the cost of printing and shipping.

Updates

Every time Adobe announce a new dot release (such as 3.1), I get an influx of emails asking whether there's a book update available, so let me save you a job... Adobe doesn't usually add new features to dot releases, so the book should still be current even when 3.6 is released. If there are any major changes, an update will be sent out automatically by email to anyone who has joined the mailing list at the time of purchase,

and a post will go up in the Book Updates category on my blog: http://www.lightroomqueen.com/blog/category/book-updates/

Talk to me!

I'd love to hear your feedback on the things you like about this book, and the things you don't. I'm always looking for ways to make this book even better, so if you come across a question that I've missed, something that's not clear, or you just want to tell me how much you love the book, my email address is victoria@victoriabampton.com. I do reply! If you enjoy the book, posting a review on Amazon or your favorite online bookstore would make my day.

Now, where shall we start...?

Quick Start Essentials

If you're anything like me, the first thing you want to do with a new program is dive right in. Who wants to read an instruction manual when you can experiment? If you're nodding in agreement, that's fine, but do yourself a favor and just read this short chapter before you jump in head first. You'll save yourself a lot of headaches!

There's no doubt about it, Lightroom has a mind of its own. It's a great mind, but it doesn't always think in exactly the same way that you and I do, or in the way that we're used to working with other programs, so there are a few things that you really need to understand. Read on...

The Basics

Lightroom's designed for nondestructive editing. That's to say, changes you make to your photos within Lightroom's interface aren't applied to the original image data until you export them, and even then it doesn't overwrite the original file, but creates an edited copy.

Firstly you 'import' your photos into Lightroom. That doesn't mean they're actually in Lightroom. They're still on your hard drive as normal files, and in the Import dialog you can decide whether to leave them where they are, or whether to copy or move them to a new location of your choice. To be clear, don't delete your files thinking that they're in Lightroom—they're not.

The Lightroom catalog holds data about your photos. It's just a long text database with small JPEG preview files in a nearby folder structure. It keeps a record of where the photos are stored on your hard drive, and other metadata describing your photos. That's where any changes you make in Lightroom are stored too. So next essential tip—don't tidy up your photos on your hard drive or rename them in other programs, or Lightroom will ask you to find them all. If you need to tidy up, do it within Lightroom's interface.

Next in line, you're going to organize your photos in the Library module, sorting them into groups, choosing your favorites, adding metadata describing the photos such as keywords, and then editing the photos in the Develop module. Because it's a database, you don't have to hit 'Save' every few minutes. All of the changes you make are recorded as you go along, but this isn't like resaving a JPEG over and over again, which would reduce the image quality. Instead, all of your changes are saved as text instructions in the catalog until you choose to remove the photos from the catalog. Here comes another essential—if you remove photos from your Lightroom catalog, and then import them again, all of the work you did in Lightroom will be gone. There is a partial exception called XMP, but we'll come back to that later. The main things to remember are to back up the catalog regularly, and if you lose track of the files, don't use Synchronize to remove them and re-import—redirect the links to the new file locations by clicking on the question marks instead.

Finally, how do you get your adjusted photos out of Lightroom? You 'export' them. Consider it a 'Save As'—it creates a new file in the location of your choice, in whatever file format, size and color space that suits your purpose. But that's the great thing about Lightroom—you don't have to keep different sized finished copies of every photo unless you want to, because as long as you have the originals and the catalog, you can output finished photos on demand. You're not just limited to exporting single photos either. The Slideshow, Print and Web modules allow you to create... well, slideshows, prints and web galleries. Publish

Services also allows you to keep your photos synchronized with online photo sharing websites such as Flickr.

Think about your file format - raw vs. JPEG

Basic Workflow

Capture

Expose the photo correctly in the camera to produce the best quality Store photos in organized folders Consider renaming and converting raw files to DNG format Apply basic metadata such as copyright and general keywords Apply any Develop presets as a starting point, such as a camera profile Render previews to save time later

Organize

- Browse through your photos
- · Manage photos in folders
- Group photos into collections and stacks
- Add star ratings and labels to identify your favorite photos
- Add additional metadata, such as keywords
- Search for photos using filters and smart collections
- Don't forget to back up the catalog as well as the photos themselves

Develop & Retouch

- · Adjust tone & color
- Remove noise, sensor dust, sharpen and apply lens corrections
- Straighten & crop
- Apply effects, such as black & white or split tones
- Switch to Photoshop and other external editors for pixel based editing
- Create panoramic shots and HDR photos in external editors

Output

- Create finished files in the size, format and color space of your choice
- Use Export plug-ins to enhance your export, such as adding borders
- View slideshows and export them to video,
 PDF and JPEG formats
- Print to a local printer or save layouts to JPEG to print at a local print lab
- · Create web galleries to upload to your website
- Use Publish Services to synchronize with Flickr and other photo sharing websites or folders on your hard drive

The Top 10 Gotchas

There are a few things that catch most people out at some stage, so I can't repeat these often enough. We'll go into them in more detail in later chapters.

- Lightroom is designed for nondestructive editing, so don't try to save over your originals.
- Lightroom doesn't 'contain' photos—it just holds data about them—so don't delete your photos from your hard drive thinking that they're safely stored in Lightroom.
- Lightroom's backups only back up the catalog and not your photos—you still need to do that.
- Lightroom's catalog is just a database and, while comparatively rare, databases can become corrupted—so backup regularly, and keep older backups for a while.
- Lightroom needs to know where the original files are, so don't move or rename files outside of Lightroom (for example in Explorer or Finder) otherwise you'll have a long job fixing all of the links.
- Lightroom will not exactly match your camera's rendering when
 working with raw files, as it's just raw data and there's no right or
 wrong way of processing it. If you like the camera manufacturer's
 rendering, you can use profiles in the Calibration panel to emulate
 that style, or you can build your own profiles to suit your taste.
- Lightroom has 2 or 3 different levels of selection—there's mostselected or active, shown by the lightest grey shade, there's the mid-grey shade denoting the photos are also selected but are not the active photo, and there's the dark grey showing the photo isn't selected. Notice the difference, otherwise you could accidentally apply a command to multiple photos.
- Lightroom's Grid view behaves differently to other views anything you do in Grid view on the primary monitor applies to

- all selected photos, whereas most other views only apply to the active or most-selected photo (unless you have AutoSync turned on—there's always an exception)!
- Lightroom's flags are local to the folder or collection, whereas star ratings and color labels are global. As a result, a photo can be flagged in one collection but not flagged in another.
- Lightroom offers a choice of different color spaces when you output photos, but Adobe RGB and ProPhoto RGB will look odd in programs that aren't color managed, such as web browsers. Use sRGB for screen output, emailing or uploading to the web.

Remember Lightroom's Rule Number 5

If you want an additional quick start introduction, visit Adobe's website and watch the short Getting Started videos at:

http://tv.adobe.com/show/learn-lightroom-3/

They'll give you a quick overview of the basics, and then read on or dive right in.

And most importantly, never forget Lightroom's rule number 5...

Import

Because Lightroom is designed around a database, you can't just browse to view the photos—you have to first import them. Importing the photos simply means that the metadata about the photos is added to the database as text records, along with a link to that file on the hard drive.

Importing photos into Lightroom doesn't force you to move them. Lightroom can copy or move them into a new folder structure if you ask it to do so, but if you already have a good filing system you can also choose to leave them in their existing locations. Either way, the photos remain fully accessible by other programs.

SHOOTING RAW, SRAW OR JPEG

Before you can import photos into Lightroom, you need to have taken some photos. I'll assume you already know how to do that, but there are a few points to look out for when making decisions at the time of capture.

Also check...

"Why don't the Temp and Tint sliders have the proper white balance scale when I'm working on JPEGs?" on page 278 and "Why do my presets look wrong when used on JPEG/TIFF/ PSD files, even though they work on raw files?" on page 305

Can I use Lightroom on JPEG files as well as raw files?

Although Lightroom works best with raw files, it also works with rendered files (JPEG, TIFF and PSD), giving you an easy way to process batches of photos.

Any adjustments you make within Lightroom's interface are nondestructive—they're stored as metadata in the catalog, and even writing that metadata to the file using Ctrl-S (Windows) / Cmd-S (Mac) only updates the text header of the file, and doesn't modify the image data itself. When you export that photo, the adjustments are applied to the image data and a new file is created, so the original still remains untouched.

When you come to edit those photos in the Develop module, you'll find that certain controls are different when working on rendered files, for example, the White Balance sliders change from Kelvin values to fixed values, as you're adjusting from a fixed color rather than truly adjusting white balance. You'll also find that presets behave differently on JPEG/TIFF/PSD photos than they do on raw photos.

If I can use all of Lightroom's controls on JPEG files, why would I want to shoot in my camera's raw file format?

So if you can use Lightroom with JPEGs, and take up less hard drive space, why would you want to shoot raw? Well, think of it this way... did you ever play with colored modeling clay when you were a child?

Imagine you've got a ready-made model, made out of a mixture of different colors, and you've also got separate pots of the different colors that have never been used. Yes, you can push the ready-made model around a bit and make something different, but the colors all smudge into each other, and it's never quite as good as it would have been if you had used the separate colors and started from scratch.

Your JPEG is like that ready-made model—it's already been made into something before. You can take it apart and change it a bit, but if you try

to change it too much, it's going to end up a distorted mess. Your raw file is like having the separate pots of clay—you're starting off with the raw material, and you choose what to make with it.

So yes, editing JPEGs is nondestructive, in as much as you can move the sliders as many times as you like and the original file isn't destroyed in the process, but when you do export to a new file, you're applying changes to ready-made JPEG image data. If you're working on a raw file

format, you're making a single set of adjustments to the raw data, rather than adjusting an already-processed file. You'll particularly notice the difference when making significant changes to white balance or rescuing a very under or overexposed photo.

If I shoot raw, can Lightroom understand the camera settings?

When you shoot in your camera's raw file format, the data isn't fully processed in the camera, and the mosaic sensor data is recorded in the raw file.

The camera manufacturers don't share the information they use to process their files, so instead Adobe backwards engineer the file formats. Adobe could use the camera manufacturer's SDKs (Software Development Kits), where provided, but if they did so, they couldn't then add additional features such as the local adjustments. The SDKs are all or nothing. The result is Lightroom, and other raw processors, can process the raw file, but the result isn't identical to the camera JPEG.

Most of the settings you can change on your camera, such as contrast, sharpening and picture styles, only apply to the manufacturer's own processing. It'll affect the preview you see on the back of the camera, but not the raw data. However, certain camera settings can affect the exposure of your raw file directly or indirectly.

Canon's Highlight Tone Priority automatically underexposes the raw data by one stop to ensure you retain the highlights, leaves a tag in the file noting that this setting was applied, and applies its own special processing to the JPEG preview that you see on the back of the camera. Lightroom understands that tag and increases the exposure by one stop behind the scenes to compensate, but if you accidentally underexpose the image with HTP turned on too, you can end up with a very noisy file. When shooting raw for use in Lightroom, there's no advantage to using that setting instead of changing the exposure compensation yourself, so you may wish to turn off HTP and set your exposure to retain the highlights manually.

Canon's Auto Lighting Optimizer and Nikon's Active D-Lighting don't affect the raw data itself, but Lightroom has no idea that you've used those settings, and even if it did, the processing applied by the camera is variable. When ALO or ADL are turned on, that special processing is applied to the JPEG preview that you see on the back of the camera, as well as to the resulting histogram. Seeing that false brighter preview could cause you to unknowingly underexpose the file, and then be disappointed to find it's very underexposed when you view the raw photo in Lightroom, so it's a good idea to turn those settings off unless you're shooting JPEG or only using the manufacturer's own software.

If I shoot sRAW format, can Lightroom apply all the usual adjustments?

Canon's sRAW and mRAW formats work slightly differently to standard raw formats. Full raw files are demosaiced by the raw processor, whereas sRAW files are demosaiced by the camera. They're 'half-baked'.

You still have access to all of the sliders that are available for raw files, however there are a few things which are usually part of the demosaicing process which will not be applied to your sRAW files and other artifacts may be present, for example, Lightroom maps out hot pixels on full raw files, but can't do so on sRAW files. Other settings may also behave

differently, for example, the sharpening and noise reduction may need slightly different settings.

If you convert to DNG, you'll notice that sRAW files get bigger instead of smaller, because the way that the sRAW data is stored is specific to the manufacturer, and not covered in the DNG specification.

Also check...

"Proprietary Raw vs. DNG" section on page 91

THE IMPORT DIALOG

To get started with Lightroom, go to File menu > Import Photos..., or press the Import... button at the bottom of the left panel, and the Import dialog will appear. The first time you open the Import dialog you'll see an empty expanded Import dialog, but any future visits to the Import dialog should remember your last used settings.

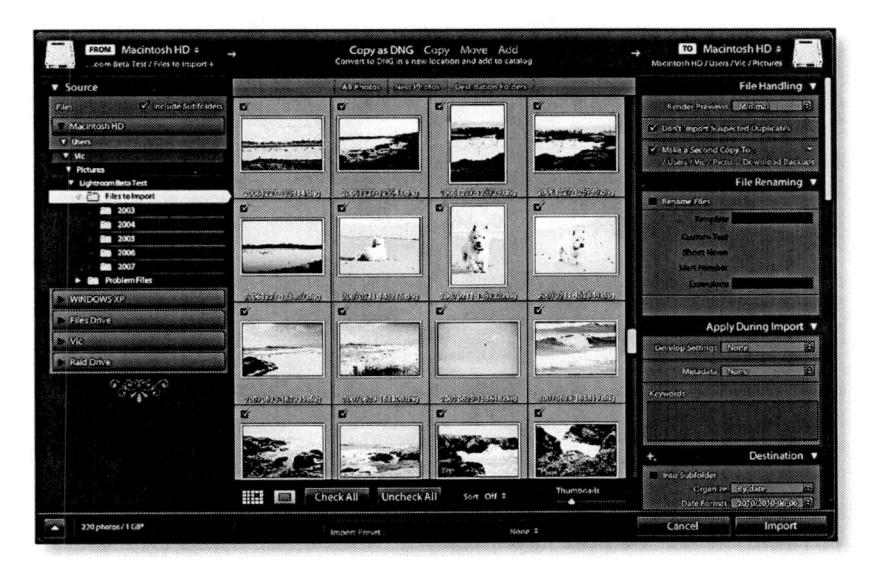

The Import dialog is where you choose which photos to import, how to import them (copy/move/convert to DNG/add without moving), and where to put them. It allows you to choose what you would like to do with the photos while you're importing them too, such as renaming,

applying metadata and keywords, creating backups, and building previews. We'll cover all of those options in the following pages.

What's the difference between the compact Import dialog and the expanded Import dialog and how do I switch?

If you press the arrow in the lower left corner of the Import dialog, it toggles between compact and expanded dialog views. The compact Import dialog allows you to change a few of the settings, such as the Source or Destination folders, and add basic metadata. It also gives you a quick view of your other settings, but if you want to change those other settings, you need to switch to the expanded Import dialog, which gives further options including selecting specific photos, importing from multiple folders and previewing the photos before import.

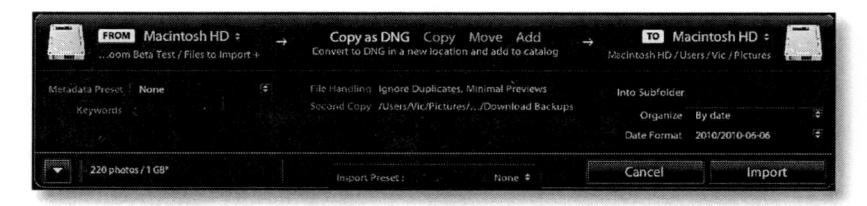

What's the difference between 'Add,' 'Copy,' 'Move,' and 'Copy as DNG'?

Along the top of both the compact and expanded Import dialogs is the option to copy or move the files, or leave them where they are.

'Copy as DNG' copies the files to a folder of your choice, and converts the copies of any raw files to DNG format, leaving the originals untouched. There's more on the pros and cons of DNG later in the chapter.

'Copy' does the same as 'Copy as DNG' except it doesn't convert them, and 'Move' also removes the files from their original location. All of the

"Proprietary Raw vs. DNG" section on page 91

Copy and Move options give you additional choices on the folder structure, and allow you to rename at the same time.

'Add' leaves the files in their current folder structure with their existing filenames, and references them, or links to them, in that original location. This is a great option for importing existing photos if you already have a good filing system that you would like to keep.

"Destination Folders" section on page 82

SELECTING FOLDERS & FILES FOR IMPORT

Having explored the Import dialog, you then need to decide which photos to import. In the compact Import dialog you're limited to selecting which folders to import, whereas switching to the expanded Import dialog allows you to narrow down the specific photos too. You see the Source panel down the left hand side? At the top you will see your devices—cameras, card readers, iPhones, and so forth—and then you

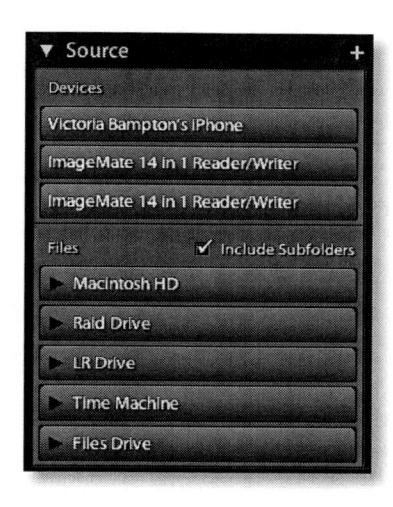

have the hard drives attached to your computer. When you click on one of those devices or folders, the central preview area will start to populate with thumbnails of the photos that are available for import, which you can then check and uncheck to choose specific photos.

How do I import multiple folders in one go?

If you want to import from more than one folder, you can Ctrl-click (Windows) / Cmd-click (Mac) on multiple folders in the Source panel

to select them, and those multiple folders don't even have to be on the same drive.

If all of the photos you want to import are in subfolders under a single parent folder, for example, within your 'Photos' folder, then you can select that parent folder and check the 'Include Subfolders' checkbox.

Is it possible to import from multiple card readers at the same time?

You can't currently import from two separate devices in one go, for instance, 2 card readers. However if your operating system sees the memory cards as two drives, and they appear in the lower Files part of the Source panel, you can Ctrl-click (Windows)/Cmd-click (Mac) on the folders to import both at once.

Why do the folders keep jumping around and what is Docking?

When you navigate around the Source and Destination panels in the Import dialog, they initially appear to have a mind of their own, with different behavior depending on whether you single-click or double-click, but it's actually a really useful feature.

If you navigate around by single clicking on the folder arrows or folder names, the navigation will behave normally. If you double-click, or if you right-click and choose Dock Folder from the context-sensitive menu, you can expand and collapse the folder hierarchy to hide unnecessary folders. It makes it easier to navigate through a complex folder hierarchy, especially if it's many levels deep and the panel is too narrow to read the folder names. If you've collapsed it down too far, just double-click on the parent folder to show the full hierarchy again.

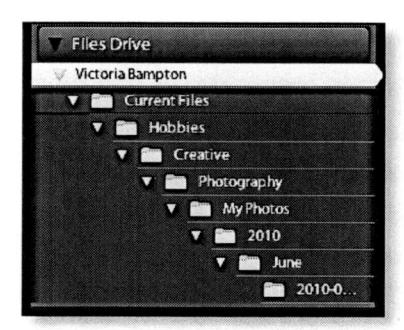

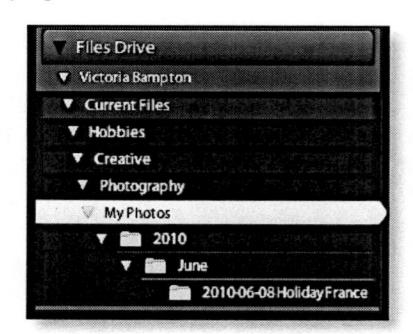

For example, if your photos are all stored in Files Drive/Victoria Bampton/Current Files/Hobbies/Creative/Photography/My Photos, and they're divided into another long hierarchy below that, you might choose to dock the My Photos folder by double-clicking on it. That would change the view from the screenshot on the left to the screenshot on the right.

Can I use the operating system dialog to navigate to a folder instead of using Lightroom's Source panel?

Admittedly the new Import dialog can take a little getting used to, so if you would prefer to be able to navigate to your folder using the operating system dialog instead, click on the large button above the Source panel and choose Other Source... from the menu. The Source panel will open directly to the location you choose.

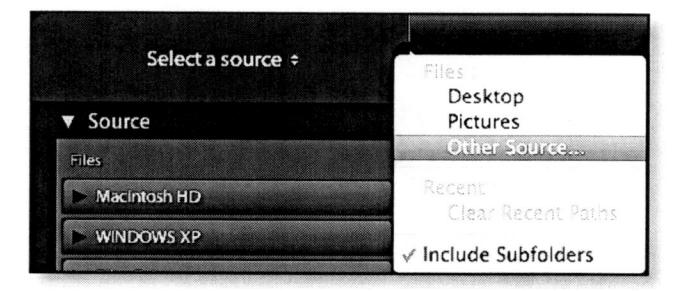

Can I save favorite folders?

You can't currently save favorite folders, however clicking the button above the Source panel will show you a list of your most recent import folders. Later, in the Library module, right-clicking on a folder in the Folders panel will show an 'Import into this folder...' option. This automatically sets your Destination folder, which is particularly useful when importing from memory cards.

How do I select only certain photos to import?

In the Grid view, in the center of the Import dialog, you can choose which photos to import by checking or unchecking their individual

checkboxes. The Check All and Uncheck All buttons can be used to mark all photos or no photos for import, and only the checked photos will be imported into your catalog.

To check or uncheck a series of photos in one go, hold down Ctrl (Windows) / Cmd (Mac) while clicking on photos to select non-consecutive photos, or use Shift to select a group of consecutive photos. Once you have the photos selected, shown by a lighter grey surround, checking or unchecking the checkbox on a single photo will apply that same checkmark setting to all of the other selected photos.

The sort order on the toolbar allows you to sort by Capture Time, Filename or Checked State, making it easy to sort through your photos, and if you select any of the photos in the Grid, you can also use the arrow keys on the keyboard to move around, and the P, X and `keys to check and uncheck photos.

How do I select photos from a specific date?

If you select one of the Copy or Move options along the top of the Import dialog, you can select a dated folder structure in the Destination panel.

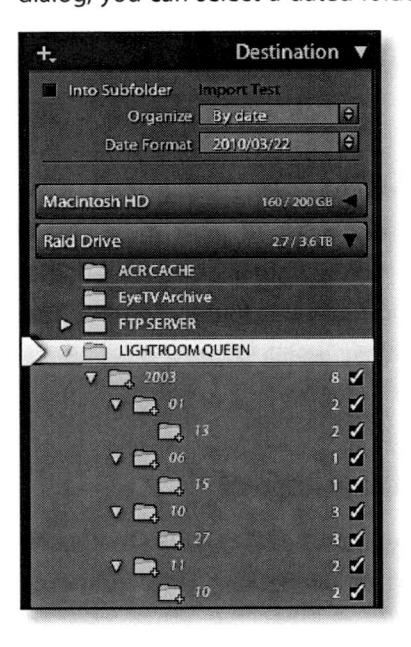

The dated folders that are shown in italics have checkboxes, which allow you to check or uncheck specific dates, and unchecking one or more of those dates also unchecks the photos from those dates. Selecting

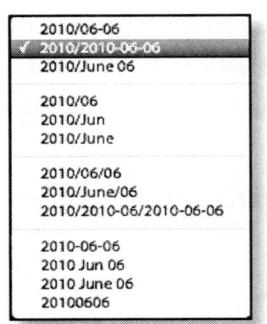

the 2010/06/08 option works particularly well for this purpose, allowing you to deselect single days or whole months, depending on which folders you uncheck. The dated folders pop-up updates to use the current date, so I've just used Lightroom 3's release date as an example.

If you're browsing through the photos in the Grid view, choosing the Destination folders view at the top of the Grid splits the thumbnails up into sections and you can check and uncheck them there too.

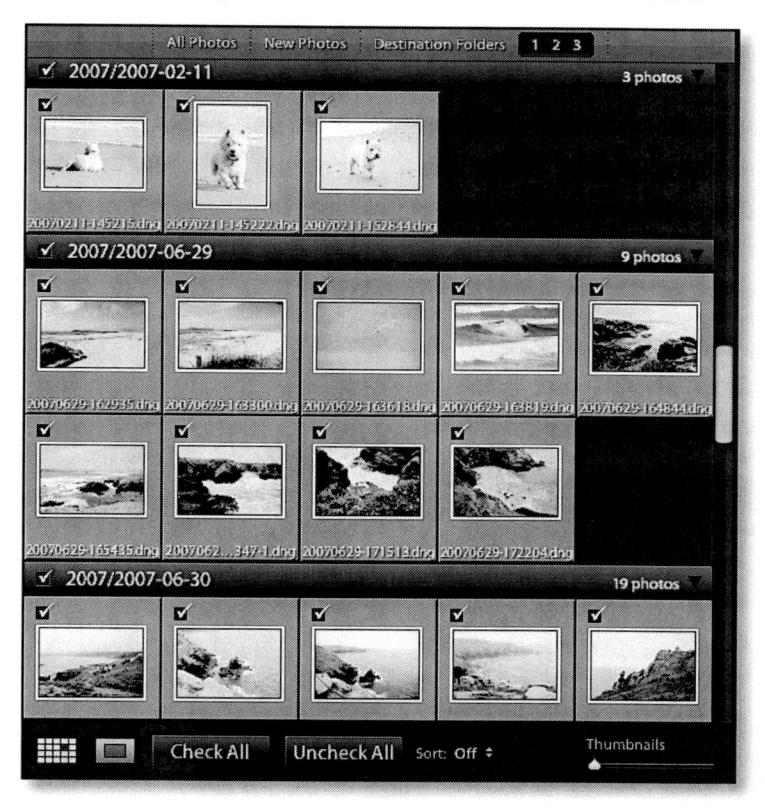

How do I select specific file types to import?

There isn't currently a way to choose specific file types within Lightroom's Import dialog. You can, of course, import all of the photos into Lightroom, and then remove specific photos later using the Library module's Filter bar.

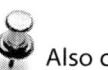

Also check...

"How do I filter my photos to show photos fitting certain criteria?" on page 189 As a workaround, you can also make use of your operating system's 'sort by file type' in Explorer (Windows) / Finder (Mac). You can select the files you want to import and drag and drop them onto Lightroom's icon in the Dock (Mac only) or directly on the Grid view in the Library module (Windows or Mac), and the Import dialog will open with those specific photos already selected.

Why are some photos unavailable or dimmed in the Import dialog?

Dimmed photos that don't have a checkbox are unavailable for import. That's because they're either already imported into your current Lightroom catalog in that location, or you have 'Don't Import Suspected Duplicates' checked in the File Handling panel and they're duplicates of existing photos that are stored somewhere else.

Can I see larger previews of the files before importing?

If you need to see larger previews, you can increase the size of the thumbnails using the slider on the toolbar, but the embedded thumbnails are usually small and low quality. In addition to the embedded thumbnails, there's also a larger JPEG preview embedded in most photos, including raw files, but they can be a little slower to fetch, so they're not used for the Grid view.

There's now a Loupe view in the Import dialog which allows you to take advantage of that larger preview. Selecting any thumbnail and pressing the E key, double-clicking on the thumbnail, or pressing the Loupe button on the toolbar, will show a larger preview of the photo, depending on the size of the embedded preview.

At the bottom of that Loupe preview is the checkbox to include or exclude the photo from the Import and, like the Grid view, the left and right arrow keys will move between photos and the P, X and `keys will check and uncheck them. Pressing the G key, double-clicking on the preview, or pressing the Grid button in the toolbar will return to Grid view again.

As the previews are the small JPEG previews embedded in the files, it can be a faster way of doing any initial culling than waiting for Lightroom to build previews.

IMPORT OPTIONS

Having chosen the photos that you want to import, you now need to decide what you would like to do with them while you're importing them. You make those choices in the panels on the right hand side of the Import dialog.

Why do I have to create previews? Why can't I just look at the photos?

The first option in the File Handling panel is Render Previews. All raw processors create their own previews because raw data has to be converted in order to be viewed as an image. Lightroom offers nondestructive processing for other file types too, so any changes you make later in the Develop module will be applied to previews so you can view your adjustments without affecting the original image data. Those previews also enable you to continue to view the photos when the original files are offline.

Initially Lightroom shows you the embedded JPEG preview from the file, but then it creates higher quality previews which are stored next to the catalog. Select Standard size for the moment, and we'll cover the options

in more detail in the Previews & Speed chapter.

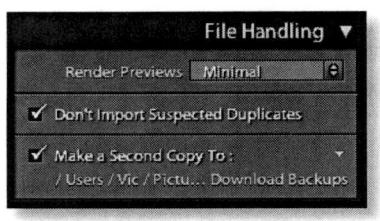

'Don't Import Suspected Duplicates' checks the photos that you're importing against those that are already in the catalog, to see if you're trying to import photos

between Minimal, Embedded & Sidecar, Standard and 1:1 previews?" on page 253

which already exist in the catalog. If photo1.jpg in folder A is already in the catalog in that location, then Lightroom will skip it regardless of your suspected duplicates checkbox as it can't import it twice at the same location. If you then put another copy of photo1.jpg into folder B, or you've moved it outside of Lightroom, it will be recognized as a duplicate and only imported it into your catalog if the checkbox is unchecked.

To be classed as a suspected duplicate, it must match on the original filename (as it was when imported into Lightroom), the EXIF capture date and time, and the file length. It won't recognize photos that you've re-saved as an alternative format—only exact duplicates.

What does the 'Make a Second Copy' option do?

When using one of the 'Copy' or 'Move' options, you'll notice 'Make a Second Copy To:' in the File Handling panel. This will back up your original files to the location of your choice but, in a change from Lightroom 2, it no longer creates dated folders automatically. If you choose to rename your files while importing, those backups will now be renamed to match, but they will always remain in their original file format, even if you're converting to DNG while importing.

The Second Copy option is very useful as an initial backup, while the photos make their way into your primary backup system, but it's not a replacement for good primary backups. We'll come back to backup systems in the Working with Catalogs chapter.

What Develop settings, metadata and keywords should I apply in the Import dialog?

The Develop Settings pop-up menu allows you to apply a Develop preset to the photos while importing, for example, you may always apply a specific preset to all studio portraits as a starting point. 'None' will just

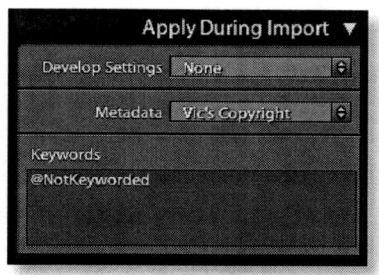

Also check...

"I back up photos using the Import dialog isn't that enough?" on page 223, "Backup" section on page 221 and "Presets" section on page 300

Also check...

"How do I create a Metadata preset?" on page 171 apply the default settings to new photos but will preserve any existing Develop settings stored with the files, and it's the option to choose if you're ever uncertain. Be careful not to confuse 'None' with 'General—Zeroed,' which sets every slider back to zero regardless of the file type.

We'll come back to Metadata presets in more detail in the Library chapter, but you can also create Metadata presets from the Import dialog by selecting 'New...' from the Metadata Presets pop-up menu and entering your details in the following dialog. It's particularly useful for adding copyright information to all photos while importing, to ensure

that none of your photos are missed. To add symbol in the Copyright field, hold down Alt while typing 1 6 (Windows) Opt-G (Mac). Only checked fields will be saved in the preset, and leaving any fields blank

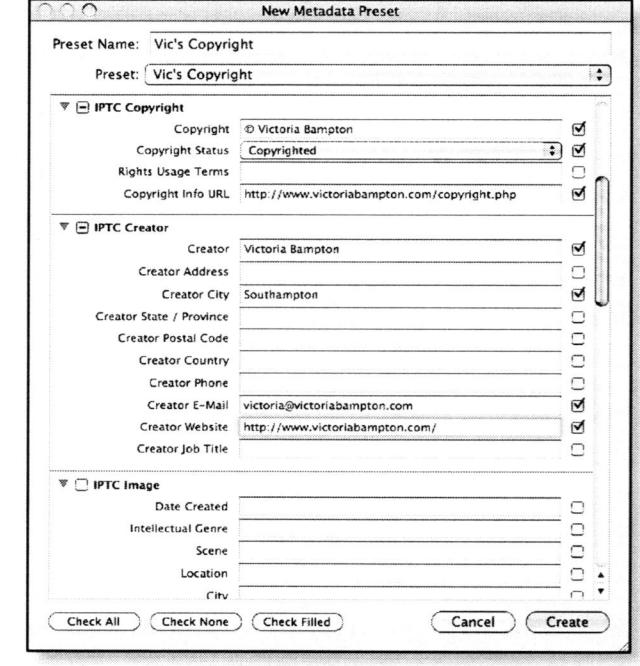

but checked would clear any existing metadata saved in the file, that you may have added in another program.

Keywords can also be applied while importing the photos, however remember that they will be applied to all of the photos in the current import, so it's only useful for keywords that will apply to everything. Specific keywords are better applied individually in the Library module.

"Viewing & Editing
Metadata" section on
page 170, "Presets"
section on page 300
and "Keywording"
section on page 173

How do I apply different settings to different photos while importing?

You can't apply different settings to different photos in the same import. You could start the first import with selected photos, and then go back to the Import dialog, import the next set with different settings, and keep repeating until you've imported all of the photos, but doing so runs the risk of missing a photo or two. It's far easier to import all of the photos in a single import, and then add the different settings, or move photos into different folders, in the Library module once they've all finished importing. All of the settings, such as Metadata and Develop presets, that are available in the Import dialog can also be added later in the Library module.

RENAMING

Most cameras use fairly non-descriptive file names such as IMG_5968, and the problem with those names is, over the course of time, you will end up with multiple photos all with the same name. You don't have to keep those camera filenames though, unless you're particularly attached to them. You can either rename the photos at the time of import, or at any point later in your workflow, but bear in mind that renaming later in your workflow will impact your backup systems as well as the working copies, so the import stage is as good a time as any.

How do I rename the files while importing?

If you look in the File Renaming panel there are various template options available, which are as simple to use as just selecting them from the pop-up menu. You're not limited, however, to just using those existing templates. Further down

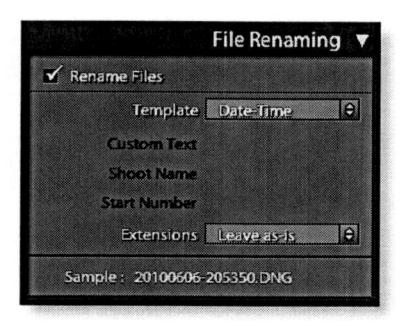

that pop-up menu is the Edit... option which will show the Filename Template Editor dialog. In that dialog you can create the file naming structure of your choice by adding, deleting and rearranging the tokens. We'll cover how to use those tokens and save templates in dialogs in the Workspace chapter, so I won't repeat it here, but don't hesitate to jump forward a few pages if you want to get going now.

Many choose a YYYYMMDD-HHMM filename structure, which translates to the year, the month, the date, and then the time, 20100608-2100.jpg would be the filename for a photo captured at 21:00 on 08 June 2010. If shoot you multiple shots per minute, for

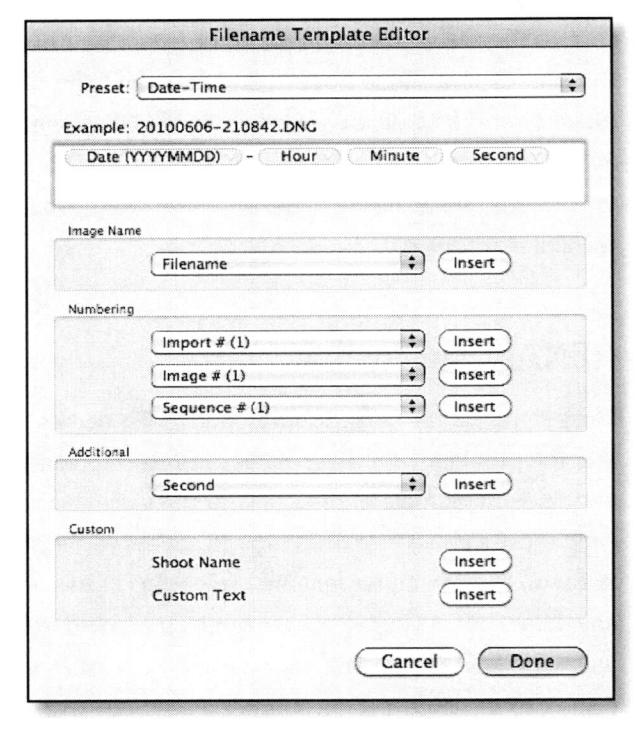

example, sports photography, you might like to add a Seconds token on the end of that too. The benefit of a filename like this is it's unlikely to be duplicated, and it gives you a quick identification of when the shot was taken, without having to look at the EXIF data. Some like to add a custom text token to include descriptive words like 'BenWedding' to the end of that filename, to easily find specific photos using your normal file browser too.

Others prefer a sequence number combined with some custom text. BenWedding_003.jpg is a popular option, created using the Custom

"Using Tokens in Dialogs" on page 139 Text and SequenceNumber(001) tokens. Don't actually add the words 'BenWedding' into the preset itself, otherwise you will have to go back to the Filename Template Editor each time you need to change it. If you use a Custom Text or Shoot Name token instead, you can enter those details directly in the Import dialog.

It's sensible to only use standard characters, such as plain letters and numbers, and use hyphens (-) or underscores (_) instead of spaces when you're setting up your filenames, so your filenames will be fully compatible with web browsers and other operating systems without having to be renamed again. Having created your filename template, save it using the pop-up menu at the top of the dialog, giving it a logical name to identify it.

What's the difference between Import#, Image#, Sequence# and Total#?

When you're setting up your file naming structure in the Filename Template Editor, you will notice that there are a number of different types of sequence number available.

Import # is a number identifying that particular import, which you may want to combine with Image #. It increases each time it's used, for example, if you import some photos from a memory card, that token would be replaced with the number 1, and the next time you import a batch of photos, it would be 2, and so forth. As it's specific to Import, you won't find it in the Library module renaming.

Image # is another ever increasing number that doesn't automatically reset.

Both Import # and Image # have starting numbers set in Catalog Settings > File Handling tab, with 'Import Number' used for 'Import #' and 'Photos Imported' used for 'Image #'.

Also check...

"How do I rename one or more photos?" on page 166 Sequence # is an increasing number which starts at the number of your choice each time you use it—you set the start number in the File Naming panel in the Import dialog or later in the Rename Photos dialog. It's probably the most useful of the automatic numbers, and the variety we're most familiar with from other programs.

Total # refers to the number of photos it's renaming in one go, so if you're renaming 8 photos, the Total# token would be replaced with '8'. Like the Import # token, it usually needs to be used with a sequence number, otherwise Lightroom will have to add -1, 2, -3, etc., to each filename to make them unique within the folder. Total# only appears in the Library module Rename Photos dialog, which we'll come back to in a later chapter.

Can Lightroom continue my number sequence from my previous import?

If you want Lightroom to automatically remember your last sequence number, you need to choose the Image# token rather than Sequence#. The starting number for Image# is set in the Catalog Settings dialog rather than in the Import dialog, and it's remembered from your last import, whereas Sequence# uses the start number that you set in the Import dialog.

How do I pad the numbers to get Img001.jpg instead of Img1. jpg?

If you use the default sequence number, it doesn't have extra zeros for padding. That can cause a problem sorting in some programs, where it sorts them as 1, 10, 11... 19, 2, 20, 21 instead of intelligent numerical order. The solution is to add extra padding zeros to set the filenames to 001, 002, and so forth.

To get a padded sequence number when creating your filename template, click on the number token of your choice and choose "Sequence#(001)" instead of "Sequence#(1)" from the pop-up menu.

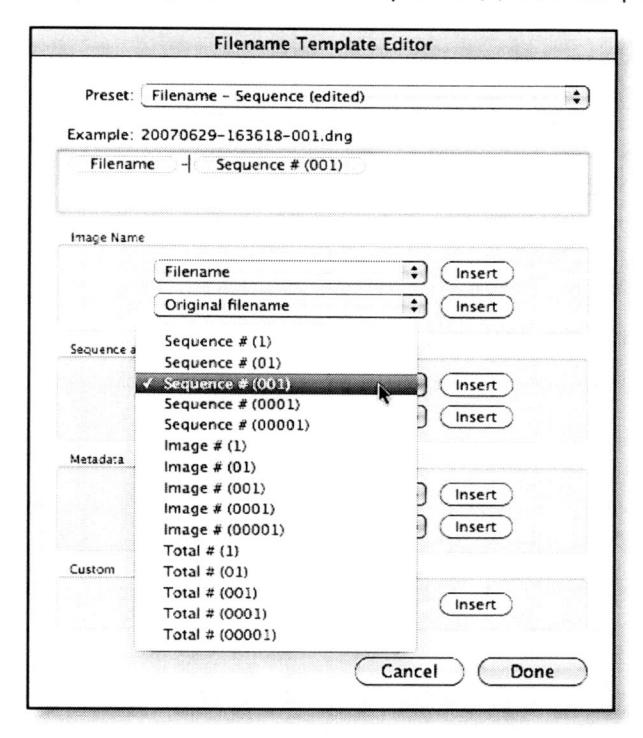

Can I have more than 5 digit numbers?

A maximum of 5 digits are available directly within the Filename Template Editor, however if you create your template with a 5 digit sequence number using the Sequence # (00001) option, you can then edit that template in a text editor. You'll find your template in the Filename Templates subfolder with the other presets—the folder locations for all operating systems are listed in the Useful Information chapter.

Having opened the template in a standard text editor, edit the line saying: value = "naming_sequenceNumber_5Digits" and change the number

5 to either 6, 7, 8 or 9, depending on the number of leading zeros you would like to see.

DESTINATION FOLDERS

Having chosen the photos to import, unless you're using Add to Catalog at Existing Location, you now need to decide where to put them, and that's where the Destination panel comes into play.

I've chosen 'Copy' or 'Move'—how do I organize the photos into a folder structure that will suit me?

You have 3 main options...

'Into one folder' imports the photos into the single folder that you select.

'By original folders' imports in the same nested hierarchy as their existing structure, but in their new location.

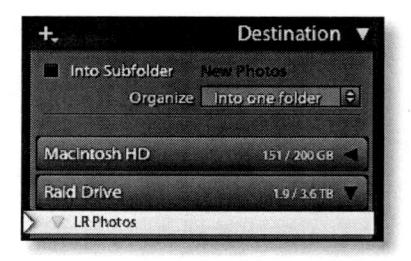

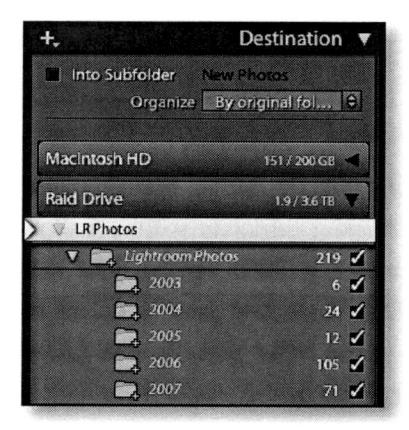

'By date' gives you a choice of date based folder structures—the slash (/) creates nested folders so 2010/06/08 will create a folder 08 inside of a folder 06 inside of a folder 2010, not a single folder called 2010/06/08.

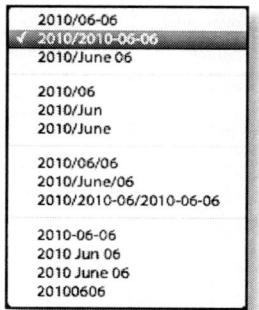

If you want a single folder called 2010/06/08, you need to use other characters such as a hyphen (-) or underscore (_), such as the 2010-06-08 format.

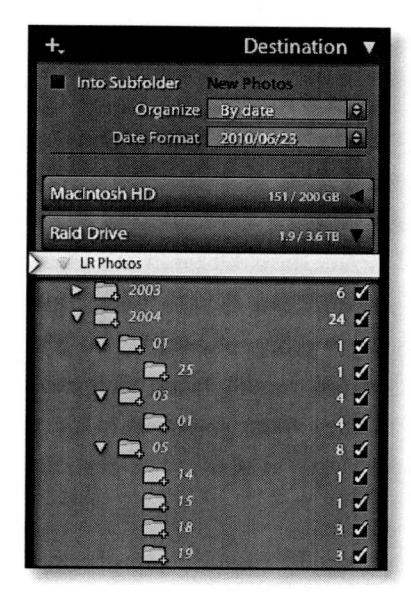

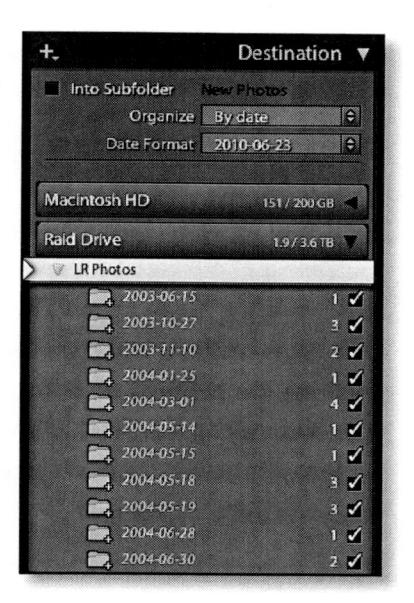

There isn't an option to edit the new folder names in the Import dialog, as there was in earlier releases, but you can rename any of the folders in the Folders panel once the photos have finished importing.

Any of those folder structures can also be placed into a subfolder within the folder you choose at the top of the Destination panel, and you can preview the result below.

Why are some of the Destination folders in italics?

The folders shown in italics are folders that don't currently exist, but will be created by the import. It's a really easy way to check that the folder organization setting that you've chosen is the one that you want.

If you've chosen a dated folder structure, you can also use the checkmarks next to the italicized folders to select and deselect photos from specific dates, as we mentioned earlier.

"How do I select photos from a specific date?" on page 70

How should I organize my photos on my hard drive?

There's no right or wrong way of organizing photos on your hard drive, but it's worth spending the time to set up a logical folder structure before you start. There are a few important factors to bear in mind when deciding on your folder structure.

Folders work best primarily as storage buckets rather than organizing tools. A file can only be in one folder at a time, so if you divide your photos up by topic, how do you decide where a photo should go? If you have a photo with both Mary and Susan, should it go in the 'Mary' folder or in the 'Susan' folder? Perhaps you duplicate in both folders, but then, what happens when you have a larger group of people? Do you duplicate the photo in all of their folders too, rapidly filling your hard drive and making it difficult to track? And then when you come to make adjustments to that photo, do you have to find it in all of those locations to update those copies too?

Trying to organize photos in folders can rapidly become complicated, but that's where Lightroom's cataloging facilities come into their own. If you catalog each photo once, stored in a single location, you can then use keywords, collections and other metadata to group and find photos easily. That photo of Mary and Susan may be stored in a '2010' folder, but would show up when you searched for Mary, Susan, or even that it was taken at the beach.

Using Lightroom to catalog your photos, however, doesn't mean you can just spread the photos across your hard drive. There still needs to be a level of organization, but for a different purpose.

First and foremost, your folder structure must be scalable. You may only have a few thousand photos at the moment, but your filing system needs to be capable of growing with you, without having to go back and change it again. As with file names, stick to standard characters—A-Z, 0-9, hyphens (-) and underscores (_) to prevent problems in the future. Although your operating system may accept other characters, you might

decide to move cross-platform one day, leaving you the time-consuming job of renaming all of the folders.

Your folder structure also needs to be easy to back up, otherwise you may miss some photos, and it must be equally as easy to restore if you ever have a disaster. We'll come back to backup systems in the Working with Catalogs chapter, but as a general rule, that will involve limiting your photos to one, or a few, parent folders. You may choose to use a folder within your My Pictures (Windows) / Pictures (Mac) folder, a folder at the root of your boot drive, or better still, another hard drive entirely. Wherever you choose to put that folder, the main aim is to congregate all of the photos in that one place.

Being able to back up your photos the first time is great, but then how will you add new photos to your backups? If you're adding photos to lots of different folders, it can be hard to track which photos have already been backed up, so sticking to a dated structure is usually the

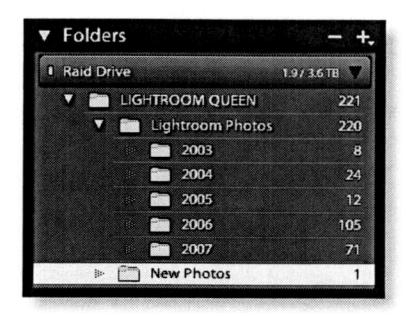

simplest option. Adding a 'New Photos' folder, where all new imports are placed until they're backed up, before being moved into the full filing system, can also help to keep track of your backups.

You'll also need to bear in mind the limitations of your backup system. In addition to your working backups, are you backing your photos up to other hard drives or optical media? If you're limited by the size of optical media, storing the photos in 'buckets' of around of 4.3GB, can help you see at a glance which photos have already been backed up, and where.

Over the course of time, your collection of photos will grow, and you'll likely add new hard drives, so a quick tip—if you're putting photos at the root of a hard drive, always put them inside a folder rather than directly at the root, for example, e:\Photos\ (Windows) or PhotosHD/Photos/ (Mac). You can set that Photos folder to show within Lightroom's Folders

"I have a long list of folders—can I change it to show the folder hierarchy?" on page 149

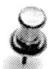

Also check...

"How do I archive photos to CD/DVD/Blu-Ray?" on page 252 panel to make it easy to relink those photos if they ever get 'lost'. The same applies to backup optical media such as DVD's, but for those, it's worth giving the parent folder a name that will identify that DVD, such as 'Backup2010-34'

Keeping it simple, many photographers use a dated folder structure, with the number of subfolders dependent on the number of photos you shoot each day, week, month or year. If you shoot few photos each year, a simple folder for each year may be plenty, leaving further organization to Lightroom. If, on the other hand, you shoot most days, a hierarchy of days, within months, within years may be better suited to your needs. If you're dividing by day, you may also want to add a descriptive word to the end of the day's folder name to describe the overall subject, for example, '2010-06-08 Zoo'. That makes it easy to find the photos in any other file browser too.

Lightroom's import dialog sets up some popular date formats for dated folders, which are a good starting point if you're beginning to

organize your photos. If you would like your Folders panel to read in chronological order, use 06 for the month rather than the word June, as it sorts in alpha-numeric order and isn't quite smart enough to know that June should come before August.

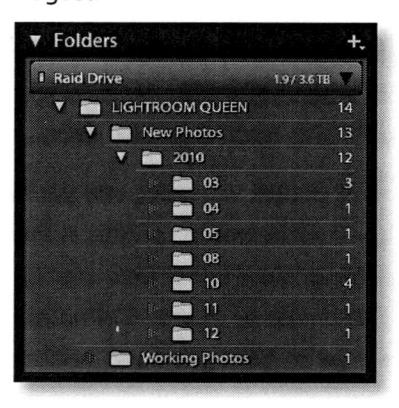

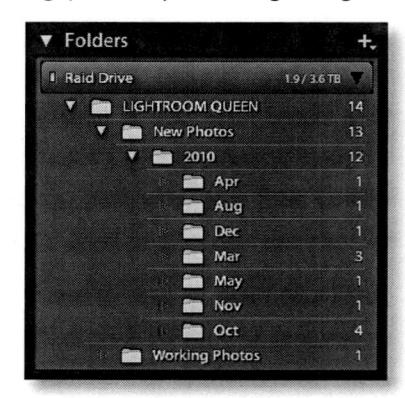

There are exceptions, for example, a wedding photographer may prefer to use a folder for each wedding within a parent year folder, for example, 2010/John_Kate_wedding_20100608, that sorts by name rather than by date. You may

prefer to group all of your Personal photos separately from your Work photos, under a 'Personal' parent folder, for example, Personal/2010/06_ Florida, which can also work as long as there's no crossover.

Alternative filing systems aren't a problem as long as you follow the basic principles, but if you're not using a basic dated structure, make sure you think it through properly, and perhaps discuss it with other experienced digital photographers, in case they can see a pitfall that you've missed.

Also, consider how you're going to manage derivatives—retouched masters, and copies exported for other purposes. Are you going to manage those alongside your originals, and if so, how are they going to be backed up and archived?

We could write a whole book on Digital Asset Management, and the pros and cons of various systems, but fortunately Peter Krogh, world-renowned DAM expert, has already done so. If it's a subject that you would like to learn more about, I can't recommend *The DAM Book* highly enough.

In summary:

- Don't duplicate photos in different folders—folders are best used for storage, not organization by topic
- It needs be scalable for larger numbers of photos in the future
- It's best to use standard folder and filenames that will work cross-platform
- It must be easy to back up new photos
- It must be easy to restore from backups
- Add parent folders to make it easy to relink files if Lightroom loses track

Can I create a different dated folder structure automatically?

Lightroom offers 13 different folder structures in the Organize by Date pop-up menu, but what happens if you prefer a different folder structure—perhaps using underscores (_) rather than hyphens (-)? There's a low risk hack, originally published by Mark Sirota, which makes use of the TranslatedStrings.txt file that Lightroom uses for language translations. This isn't supported by Adobe, Mark or myself, and it may not continue to work in the future, but if you like to be a little daring from time to time, here's how it works...

Lightroom uses a file called TranslatedStrings.txt, which is contained in the language project file along with the program files.

Windows: c:\Program Files\Adobe\Adobe Photoshop Lightroom 3\
Resources\en\

Mac: Macintosh HD/Applications/Adobe Lightroom 3.app/Contents/ Resources/en.lproj/

If you're using the English version of Lightroom, the file probably doesn't exist, so you can just create a plain text file called TranslatedStrings.txt inside that 'en' or 'en.lproj' folder. If you're using another language, the file will already be in your language's project folder, for example 'fr.lproj' for French, and you'll need to edit that file. If you're editing an existing file, obviously back it up first!

The default lines should read as follows:

"\$\$\$/AgImportDialog/ShootArrangement_1/Template=%Y/%m-%d"
"\$\$\$/AgImportDialog/ShootArrangement_2/Template=%Y/%Y-%m-%d"
"\$\$\$/AgImportDialog/ShootArrangement_3/Template=%Y/%B/%d"
"\$\$\$/AgImportDialog/ShootArrangement_4/Template=%Y/%B/%d"
"\$\$\$/AgImportDialog/ShootArrangement_5/Template=%Y/%B %d"
"\$\$\$/AgImportDialog/ShootArrangement_6/Template=%Y-%m-%d"
"\$\$\$/AgImportDialog/ShootArrangement_7/Template=%Y %b %d"
"\$\$\$/AgImportDialog/ShootArrangement_8/Template=%Y/%m%d"
"\$\$\$/AgImportDialog/ShootArrangement_9/Template=%Y/%Y-%m/%Y-%m-%d"

"\$\$\$/AgImportDialog/ShootArrangement_10/Template=%Y/%m" "\$\$\$/AgImportDialog/ShootArrangement_11/Template=%Y/%b"

"\$\$\$/AgImportDialog/ShootArrangement_12/Template=%Y/%B"

"\$\$\$/AgImportDialog/ShootArrangement_13/Template=%Y %B %d"

Assuming today's date is 8th June 2010, those translate, in order, to:

1 - %Y/%m-%d - 2010/06-08

2 - %Y/%Y-%m-%d - 2010/2010-06-08

3 - %Y/%m/%d - 2010/06/08

4 - %Y/%B/%d - 2010/June/08

5 - %Y/%B %d - 2010/June 08

6 - %Y-%m-%d - 2010-06-08

7 - %Y %b %d - 2010 Jun 08

8 - %Y%m%d - 20100608

9 - %Y/%Y-%m/%Y-%m-%d - 2010/2010-06/2010-06-08

10 - %Y/%m - 2010/06

11 - %Y/%b - 2010/Jun

12 - %Y/%B - 2010/June

13 - %Y %B %d - 2010 June 08

You can't create additional templates, but you can edit the existing ones, and when you restart Lightroom, they should be available in the list of dated folder structures. The available date tokens are:

%Y = year in 4 digits (2010)

%y = year in 2 digits (10)

%B = month in full (June)

%b = month abbreviated (Jun)

%m = month number (06)

%A = weekday in full (Tuesday)

%a = weekday abbreviated (Tue)

%d = day of month (08)

If you're happy with the result, don't forget to back up the TranslatedStrings.txt file, as it may be replaced each time you update Lightroom. If you have any problems, delete the file if you're using the English version, or restore the backup of the other language version.

Can I leave Lightroom to manage my photos like iTunes moves my music files?

Lightroom doesn't automatically rearrange your photos once they've been imported. You can, of course, rearrange the photos manually by dragging and dropping them into other folders within the Library module, but that could be a big job, so it's better to decide on a sensible filing system at the outset. Remember, once you've imported the photos, don't tidy up or rename them using other software, because all of Lightroom's links would be broken, and you would have to relink all of the files again.

IMPORT PRESETS

Don't worry, having made all of these decisions the first time, you can save them to reuse again later. Lightroom will remember your last used settings, but you might find you have different settings for different uses—one set for copying from a memory card, a different set for importing existing photos, and so forth. You can save all of those settings as an Import Preset, which can be accessed from both the compact and expanded Import dialogs, and then go ahead and press Import.

How do I create Import presets, and what do they include?

The Import presets are tucked away at the bottom of the Import dialog in both the compact and expanded Import dialog views. Set up your Import settings and then choose Save Current Setting as New Preset... from the pop-up menu. You can also update or delete existing presets from that menu, just like the other pop-up menus that we'll cover in the next chapter.

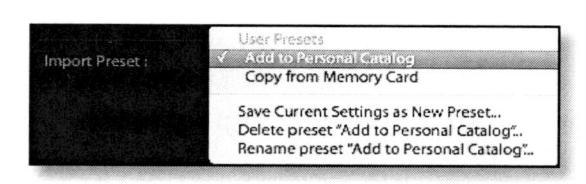

Everything in the right hand panels is included in the presets, along with the Copy as DNG/Copy/Move/Add choice and the Destination. The photos you're importing aren't included in the preset, as those will change each time you import, so Source panel selections and checked/unchecked thumbnails aren't saved.

PROPRIETARY RAW VS. DNG

One of the Import options available is to convert to DNG—but what does that actually mean? DNG stands for Digital Negative. It's another file format, designed primarily for raw image data, but the biggest difference is that it's openly documented unlike proprietary raw files (CR2, NEF, etc.), so anyone can download the information to decode the file.

A DNG file is comprised of 3 different parts—the image data itself, the metadata that describes that photo, and an embedded preview which can be updated to show your adjustments without affecting the raw data.

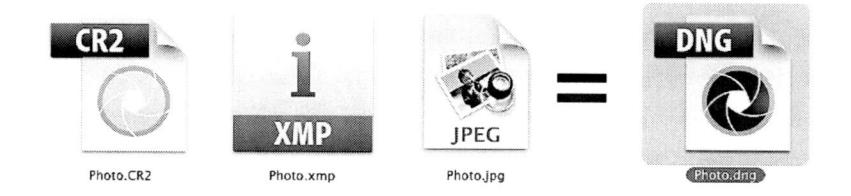

So why consider DNG as an alternative to storing files in your camera manufacturer's format?

Should I convert to DNG?

DNG is a well worn debate on every forum on the web, and there's no right or wrong answer, but there are a few pros and cons to consider when weighing your personal decision.

Long Term Storage

The DNG format is openly and completely documented, which means that it should be supported indefinitely, whereas proprietary formats such as CR2, NEF, RAF, etc., aren't. The question is, will you be able to find a raw converter in 20 years time that will convert your camera's proprietary format when that camera model is ancient history? Some of Kodak's early digital formats are already unsupported by Kodak themselves, so how long will it be before other formats start to go the same way? It may not be an issue at the moment, but do you want to have to keep checking your old files to make sure they're still supported?

Although DNG is Adobe's baby, there are a long list of other companies supporting it, including Apple, Corel, Extensis, Hasselblad, Leica, Pentax, Ricoh and Samsung, to name a few. It's also been submitted to the ISO to become an ISO Standard, just like Adobe's PDF format many years ago, so it's here to stay.

XMP

In addition to storing metadata in your Lightroom catalog, it's also possible to write that data back to the files in a header section called XMP. Because proprietary raw formats are largely undocumented, it's not safe to write most data back to those original files, so it has to be written to a sidecar file instead, whereas DNG files can have that information stored within the DNG wrapper, like JPEG, TIFF and other documented file types. The question is, do you find sidecar files a pro or con? If you use an online backup service, they could be a disadvantage as they would need uploading again each time you updated the embedded metadata, but on the other hand, sidecar files can easily become separated from their raw files.

Embedded Preview

If you choose the DNG format, along with that XMP data in the DNG wrapper, there's an embedded preview. You're in control—you choose how big you want that preview to be, and you can update it to show

"XMP" section on page 241

the Develop adjustments you make in Lightroom. That means that other programs that rely on the embedded preview will be looking at your processed image preview rather than the original camera preview. Updating that preview doesn't touch the original raw data, so it's a nondestructive way of updating the photos to look their best.

File size

The DNG lossless compression algorithms are better than those applied by the camera, so DNG files are generally 10-40% smaller than their original proprietary format, depending on the camera and on the size of the preview that you choose to embed. Although hard drives may be comparatively cheap now, they're not free, so space savings are still a benefit.

Early Corruption Warning

If the file's seriously corrupted, it often won't convert, and instead will warn you of the corruption, so you can download the file again before you reformat the cards. It's not infallible, and it's not a replacement for a visual check, but it's an additional check worth having.

DNG Hash

One of the most promising new features is the DNG Hash, which is written into files created by Lightroom 1.4.1, ACR 4.4.1, and DNG Converter 4.4.1 or later. The DNG hash allows you to validate that the image data itself hasn't changed since the DNG file was created. Very few programs can currently check that DNG hash, but the technology is moving forward rapidly, and any DNG files created now will be able to make use of that validation software in the future.

Manufacturer's Software

Until the main manufacturers start supporting the DNG format, their own software will not read a DNG file. If you use the manufacturer's software regularly, that may be an issue, although if you only use it occasionally, keeping one of your backup copies as the proprietary format for those occasions, could give you the best of both worlds.

MakerNotes

Never heard of MakerNotes? Then you probably won't care. All of the important data is carried over into the DNG file, but some camera manufacturers also put some secret data in their files. There is DNG support for MakerNotes, however some manufacturers don't stick to the rules, and therefore MakerNotes embedded in an undocumented format can't always be carried over completely to the DNG file. If you shoot CR2 or NEF, as well as a few other formats, all of the data is copied to the correct place in the DNG file, even if Adobe doesn't understand it.

Compatibility with older ACR and Lightroom versions

In order to open files from the latest cameras newly introduced to the market, you have to be running the latest version of Photoshop/ACR or Lightroom. If you buy a new camera, but choose not to upgrade Photoshop or Lightroom to the latest release at the same time, converting the raw files to DNG using the latest free standalone DNG Converter allows you to open those files with your older versions. The DNG Converter may need to be updated before it will convert the latest camera's files.

Do I lose quality when converting to DNG?

There are 2 flavors of DNG—mosaic or linear.

A standard or mosaic DNG file takes the existing mosaic data straight out of the proprietary raw file without applying any processing, and simply wraps it in a DNG wrapper. That's usually the best option as it maintains flexibility for the future, and there's no loss of quality. Lightroom automatically uses this option where possible, with the main exception being sRAW files.

The DNG Converter, under Compatibility > Custom, offers a linear DNG option which changes the way that the data is stored, resulting in much larger files. A linear DNG is demosaiced at the time of conversion, so you lose the option of using a newer or better demosaic algorithm in the

"If I shoot sRAW format, can Lightroom apply all the usual adjustments?" on page 64 future, such as the new demosaic just introduced in Lightroom 3. A few programs will only read or output a linear DNG and not a mosaic DNG. DXO is a well known example which can only create linear DNGs.

If I convert to DNG, can I convert back to the proprietary raw file format again?

Conversion to DNG is a one-way process, unless you've embedded the proprietary raw file which could then be extracted.

If you're concerned about accessing the proprietary raw file, either archive the proprietary raw file as well as the DNG file, embed the proprietary raw file in the DNG file, or forget DNG altogether.

As you no doubt keep more than one copy of your photos, storing one of those backups as the proprietary format would leave all of your options open, while still gaining the benefits of DNG. Being a true pack-rat, one set of my backups are the photos straight out of camera and they remain in the proprietary format, however in the 2 years since I converted to a DNG workflow, I've never yet needed a proprietary version, other than to write about the process in this book.

Which preferences should I choose when converting to DNG?

In Lightroom, the DNG Preferences are found in the main Preferences dialog > File Handling tab, which you can find under the Edit menu (Windows) / Lightroom menu (Mac). You will only need to set them once.

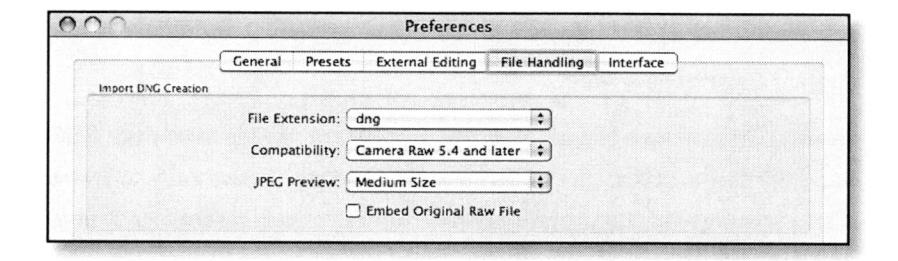

"I embedded the proprietary raw file how do I extract it to use it?" on page 101

File Extension

Upper or lower case file extension is just a matter of personal choice and makes no difference to the DNG file itself.

Compatibility

The DNG Specification has grown over the years, as new features have been added. All DNG files are forwards compatible, which means that they can definitely be opened by future programs. In most cases the files are also backwards compatible, however there are exceptions, so if you need to guarantee compatibility with an older program such as CS2, you can select an older compatibility version. It's like saving a Microsoft Word 2010 document in Word 98 format—by selecting that format, you're guaranteeing compatibility with the older version, but losing out on the benefits of the features that have been added more recently. As a general rule, you'll want to select the latest version.

Preview size

None creates a thumbnail of only 256px along the longest edge, which results in the smallest file size.

Medium creates a preview of 1024px along the longest edge, which is ideal for general file browsing.

Full creates a full resolution preview, which is useful if you want to print or zoom in on an image using DNG-compatible software without having to render the raw data, but does also create the largest file size.

None of the preview sizes make any difference to Lightroom 3 itself, as Lightroom has its own preview system.

Embed Original Raw File

Embed Original Raw File embeds the proprietary raw file inside the DNG wrapper too, and that can be extracted again later to use with software that can only read the proprietary raw format. It does essentially double the file size, so you may prefer to keep copies of the proprietary raw backup separately instead.

Ouick Defaults

If you're still not sure, here are some defaults to get you started:

Compatibility: the highest number, currently 5.4 at the time of writing

JPEG Preview: Medium

Embed Original Raw Files: turned off

How do I convert to DNG?

There are a few different stages of your Lightroom workflow when you can convert to DNG—while importing, while in your catalog, while exporting, or entirely separately using the DNG Converter. We'll cover them all together here, but if you're new to Lightroom, you may decide to skip some and refer back to them later, instead of joining me on this slight tangent.

Converting when importing into Lightroom

In the Import dialog, one of the Import options is 'Copy and Convert to DNG'. Selecting that option will import the photos in the DNG format, converting on the fly, using the DNG options set in the Preferences dialog. If you use the 'Make a Second Copy' option in the File Handling panel, the copy will be of the original file format, not the converted DNG file.

Converting existing Lightroom files

Why might you want to convert files that are already in your Lightroom catalog?

- You're in a hurry and just want them imported without stopping to convert at the time—you can then leave the DNG conversion running overnight.
- You want to copy the proprietary raw files over to your backup in their mirrored folder structure before converting your working copies to DNG.

Also check...

"What does the 'Make a Second Copy' option do?" on page 75 You want to convert photos that were in the catalog before you decided on a DNG workflow.

Simply go to Library module's Grid view and select the photos you want to convert, and then select Library menu > Convert Photos to DNG... Choose the DNG options as discussed above, and press OK. The progress will be shown in the Activity Viewer in the top left corner of Lightroom's workspace.

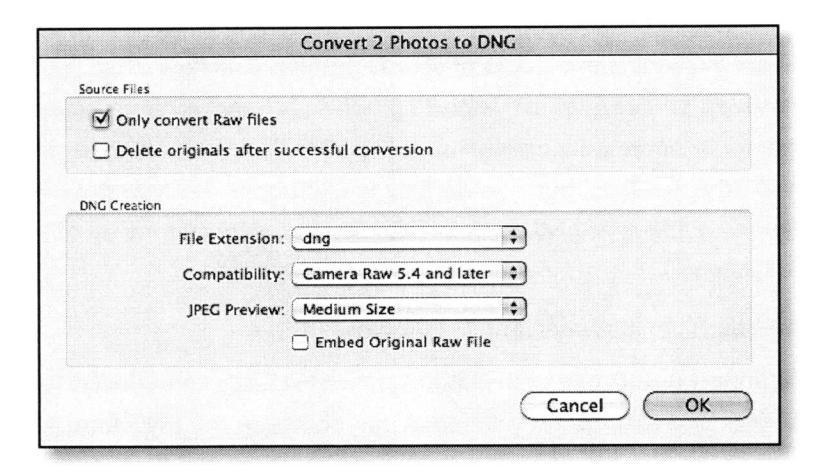

You have 2 additional options in this dialog, but they're not rocket science. 'Only convert raw files' will, fairly logically, only convert the raw files. That's useful if you've accidentally included other formats such as JPEGs in your selection. 'Delete originals after successful conversion' will move the proprietary raw files to the Recycle Bin (Windows) /Trash (Mac) once the DNG file has been created, instead of leaving it in the same folder.

Converting when exporting from Lightroom

Lightroom has one more DNG conversion option, at the opposite end of the workflow. You have the option of converting to DNG when you export the files—perhaps you prefer to work on proprietary raw files within your own workflow, but then archive as DNG, or you want to send a DNG format to someone else.

Go to File menu > Export... and the DNG options are under the File Settings section. All of those preferences are no doubt quite familiar by now!

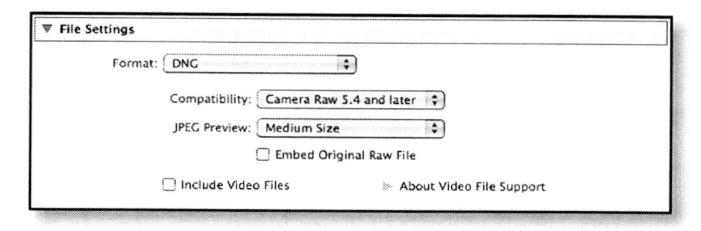

Using the DNG Converter

So that's it for Lightroom, but what happens if you don't have Lightroom around at the time, or you're using an older version of Lightroom that doesn't support your camera? Not a problem! Adobe provides a free standalone DNG Converter which is updated at the same time as each Adobe Camera Raw release. You can download it from http://www.adobe.com/products/dng/—the download links are on the right. The DNG Converter now comes with a standard installer. Once installed, it will be available in Start menu > Program Files > Adobe > Adobe DNG Converter for Windows, or Applications folder > Adobe DNG Converter for Mac.

The DNG Converter will take any ACRcompatible raw format and convert it to DNG format, First select the folder containing the proprietary raw files and choose where to save

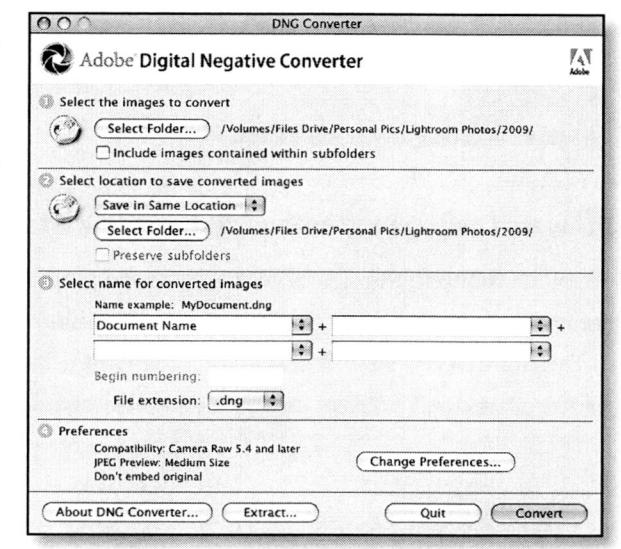

the resulting DNG files, set the renaming options if you wish to rename at the same time, and choose the Preferences discussed earlier. Pressing Convert will begin the conversion, and a second dialog will keep you informed of the progress. When you've finished, simply quit the program.

Should I convert other formats like JPEG or TIFF to DNG?

It's possible to convert JPEG and TIFF files to DNG using Library menu > Convert Photos to DNG..., however that doesn't turn them into raw files—it just wraps the rendered data in the DNG wrapper.

There are two advantages—you can update the preview without affecting the original image data, and you can't accidentally save over your original. The disadvantages, however, usually outweigh those advantages—the resulting linear DNG files aren't compatible with as many programs as their more universal JPEG or TIFF counterparts, and JPEGs converted to DNG are usually bigger than their JPEG original, for example, a 1.7MB JPEG becomes a 7MB DNG file.

How do I update my embedded preview?

If you have a DNG file in Lightroom and you've made Develop adjustments to the photo, you may want to update the embedded preview to reflect those changes. To do so, go to Library module > Grid view, select the photos you want to update, and go to Metadata menu > Update DNG Preview & Metadata.

How do I change my embedded preview size?

If you've changed the size of your embedded preview in Preferences, for example, switching from Medium size to 1:1, using the Metadata menu > Update DNG Preview & Metadata command will also update the size of the embedded preview to match your new setting.

Why do some files get bigger when converting to DNG?

Standard raw files get smaller when converting to DNG due to the improved lossless compression, however some files, such as sRAW files, have to be stored as Linear DNG files as their formats aren't supported by the DNG specification.

I embedded the proprietary raw file—how do I extract it to use it?

If you chose to embed the proprietary raw file, and then you want to extract it, you need the standalone DNG Converter, which you can download from http://www.adobe.com/products/dng/ Press the Extract button at the bottom of the dialog, choose the source and target folders, and press Extract to start the process. It only works on whole folders, and not single files, so move the file into a temporary folder if you only want to process a single file. The DNG file isn't affected by the process and the embedded raw file remains within the DNG wrapper, in addition to the extracted version.

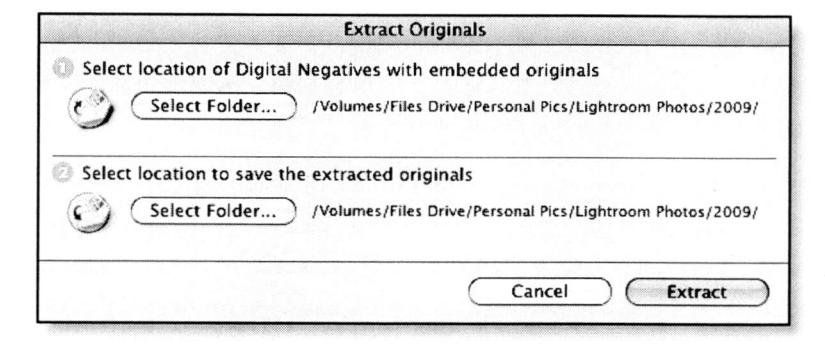

I embedded the proprietary raw file—is there any way to remove it?

If you originally embedded the proprietary raw file, but then change your mind, you can strip it, again using the standalone DNG Converter. Uncheck the 'Embed Original Raw File' checkbox in the DNG Converter Preferences dialog, and run the files through the DNG Converter again.

Also check...

"If I shoot sRAW format, can Lightroom apply all the usual adjustments?" on page 64 Once they've finished converting, you can replace Lightroom's DNG files with those smaller DNG files using Explorer (Windows) / Finder (Mac). Stripping the proprietary format deletes it, rather than moving it elsewhere, so be careful to extract the proprietary raw file first if you want to keep it.

OTHER IMPORT QUESTIONS

Having explored all of the Import dialog options, there are a few other related questions which regularly appear on the user forums, including what the error messages actually mean.

How do I import my existing photos into Lightroom?

If you haven't used previous Lightroom versions, you may have a large quantity of existing photos to import into Lightroom. If those are already arranged in a suitable folder structure that you would like to keep, you can import them using 'Add photos to catalog without moving them,' so that they're referenced in their existing location. If, on the other hand, your photos are spread across your hard drives in a slightly disorganized fashion, it may be a good time to move them into a new logical dated folder structure that you can easily manage.

If you've already used other software to start cataloging your photos, the move may be a little more complicated. Switching between Adobe software is relatively simple. Bridge writes your metadata to XMP, which should be read when importing the photos, and Lightroom offers a File menu > Import Photos from Elements... option to upgrade your Elements catalog into a Lightroom catalog. If you're switching from other programs, the options vary, particularly if you want to transfer existing metadata, but writing any metadata to XMP, where possible, is an excellent start.

"XMP" section on page 241

Why does Lightroom load or open the Import dialog every time I insert a memory card or device?

There are 2 different factors involved in Lightroom automatically launching—whether Lightroom opens the Import dialog if the program is already open, and whether the programs loads by itself even though it was closed. You may wish to disable either or both.

If Lightroom's already loaded, and inserting a memory card causes the Import dialog to open, go to Preferences > General tab and check or uncheck 'Show Import dialog when a memory card is detected' to change the behavior.

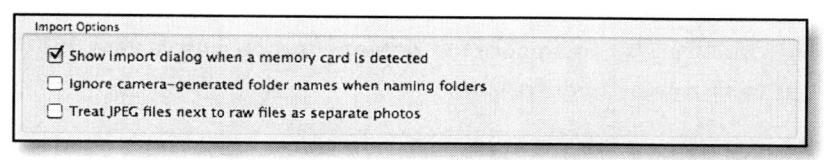

If Lightroom's closed, and inserting a memory card causes it to load, then Windows is opening it, so you'll need to check the Windows AutoPlay settings instead. You'll find the AutoPlay settings under Control Panel > Hardware & Sound > AutoPlay (Windows Vista/7) or by right-clicking on the drive in Explorer and choosing Properties > AutoPlay tab (Windows XP).

The same logic applies, not just to card readers and cameras, but also to iPhone, iPod, USB keys, printers with card readers, and various other devices.

I can't see thumbnails in the Import dialog, I just see grey squares. How do I fix it?

If not all of the photos exhibit the problem, it may be that the file is corrupted, not supported by Lightroom, doesn't have an embedded preview, or that Lightroom simply hasn't finished retrieving all of the embedded previews yet. Make sure you're running the latest Lightroom update—if your camera is a new release, support may have been added

Also check...

"Why do I just get grey boxes instead of previews?" on page 257 recently, or may not be available yet. If Lightroom can't import the photo, the error message that will follow should give more information on the reason.

If your camera's connected directly to the computer, a lack of previews can be a result of problems with the camera driver at the operating system level. In that case

you should be able to import the files without seeing the Import dialog previews and then Lightroom's own previews will be rendered once the photos are imported. You may consider purchasing a card reader, as they are usually quicker and reduce the wear and tear on your camera, and it can show previews more reliably.

Being unable to see previews anywhere within Lightroom's interface is a slightly different problem which we'll cover in more detail in the Previews chapter.

Can I set Lightroom to delete the photos from the memory card once they've uploaded?

When you're importing from a device, such as a camera or card reader, Lightroom disables the Move and Add options to protect you from accidental loss. Most file corruption happens during file transfer, and if you selected Move, you would no longer have an uncorrupted copy on the card if corruption did occur. If you selected the Add option, you could format the card believing that the files are safely imported into Lightroom, only to find that Lightroom can no longer find the files as it was reading them directly from the memory card.

For that same reason, there's no 'delete photos from memory card once uploaded' option because it's good practice to verify that the data is safe before you delete the files, and also, formatting the cards in your camera, rather than the computer, minimizes the risk of card corruption.

"Lightroom appears to be corrupting my photos—how do I stop it?" on page 108

What happens to the other files on a memory card, such as sound or video files?

Lightroom now imports video files from most digital cameras, but for management only, not editing. Sound files (i.e., WAV and MP3) with the same names as imported photos are copied and marked as sidecar files.

Files that aren't created by digital cameras, for example, text files that you may have placed alongside the photos, will not be copied to the new location, so always check before formatting if you've mixed file types.

Can I import CMYK photos into Lightroom?

As of Lightroom 3, you can now import CMYK photos to manage them alongside your other photos, use the Edit in Photoshop menu command to pass the original file back to Photoshop, and export as 'Original' format, all still in CMYK. Any Develop editing within Lightroom, and export to any format other than 'Original' will, however, use the RGB color space, which can result in unexpected shifts in untagged images.

It says: 'Some import operations were not performed. Could not copy a file to the requested location.'

If Lightroom can't copy or move the photos to their new location, it's probably because the Destination folder is read-only. You can try another location, or correct the permissions for that folder. If the permissions appear to be correct already, it may be a parent folder that has the incorrect permissions, or perhaps you're trying to write to an incompatible drive format, such as a Mac computer trying to write to an NTFS formatted drive.

Also check...

"Managing Videos" section on page 186

Also check...

"How do I find out whether my new camera is supported yet?" on page 473

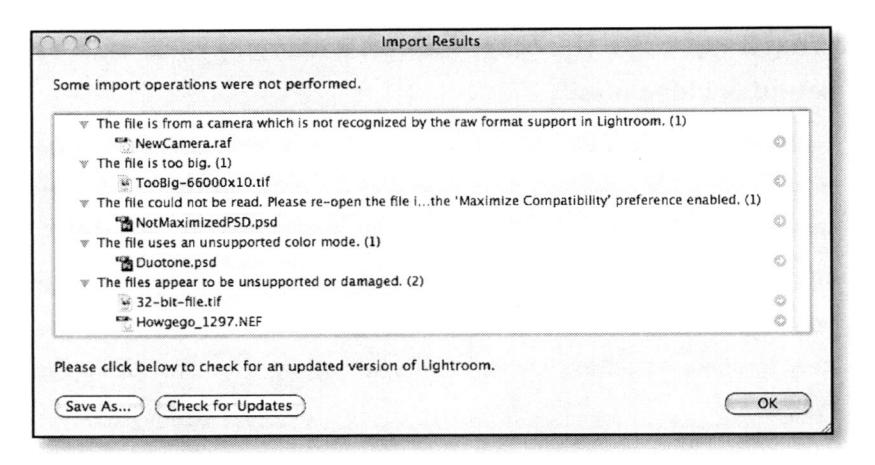

It says: 'Some import operations were not performed. The file is too big.'

Lightroom 3 has a file size limit of 65,000 pixels along the longest edge, and up to 512mp, whichever is the smaller. If it tells you that the file is too big, then you're trying to import a photo that's larger than that—perhaps a panoramic photo. If you have any such files that you can't import, you could create a small version of the photo to import into Lightroom to act as a placeholder.

It says: 'Some import operations were not performed. The file is from a camera which isn't recognized by the raw format support in Lightroom.'

Lightroom needs to be updated to read raw files from new cameras, so if Lightroom says that it doesn't recognize the raw format, make sure you're running the latest Lightroom update. You can check whether your camera is supported by the latest version of Lightroom by visiting: http://www.adobe.com/products/photoshop/cameraraw.html

Updates are usually released every 3-4 months, along with an update for ACR (Adobe Camera Raw plug-in for Photoshop/Bridge), so if your new camera doesn't yet appear on the list, it shouldn't be too long a wait.

"How do I update Lightroom with the latest version of ACR?" on page 473

It says: 'Some import operations were not performed. The files use an unsupported color mode.'

If a photo is in a color space which Lightroom doesn't support, such as Duotone, it'll be unable to import it, so you'll need to convert the photo to RGB, CMYK, Lab, or Grayscale, or import an RGB copy as a placeholder instead. If you're going to edit the file in Lightroom, remember that all editing and export takes place in RGB color spaces, which could result in unexpected shifts in files with other color spaces, so you may prefer to control the conversion to RGB yourself using Photoshop, and then import the RGB file into Lightroom for further editing.

It says: 'Some import operations were not performed. The files could not be read. Please reopen the file and save with 'Maximize Compatibility' preference enabled.'

Lightroom doesn't understand layers, so if there's no composite preview embedded in a layered file, it can't be imported, and you'll need to resave those PSD files with a composite preview.

You'll find Photoshop's Preferences under the Edit menu (Windows) / Photoshop menu (Mac), and in the File Handling > File Compatibility section, there's an option to 'Maximize Compatibility' with other programs by embedding a composite preview in the file. The preference only applies to PSD and PSB format files, as other formats such as TIFF embed the composite by default.

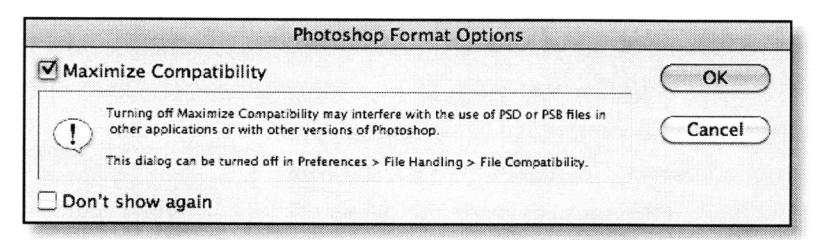

Maximize Compatibility does increase file size, but it ensures that other programs—not just Lightroom—can read the embedded preview even

if they can't read the layers, so it's best to set your Photoshop Preferences to 'Always'. If you set it to 'Ask,' it'll show this dialog every time you save a layered PSD file.

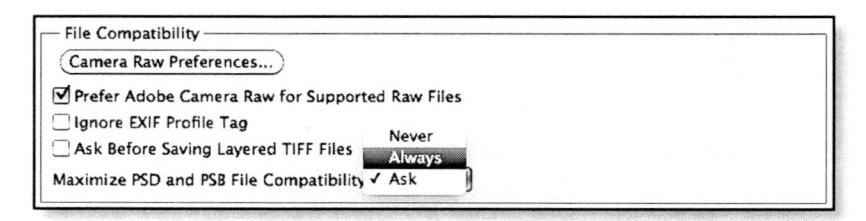

It says: 'Some import operations were not performed. The file appears to be unsupported or damaged.'

Lightroom requires 8-bit or 16-bit images, however some HDR images are 32-bit, which won't import. In that case, you could create a small 8-bit version of the photo to import into Lightroom to act as a placeholder.

If the file's not 32-bit, then the photo you're trying to import may be corrupted instead. File corruption sometimes prevents the photo from being imported, resulting in the 'unsupported or damaged' error message, but more often it shows up once the photo is imported into Lightroom and the previews are being built.

Lightroom appears to be corrupting my photos—how do I stop it?

Even if photos import into Lightroom, corruption may appear when you start working with the photos. The preview you see in other browsers, and initially in Lightroom, is the small JPEG preview embedded into

each file by the camera, which often escapes corruption because it's confined to a small area of the file. Lightroom then reads the whole file to create an accurate preview, and is unable to read it fully due to corruption, resulting in the distorted view.

Unfortunately the files are usually corrupted before they reach Lightroom, and in all of the cases investigated by Adobe, it's turned out to be a result of hardware problems. Corrupted files are most often caused by a damaged card reader or cable, but other regular suspects include damaged flash cards or problems with the camera initially writing the file. If a photo gets corrupted some time after the original import, a damaged hard drive or connection, damaged memory, or a variety of other hardware issues would also be worth investigating. Most file corruption happens at the time of file transfer, so moving photos between hard drives repeatedly increases the risks. Using file synchronization software which will allow byte-for-byte verification helps to minimize the risk of data loss if you do have to move files between hard drives.

Why is Lightroom changing the colors of my photos?

If Lightroom starts changing the appearance of the newly imported photos automatically, there are a few settings that you might have changed.

Are the photos raw? If so, the changes are likely just a difference in rendering, because raw data is just that—raw—and each raw processor has its own style. We'll come back to raw profiling options in the Develop chapter.

There are a few other possibilities, however, which would also apply to JPEG and other rendered formats. We'll cover the options in more detail later, but a quick checklist for now:

- Have the photos been edited in Lightroom or ACR previously? If so, they may have Develop settings recorded in the metadata.
- Did you apply a Develop preset in the Import dialog? Set it to None and see if the problem recurs on future imports.
- If you go to Lightroom's Preferences > Presets tab, is 'Apply auto tone adjustments' checked? If so, uncheck it for future imports.

Also check...

"What Develop settings, metadata and keywords should I apply in the Import dialog?" on page 75 and "Raw File Rendering" section on page 271

Also check...

"Defaults" section on page 306 and "Everything in Lightroom is a funny color, but the original photos look perfect in other programs, and the exported photos don't look like they do in Lightroom either. What could be wrong?" on page 258

For photos that are already imported, if you go to the Develop module and press the Reset button at the bottom of the right hand panel, does it change? If not, you may have changed the default settings, so go to Preferences dialog > Presets tab and press the 'Reset all default Develop settings' button.

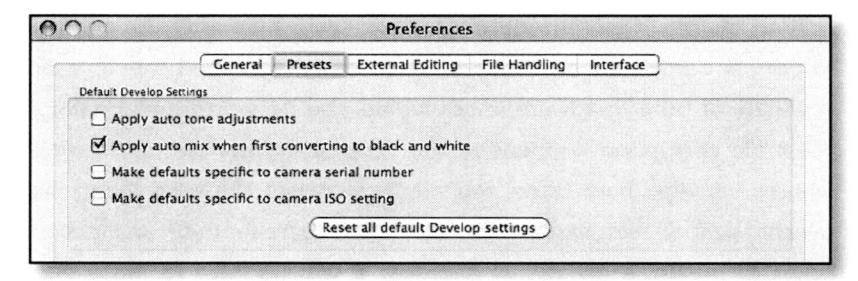

There's one other final possibility, which is a corrupted monitor profile, which we'll discuss in the Previews & Speed chapter a little later.

I shot Raw+JPEG in camera—why have the JPEGs not imported?

In Lightroom's Preferences > General tab is an option to 'Treat JPEG files next to raw files as separate photos'.

With that option checked, Lightroom will import the JPEG files alongside the raw files. If the checkbox is unchecked, then the JPEGs are recorded as sidecar files, showing the filename as 'IMG0001.CR2 + JPEG,' and noting the JPEG as a sidecar in the Metadata panel. Photos imported as sidecar files aren't treated like photos, so you can't view them separately, and if you move or rename the raw file, the sidecar goes too.

If you've imported the raw files already, and you now want to import the JPEGs as separate photos, you can turn off the checkbox and re-import

that folder—the raw files will be skipped as they already exist in the catalog, and the JPEGs will be imported as separate photos. The raw files will remain marked as Raw+JPEG, and there isn't an easy way of changing that. Removing them from the catalog and reimporting them will reset that label, but if you've made any changes

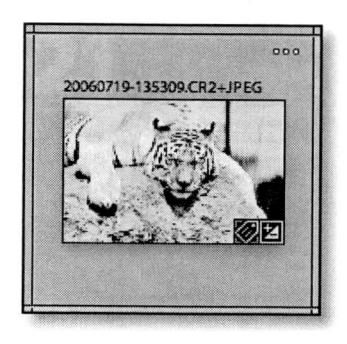

since import, those changes may be lost, so the best solution currently is to close your eyes and ignore them.

TETHERED SHOOTING & WATCHED FOLDERS

Tethered shooting involves connecting your camera directly to the computer, and as you shoot, photos appear on the computer's monitor immediately, rather than having to download them later. Lightroom offers two different options, depending on your requirements.

If you're using one of the supported cameras, you can use the new Tethered Capture tool, which allows you to connect your camera to the computer, view your camera settings and trigger the shutter using Lightroom's interface.

If you're shooting wirelessly, or you want to use other remote capture software, perhaps because your camera isn't supported by Lightroom's Tethered Capture tool, or you need to control all of the camera's settings remotely, you can use Auto Import to monitor a watched folder instead. Auto Import collects photos from a folder of your choice as they appear and automatically imports them into Lightroom, moving them to a new location in the process.

Which cameras are supported by the built-in Tethered Capture?

At the time of 3.0's release, the list of certified cameras is limited to:

Canon:	Nikon:
1D Mark II (firewire only, not Windows x64)	D3
1DS Mark II (firewire only, not Windows x64)	D3s
1DS Mark III	D3x
1D Mark III	D200 (Mac only)
1D Mk IV	D300
5D (not Windows x64)	D300s
5D Mark II	D700
7D	D90
20D (Mac only)	D5000
30D	
40D	
50D	
350D / Digital Rebel XT / Kiss Digital N	,
400D / Digital Rebel XTi / Kiss Digital X	
450D / Digital Rebel XSi / Kiss X2	
500D / Digital Rebel T1i / Kiss X3 Digital	
1000D / Digital Rebel XS / Kiss F	

You can check the current list at:

http://kb2.adobe.com/cps/842/cpsid_84221.html

Other Canon cameras may also already work, but Nikon cameras are limited to the list above at the time of writing, due a difference in the SDK's.

Lightroom uses Canon and Nikon's own SDKs to control the camera, which results in some slight differences between manufacturers, for example, if there's a memory card in the camera, Canon cameras can write to the memory card in addition to the computer hard drive, whereas Nikon cameras will only write to the computer hard drive.

How do I set Lightroom up to use Tethered Capture?

Connect your camera to the computer using your USB or Firewire cable and go to File menu > Tethered Capture > Start Tethered Capture... and

choose your settings in that dialog. Canon 5D, 20D and 350D need to be in PC Connection mode, whereas all of the others need to be in PTP Mode.

Photos will be placed into a subfolder within the Destination folder you choose, with the subfolder name taken from your Session Name. The 'Segment Photos by Shot' option subdivides the shots into further subfolders, using the Shot Name. That Shot Name can be changed at any point, automatically creating another new subfolder, by clicking on the Shot Name in the Tethered Capture window.

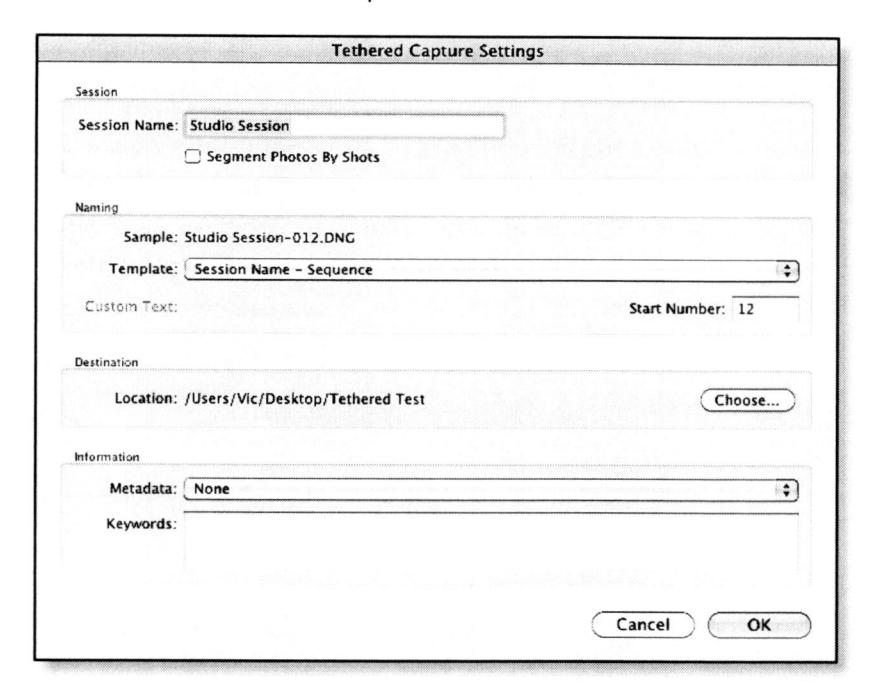

The Tethered Capture window shows you the current camera settings, but doesn't currently allow you to change those settings remotely. In that dialog you can set a Develop preset to apply to each photo on import, and you can drag the dialog to another location if it's getting in your way. It floats over the top of Lightroom's standard window so you can carry on working without closing the Tethered Capture window.

Press the shutter button on the camera, or the silver button on the dialog, to trigger the shutter.

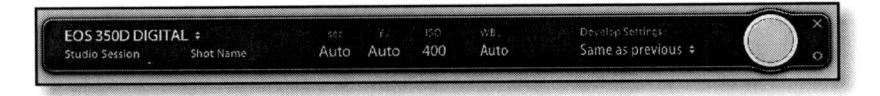

Crops can't be saved in presets, so how do I get it to apply a crop to my Tethered photos?

As in the main Import dialog, Develop presets allow you to automatically apply certain Develop settings to your photos, and those same presets are available in the pop-up menu in the Tethered Capture window.

Certain settings, such as Crop, can't be included in Develop presets, however that doesn't prevent you from applying them automatically. Simply shoot the first photo, apply your crop along with any other Develop settings, and then select the 'Same as Previous' option in the Develop presets pop-up menu. Any further tethered shots will automatically have those previous settings applied, including the crop.

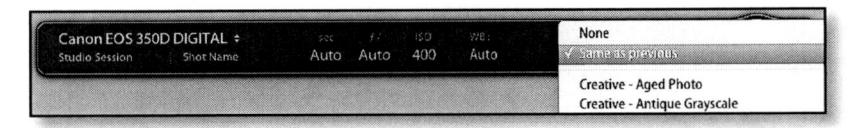

Can I convert to DNG while tethering?

You may usually convert to DNG when importing, but Tethered Shooting doesn't offer that option for performance reasons. If you allow it to import the photos and work on them as usual, you can then use the Library menu > Convert Photos to DNG... command to automatically convert and swap the proprietary raw files for DNG files later without losing anything.

How do I set Lightroom up to use a watched folder?

You can use your own camera manufacturer's software (EOS Utility, Camera Control Pro , etc.) or other remote capture software to capture the photos, and set it to drop the photographs into Lightroom's watched folder. Lightroom can then collect the files from that watched folder, and move them to another folder of your choice, importing them into your Lightroom catalog, renaming if you wish, and applying other settings automatically. You select those options in the File menu > Auto Import Settings dialog, and then switch it on by checking File menu > Auto Import > Enable Auto Import.

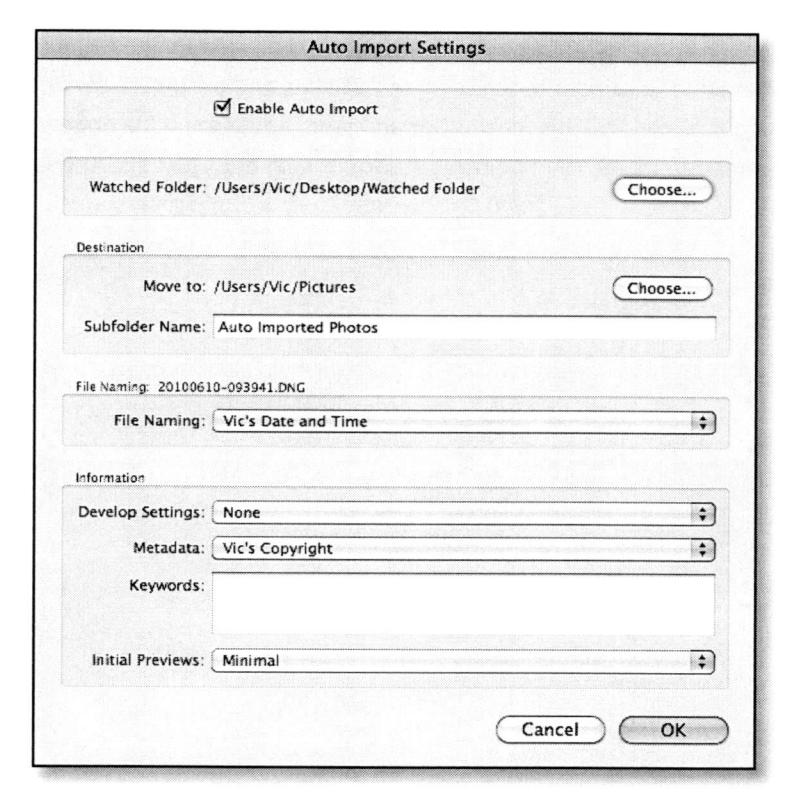

Set up your camera's remote capture software to drop the photos into a specific folder, perhaps on your desktop, and set Lightroom's Auto Import to watch that folder. Lightroom moves the files from the watched folder to the destination folder as photos appear there, so it needs to be empty when you set it up. Make sure your camera's remote capture software (i.e., EOS Utility, Camera Control Pro) doesn't create a dated subfolder as Lightroom won't look in any subfolders in the watched folder.

You can test that Lightroom's Auto Import is working by simply copying a file from your hard drive into the watched folder. As soon as the file lands in the folder, it should start the import, you should see the file vanish from the watched folder, and then it should appear in the destination folder and in Lightroom's catalog. If that works, then you've set up Lightroom properly.

Then connect the camera to the capture software, and ensure it's saving to the right folder. Release the shutter and you should see a file appear in the watched folder, then Lightroom should take over, just like in the test.

Workspace

This is one section where we will break partially from the FAQ format, and cover some of the basics of working within Lightroom's interface, because you may need to refer back to some of these sections later in the book. We'll not only cover the obvious parts, such as the different sections of the screen, but also how to work with selections, sliders, tokens in dialog boxes, and updating presets in pop-up menus.

THE MAIN WORKSPACE

When you first open Lightroom, you'll be viewing the main workspace.

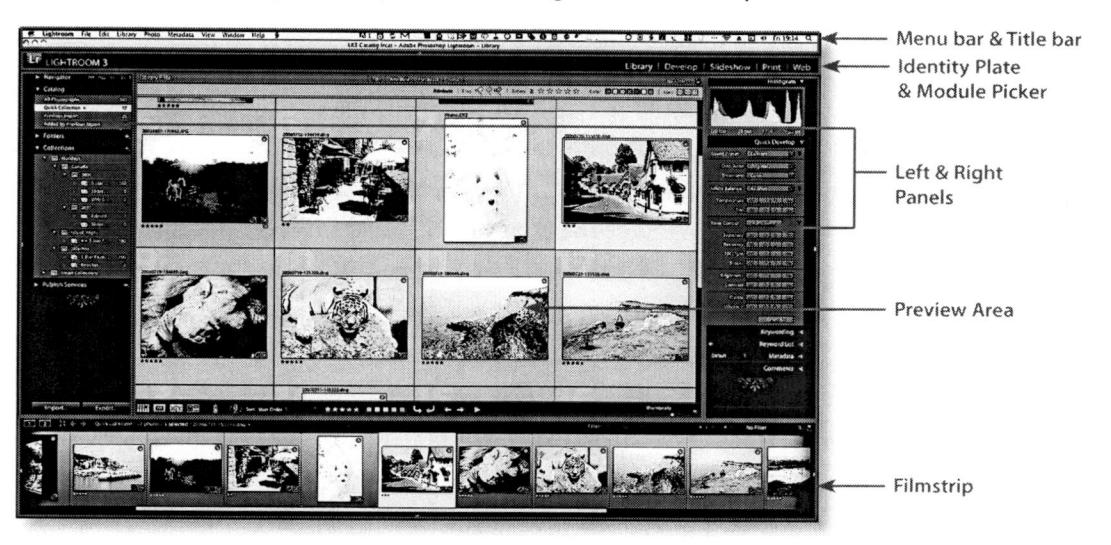

Menu bar, Title bar and screen modes

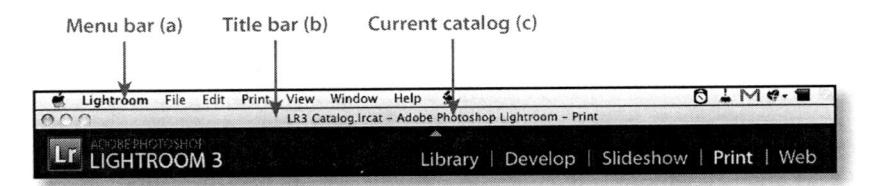

Lightroom offers 3 different screen modes, each offering a few less distractions than the previous, and you press the F key to cycle through them. The normal window mode allows you to resize or move the window, and the Title bar (b) along the top of the window shows the name of the current catalog (c). The next mode is 'Full Screen with Menu Bar,' which fills the screen but leaves the menu bar (a) showing. The final mode is 'Full Screen' where the menu bar disappears from view. Floating the mouse right to the top of the screen will briefly show the menu bar, or you can press F once or twice to return to another view.

Module Picker

Lightroom is divided up into modules. Library is where you manage your photos, Develop is where you process them, and then Slideshow, Print and Web are for displaying your photos in different formats.

Along the top of the Lightroom workspace is the Module Picker where you click to switch between the different modules. As you'll likely spend most of your time switching between the Library and Develop modules, it's worth learning those keyboard shortcuts—G for Grid view, E for Loupe view, and D to switch to the Develop module. We'll come back to those different view modes a little later.

Identity Plate / Activity Viewer

The Module Picker also holds 2 other items—the Identity Plate and the Activity Viewer.

on page 133

Page 118

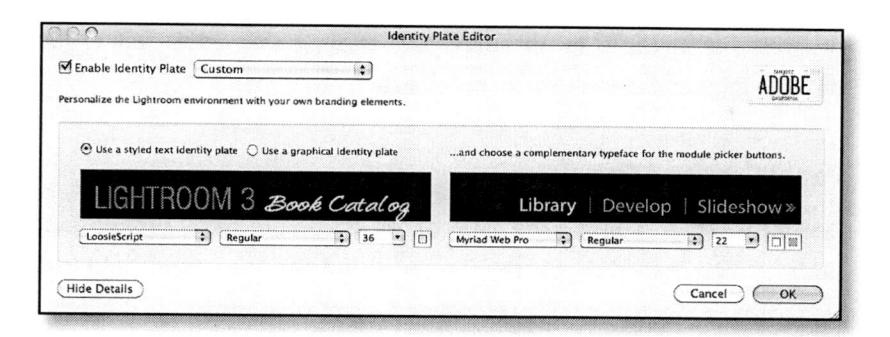

The Identity Plate allows you to personalize your Lightroom catalog. It's particularly useful if you keep multiple catalogs for different purposes, allowing you to see which catalog you have open at a glance. To create an Identity Plate, go to Identity Plate Setup under the Edit menu (Windows) / Lightroom menu (Mac). Click 'Enable Identity Plate' and select 'Use a graphical identity plate'. Drag a photo into the space available, or use the 'Locate File...' button to find a suitable file. Standard image formats are fine, but the PNG format will also allow for transparency. You can also 'Use a styled text identity plate' and type the text of your choice, changing the font, size and color to suit. These Identity Plates can also be used in the Slideshow, Print and Web modules, so you'll want to save them using the pop-up menu. They're stored with the catalog, rather than in a global location, so if you have multiple catalogs, you'll need to set them up in each catalog.

When there's an active process running, for example, a large export, the Identity Plate is temporarily replaced by the Activity Viewer. It shows the progress of any current tasks, and clicking on the X at the end of any of those progress bars will cancel it. Lightroom is multi-threaded, which means it can do lots of tasks at once, so you don't need to wait for it to finish before doing something else. When there are too many tasks to show in one view, for example, more than 2 exports, it will show a combined progress bar. In that case, the X at the end of that combined

progress bar changes to an arrow, and clicking that arrow will cycle through each of the individual active tasks.

Panel Groups & Panels

Down the left and right hand sides of the screen are panel groups and each holding individual panels. The panels on the left always hold the Navigator or Preview panels and other sources of information—folders, collections, templates, presets, etc. The panels on the right allow you to work with the photos themselves, adding metadata, changing Develop settings, and adjusting settings for slideshows, prints and web galleries.

You can customize some of the panel options. If you drag the inner edge (a) of those panel groups to make them wider or narrower, it also changes the width of the sliders, making them easier to adjust. In the Preferences dialog > Interface tab you can also adjust the font size and change the panel end marks at the bottom of each panel group (b). If you want even more control over the interface such as changing font sizes, extending the panel widths further and making other non-standard changes, consider Jeffrey's Configuration Manager: http://www.regex.info/blog/lightroom-goodies/

Many users have asked for tear-off panels that can be placed on another screen, such as those in Photoshop, but that's not currently possible with the modular design. The alternative is Solo Mode. If you right-click on the panel header next to the panel label, you can select 'Solo Mode' from the menu. Clicking on a panel header would usually open that panel, but

with Solo Mode activated it also closes the other panels, so you just have one panel open at a time. Shift-clicking on another panel while in Solo Mode opens that panel without closing the first one. Particularly in the Develop module, where there are lots of panels to switch between, it's quicker than leaving them all open and having to scroll up and down constantly. If you find that there's a specific panel that you never use, you can uncheck it in

that same menu, which will hide it from view. If you ever need it back, right-click on a panel header to show that menu again.

Panel Auto Hide & Show

The black bar along the outer edges of the panels (a) control whether that panel is showing or hidden, and when you click on that bar, it opens or closes the panel group. The most useful panel keyboard shortcuts are Tab to hide and show the side panels and Shift-Tab to hide and show all of the panels including the Filmstrip.

The panels are set to 'Auto Hide & Auto Show' by default, which means that if you click on the black bar to hide the panel, every time you float the mouse close to the edge, the panel will pop into view. A solid arrow

(b) in that bar indicates that the panel is locked into position, and an opaque arrow (c) indicates that it's set to automatically show or hide itself when you float the mouse over that bar. If you right-click on those black bars, you can change the behavior for each panel. Personally I have the side panels set to 'Auto Hide,' so I have to click to show the panels, but when I've finished using them, they automatically hide again. I leave the Filmstrip on 'Manual' so that it remains in view unless I choose to hide it.

Filmstrip

The bottom panel is called the Filmstrip. It shows thumbnails of the photos in your current view, which makes them accessible from the other modules. If you find that the Filmstrip thumbnails become too cluttered, you can change the visible information using the Preferences dialog > Interface tab, or the right-click menu > View Options. To change the size of the thumbnails, drag the top of the Filmstrip to enlarge it.

Along the top of the Filmstrip are other useful tools. The Secondary Display icons are on the left (a) followed by a Grid view button (b). The Forward and Back buttons (c) step backwards and forwards through recent sources, like your web browser buttons. For example, it will remember each time you switch between different folders.

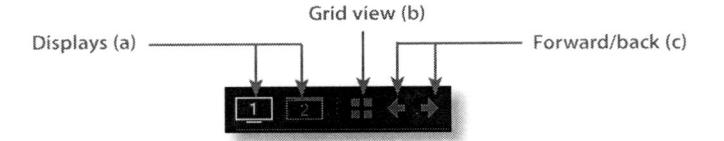

The breadcrumb bar lists additional information about your current view. It shows whether you're viewing a folder or a collection (d), the folder or collection name (e), the number of photos that are currently visible and aren't hidden by a filter or collapsed stack (f), the total number of photos in that folder/collection (g), the number of photos selected (h), and finally the name of the currently selected photo (i).

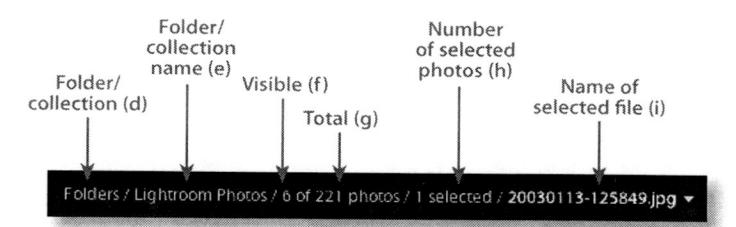

Clicking on that breadcrumb bar shows a list of your recent folders or collections, so you can easily skip back to a recent view, and it allows you to add favorite folders/collections that you visit regularly.

At the other end of the Filmstrip are the Quick Filters. They give easy access to basic filtering without having to switch back to Grid view. We'll come back to filtering in the Develop chapter, but to toggle between the compact and expanded views, click the word 'Filter:' and to disable the filters temporarily, toggle the switch on the right.

Preview Area

In the centre of the window is the main work area which shows the photo(s) that you're currently working on. In the Library module, that can be a Grid, Compare or Survey view with multiple photos, or a large Loupe view of the whole photo. We'll come back to those view options in the Viewing & Comparing Photos section. In the Develop module it shows a high quality preview of your photo, and in the other modules the main preview area shows the output layout you're working on, such as slides, print packages or web gallery previews.

Toolbar

Beneath the main work area, or preview area, you'll see the toolbar. If it ever goes missing, press the T key on your keyboard or select View menu > Show Toolbar. The options that are available on this toolbar change depending on your current module or view, but if you click the arrow at the right hand end, you can choose to show different tools. In the Grid

Also check...

"Viewing & Comparing Photos" section on page 133

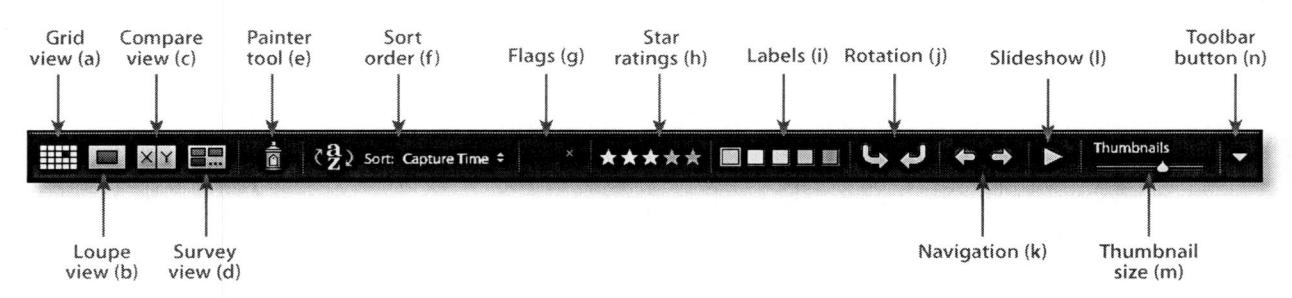

view, the available options are Grid view (a), Loupe view (b), Compare view (c), Survey view (d), Painter tool (e), sort order (f), flags (g), star ratings (h), color labels (i), rotation (j), navigation arrows (k), impromptu slideshow (l), thumbnail size slider (m) and finally the arrow which allows you to change the toolbar buttons (n).

Grid View & Filter Bar

If you press the Grid view button on the toolbar, or press the G key, you'll switch to Grid view. The Grid is made up of thumbnails, which we'll dissect in a moment. You change the thumbnail size using the slider on the toolbar or the = (or +) and - keys on your keyboard.

At the top of the Grid view is the Filter bar. We'll come back to the different filter options and their icons in the Library chapter, but if you can't see the Filter bar, press the \ key on your keyboard or select View menu > Show Filter Bar.

On the right of the Grid view is a scrollbar which allows you to scroll through the thumbnails. My favorite trick is to Alt-click (Windows) / Opt-click (Mac) anywhere on that scrollbar to scroll directly to that point. It's much quicker than having to scroll a line at a time and get dizzy watching the thumbnails pass before you!

"Sorting, Filtering & Finding Photos" section on page 187

Loupe View, Info Overlay & Status Overlay

If you press the Loupe button on the toolbar, or press the E key, you'll switch to Loupe view, which allows you to see a larger preview of your photo. In the top left corner of the preview you can show the Info

Overlay (a), which gives information about that selected photo. If you go to View menu > View Options..., you can change the information that is shown in each of the two Info Overlays, and then you can turn them on or off using the I key.

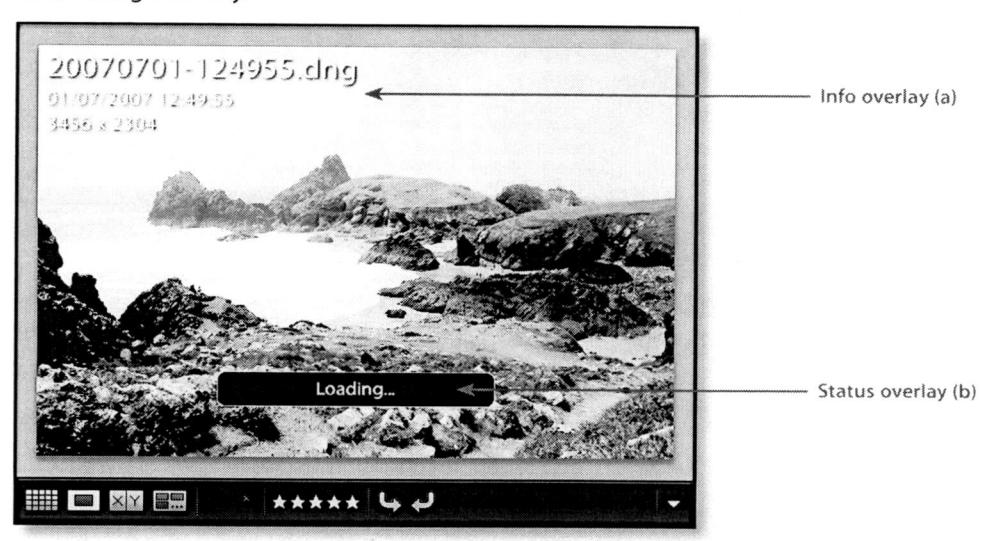

The Status Overlay (b) appears whenever you use a keyboard shortcut to apply a setting, such as 'Set Rating to 3,' but it also appears when Lightroom is loading or rendering previews. If you find that 'Loading...' overlay distracting, you can turn it off in View menu > View Options... I always leave it turned off in the Develop module, as you can start work on the photo long before it's finished loading.

Zooming using the Navigator panel

Along the top of the Navigator panel are the zoom options. The standard view is the Fit view which fits the whole photo within the preview area. Fill view fills the entire width or height, hiding some of the photo, but personally I haven't found a good use for it yet.

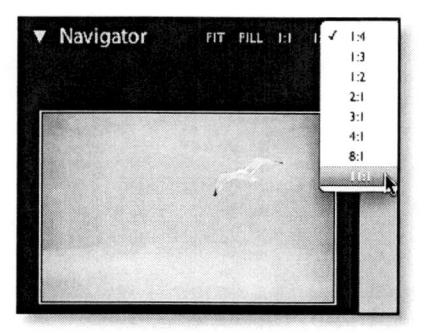

1:1 is a 100% view, and the final option is a pop-up menu which allows you to switch through other zoom ratios. And yes, that last 11:1 option is a 'This is Spinal Tap' movie reference!

You can change the zoom ratio by clicking on those buttons on the Navigator panel, by clicking on the photo itself, or by using the keyboard shortcuts. Spacebar switches between your two most recent zoom settings, so to switch between Fit and 3:1, you'd click on Fit and then 3:1, and they would then be set as your Spacebar zoom ratios. The Z key does the same, except if you're in Grid view, it will toggle between Grid view and a 1:1 or greater zoom.

In Compare, Loupe or Develop, clicking directly onto the photo toggles between your two most recent zoom settings. Ctrl + and Ctrl - (Windows) / Cmd + and Cmd - (Mac) will step through each of the four main zoom ratios and adding the Alt (Windows) / Opt (Mac) key to those shortcuts zooms through each of the smaller zoom ratios as well.

Once you've zoomed in to the photo, the cursor will become a hand tool and you can drag the photo around to view different areas. You can also move the selection box on the Navigator preview.

THUMBNAILS

In the Grid View and Filmstrip, the thumbnails of the photos are contained within cells which hold additional information about the photos. There are 3 varieties of cell, which you cycle through using the J key or View menu > Grid View Style. First is a very minimal view

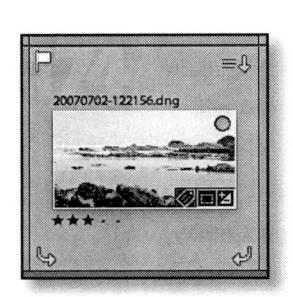

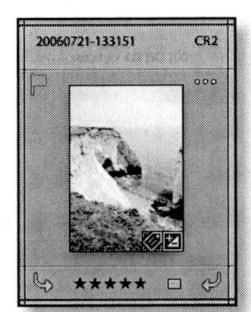

showing the thumbnail without any other distractions, a compact cell view showing the icons and some file information, and an expanded cell view showing additional lines of information.

If you go to View menu > View Options..., you can choose the information you want to show, and the view of the thumbnails will update in the background as you test various combinations of settings.

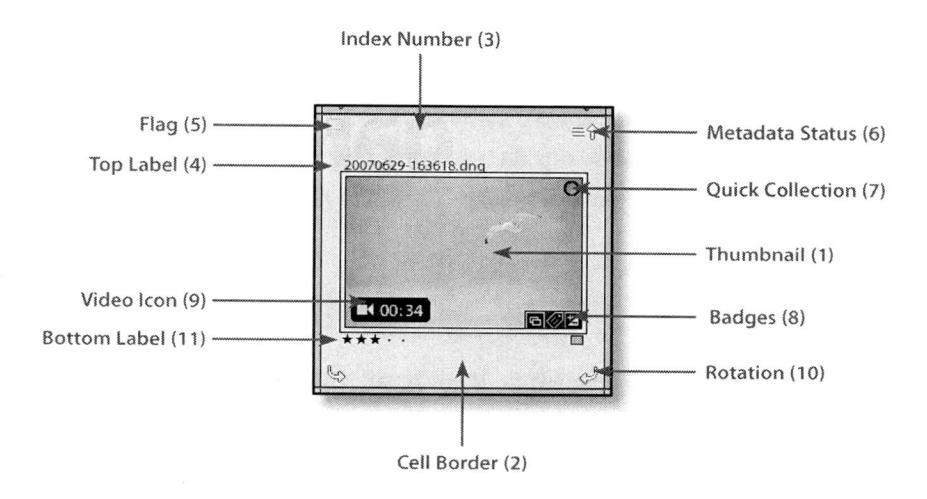

Also check...

"What's the difference between the selection shades of grey?" on page 131

Thumbnail (1)

When you need to drag a photo, perhaps to another folder or collection, click on the thumbnail itself rather than the cell border surrounding it.

Cell Border (2)

The cell border surrounds the thumbnails, and clicking on that border is a quick way of deselecting all of the other photos. The color of the cell border changes through 3 different shades of grey, depending on the level of selection, and we'll come back to that in more detail in the next section. You can also tint the cell border with the label color, which makes them easy to see at a glance. You'll find that option under View menu > View Options...

Index Number (3)

The index number is relative to the current view, so if you have 230 photos in your current folder, the first will be marked as 1 and the last as 230. It's encouraging when you're processing, to see that you've already done 178 out of 230!

Also check...

"Is it possible to view flag/rating/color labels status when in other modules?" on page 163 and "How do I filter my photos to show... just one flag/color label/rating?" on page 191

Top Label (4)

On the cell border you can also add file information. By default, the top label is turned off, but if you go to View menu > View Options... you can turn it on and assign the information you want to show on each cell. File Name is the default, and often the most useful, but you can also set it to other EXIF data such as the camera settings. If you switch to the Expanded Cells, there are additional lines for file information.

Flag (5)

The flags can be in one of 3 states—flagged, unflagged, and rejected. We'll come back to the use of flags in the Library chapter.

Metadata Status Icon (6)

Lightroom stores all of its metadata in its own catalog, but it's also possible to store in the XMP with the files too. The Metadata Status icons keep you informed of the status of the external files, and whether the metadata in those external files matches the catalog or not.

Lightroom is checking metadata in the file to see whether the catalog or external file was most recently updated.

The file is missing or is not where Lightroom is expecting, so click the icon to locate the missing file. More on that in the Library chapter.

The file is damaged or cannot be read, likely as a result of file corruption, which we mentioned in the Import chapter.

If you have 'Unsaved Metadata' icons turned on in View menu > View Options, you may also see additional metadata icons. These show the result of checking the file against any XMP data in the files or sidecars. We'll come back to XMP in the Working with Catalogs chapter.

Lightroom is reading or writing metadata.

Lightroom's catalog has updated metadata which hasn't been written to XMP. Click the icon to write to XMP.

Metadata in the XMP file has been updated by another program and is newer than Lightroom's catalog. Click the icon to read from XMP.

Metadata conflict—both the XMP file and Lightroom's catalog have been changed. Click the icon to choose whether to accept Lightroom's version or the XMP version.

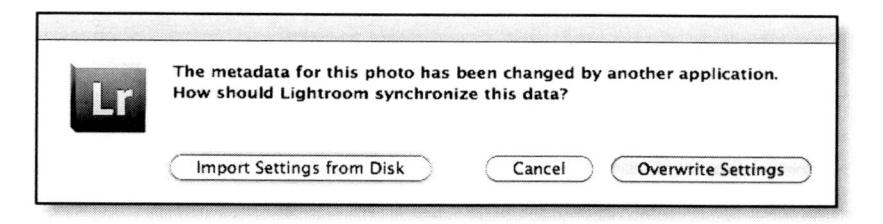

Also check...

"Lightroom thinks my photos are missing—how do I fix it?" on page 200, "Lightroom appears to be corrupting my photos—how do I stop it?" on page 108 and "XMP" section on page 241

Also check...

"What are the Quick Collection and Target Collection?" on page 156

Quick Collection Marker (7)

The Quick Collection is a way of temporarily grouping photos, but if you accidentally hit the circular Quick Collection marker regularly, you can turn it off in the View Options. More on that in the Library chapter.

Badges (8)

Badges give additional information about the settings you've applied to the photo within Lightroom. From left to right, they show:

This photo is in at least one collection—clicking will show a list of the collections containing that photo.

Keywords have been applied to this photo—clicking will open the Keywording panel.

A crop has been applied to this photo—clicking will go to Crop mode.

Develop changes have been applied—clicking will to go to the Develop module.

Video Icon (9)

The video icon shows the length of the video and clicking it opens the video into your default video software.

Rotation (10)

The rotation icons rotate your photo when you click on them. If you have lots of photos to rotate, it's often quicker to use the Painter tool as you don't have to hit an exact spot, so we'll come back to that in the Library chapter.

Also check...

"Managing Videos"
section on page 186
and "How do I use the
Painter tool to quickly
add metadata?"
on page 163

Bottom Label (11)

Like the earlier top label, you can adjust the file information shown in the bottom label. By default, the bottom label shows the star ratings and color labels, and you can click on those ratings and labels to change them. Right-clicking on those labels allows you to change the file information shown, without going back to the View Options dialog.

SELECTIONS

To work on photos in Lightroom, you have to first click on the photos to select them. Selections in Lightroom catch most people out at some stage, because there are multiple levels of selection, rather than simply selected or not selected.

What's the difference between the selection shades of grey?

When you select photos in Lightroom's Grid view or in the Filmstrip, you'll notice that there are 3 different shades of grey. Because Lightroom allows you to synchronize settings across multiple photos, there needs to be a way of choosing the source of the settings as well as the target photos, so Lightroom has 3 levels of selection, rather than 2—or 2 levels of selection plus a deselected state, depending on how you look at it.

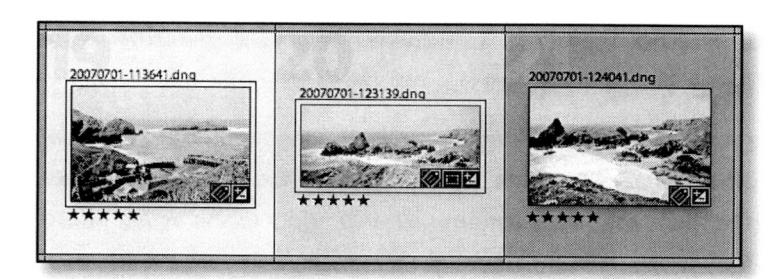

The lightest shade of grey is the active, or most-selected, photo. If you're synchronizing settings across multiple photos, Lightroom will take the settings from that active photo and apply it to the others.

The mid grey is also selected, but is not the active photo. If you're synchronizing settings across multiple photos, Lightroom will apply the settings to those photos.

The darkest shade of grey isn't selected.

Why don't the rest of my photos deselect when I click on a single photo?

The key to deselecting photos is knowing where to click. Clicking on the thumbnail itself will retain your current selection and make that the active photo, leaving the others selected too. Clicking on the cell border surrounding the thumbnail will deselect all other photos, just leaving that photo selected.

How do I select multiple photos?

To select non-contiguous photos—ones that aren't grouped together—click the first photo and then hold down the Ctrl key (Windows) / Cmd key (Mac) while clicking on the other photos. If you want to select contiguous or sequential photos, click on the first photo, but this time hold down the Shift key while you click on the last photo, and all of the photos in between will also be selected.

I've got multiple photos selected—why is my action only applying to a single photo?

If you're in Grid view, actions will apply to all selected photos, however in any other mode or module, for example, Loupe view, Survey view, Develop module, etc., most actions will only apply to the active (most-selected) photo by default.

You can change that behavior by turning on AutoSync under the Metadata menu, which will cause any actions to apply to all selected regardless of the current view—but use it with caution, as you could just as easily apply a setting to all of the photos without realizing they're

"How do I copy or synchronize my settings with other photos?" on page 291 selected, undoing hours of work. There's also a separate AutoSync in the Develop module for applying Develop changes to multiple photos in one go, but we'll come back to that in the Develop chapter.

Of course, with every rule, there are always exceptions, and on this occasion the main exception is the right-click context-sensitive menu on the Filmstrip or Secondary Display Grid view, which applies the menu selection to all selected photos regardless of the AutoSync setting, and also a few commands such as Export which export all selected photos regardless of your current view.

"Secondary Display" section on page 139

VIEWING & COMPARING PHOTOS

Lightroom offers a number of different ways of viewing your photos in the Library module, where you'll do most of your browsing and management.

Grid View

Much of the work you'll do in Lightroom will be in the Grid view, which can be accessed using the Grid icon on the toolbar, by pressing the G key on your keyboard, or via the View menu.

Anything you do in Grid view, such as adding star ratings or keywords, applies to all of the selected photos, whereas other views only affect the active or most-selected photo. There are, of course, exceptions which we mentioned in the previous section.

You can drag and drop photos around, changing the sort order or drag them onto other folders, collections or keywords. To do so, you have to pick them up by the thumbnail itself and not the border surrounding it. The cell border only affects selections, as we mentioned earlier in the chapter.

The thumbnail size is changed using the slider on the toolbar, or using the = and - keys on your keyboard. As the thumbnails get smaller, the

badges and other information become more distracting, so you may want to hide these by pressing the J key once or twice.

Compare View

When you start sorting through your photos, you'll need to view them in greater detail and compare them to choose your favorites.

The Compare view allows you to view 2 photos at the same time. The C key, or Compare view icon on the toolbar, will take you into the Compare view. First you select two photos, and the active or most-selected photo becomes the Select, marked with a white diamond icon, and the other becomes the Candidate, marked with the black diamond icon. The

Select on the left is fixed in place, and as you select different photos, the Candidate on the right changes. When you find one you like better than the current Select, you can press the XY buttons on the toolbar to

switch them round, making the other photo your new Select.

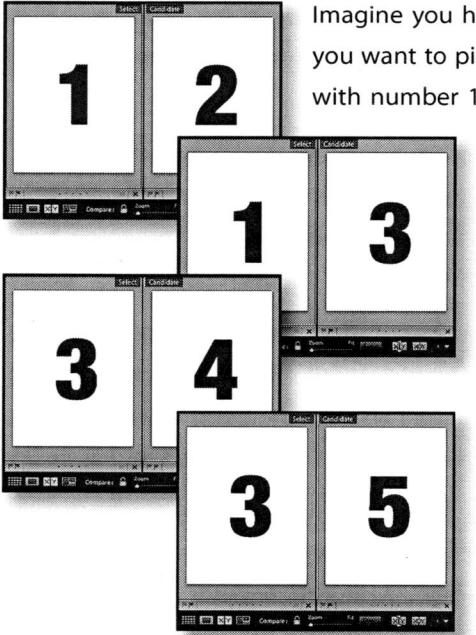

Imagine you have a series of 5 photos, and you want to pick the best one. You start out with number 1 as the Select and number 2

as the Candidate. You decide you don't like number 2, so you move to the next photo by pressing the right arrow key. You're now comparing photos 1 and 3, and you decide you like 3 better, so you press the X<Y button to make number 3 the new Select. You compare that against number 4, but you still like 3 better, so you

press the right arrow key to compare 3 and 5. In the end, number 3 is your favorite, so you mark it with a star rating.

The Compare view also allows you to zoom in on one or both photos at the same time. The Zoom Lock icon is particularly useful when you need to check focus on similar photos, or perhaps whether all of the people in a group photo have their eyes open. If both photos are identically aligned, you can click the lock before zooming, and as you pan around the photo, both photos will pan. If they're not aligned, zoom in first and match up the alignment and then lock the position, so that the positioning follows you on both photos. With the lock unlocked, they pan and zoom independently.

Survey View

Survey view allows you to view numerous photos in one go, perhaps comparing for composition. When you click the Survey button, or the N key, the selected photos are added to the Survey view. Most of the shortcuts use quite logical letters, but there isn't even an N in the word Survey. As an interesting piece of trivia, and easier way of remembering the N shortcut, this view was originally called N-Up while it was being developed, which is where the shortcut came from. When you hover over a photo, the rating/flag/label icons appear, along with an X icon which removes the photo from the selection and the Survey view.

Loupe View

The Loupe view shows you a full preview of your photo, and allows you to zoom in on the photo to check the detail. We'll come back to preview quality and size in the Previews & Speed chapter.

Lights Out

Lightroom offers a couple of distraction-free viewing modes, called Lights Dimmed and Lights Out. They dim or black out the interface around the photo, allowing you to focus solely on the selected photos

"Previews" section on page 253

in the preview area. To cycle through the Lights Out modes, press the L key on your keyboard. You can adjust the color and dim level in the Preferences dialog under the Interface tab.

WORKING WITH SLIDERS & PANEL ICONS

Within the right hand panels are sliders and buttons. Moving sliders, pressing buttons and selecting presets from pop-up menus are all quite obvious, but there are a few other tips and tricks which can save some time.

Moving Sliders

The obvious thing to do with a slider is to grab the marker and move it, and of course that works, but there are also other options which may suit your workflow better.

If you like dragging sliders, but find it difficult to make fine adjustments, drag the edge of the panel to make the panel wider. It will make the sliders longer and easier to adjust.

Scrubby sliders, such as those used in Photoshop, also work in Lightroom. As you float over the numeric value field at the

end of the slider, the cursor changes to a hand with a double arrow, and clicking and dragging to the left or right moves the slider.

While we're looking at the numeric value fields, you can click directly in one of those fields and either type the number that you're aiming for, or use the up/down arrow keys to move in smaller increments. If you've activated a field to type directly, don't forget to hit Enter or click elsewhere to complete your adjustment.

There are other shortcuts which are specific to the Develop module, such as floating over the slider and using the up/down arrow keys to move it, but we'll come back to those in more detail in the Develop chapter.

"Working with Sliders & Targeted Adjustment Tool" section on page 283

Resetting Sliders

We'll come back to resetting sliders to their defaults in the Develop chapter too, as that's the primary place it applies, but in short, to reset a single slider, you can double-click on the slider label. Within many panels, you'll also find a panel label, such as Tone in the screenshot, and double-clicking or Alt-clicking (Windows) / Opt-clicking (Mac) on that label resets that whole

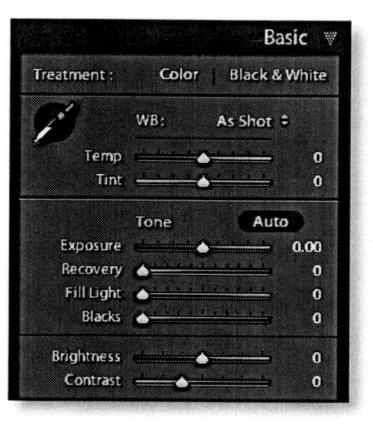

panel section. Finally, if you want to reset the whole photo, there's a large 'Reset' button at the bottom of the right hand panel in the Develop module, in the Quick Develop panel in the Library panel, and in the right-click menus too.

Disclosure Triangles

The little triangles that appear in various places in Lightroom's interface are officially called 'Disclosure Triangles.' When you click on them, they toggle to show or hide parts of the interface, such as sliders, buttons, folders, etc.

You'll also find those triangles in the Folders, Collections, Publish Services and Keyword List panels, where they have two different styles. The solid arrows indicates that the folder, collection or keyword has subfolders and those marked with opaque arrows don't have any subfolders.

Panel Switches

On the end of some panel headers in the Develop module, such as the Tone

Curve panel, there's a toggle switch. That toggle temporarily enables or disables the sliders in that section, so you can preview the photo with and without the effect of those panel sliders. You'll also find the toggle switch at the bottom of the Adjustment Brush and other tool options panels, which enable and disable your retouching.

WORKING WITH DIALOGS

Besides the Presets and Template Browser panels in the Develop, Slideshow, Print and Web modules, Lightroom also uses pop-up menus to allow you to save settings as presets. You'll find them in dialogs, such as the Filename Template Editor dialog used when renaming photos, and also in the small pop-up menus such as the Presets pop-up at the bottom of the Import dialog.

Saving Presets in Pop-Up Menus

To save a preset using one of those pop-up menus, select your new settings and then choose 'Save Current Settings as New Preset...' at the bottom of the pop-up menu. Give it a name, press OK, and your new preset will appear in the pop-up menu.

Renaming, Updating and Deleting Presets in Pop-Up Menus

To edit an existing preset, you first have to select that preset in the popup menu. The Delete and Rename options appear at the bottom of the menu, and obviously delete or rename that selected preset.

If you want to update an existing preset, for example, in the Watermarking dialog, you first have to select that preset in the pop-up

menu and then edit it. Once you've done so, the pop-up menu will show (Edited) next to the preset name, and 'Update Preset' will appear in the menu.

Using Tokens in Dialogs

In many of Lightroom's dialogs, such as the Filename Template Editor dialog, you'll find tokens which look like small blue lozenges on the Mac version, but are only text surrounded by curly brackets on the Windows version.

You use those tokens to build filenames or other text directly from the photo's metadata, rather than typing fixed text. For example, if you combine the Date (YYYY) Date (MM) and Date (DD) tokens, it will take the Capture Date from the file, resulting in 20100608. You can drag and drop those tokens around to change the order and use the Delete key to delete them as if they were text.

You can type additional fixed text between those tokens, for example, you can add hyphens, resulting in 2010-06-08. If you're going to add custom text which won't be the same every time you rename, use the 'Custom Text' token and then add the custom text in the main dialog, rather than entering it directly into the Filename Template Editor dialog, otherwise you'll have to keep editing the template each time you need to change the text.

SECONDARY DISPLAY

When many users think of using dual monitors, they think of Photoshop and tear off panels. Lightroom's current Secondary Display options don't allow you to tear off panels, but they do allow you to display the photos on a secondary display, whether that's a second monitor or just another floating window on the same monitor.

The Display controls are at the top of the Filmstrip on the left. Depending on your current full screen settings, the Secondary Display icon will either be a second monitor or a window icon.

A single click on the Secondary Display icon turns that display on or off, and a long click or right-click on each icon shows a context-sensitive menu with the View Options for that display. Additional options are available via Window menu > Secondary Display.

Which views are available on the Secondary Display? How are they useful?

The Secondary Display offers a few different view options.

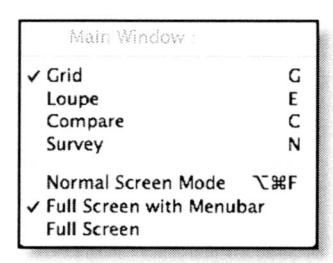

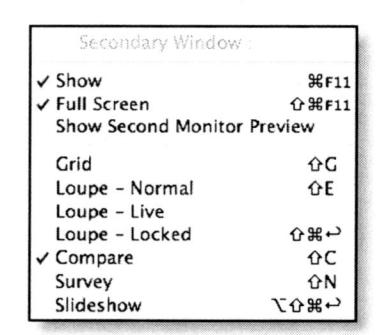

Grid is particularly useful for gaining an overview of all of the photos whilst working on a single photo in Develop module, or for selecting photos for use in Slideshow, Print or Web modules. You can only have a Grid view on one display at a time.

Normal Loupe shows a large view of the photo currently selected on the main screen.

Live Loupe shows the photo currently under the cursor, and updates live as you float the mouse across different photos.

Locked Loupe fixes your chosen photo to the Loupe view, which is particularly useful as a point of comparison or reference photo/Shirley image.

Compare is the usual Compare view, but allows you to select and rearrange the photos in Grid view on the main screen whilst viewing Compare view on the secondary display.

Survey is the usual Survey view, but allows you to select and rearrange the photos in Grid view on the main screen whilst viewing Survey view on the secondary display.

Slideshow is only available when the Secondary Display is in Full Screen mode, where it runs a slideshow of the current folder or collection, while you carry on working on the main screen.

If you're using Loupe, Compare or Survey at the same time as the Grid, it's usually better to switch the displays so that the Grid is on the Secondary Display. This is because there's no way of assigning a flag, rating or label to a single photo when Compare or Survey are used on the Secondary Display and Grid is on the Primary.

Why do shortcuts and menu commands only apply to a single photo even though I have multiple photos selected on the Secondary Display Grid?

Lightroom doesn't know which screen you're looking at when you press a keyboard shortcut or menu command. For that reason, it always assumes that you're looking at the Primary Display. Any shortcuts or menu commands will apply to the photo(s) shown on the Primary Display, unless you have Metadata menu > AutoSync turned on, in which case it will apply to all selected photos.

The exception is the context-sensitive menu command on Grid on the Secondary Display, because if you've just right-clicked on the Secondary Display, you're obviously looking at it, and you realize that multiple photos are selected. That same principle doesn't work in Compare or Survey on the Secondary Display.

Also check...

"I've got multiple photos selected—why is my action only applying to a single photo?" on page 132

Why does the Secondary Display switch from Grid to Loupe when I change the Main Screen to Grid?

Grid view can only be open on one display at a time for performance reasons. If you already have Grid view open on one display, and you switch the other display to Grid view, the first display will automatically switch to Loupe view.

What does 'Show Second Monitor Preview' do?

If the Secondary Display is in full screen mode, there is an additional option available—'Show Second Monitor Preview.' If your second monitor is facing away from you, for example, facing a client on the opposite side of the table, you can view and control what they see without repeatedly running round to the other side of the table. The pop-up menu in the top left corner controls the current view.

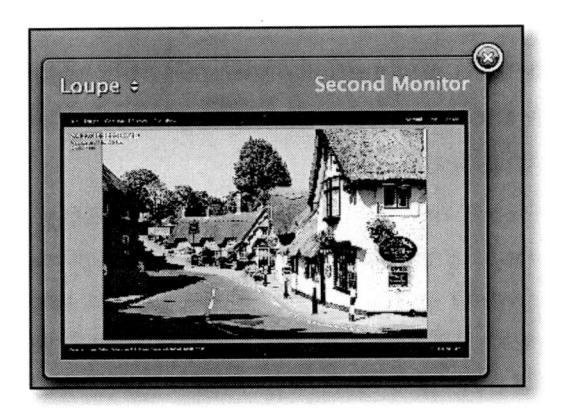

"Sorting, Filtering & Finding Photos" section on page 187

How do I move the Library Filter bar to the Secondary Display?

If you have the Grid view open on the Secondary Display, the shortcut Shift-\ or Window menu > Secondary Display > Show Filter View will move the Library Filter bar to the top of the Grid view on the Secondary Display.

FREQUENT WORKSPACE QUESTIONS

Many of the answers to the following questions are covered in the previous pages, but they're asked so often on the forums, I had to include them separately too.

My toolbar's disappeared—where's it gone?

If your toolbar disappears, press T—you've hidden it!

How do I stop the panels opening every time I float near the edge of the screen?

To stop the panels automatically opening, right-click on the outside black edge strip of each panel and choose 'Manual' or 'Auto Hide.'

Where have my panels gone?

Press Tab to hide the side panels, Shift-Tab to hide all of the panels, and repeat to bring them back. Alternatively, clicking on the black outer edge strip of each panel controls the individual panel groups.

Can I detach the panels and rearrange them?

The panels aren't detachable, but you can hide panels you don't use by right-clicking on the panel header and unchecking the panels you don't want to see.

The alternative to consider is Solo Mode, which you'll find in the panel header right-click menu. It closes one panel as you open another, keeping just one panel per side open at any time. You can show multiple panels while in Solo Mode by Shift-clicking on each panel to open it.

"Badges (8)" on page 130

Where have the Minimize, Maximize and Close Window buttons gone?

If you can't see the standard window buttons, you're in Full Screen mode. Press the F key once or twice to get back to your normal view.

It's all gone black! How do I change the view back to normal?

If everything goes black except for the photos, then you're in Lights Out mode. Press the L key once or twice until it reverts to normal view.

I can see Badges in Grid view, but not in my Filmstrip. Where have they gone?

Ensure 'Show badges in Filmstrip' is turned on in Preferences > Interface tab, and if they still don't appear, enlarge your Filmstrip by dragging the top edge of the Filmstrip, because the badges disappear when the thumbnails become too small to fit at least 4 badges in view at once.

How do I turn off the overlay which says 'Loading...'?

Go to View menu > View Options > Loupe Info panel and uncheck 'Show

message when loading or rendering photos' if you find the overlay distracting.

Is it possible to see camera setting information while in Develop module, rather than constantly switching back to the Metadata panel?

Just under the Histogram is always basic information about your camera settings, which are visible whenever your mouse isn't hovering over the photo itself.

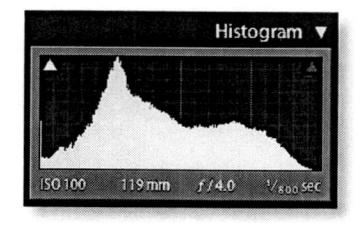

Additional information can be shown in the Info Overlay, which you toggle using

the I key, or selecting View menu > Loupe Info > Show Info Overlay. You can select the information shown in the Info Overlay using the View menu > View Options dialog.

20050719-130515,CR2 V₃₀₀ sec at 1/5.0, ISO 100, 190 mm (70.0-300.0 mm) Canon EOS 3500 DIGITAL

Why is there an exclamation mark near the preview in the Develop Module?

The exclamation mark to the lower right of the preview shows that you're using the old Process Version 2003 from earlier Lightroom or ACR versions, and you're not taking advantage of the new Noise Reduction,

Sharpening and Fill Light improvements. If you click on that icon, the process version is updated to the new rendering. Your photo may visibly change, and you can then adjust the sliders to taste. We'll come back to Process Versions in the Develop chapter.

Adobe Lightroom 3 - The Missing FAQ

Also check...

"How do I delete the Preferences file?" on page 459

How do I bring back the warning dialogs I've hidden?

If you've hidden some of the dialogs by checking the 'Don't Show Again' checkbox, you can bring them back by pressing the 'Reset all warning dialogs' checkbox in the Preferences dialog > General tab.

Why won't Lightroom show a dialog, such as the Export dialog?

When using dual monitors, Lightroom remembers which monitor you last used to display each dialog. If you then unplug one of those monitors, Lightroom may still try to show the dialog on the detached monitor, resulting in an error beep when you try to press anything else. To solve it, press Escape to close the imaginary dialog, and either plug the second monitor back so you can see the dialog to move it back, or delete the Preferences file, which will reset the dialog locations along with the other settings. The location of the Preferences file is listed in the Useful Information chapter.

Library Module

Having imported and viewed your photos, it's time to start managing them—organizing them into groups, sorting through them and choosing your favorites, adding metadata to describe the photos, and then later going back to find specific photos using various filtering options.

FOLDERS

Let's start with managing the files on your hard drive. The folders in the Folders panel are references to folders on your hard drive or optical discs, so when you import photos into Lightroom, the folders containing those photos are automatically added to the Folders panel ready to browse.

Anything you do in Lightroom's Folders panel will be reflected on the hard drive. For example, creating, renaming or deleting folders does the same on your hard drive. You can drag photos and folders around to reorganize them, just like you would in your file browser. The opposite doesn't work in the same way—when you rename or delete a file or folder on your hard drive, Lightroom will simply mark it as missing rather than deleting it automatically, otherwise you could accidentally lose all of your settings.

Also check...

"Lightroom thinks my photos are missing—how do I fix it?" on page 200

Also check...

"Renaming, Moving & Deleting" section on page 166 We'll come back to moving, renaming and deleting the photos themselves later in the chapter, along with how to deal with missing photos, but for the moment, let's concentrate on the Folders panel.

Can I change the way the folders are displayed?

The Folders panel is divided into Volume Bars for each volume (drive) attached to your computer, whether they're internal or external hard drives, network attached storage, or optical drives. Although the disclosure triangle is shown on the right, clicking anywhere on a Volume Bar will expand it to show the folders contained in that drive.

Each of those Volume Bars can give you additional information about the drive—how many imported photos are on each volume, whether it's online or offline, and how much space is used or available. You can choose which information to show by right-clicking on the Volume Bar.

The colored rectangle on the left shows the drive space available:

Green = drive online with space available

Yellow = drive online but getting low on space

Orange = drive online but very low on space

Red = drive online but full

Black = drive offline (and volume
name becomes darkened)

While you're exploring the Folders panel view options, clicking on the Folders panel + button also gives additional path view options for the root folders.

Add Subfolder...
Add New Root Folder...

Root Folder Display:

Folder Name Only
Path From Volume
Folder And Path

For example, this folder is RAID Drive/LR eBook Files/Images. Depending on the option you choose, that can be shown as:

'Folder name only'

'Path from Volume'

'Folder and Path'

When I look at a parent folder in Grid view, I see the photos in the subfolders as well. Can I turn it off so I can only see the contents of the selected folder?

In many situations, it's useful to see a composite view of all the subfolder contents, but there are certain restrictions—you can't apply a custom sort (user order) or stack photos across multiple folders in a composite view.

If you want to turn the composite view on or off, go to Library menu > Show Photos in Subfolders and check or uncheck it. You will find the same option in the Folders panel menu, accessed via the + button. The folder counts will update at the same time, showing either the composite count, or the number of photos directly in that folder.

I have a long list of folders—can I change it to show the folder hierarchy?

Depending on your Import dialog settings, the folders may be in one long list regardless of their hierarchy on the hard drive, which can make them hard to find and relocate if they're ever marked as missing. Instead,

as a preventative measure, you can configure Lightroom to show a few top level folders, with subfolders below. If Lightroom ever loses track of your photos, perhaps as a result of a hard drive failure or the drive letter changing, you will only need to relink the top level folders and that will cascade through the rest.

So how do we go from this slightly nondescript tangle of folders on the left... to the tidy hierarchy on the right...?

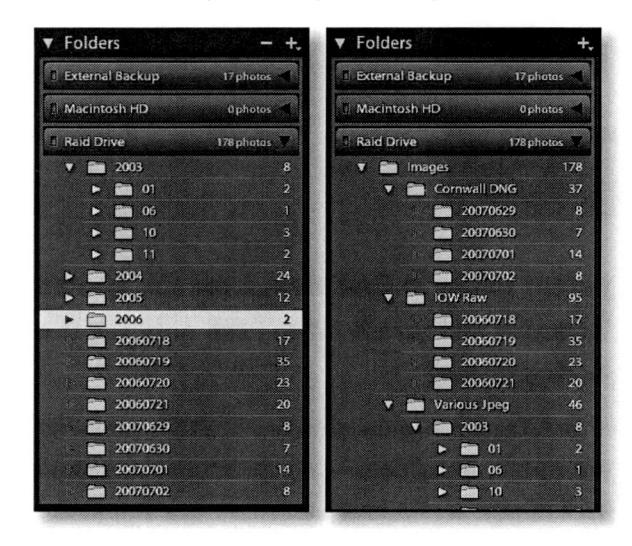

Right-click on the current top level folder and select 'Add Parent Folder.'
This doesn't import new photos—it just adds an additional hierarchy level to your Folders panel, and does a lot more behind the scenes.

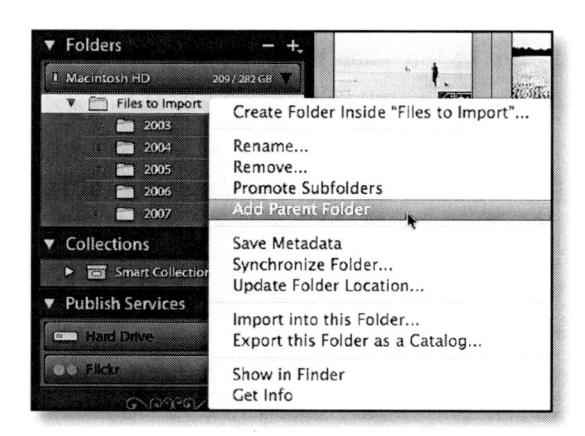

Keep repeating that process on each top level folder until it shows your chosen parent folder.

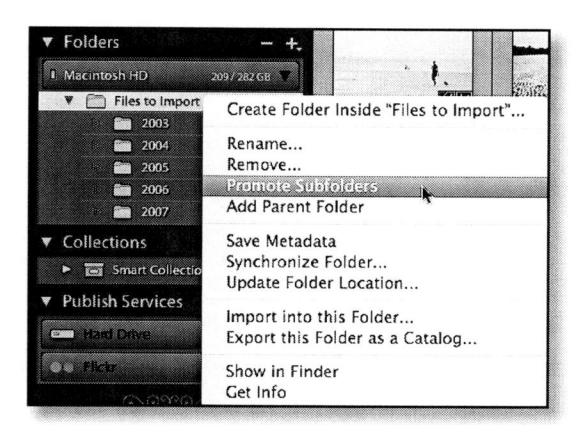

If you go too far and want to remove a top level folder, right-click on that folder and choose 'Promote Subfolders.' It does the opposite of 'Add Parent Folder,' and will ask for confirmation before removing that top level folder from your Folders panel, as there may be photos directly in that folder that would be removed from the catalog.

Why aren't 'Add Parent Folder' and 'Promote Subfolders' showing in my context-sensitive menu?

If the 'Add Parent Folder' and 'Promote Subfolders' options don't appear in the menu, you're right-clicking on the wrong folder. You have to right-click on the top level folder, rather than a subfolder or Volume Bar, for those options to appear. In the screenshot, you would need to right-click on the folder 'Files to Import' instead of '2003.'

How do I expand or collapse all of a folder's subfolders in one go?

If you want to open or close all of the subfolders in one go, you can Alt-click (Windows) / Opt-click (Mac) on the parent folder's disclosure triangle.

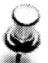

Also check...

"How does Export as Catalog work?" on page 234 If you find your subfolders appear to have a mind of their own and are automatically opening themselves when you open your Lightroom catalog or move photos between folders, select everything and export it all to a new catalog. The odd behavior usually gets left behind in the process.

How do I find out where a photo is stored on my hard drive?

If you ever need to find a photo on the hard drive, for example, to open in another program, you can right-click on a single photo and the context-sensitive menu will give you the choice of selecting the folder in the Folders panel or showing you that photo in Explorer (Windows) / Finder (Mac).

I've added new photos to one of Lightroom's folders—why don't they show in my catalog?

Lightroom doesn't perform live checking against all of your folders for performance reasons. If you import a folder into Lightroom's catalog and then later add additional photos to that folder using other software, Lightroom won't know about those additional photos until you choose to import them.

If you go back to the Import dialog and import that folder again, Lightroom will just import the new photos, skipping the existing ones, or you can use the Synchronize command in the folder's context-sensitive menu. If you choose to use Synchronize, only check the 'Import New Photos' checkbox and leave the 'Remove' and 'Scan' checkboxes unchecked.

How does the Synchronize Folder command work?

If you right-click on a folder and choose Synchronize Folder... from the context-sensitive menu, it gives you a few different options, but be careful as they can cause trouble! It's main purpose is to update Lightroom's catalog with changes made to that folder by other programs, for example, adding or deleting photos or updating the metadata.

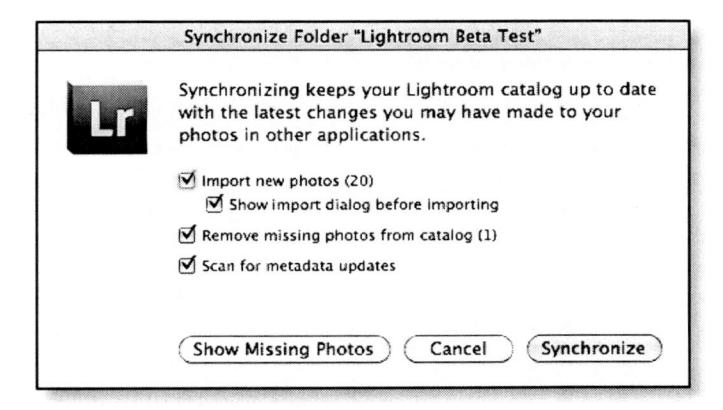

First, it searches the folder and subfolders for any new photos not currently in this catalog and asks you if you want to import them. If you've dropped photos into the folder using other software, it saves you navigating to the folder in the Import dialog.

Synchronize Folder also checks for photos that have been moved, renamed or deleted from that folder and gives you the option to remove those missing photos from the catalog. Be very careful using that option because any metadata for those photos, such as Develop settings and ratings would be lost, even if the photos have simply been moved to another location. When in doubt, leave that option unchecked, as we'll cover relinking missing photos later in the chapter. Synchronize doesn't do intelligent relinking at this point in time.

Scan for metadata updates checks the metadata in the catalog against the file, to see whether you've edited the file in any other programs, such as Bridge. If it's changed in another program, but not in Lightroom, Lightroom's catalog will be overwritten by the external metadata. If both Lightroom's catalog and the external file have changed, you'll get a Metadata Conflict badge, and you'll have to click on that icon to be able to choose which set of data to keep—the metadata in your catalog or the metadata in the file. We'll come back to that XMP header section in

Also check...

"Lightroom thinks my photos are missing how do I fix it?" on page 200 and "XMP" section on page 241 more detail in the next chapter, including the use of that Metadata Conflict dialog.

The 'Show Missing Photos' button searches for photos missing from that folder and creates a temporary collection in the Catalogs panel. You can then decide whether to track them down and relink them, or whether to remove those photos from the catalog. If you want to check your entire catalog for missing photos, it's quicker to use the Library menu > Find Missing Photos command instead. Once you've finished with that temporary collection, you can right-click on it to remove it.

COLLECTIONS

Having found the photos on the hard drive, it's time to start organizing them. Remember, folders are primarily storage buckets, and Lightroom offers other tools that are better suited to organizing your photos.

How are Collections different from Folders?

Collections are a way of grouping photos together without actually moving them on your hard drive, so a photo can belong to multiple collections at the same time, but still only be stored in one folder on your hard drive.

Collections aren't limited to containing photos. They also store your chosen sort order and any slideshow, print or web settings too, so they're often used to group photos for different outputs, for example, a collection of photos for a slideshow.

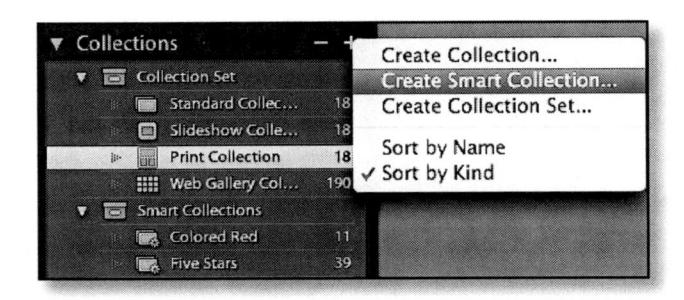

They can be organized into nested collection sets, just like folders, and you can choose whether to sort them by name or type, using the + button on the Collections panel to show the menu.

Depending on where you created the collection, they have different icons as a reminder, but there aren't fundamental differences between the different types of collection—a collection created in the Slideshow module can still store print settings, etc.

"Smart Collections" section on page 196

Print collections were originally created in the Print module

Web collections were originally created in the Web module

Smart collections are saved search criteria, smart folders or rules, so we'll come back to those later with the filtering tools.

Collections can easily be reselected at any time simply by clicking on them, and double-clicking on any module-specific (Slideshow, Print or Web) collection will take you directly to that module too.

How do I organize my collections into collection sets?

There's a notable difference between collections and collection sets. Collections can only contain photos whereas collection sets can contain collections or other collection sets, but not the photos themselves.

Those collection sets allow you to build a hierarchy of collections, just like you would with folders. For example, you may have a collection set called Holidays, and within that set, sets for each of your holiday destinations. Those holiday destinations might divide down further into sets for each year that you visited, and then individual collections for

the long slideshow of all of your photos from each holiday, the web galleries you created to show your friends, and the pictures you printed. You can also include smart collections inside your collection sets too, so you might have additional smart collections for all the 5 star photos, all of the photos of beaches, and so on. We'll come back to smart collections later in the chapter.

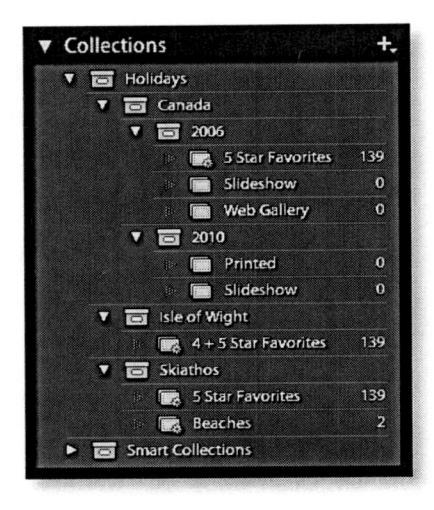

How do I add photos to a collection?

You can either first create an empty collection by clicking on the + button on the Collections panel and choosing 'Create Collection...' and then add photos to that empty collection, or you can select the photos first and then create the collection with 'Include Selected Photos' checked.

To add photos to a collection that you've already created, you just drag and drop them, making sure you pick up the photos by the middle of the thumbnail, rather than the cell border, otherwise you'll deselect them. You can also select the photos and right-click on the collection and choose 'Add Selected Photo to this Collection' if you prefer not to drag and drop.

Removing them from a collection is as simple as hitting the Delete key. When you're viewing a collection, Delete only removes the photo from the collection, rather than from the catalog or hard drive.

What are the Quick Collection and Target Collection?

The Quick Collection is a special collection for temporarily holding photos of your choice, and it permanently lives in the Catalog panel

along with other special collections (All Photographs, Previous Import, etc.). If you've added a group of photos to the Quick Collection and then you decide you would like to turn it into a permanent collection, you can right-click on it and choose 'Save Quick Collection...' from the context-sensitive menu.

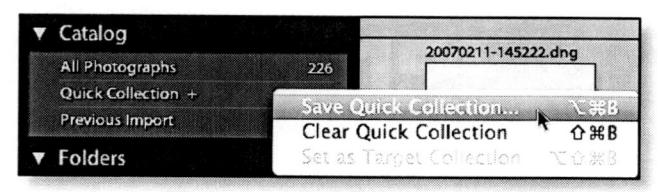

The Target Collection isn't a collection in its own right—it's just a shortcut linking to another collection. It's marked by a + symbol next to the collection name, and pressing the shortcut key B or clicking the little circle icon on the thumbnail will add to, or remove the photo from, that Target Collection. By default it's assigned to the Quick Collection, but you can change the Target Collection to the collection of your choice by right-clicking on your chosen collection and choosing Set as Target Collection.

How do I see which collections a photo belongs to?

If you right-click on any photo and choose 'Go to Collection,' it'll show you a list of your collections containing that photo, or just clicking on the Collection badge in the corner of the photo will show the same list if you have badges showing on the thumbnails.

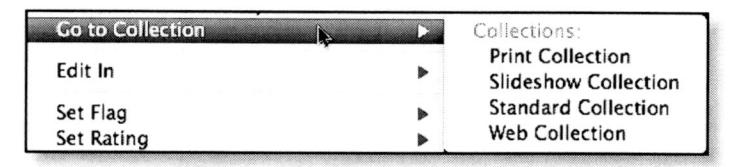

If you're checking a large number of photos, switch to Grid view and hover the cursor over the collections individually and any photos belonging to that collection will show a temporary thin white border around the thumbnail.

STACKING

Stacking is an alternative way of grouping photos in their folder. It's currently quite limited—it only works directly within that photo's folder—but it's useful for grouping similar photos such as 5 shots of same flower, bracketed shots, or original photos and their TIFF/PSD/JPEG derivatives. Once the photos are stacked, you can put your favorite photo on top of the stack and collapse the stack down, hiding the other photos underneath, to clear some of the visual clutter.

How do I stack photos?

To create a stack, select the photos and press Ctrl-G (Windows) / Cmd-G (Mac) or go to Photo menu > Stacking > Group into Stack. When you create a stack it immediately collapses, but you can open it up again by clicking on the stacking icon or pressing the S key.

To remove a photo from a stack, you can either ungroup the whole stack using Ctrl-Shift-G (Windows) / Cmd-Shift-G (Mac), or you can drag the single photo out of the stack to a different place in the Grid view, leaving the rest of the stack intact.

Why are the stacking menu options disabled?

Stacks only work when all of the stacked photos are stored in a single folder, so if the stacking options in the Photo menu are disabled, you're probably viewing a collection or you're trying to stack photos which are in different folders.

If you go to the Folders panel and select a folder which doesn't have subfolders, or deselect 'Show Photos in Subfolders' in the Library menu, then you will be able to see which photos you're able to stack together.

How do I move a photo to the top of the stack?

The idea behind stacking is that you can put your favorite version of a photo on top of the stack and have the others hidden underneath. If

your favorite isn't already on the top of the stack, selecting the photo and going to Photo menu > Stacking > Move to Top of Stack will move it. Better still, just click the stacking number box of your favorite picture once, and that photo will jump to the top of the stack.

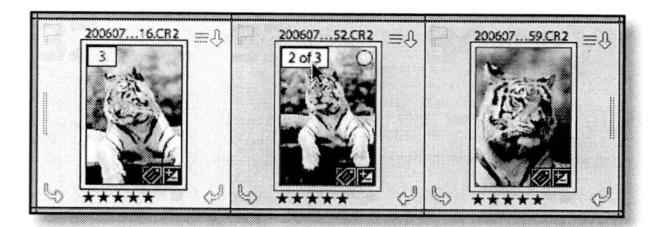

How do I apply metadata to multiple photos in a stack?

If a stack is closed, adding metadata such as keywords to the stack will only apply that metadata to the top photo. There's a trick, however, to make it a little quicker. If you double-click on the stack number, it will open the stack with all of the stacked photos already selected, so you can go ahead and add the metadata without having to stop to select them.

If you want to expand all of the stacks in one go, perhaps because you want to filter for photos that are currently hidden in collapsed stacks, use the Photo menu > Expand All Stacks command.

I've placed retouched derivatives into the same folder as the originals and I'd like them stacked in pairs. Can I do it automatically?

If you want to automatically stack photos by their timestamps, for example, to stack retouched files with their originals, you can select the photos and choose Photo menu > Stacking > Auto-Stack by Capture Time and choose a 1 second time difference (0:00:01). You will see the number of stacks change at the bottom of the dialog. 0 seconds would, of course, be more helpful, but that doesn't work. It might need a little

tidying up where you've shot in really quick succession, but it should do most of the work for you.

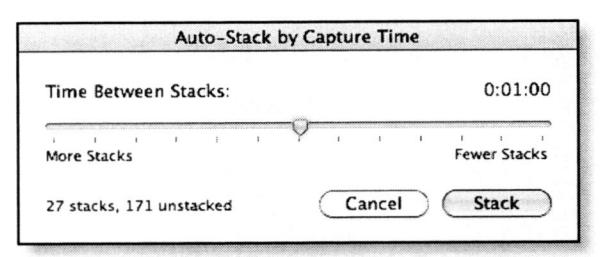

When I create a virtual copy, it should automatically stack them, but it hasn't—why not?

When you create a virtual copy, it'll automatically be stacked with the original in the folder view. If you can't see those stacks, you may be viewing a collection rather than a folder view, or the stacks might be open, which makes them more difficult to spot. The border surrounding the thumbnails is slightly different, as you can see in the screenshot, but it's not always obvious as the thumbnail divide lines don't disappear until the photos are deselected.

RATING & LABELING

Having found your photos in the folders where they're stored, and perhaps created collections for each shoot, it's then time to sort through those photos to choose your favorites and weed out the rubbish. Lightroom offers 3 different labeling systems—flags, ratings and labels—so you can decide how to use them in your own workflow.

Which rating or labeling system should I use?

Star ratings have a fairly universal meaning. They're used to record the quality or value of the photo, with 1 star photos being poor and 5 star photos being the best you've ever taken. Star ratings are standard across almost all DAM software, so if you chose to use other software in the future, these settings could be transferred.

There isn't an equivalent standard usage for color labels. You can use them for your own purposes. Many photographers use them as workflow tools, perhaps using Red for dust retouching, Yellow for other retouching, Green and Blue to mark groups of photos for HDR and Panoramas, and Purple for finished files. Personally, I find them most useful when processing a shoot with a mix of different cameras. When synchronizing Develop settings, each camera may need different settings, and the labels make each camera easy to identify at a glance.

The final rating system is the flags, which aren't only specific to Lightroom, but also to that particular folder or collection. Photos can be flagged in one folder and rejected in another collection.

Let's say you went to the zoo and you took photos which are going to be used for different things—some to send to Granny, some to submit to a competition, some to put in the family album, etc. You'll look for different things in the photos depending on their destination. You likely go through your photos initially and give them star ratings according to their quality, but then you may want to select certain photos to send to other people.

Imagine you put all of your 4 and 5 star photos from the zoo into 3 collections to sort further—a collection for Granny, one for competition shots, and, of course, the family album—and then you start sorting

through those photos in their collections. The photo of the kids sticking their tongues out at the elephant may be a reject for the competition, but a pick for the family album, and the beautiful headshot of the lion would be a firm favorite for the competition, but Granny might not like it. That's when the local flags come into their own. This means that the same photo can be flagged in Granny's collection but not in the Competition collection.

How do I apply ratings and labels quickly?

The quickest way of adding star ratings, color labels and flags is using their keyboard shortcuts rather than trying to click on exactly the right spot.

The 0-5 keys are for star ratings, with 1-5 obviously setting 1-5 stars, and 0 clearing your star rating. The 6-9 keys apply colors Red, Yellow, Green and Blue, and Purple doesn't have a keyboard shortcut because there aren't enough numbers. Flags have P for Picked or Flagged, U for Unflagged, and X for rejected. Those keys are spread a little further over the keyboard, so if you would prefer to use keys a little closer together, the `key will toggle between Flagged and Unflagged. Select your first photo, press the shortcut for the rating you want to add, and move on to the next photo.

If you're in a decisive mood and would like Lightroom to automatically move on to the next shot as soon as you've added a flag, rating or label, turn on Caps Lock or hold down Shift while using those keyboard shortcuts, and Lightroom will apply the rating and move on to the next photo. You can do the same by turning on Auto Advance under the Photo menu.

You can add the flags, ratings and labels to the toolbar by clicking the arrow at the end of it, and they're available in the right-click menu as well as the Photo menu too. If you prefer to use the mouse, you can set the View menu > View Options to show the star ratings, labels and flags

around the edge of the thumbnails. If you like working in Grid view with the mouse, the Painter tool is even quicker.

How do I use the Painter tool to quickly add metadata?

The Painter tool, shown by a spray can icon in the toolbar below the Grid view, is ideal for quickly applying various metadata and settings to larger numbers of photos without having to be too careful about where you click.

The Painter tool can be used to assign not only labels, ratings

and flags, but also to add keywords, metadata presets, settings (Develop presets), change the rotation or add to the Target Collection.

Simply select the Painter tool from the Grid view toolbar—press T if you've hidden the toolbar. Choose the setting you would like to paint, and start spraying—click anywhere on a thumbnail image to apply the setting, or click-and-drag across a series of photos to apply the setting to all of the photos it touches.

To use the Painter tool to remove a setting, hold down the Alt (Windows) / Opt (Mac) key and the cursor will change to an eraser, then you can click or click-and-drag across the photos to remove the setting.

Is it possible to view flag/rating/color labels status when in other modules?

When you turn on the toolbar, you can choose which information to show in each module by clicking on the arrow at the right hand end, and flags, ratings and labels are amongst those choices. If you work with the Filmstrip open at the bottom of the screen, you can also see the flags, ratings and labels on the thumbnails, as long as you have 'Show ratings and picks in filmstrip' turned on in Preferences > Interface panel and 'Tint grid cells with label colors' turned on in View menu > View Options...

I've flagged my photos, but the flags disappear when I view these photos in another folder or collection—why?

Because flags are local, unlike ratings or labels, they disappear when you switch to a different folder or collection view. They only apply in the context in which they were originally set, so a photo may be flagged in one collection and unflagged in another. Flags aren't saved in XMP either, which we'll discuss further in the next chapter, so if you need a marker that will show everywhere, use ratings or labels.

If you flag photos in a folder or Quick Collection, and then create a collection from that, the collection will show the same flags. Once the collection is created, however, it becomes detached, and changes made to the flags in that collection will not be updated in other locations. There are some slight variations, for example, flags set in Quick Collection or smart collections are reflected in the original folder as they're not true collections in their own right, whereas flags set in a standard collection aren't reflected in the folder view.

I gave my photos stars or color labels in Lightroom—why can't I see them in Bridge?

Lightroom's settings are only stored in Lightroom's own catalog, which Bridge can't read, so if you want to view those stars or labels in Bridge, you need to write your settings back to the files. They're stored in a metadata section called XMP, which we'll come to in the next chapter, but in the meantime, select the files in Grid view and press Ctrl-S (Windows) / Cmd-S (Mac) to write to the external files.

"How do I write settings to XMP?" on page 243

I gave my photos different color labels in Lightroom—why are they all white in Bridge? Or I labeled my photos in Bridge why isn't Lightroom showing my color labels?

If you've changed label names, or you're using different label sets in Lightroom and Bridge, the labels may show as white in Bridge, showing

0

Edit Color Label Set

6

Preset: Lightroom Default

Red

Yellow

Green

Blue

Purple

that they don't match. You can check Lightroom's label names by going to Metadata menu

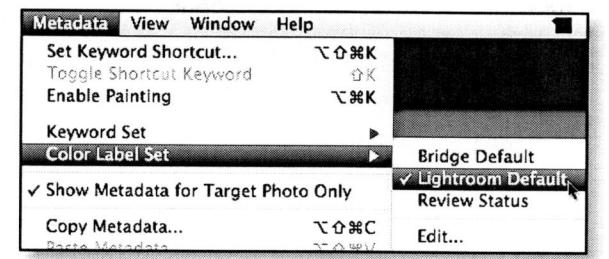

> Color Label Set

> Edit..., and to check in Bridge, go to Bridge's Preferences > Labels section. If you change them both to the same values, they'll show in the same colors. Lightroom ships with a label set called 'Bridge Default' which will match Bridge's default settings, which you'll find under Metadata menu > Color Label Sets.

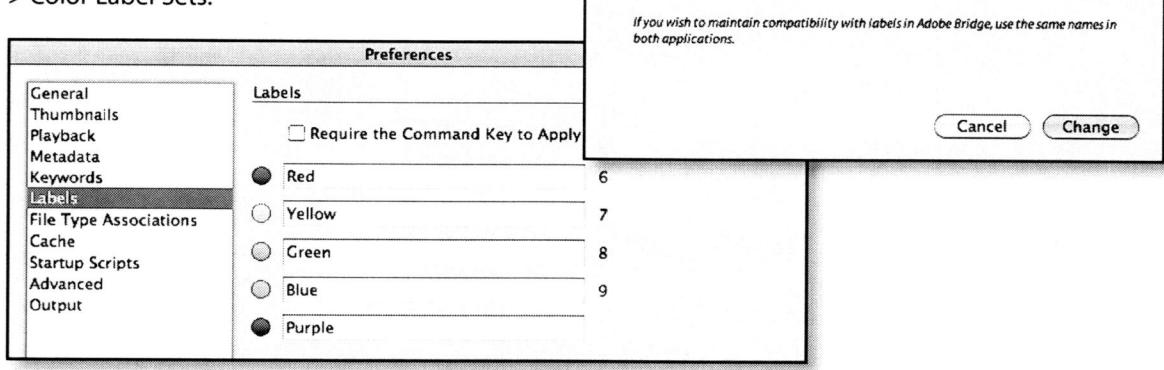

Lightroom's not quick enough to sort through a large shoot is there anything I can do to speed it up?

Lightroom likes a fast computer however there are a few things you can do to help speed it up when you're sorting through your shoot. We'll come back to speed tips in more detail in the Previews & Speed chapter, but here are a few tips to get started in the meantime.

- Work in Library module, not Develop module, as Develop reads the original raw file and is therefore slower moving from one photo to the next.
- Render previews before you start—there's nothing more frustrating than waiting for a preview to become sharp. If you're going to need to zoom in on many photos, render 1:1 previews rather than standard size.
- Resist the urge to start making Develop changes while you're sorting through them. If you correct one, then sync the changes with others, Lightroom has to regenerate the previews for the photos that have changed. Do your tweaking after you finish sorting though them.
- Turn on Auto Advance either under the Photo menu or by leaving caps lock turned on—as you rate a photo, it will move on to the next photo automatically.
- Use filters to hide photos you've rejected rather than deleting immediately.

RENAMING, MOVING & DELETING

Once you've finished sorting through your photos, there are one or two more file management tasks you might need, namely renaming, moving or deleting photos. Remember, anything you do in the Folders panel is reflected on the hard drive as well as within Lightroom's catalog.

How do I rename one or more photos?

We've already considered the basics of file renaming in the Import chapter, however you're not limited to renaming only while importing—you can also rename while working in the Library module or later when exporting the photos.

To rename photos in the Library module, select them in Grid view, and then the F2 shortcut key or Library menu > Rename... will take you

Also check...

"How do I rename the files while importing?" on page 77

to the Rename dialog, which is similar to the File Naming panel in the Import dialog.

That's great if you want to rename multiple photos, but to rename just a single photo, it's often quicker to open the Metadata panel. If you click in the Filename field, you can edit the existing filename rather than having to use a template in the full Rename dialog. Clicking the little icon at the end of the Filename field takes you directly to the full Rename dialog if you do decide to use a template after all.

There's another useful rename option which wasn't available in the Import dialog—Original Filename. If you've renamed a photo within Lightroom since you imported it into the current catalog, Lightroom should still have a record of the original filename. That Original Filename field would actually be better named Import Filename, as it's the name at the time of import, not the original name at the time of capture. If you want to check whether you have an original filename to revert to, select the 'EXIF and IPTC' view at the top of the Metadata panel. If the original filename is present in the database, you can select Edit... in the

Rename dialog to show the Filename Template Editor, and you will find the Original Filename token in the Image Name section.

How do I move or copy photos between folders?

Although folders are primarily storage buckets, you may need to move photos at times, and to do so you simply drag and drop them around the Folders panel within Lightroom.

Copying isn't quite so simple, because the idea is that you use collections rather than having multiple copies of the same photo. If you do need to create a physical copy on the hard drive, use File menu > Export..., set to save the duplicate in the location of your choice, adding to the catalog automatically, and using the Original file format setting.

"Why would I want to use virtual copies?" on page 309 If you only need a copy of the photo to try out some different Develop settings, or you want to apply different metadata, consider virtual copies instead. They don't create an additional copy on the hard drive, but they behave like separate copies within Lightroom. We'll come back to virtual copies in the Develop module chapter.

When I delete photos, am I deleting them only from Lightroom, or from the hard drive too?

Within Lightroom, there's a difference between the word remove, which only removes the photo from the catalog, and delete, which moves the original file to the Recycle Bin (Windows) / Trash (Mac) too.

When you press the Delete key, or use Photo menu > Delete Photo... or Delete Rejected Photos..., it will show a dialog box asking whether to remove them from the catalog or delete them from the disk. Removing from the catalog can be undone using Ctrl-Z (Windows) / Cmd-Z (Mac) if you immediately realize you've made a mistake, whereas Delete doesn't have an undo option.

Why can't I delete photos from the hard drive when I'm viewing a collection?

The Delete key works slightly differently when viewing a collection, than it does in a folder. It assumes that you want to remove the photo from that collection rather than from the catalog or hard drive. The wonderfully named 'splat-delete' or Ctrl-Alt-Shift-Delete (Windows) / Cmd-Opt-Shift-Delete (Mac) will delete from the hard drive whether

you're viewing a folder, collection or even smart collection, and bypasses the dialog.

I'm deleting photos in Lightroom, set to send to Recycle Bin/ Trash, so why isn't it deleting them?

If you're having problems deleting, or even renaming photos, check the file permissions within your operating system, as you might not have the correct permissions. It's also worth double-checking that you're looking at the right files on your hard drive by right-clicking on a photo and selecting Show in Explorer (Windows) / Show in Finder (Mac). You may be looking at duplicate files in a different location, perhaps by accidentally selecting one of the 'Copy' options in the Import dialog.

I accidentally deleted my photos from my hard drive and I don't have backups! Can I create JPEGs from Lightroom's previews?

If you've deleted your original files, you don't have backups, and they're not in the Recycle Bin (Windows) / Trash (Mac), the next thing to check is whether the photos are still on the memory card. If you haven't reshot the entire card, it may be possible to rescue some of the original photos using recovery software.

If that's not possible, before you do anything else, close Lightroom, find the catalog on the hard drive, and duplicate the catalog and previews just in case something else goes wrong.

It's possible to retrieve Lightroom's previews using Marc Rochkind's free LRViewer software, which can be downloaded from: http://basepath.com/ImageIngester/LRViewer-info.php The resulting JPEGs will only be the size and quality of the previews, but they're better than nothing.

Having downloaded the software from the link above, install and open it. It'll ask for your catalog location, and once you've navigated to your

catalog, it'll open into the viewer window. You can then select the photos and go to File menu > Export JPEGs... to export the previews to the location of your choice.

VIEWING & EDITING METADATA

Now you've decided which photos to keep, it's time to add some additional metadata so you can easily find those photos again at a later date.

Certain metadata such as camera settings, called EXIF data, is added by the camera at the time of shooting, and apart from the capture time, Lightroom doesn't allow you to edit that EXIF data. IPTC data, which Lightroom does allow you to add and edit, primarily includes information about the creator of the photo, the subject and its ownership.

You may have already entered your copyright data in the Import dialog, but some other photo-specific information is also worth adding to the Metadata panel. The location of the photo could be added using keywords, but there are official Country, State, City and Location IPTC fields that are better suited. You might also add a caption to your photos in the Metadata panel, especially if you're going to use them in a slideshow.

How do I add metadata to multiple photos at once?

Adding metadata would quickly become boring if you had to do one photo at a time by just typing that information into the Metadata panel. To make it quicker, however, you can select multiple photos in Grid view and apply it to all of those photos in one go, as long as Metadata menu > Show Metadata for Target Photo Only is unchecked.

Working directly in the Metadata panel can be a bit slow when working on a volume of photos, as it updates each time you move between fields,

so it's often quicker to select the photos and press the Sync Metadata button below the Metadata panel (not

"How do I add captions to the slides?" on page 421

Sync Metadata

the Sync Settings button). In the Metadata dialog, enter the details for any fields you want to update, and put a checkmark next to those fields, as only checked fields will be changed. Press Synchronize when you're finished, and the metadata will be applied to all of the selected photos.

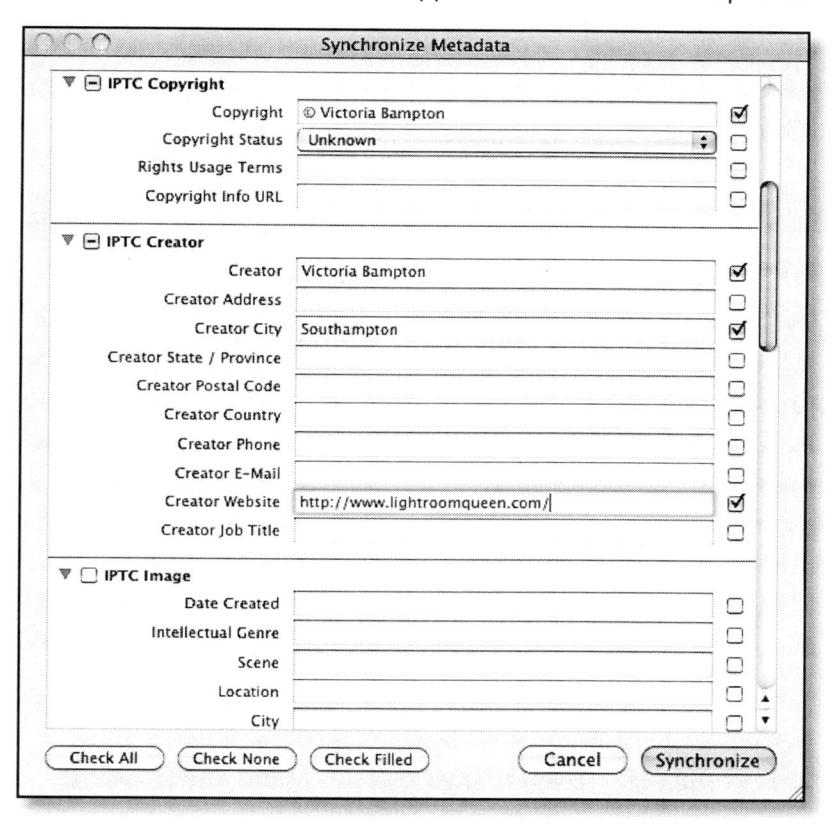

How do I create a Metadata preset?

If you find you're regularly applying the same metadata, you can save it as a Metadata preset for use in the Import dialog as well as the Library module. Go to the Presets pop-up menu at the top of the Metadata panel and choose Edit Presets... The dialog will automatically fill with

the Metadata from the selected photo, and you can edit the information that you want to save in the preset. Just like the Sync Metadata dialog, only

checked fields will be saved in the preset. Leaving any fields blank but checked would clear any existing metadata saved in that field.

There's one other thing to look out for when creating metadata presets. It's easy to accidentally save keywords in a Metadata preset, and then have those keywords mysteriously appear on all imported photos because you're applying the metadata preset while importing, so it's usually a good idea to exclude keywords from the preset.

How do I select which metadata to view in the Metadata panel?

The Metadata panel in the Library module can show a variety of information, most of which is hidden by the default view. It can be accessed from the first pop-up menu on the Metadata panel, selecting the 'EXIF and IPTC' view. If you want to view additional metadata available to Lightroom, or create your own view preset with information you most often use, try Jeffrey Friedl's Metadata Panel Builder: http://www.regex.info/blog/lightroom-goodies/ Some of the additional available metadata includes the filename at the time of import, the file size, all of the date and time stamps, and information stored by some plug-ins too.

Can I import and listen to my camera's audio annotations?

If Lightroom finds a WAV audio file alongside the photo at the time of import with the same name, it'll be listed in the Metadata panel, but you'll only be able to see it listed as an Audio File if you're using certain Metadata panel views such as 'EXIF and IPTC'.

Those audio annotation files can be played within Lightroom by pressing the arrow icon at the end of the Audio field, but it only currently works

with WAV files, and not MP3 format which some cameras use.

Why do some files say CR2+JPEG and some just say CR2?

The files marked as CR2+JPEG, NEF+JPEG or similar are raw photos that were imported with sidecar JPEG files (JPEGs with the same name in the same folder), and with the 'Treat JPEG files next to raw files as separate photos' preference setting turned off. Those JPEG sidecar files may have been created by exporting the raw files to JPEG format in the same folder, or by shooting Raw+JPEG in the camera.

Also check...

"I shot Raw+JPEG in camera—why have the JPEGs not imported?" on page 110

Some of my lenses are listed twice in the Metadata filters, for example 24.0-105.0 mm and also as EF24-105 IS USM. Why?

Although it's slightly irritating, different cameras record the same lens differently, and Lightroom just reads that metadata from the file, which can result in the same lens appearing with different names. Other than manually updating the EXIF data using tools such as ExifTool, there isn't an easy fix at this point in time.

KEYWORDING

Besides the EXIF and IPTC data, it's worth spending a little time adding keywords to help you find the photos again later. Keywords are used to describe the content of the photo, so you can quickly find all photos of a particular bird, family member, or type of scenery.

How should I keyword my photos?

There are no hard and fast rules for keywording unless you're shooting for Stock Photography. Assuming you're shooting primarily for yourself, the main rule is simple—use keywords that will help you find the photos again later! It won't help to tag photos of your pet dog with the Latin name 'canis lupus familiaris' if you don't speak Latin and you would look for 'William' or 'dog' instead.

As with folders and collections, you can use a hierarchical list of keywords instead of one long list, and there are advantages and disadvantages either way. A hierarchical list isn't always backwards compatible with older software, and some older software ignores hierarchical keywords entirely, so flat keyword lists are more universal. On the other hand, a tidy hierarchy is much easier to navigate and it keeps related items together in the list, which helps to prevent variations in spelling on the same keyword.

It's possible to download extensive controlled vocabulary keyword lists, covering just about every possible keyword you could imagine, and for Stock Photographers, those lists are ideal. You may find it less confusing to create your own list that applies to your own photos. Many of the keywords you'll use won't appear on the downloadable lists, as they'll be names of friends, family and local places.

To create a keyword, either type it in the Keywording panel, or press the + button on the Keyword List panel to view the Create Keyword Tag dialog which gives you additional options, namely Synonyms, Include on Export, Export Containing Keywords and Export Synonyms. You can also access those option for existing keywords by right-clicking on the keyword in the Keyword List panel and selecting Edit Keyword Tag...

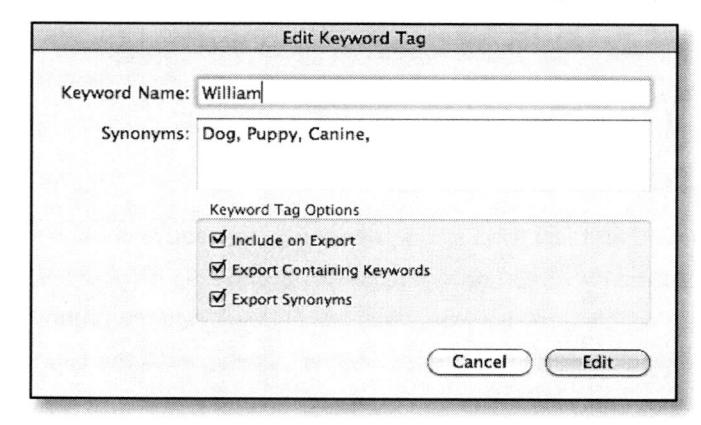

The Synonyms field is the one field where 'canis lupus familiaris' could be useful, as those synonyms can be exported with the photos and found

in searches, without cluttering your keyword list. For dog, you might add other synonyms such as 'canine,' 'hound,' 'mutt,' 'pooch,' or any other related words that you might use to search for a photo of a dog.

You might not want all of your keywords included with exported photos, particularly if they're private information, or they're just header keywords such as 'Places' or 'Subjects', but those can be excluded using the checkboxes in the Create/Edit Keyword Tag dialogs.

Don't go overboard, at least to start with, because if you make it too big a job, it's easy to get bored and give up. Just add a few basic keywords to all photos, and concentrate primarily on your higher-rated photos, as those are the ones you're most likely to want to find again in the future.

How do I change my long list of keywords into a hierarchy? Or change the existing hierarchy?

If you've started out with a long list of keywords and now want to rearrange them into a hierarchy, you can pick them up and drag and drop them into a new structure.

If you drop the keyword on top of an existing keyword, it will become a child of that keyword. As you drag, the new parent keyword will become highlighted to show that the keyword will become a child, for example, in the screenshot, we're making 'William' a child of 'Pets'.

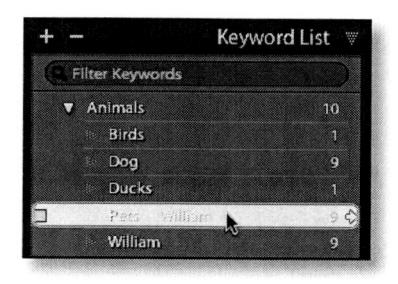

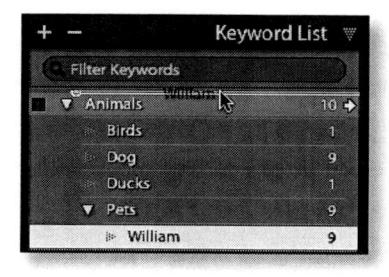

If you want to do the opposite and change a child keyword into a root keyword, drop the keyword between existing root level keywords instead. As you drag, a thin line will appear showing the new position. Don't

worry about getting it in the right place in the list, as the Keyword List is automatically set to alpha-numeric sort, for example, in the screenshot, we're now making 'William' a root keyword.

How many keywords can I have?

There isn't a known limit to the number of keywords in a hierarchical structure, but around 1630 top level keywords seems to be the magic figure due to some Windows limitations. Past that point, the keywords will exist but won't be shown in the Keyword List.

How can I keep certain keywords at the top of the list?

The list of keywords is displayed in standard alpha-numeric order, so adding a symbol to the beginning of the name, for example, the @ symbol, will keep those specific keywords at the top of the keywords list. It's particularly useful for workflow keywords, for example, I always add a @NotKeyworded keyword to all photos as they're imported, and remove it when I've finished keywording. If I get interrupted while applying keywords, those half-done photos might not show in the Without Keywords smart collection, but will still appear in my @NotKeyworded filter.

Is there a quick way of finding a particular keyword in my long list?

If your keyword list becomes really long, or keywords are hidden under collapsed parent keywords, it can be

difficult to find a specific keyword quickly. Fortunately Adobe thought of that too, and there's a Keywords Filter at the top of the Keyword List panel, which will instantly filter the keyword list to show matching keywords. It's useful if you drop a keyword in the wrong place while making it a parent or child keyword, and then can't find it again.

What do the symbols in the Keyword panels mean?

The plus symbol next to the keyword shows that the keyword is assigned to the Keyword Shortcut, just like the Target Collection we discussed earlier, so pressing Shift-K will assign

that keyword to the selected photo(s). You can change the keyword assigned to the shortcut by going to Metadata menu > Set Keyword Shortcut, or by right-clicking on any keyword and choosing that option from the menu. It can also show that the keyword is currently set in the Painter Tool for easy application to multiple photos.

To the left of the keyword are additional symbols showing whether the currently selected photos have that keyword assigned. When you hover over a keyword, a box appears, and if it's empty it means that the

keyword isn't currently assigned to the selected photos, but clicking in that box will assign that keyword. A check mark shows that all of the photos you've selected have that keyword assigned. If you see a minus symbol, it means that some of the photos you've selected have that keyword assigned, or a child of that keyword. If it's a parent keyword, it can also show that all of your selected photos have some, but not all, of its child keywords assigned.

Finally, at the right hand of each keyword is an arrow which appears when you float over the keyword. That's a shortcut to filter the photos with that keyword, and we'll come back to filtering later in the chapter.

In the Keywording panel, above the Keyword List panel, all of the keywords assigned to a photo are listed. Where a keyword is marked with an asterisk (*), some of the selected photos have that keyword assigned, but it's not assigned to all of them.

Also check...

"How can I view all of the photos tagged with a specific keyword or keyword combination?" on page 191

Is there an easier way to apply lots of keywords in one go, other than typing or dragging them all?

Adding keywords can be a time-consuming task, so anything that can make it quicker is a bonus. You can drag photos to the keyword in the Keyword List, or drag the keyword to the photo, but the quickest keywording is done in the Keywording panel.

In the Keywording panel you have a number of options. You can type the keywords directly into the main keywords field divided by commas, or into the Add Keywords field directly below if you don't want to interfere

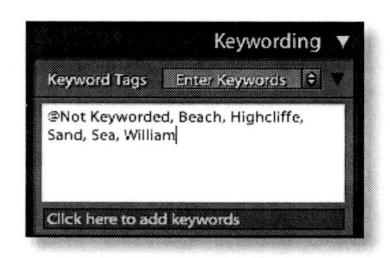

with existing keywords. As you start to type, Lightroom will offer autofill suggestions from your keyword list, and you can either click on one of those suggestions, or use the up/down arrow keys followed by tab to select the keyword you want to apply, or type a new keyword.

The Keyword Suggestions panel below intelligently suggests keywords based on your previous keyword combinations and the keywords already assigned to photos nearby, and clicking on any of those keywords assigns it to the photo. It's remarkably powerful!

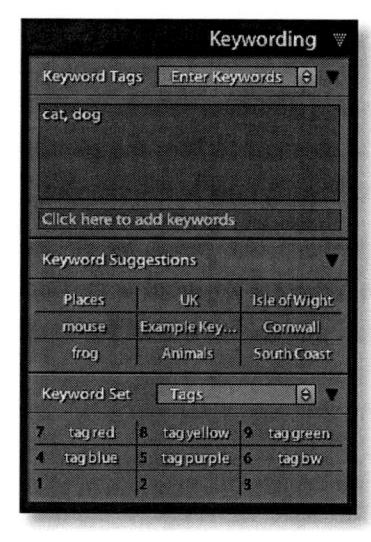

The other option in the Keywording panel is Keyword Sets. Using the popup menu in the Keyword Sets section, you can create multiple different sets of keywords that you tend to apply to a single shoot—perhaps the names of your family members. To apply the keywords you can either click on them or use a keyboard shortcut—hold down Alt (Windows) / Opt (Mac) to see which numerical keys are assigned to each word.

The Painter tool is another quick way of applying one or more keywords to a series of photos quickly and easily, particularly if you're just skimming through them in Grid view. For example, when you're getting started with keywording, you might like to assign the keyword 'William'

to the Painter tool and scroll through

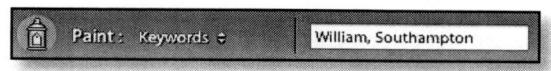

your photos clicking or dragging over each photo of William. If you find yourself regularly using a string of keywords in the Painter tool, such as 'William, Southampton,' save the strings in a text file and copy and paste them into the Painter tool to save typing the list each time.

"How do I use the Painter tool to quickly add metadata?" on page 163

Why are there only 9 keywords in the Keywords panel?

Each of the cells in the Keywords panel matches up with a key on the number pad that can be used as a shortcut, for example, top right is Alt-9 (Windows) / Opt-9 (Mac). That means that there are only 9 visible at a time, but you can create additional sets of keywords and switch between them.

I mistyped a keyword and now Lightroom keeps suggesting it—how do I clear the autofill?

If a misspelled keyword keeps being suggested, it's because it's misspelled in the Keyword List panel. If you correct it or remove it from the Keyword List, Lightroom will stop suggesting it.

While we're on the subject of misspellings, if you come across the same problem with any other metadata apart from keywords, there's a Clear All Suggestion Lists button in the Catalog Settings dialog under the Metadata tab, or you can click on the field label in the Metadata panel to clear the suggestions for that field only.

Also check...

"Sorting, Filtering & Finding Photos" section on page 187 and "Smart Collections" section on page 196

Is it possible to display all of the photos in a catalog that aren't already keyworded?

If you want to find photos that haven't yet been keyworded, look in the Collections panel. There's a default smart collection called 'Without Keywords', or you can use a Text filter set to Keywords > Are Empty. We'll come back to filtering and smart collections later in the chapter. If you don't always complete your keywording in one session, you could also use my @NotKeyworded trick mentioned previously.

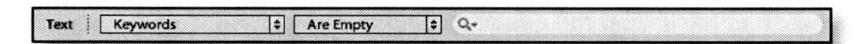

I use multiple catalogs, but I'd like to keep my keyword list identical and current across all of the catalogs—is there an easy way?

Trying to keep settings, particularly keyword lists, identical across multiple catalogs is one of the disadvantages of using more than one catalog, however there's a partial workaround. The easiest option is to use a single photo which is imported into each catalog, and keep that photo updated with all of your keywords applied.

First, import a photo into the catalog, perhaps choosing a plain grey image to make it easily identifiable, and apply all of your keywords to that photo. Write those keywords back to the file using Ctrl-S (Windows) / Cmd-S (Mac), and then import it into each of the other catalogs, making sure you set the Import dialog to 'Add photos to catalog without moving' so that all of the catalogs are referencing the same file on your hard drive. From that point on, whenever you open a catalog, select that same photo and go to Metadata menu > Read Metadata from File. That will update your keyword list with new keywords, and don't forget to write back to the file each time you close each catalog, so that they all stay up to date.

Also check...

"XMP" section on page 241
Alternatively you could use Metadata menu > Import Keywords and Export Keywords each time you open and close a catalog. Either way, keywords only get added to the list and not removed from it, so it would be easy to get into a tangle. If keeping matching keyword lists is important to you, you might want to reconsider using a single catalog instead.

Also check...

"Should I use one big catalog, or multiple smaller catalogs?" on page 215

How do I import my keywords from Bridge?

If you already have a list of keywords in Bridge, you can transfer that over to Lightroom instead of rebuilding the whole list. To do so, you have 2 main options. You can use Bridge to apply all of the keywords to one specific photo, import that photo into Lightroom, and all your keywords will show up in the Keyword List.

You can also use the keyword list import and export tools mentioned in the previous question. Open the Keywords panel in Bridge and go to the menu icon in the top right hand corner of the panel. You'll find Export in that menu, which will export the keywords to a text file, and you can then go to Lightroom and use Metadata menu > Import Keywords to import that text file into Lightroom.

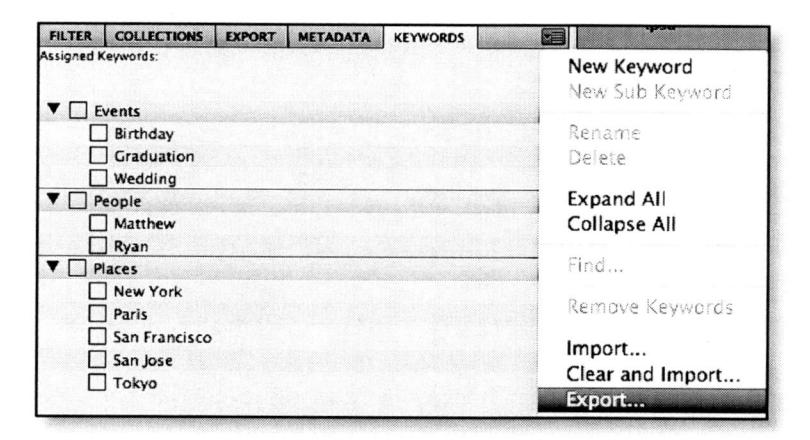

If I can import keywords from Bridge using a text file, does that mean I can create my keywords manually using a text file and then import them into Lightroom?

You can create your keyword list using a text file, but be aware that any formatting mistakes could prevent the keywords from importing, and it can be a time-consuming job to figure out what's wrong.

When creating the text file, only use a tab to show a parent-child hierarchy, and no other characters. If it won't import, you've probably got some blank lines, extraneous spaces, return feeds, etc., or perhaps a child keyword without a parent.

Here's an example showing the formatting characters:

```
Animals
 → Birds
 → Dog •
 Ducks
    Pets
    → William
Places
 → UK
    - Cornwall
     Constantine Bay
    Kynance Cove
    → Land's End ¶
          → Mullion ®
    → South-Coast
      → Hurst-Castle
         → Keyhayan
        → Milford-On-Sea
         New Forest

    Beaulier
    Southampton

              → Beaulieu®
              Clifton Road Park
              → Royal Victoria Country Park
                  Sports Centre
```

EDITING THE CAPTURE TIME

We've all done it... you go on holiday abroad, or Daylight Savings Time starts, and you forget to change the time stamp on the camera. It's not a problem though, as Lightroom makes it very simple to correct the time stamp.

What do the different options in the Edit Capture Time dialog do?

If you go to Metadata menu > Edit Capture Time..., the dialog shows 3 different options for changing the capture time of your photos.

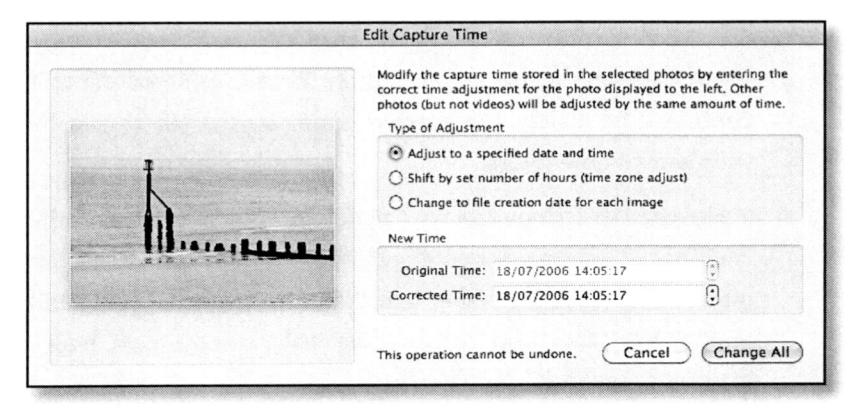

'Adjust to a specified date and time' adjusts the active (most-selected) photo to the time you choose, and adjusts all other photos by the same increment.

'Shift by set number of hours (time zone adjust)' adjusts by full hours, which is useful when you've only forgotten to adjust the time on holiday.

'Change to file creation date for each image' does exactly what it says.

There isn't an option for setting all selected photos, such as old scans, to a specific time, as Lightroom's designed primarily for digital capture. That data can be added using tools such as ExifTool and then read by Lightroom.

The time on my camera was incorrect—how do I change it?

- 1. First, make sure you're in Grid view so that your changes apply to all selected photos.
- Find a photo for which you know the correct time and note that time down—we'll call this the 'known time' photo for the moment.

- 3. Select all of the photos that need the time stamp changed by the same amount.
- 4. Click on the thumbnail of the 'known-time' photo that we identified in step 2, making that photo the active (most-selected) photo without deselecting the other photos.
- Go to Metadata menu > Edit Capture Time... to show the Edit Capture Time dialog. The preview photo on the left should be your 'known time' photo.
- 6. If you need to change the time by full hours, you can select the 'Shift by set number of hours' and enter the time difference, but otherwise, choose the first option, 'Adjust to a specified date and time,' as this allows you to change by years, months, days, hours, minutes or seconds.
- 7. If you've selected the 'Adjust to a specified date and time' option, enter the correct time—the time you noted down earlier for the 'known-time' photo. You can select each number (hours, minutes, etc.) individually, and change the value either using the arrows or by typing the time of your choice.
- 8. Click Change All to update all of the selected photos.

While not entirely obvious, when changing the time stamp on a series of photos, the active (most-selected) photo will be set to the time you enter in step 7, and the rest of the photos will be adjusted by the same incremental time difference. It won't set them all to the same date and time, and that applies whether your active (most-selected) photo is the first in the series or not. For example, if you've selected 3 photos and you set the correct time for the middle one to 16:26, that photo will be the 'known-time' photo identified in step 2, and the others will be adjusted by the same time difference.

So you would have:

	Original Time	New Time
Photo 1	10:14	14:26
Photo 2	12:14	16:26
Photo 3	15:34	19:46

If you make a mistake, the original time stamp is stored in the catalog until the photo is removed, and you can return to that original time stamp by using Metadata menu > Revert Capture Time to Original.

The updated capture time is stored in the catalog, and if you write to the files using Ctrl-S (Windows) / Cmd-S (Mac), it will be written to the metadata of the file too. For proprietary raw files, most other metadata is written to an XMP sidecar file, however the updated capture time can be written back to the raw file itself.

Writing to the file shouldn't cause any problems, as it's written to a known portion of the metadata file header and doesn't affect the raw image data itself. However it's a point of concern for some people who feel that those undocumented raw files should never be touched in any way. For that reason, there's a checkbox in Catalog Settings > Metadata tab which allows you to choose whether the updated time is stored only in the catalog, exported files, and XMP sidecar files, or whether it can be updated in your original raw files too.

How do I sync the times on two or more cameras?

If you're shooting with two cameras, matching the capture times can be even more important, as the Capture Time sort order would also be incorrect, muddling up your photos. Of course, synchronizing the time stamps on the cameras before shooting would save you a job, but if you forget, all is not lost.

The principle remains the same as adjusting the time on a single camera, but you need to repeat the process for each camera with the wrong time stamp. It's easiest if you have a fixed point in the day for which you know

Also check...

"How do I filter my photos to show photos fitting certain criteria?" on page 189 the correct time and were shooting on all of the cameras involved, for example signing the register at a wedding.

First, separate each camera, so that you're working with one camera's photos at a time. You can do that very easily using the Metadata filters, which we'll cover in more detail in the following pages. Then, using the instructions in the previous question, change the capture time for each camera in turn, until they all match.

MANAGING VIDEOS

Many digital cameras now produce, not only stills, but also video. Lightroom 3 has therefore introduced tools for managing those videos alongside your digital photos.

What can I do with my imported videos?

The video facilities in Lightroom are purely for managing video files produced by digital cameras. You can import them into your catalog and manage them like your photos, adding ratings, labels, keywords, other metadata, placing them in collections, uploading to websites like Flickr, and you can also click on the video icon to preview them in your operating system's default video player. You can't currently include them in Slideshows, Web Galleries, or do any editing using Lightroom's tools.

How I do change which program opens my videos?

When you click the small icon on the video, it will automatically open in the default video player for your system, so if you want to change that, you have to change the operating system file associations.

There aren't any Edit in... menu commands for video, but John Beardsworth's Open Directly plug-in will allow you to open the original video into the software of your choice, including video editing software. http://www.beardsworth.co.uk/lightroom/open-directly/

Also check...

"How do I install Export plug-ins?" on page 400

SORTING, FILTERING & FINDING PHOTOS

Being able to add all of this metadata to your photos is great, but the purpose of a database is to be able to easily find those photos again. Lightroom offers plenty of options for sorting and filtering based on various metadata.

How do I change my sort order?

The Sort Order pop-up menu lives in the toolbar in Grid view, so press T if you can't see the toolbar. You can reverse the sort order using the A-Z button, and you'll find all of those options under View menu > Sort too.

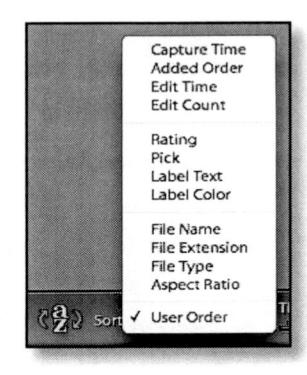

Can I set a default sort order regardless of folder?

The default sort order when you first select a folder should be Capture Time, and you can't change that. If you change the sort order for a specific folder, that sort order should be remembered the next time you return to the folder. The special 'Previous Import' collection defaults to Added Order as the photos are imported, rather than Capture Time.

How do I sort my entire catalog from earliest to latest, regardless of their folders?

If you want to view your whole catalog in date order, click on 'All Photographs' in the Catalog panel and then select Capture Time as the sort order. The 'All Photographs' collection is also useful if you need to search your entire catalog.

Also check...

"When I look at a parent folder in Grid view, I see the photos in the subfolders as well. Can I turn it off so I can only see the contents of the selected folder?" on page 149

Why can't I drag and drop into a custom sort order or User Order?

Custom sort orders, officially known as User Order, only work when viewing a single folder or collection. They don't work when you're viewing a composite view—a folder with subfolders or collection set with subcollections. You can either select a folder with no subfolders, or you can turn off Library menu > Show Photos in Subfolders, so you're only seeing photos directly in the selected folder or collection. If you need

a custom sort across multiple folders, put the photos into a collection instead.

You also need to pick up the photo by the center of the thumbnail itself, not the grey border surrounding it. As you drag the photo, you'll see a black line appear between two photos, which shows where the photo will drop.

Why does Lightroom add new photos to the end of the sort order when editing in Photoshop?

If your sort order is set to User Order, Edit Time, etc., Lightroom will put the edited file at the end of the series of photos, and if you have it set to Stack with Original in the Edit dialog, it will also move the original photo to the end. If you don't want to have to keep scrolling back again, use a sort order such as Capture Time or Filename that won't automatically be updated.

"Editing in Other Programs" section on page 353

Why does my filter disappear when I switch folders?

The behavior has changed in Lightroom 3, so that the filters are no longer sticky or specific to each folder, because many users were confused about where their photos had gone when an old filter was turned on.

When you switch folders now, all filters will be disabled, and you can turn them back on by pressing Ctrl-L (Windows) / Cmd-L (Mac), or using the switch at the end of the Filmstrip Filters. That only turns back on the last filter that you used—not the last filter used on that specific folder.

Many users have requested that the sticky filters be brought back, so they will likely return in a dot release as a preference or as a menu command under the File menu > Library Filters or Library menu.

What does the Filter Lock icon in the Filter bar do?

At the right hand end of the Filter bar is a small Filter Lock icon. If the Lock icon is locked,

the current filter remains enabled as you browse different folders or collections, so you don't have to keep pressing Ctrl-L (Windows) / Cmd-L (Mac) to turn them back on, whereas unlocked uses the default behavior and disables the filter each time you switch folders.

How do I filter my photos to show photos fitting certain criteria?

At the top of the Grid view is the Filter bar, and if it isn't visible at the top of your Grid view, press the \ key, or go to View menu > Show Filter Bar.

The filters apply to the photos in the current view, so they can be used on a single folder, collection, or a larger set of photos such as the 'All Photographs' collection. Select the folder or other view to set the context before you start applying filters.

Clicking on each of the Filter labels switches between the different Filter bars, and Shift-clicking on the labels shows multiple Filter bars at the same time. If you've already set filter options in one Filter bar, clicking on another, even without holding down the Shift key, will keep that bar in view while opening the other.

The Text filters allow you to search the metadata of each photo for the text of your choice, and it replaces the Find panel from Lightroom 1. For example, searching 'All Photographs' for part of a filename using the Text filters will quickly find that photo in your catalog.

The Attribute filters allow you to filter by flag status, star rating, color label, or master/virtual copy status, for example all of the master photos with red labels and 2 stars. The main Attribute filters can also still be found on the Filmstrip for easy access. If your Filmstrip Filters are collapsed, click on the word Filter to expand it to show the full range of options.

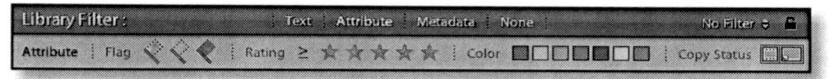

The Metadata filters allow you to drill down through a series of criteria to find exactly the photos you're looking for, for example, dates, camera models, and keywords.

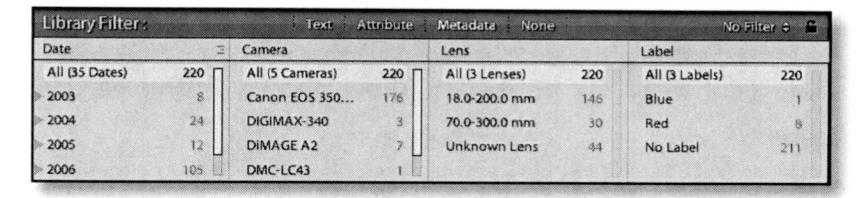

To disable the filters temporarily, select the None option, use the keyboard shortcut Ctrl-L (Windows) / Cmd-L (Mac), or Library menu > Disable Filters.

If you want to clear them completely, select the Filters Off preset on the right of the Filter bar. You can save your own filters using that pop-up menu too.

Can I save the filters I use regularly as presets?

At the right hand end of the Filter bar is a pop-up menu of default filter presets, and you can add your own by creating your filter and then selecting Save Current Settings as New Preset..., as we discussed in the Workspace chapter. Those filter presets will also be accessible from the Quick Filters on the Filmstrip,

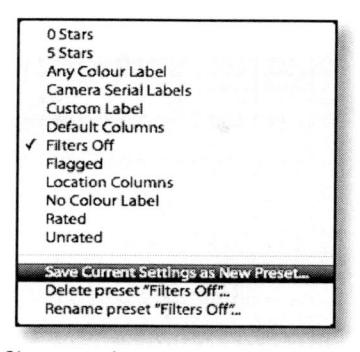

so it's useful to save your most often used filters, such as no stars, 5 stars, as well as sets of column headings and more complex filters.

How can I view all of the photos tagged with a specific keyword or keyword combination?

There are multiple ways to filter by keyword, the easiest being the Text or Metadata filters. To quickly show the photos from just one keyword, click the little arrow that appears at the right hand end of the keyword in the Keyword List panel. The Filter bar will open with that keyword already selected and you can add other keywords to the filter.

How do I filter my photos to show... just one flag/color label/rating?

To filter by flags, labels or ratings, use the options in the Attribute filter bar or on the Filmstrip Filters. They're toggle switches, so click the red icon once to add the red photos to your filter and click again to remove those red labeled photos from your filter.

The last 2 white and grey color labels are for 'custom' and 'no label'. Custom label means that the label name doesn't match a label color in the current Label Set, for example, labels set in Bridge, as we mentioned earlier.

The star ratings have additional criteria to allow 'rating is greater than or equal to,' rating is less than or equal to,' or 'rating is equal to,' and they can be accessed by clicking on the symbol to the left of the stars.

You can combine the various filters, for example, to show red and yellow labeled photos with exactly three stars, you would set it up as follows:

Can I select all photos with a specific flag, color label or rating without changing the filtering?

If you Ctrl-click (Windows) / Cmd-click (Mac) on the flag, color label or star rating in the Filters bar on the Filmstrip, the cursor will change to show that you're selecting rather than filtering, and it'll select all of the photos in the current view with that flag, label or rating without changing the filtering.

How can I use the Text filters to do AND or OR filters?

By default, the Text filters are set to 'Contains All,' which means that only photos matching all of the words you type will be shown, but there are a few other options:

 Select 'Contains' from the pop-up menu for an OR filter, such as photos with either 'dog' or 'cat' keywords, including partial matches such as 'doggy,' 'cattle' or 'tomcat.'

 Select 'Contains All' from the pop-up menu for an AND filter, such as photos with both 'dog' and 'cat' keywords, including partial words such as 'do'.

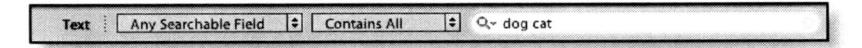

 Select 'Contains Words' from the pop-up menu for an AND filter, such as photos with both 'dog' and 'cat' keywords, but only including whole matching words.

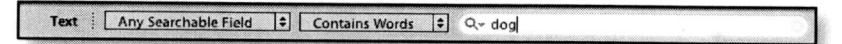

 Select 'Doesn't Contain' from the pop-up menu for a NOT filter, such as photos with the keyword 'dog,' including partial matches such as 'doggy.'

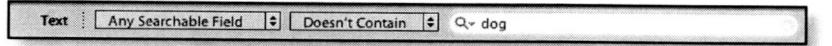

 Select 'Starts With' from the pop-up menu for an OR filter with photos starting with your chosen letters, for example 'cat' would show photos with 'cat,' 'cattle' or 'caterpillar,' but not 'tomcat'.

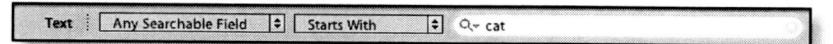

 Select 'Ends With' from the pop-up menu for an OR filter with photos ending with your chosen letters, for example 'mouse' would show photos with 'mouse' or 'dormouse,' but not 'mousetrap'.

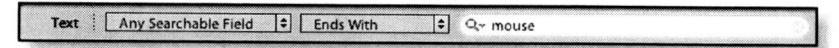

To combine AND or OR searches with NOT searches, you can add an exclamation mark symbol (!) before the NOT word in the Filter bar, for example to show all photos with the keyword 'mouse', but without 'dog' or 'cat', you would use:

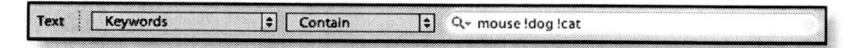

There are some special characters to remember, particularly when creating complex Text filters—a space is 'AND,'! is 'NOT,' a leading + is 'Starts With,' and a trailing + is 'Ends With'. They only affect the adjacent word, so you would use 'dog !cat !mouse' to find images with dog but not cat or mouse.

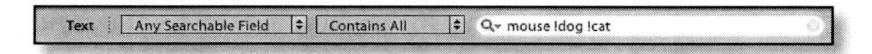

Quotation marks don't work, so you can't search for 'John Jack' to exclude photos of another man called 'Jack John.'

How do I change the Metadata filter columns?

Although the Metadata filter columns default to Date, Camera, Lens and Label, you're not limited to searching on those fields. Clicking on the name of each column in the column header shows a pop-up menu of other columns you can use.

Clicking on the button which appears at the right hand end of each column header shows another pop-up menu,

which allows you to add and remove columns, up to a maximum of 8. Certain columns, such as the date and keyword

columns, offer additional options in that pop-up menu, including a Flat or Hierarchical view. If you need a bit more vertical space to see a longer list of metadata, drag the bottom edge of the Filter bar to resize it.

How do I select multiple options within the Metadata filter columns?

Selecting across multiple columns gives an AND filter, so to search for all photos with both a cat and a dog, you would show 2 keyword filter columns, and select 'cat' in one, and 'dog' in the other. When you select 'cat' in the first column, the second column will update to only show the keywords that are also assigned to cat photos and the photo counts change accordingly.

Ctrl-selecting (Windows) / Cmd-selecting (Mac) or Shift-selecting in the same column creates an OR filter, so to search for all photos with either a

cat or a dog, you would have a single keyword filter column, and you would select 'cat' and then hold down the Ctrl (Windows) / Cmd (Mac) key while clicking

on 'dog' as well, so that they're both selected. Holding down Shift instead of Ctrl/Cmd will select consecutive keywords rather than separate keywords, so if your keyword column showed 'cat, chipmunk, dog,' clicking on 'cat' and then shift-clicking on 'dog' would include 'chipmunk' in your selection too.

Can I combine Text filters, Attribute filters, and Metadata filters?

As with most tasks in Lightroom, there are multiple ways of combining features, and the filters are no exception. For example, if you wanted to find all of the photos with the word 'dog' somewhere in the metadata, with a red, yellow or green color label, shot in 2006, on a Canon 350d, with 70-300mm lens, and changed to black and white, you could combine all 3 filter types.

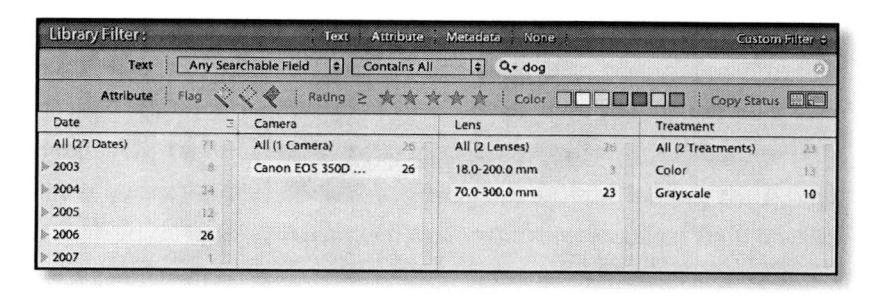

The criteria will filter down in order, from top to bottom and from left to right, and it can be narrowed down further by starting off in a specific folder or collection view.

Even more extensive filtering is available via smart collections, which we'll cover in the next section.

How do I search for a specific filename?

To go directly to a photo that you know the name of, select 'All Photographs' in the Catalog panel to search the whole catalog, and then type the filename into the Text filter bar and set it to the 'All Searchable Field' or 'Filename' options in the pop-up menu.

SMART COLLECTIONS

Smart collections are like saved searches, smart folders or rules in other programs. Like the Filter bar, smart collections automatically update as files meet, or stop meeting, the criteria you've set, but they allow you to do more extensive filtering than the Filter bar. They also show in the Collections panel in the other modules, which saves switching back to Library repeatedly.

Why would I use smart collections instead of standard collections or filters?

Standard collections, which we discussed earlier in the chapter, require you to manually add or remove photos from the collection, and filters only filter the current view, so you have to remember to switch back to 'All Photographs' to filter the whole catalog, whereas smart collections update themselves without any user-intervention, and once they're set up, you don't have to remember which metadata you used for the filter.

You can combine smart collection criteria with a folder, either by entering that folder name in the smart collection criteria, or on-the-fly by clicking on the folder and Ctrl-clicking (Windows) / Cmd-clicking (Mac) on a smart collection. Doing so limits the context, so the smart collection criteria is only applied to that folder and its subfolders.

How do I create smart collections?

To create a smart collection, click the + button on the Collections panel, and choose 'Create Smart Collection...' Select your chosen combination of criteria, adding additional criteria by clicking the + button at the end of each row.

If you hold down Alt (Windows) / Opt (Mac) while clicking on the + button, you can fine tune it further with conditional rules, which shows as indented lines of criteria.

Smart collections, particularly with conditional rules, are ideal for workflow collections. For example, I have an 'Unfinished' smart collection, in case I don't get to finish adding metadata when sorting photos. It holds all of the photos that are both rated and labeled, but are either missing keywords or my name in the Creator metadata field.

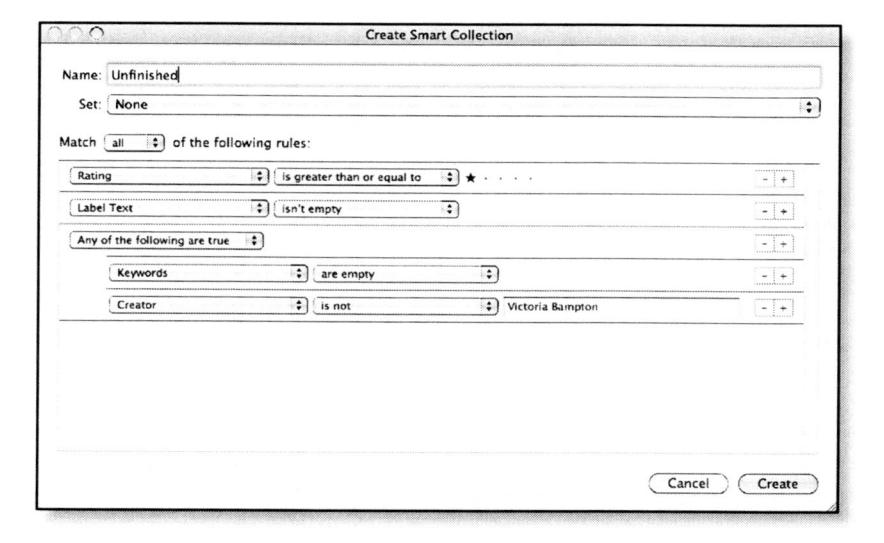

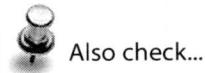

"How does Export as Catalog work?" on page 234 and "How does Import from Catalog work?" on page 236 As an example of it's workflow benefits, you can download John Beardworth's complete set of workflow smart collections from: http://www.beardsworth.co.uk/lightroom/workflow-smart-collections/

How do I transfer smart collection criteria between catalogs?

Smart collections, like other collections, are stored within the catalog, so if you want to use them in other catalogs, you need to create them in each catalog. If they use complicated criteria, that could take a while. Instead you can right-click on the smart collection and use the Import and

Export Smart Collection Settings to export them to individual template files.

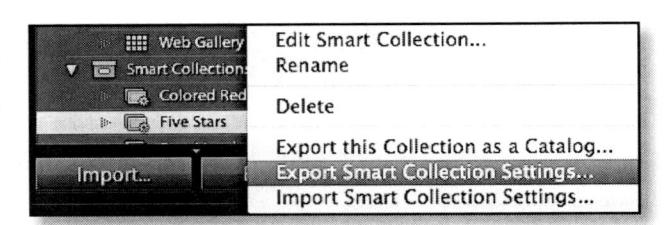

If you have many smart collections, even importing and exporting them individually can take a long time, but if you select a single photo, go to File menu > Export as Catalog to create a catalog of the single photo, switch to the target catalog, go to File menu > Import from Catalog to pull that tiny catalog into your open catalog. All of your smart collections will automatically be imported at the same time, and then you can remove that temporary photo. We'll go into importing and exporting catalogs in more detail in the next chapter.

QUICK DEVELOP

The Quick Develop panel applies relative Develop corrections to your photos, relative to their existing settings. It's useful for applying quick corrections when you're sorting through photos, to decide whether to keep them or not, and it's ideal for applying settings to multiple photos in Grid view.

Why is the Quick Develop panel so useful?

Imagine you've processed a series of photos, each with different settings, and then you decide you would like them all 1 stop brighter than their current settings. The first photo is currently at -0.5 exposure, the next is at 0 exposure, and the third is at +1 exposure.

You could use Synchronize Settings, but that would move the sliders of the selected photos to the same fixed value as the active (most-selected) photo. If you select those photos in Grid view and pressed the >> exposure button in Quick Develop however, it will add +1 exposure to the existing settings—giving you +0.5 for the first photo, +1 for the second photo, and +2 for the third. The same principle applies to the rest of the settings in the Quick Develop panel, so you can add +1 black, remove -20 brightness, and so forth.

Also check...

"How do I copy or synchronize my settings with other photos?" on page 291

Why am I missing some Quick Develop buttons?

The full Quick Develop panel looks like the screenshot on the left, however by default, part of the panel is hidden. Click the disclosure triangles down the right hand side to open it up and show all of the available options.

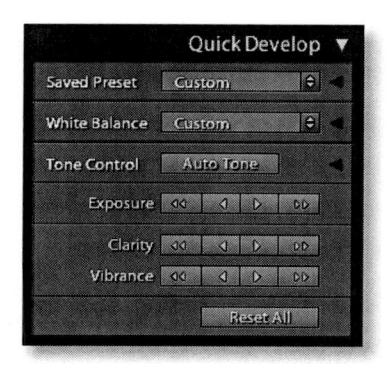

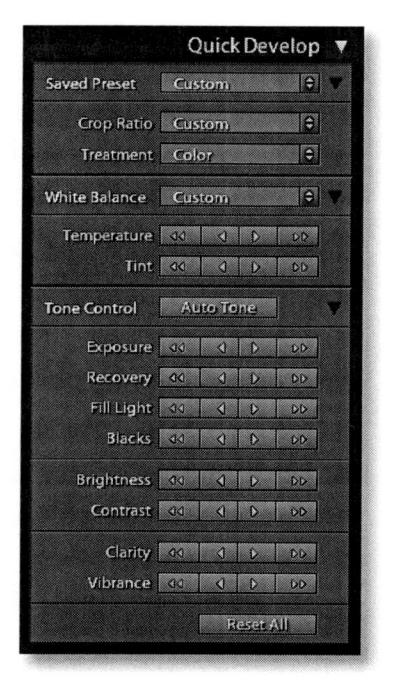

Also check...

"Disclosure Triangles" on page 137

Can I adjust any other sliders using Quick Develop?

If you hold down the Alt (Win) / Opt (Mac) key, the Clarity buttons temporarily change to Sharpening, and the Vibrance buttons temporarily change to Saturation.

MISSING FILES

At some stage, most people run into worrying question marks denoting missing files, which are usually a result of files being moved or renamed outside of Lightroom, or an external drive being unplugged and changing its drive letter. If that happens, Lightroom can no longer find the photos at their original location and needs pointing back in the right direction.

Missing files can be identified by a little question mark in the corner of the Grid thumbnail, or if the entire folder can no longer be found, the folder name in the Folders panel will go grey with a question mark folder icon. When you switch to the Develop module or try to export those files, Lightroom will tell you that the file is offline or missing.

The file named "20040515-145437.jpg" is offline or missing.

Lightroom thinks my photos are missing—how do I fix it?

If Lightroom tells you that files are missing, before you start relinking, first check whether it's only specific files, or whether the folders are missing too. If you relink a file, it won't then allow you to relink the whole folder hierarchy as that new location will already exist in the catalog.

If the whole folder's missing and the folder name has turned grey, you can right-click on the folder and select 'Find Missing Folder...' Point Lightroom to the new location, and it should update the links for all of the photos contained in that folder and its subfolders as long as their names haven't changed. If a whole hierarchy of folders has gone missing, perhaps because the drive letter's changed, you can relink just the parent folder, and it will cascade through all of the other missing files without further interaction. That's why it's useful to set your Folders panel up as a hierarchy before you run into problems.

If it's just specific files which have moved, click on the question mark icon, and a dialog will appear giving you a clue to its last known location.

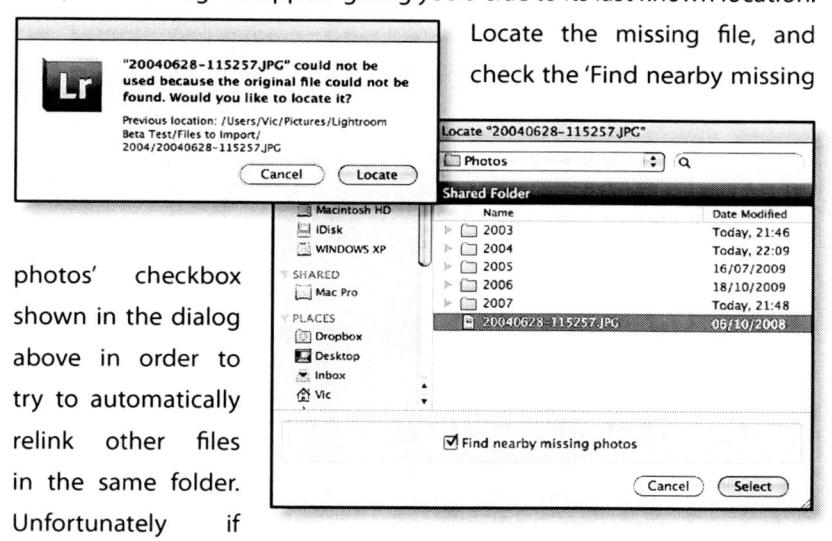

you've renamed the files outside of Lightroom, each file will need linking individually, but there are a couple of workarounds that we'll cover in a moment.

How do I prevent missing files?

Prevention is better than a cure, and preventing missing files will save you some additional work, so there are a few things to look out for...

 Set Lightroom's Folders panel to show the full folder hierarchy to a single root level folder. If that folder is moved from its previous location, or the drive letter changes, it can easily be updated

Also check...

"Renaming, Moving & Deleting" section on page 166 and "How does the Synchronize Folder command work?" on page 152

- using 'Find Missing Folder...' in the right-click context-sensitive menu.
- Move any files or folders within Lightroom's own interface, simply by dragging and dropping around the Folders panel. Folders can only be moved one at a time unless you're moving a parent folder with its subfolders.
- Rename any files before importing into Lightroom, or use Lightroom to rename them. Whatever you do, don't rename in other software once they're imported.
- Don't use Synchronize to remove missing files and import them again at their new location as you'll lose all of your Lightroom settings.

Why does Lightroom keep changing my drive letters and losing my files?

Lightroom doesn't change the drive letters, but Windows does when using external drives, and that can confuse Lightroom, requiring you to relink missing files on a regular basis. Leaving the drives plugged in to your computer, or always reattaching them in the same order can help avoid the drive letter changing. If you want to set the drive letter a little more permanently, you can go into Windows Disk Management and assign a specific drive letter, but I'll leave you to Google for specific instructions for your OS version.

Where has the Missing Files collection gone? How do I find all of the missing files in my catalog now?

In Lightroom 1, there was a Missing Files collection in the Library panel, which was removed in Lightroom 2, but it can still be created on demand using Library menu > Find Missing Photos. That will create a temporary collection of the missing photos so that you can relink them. It doesn't update live, so even after you've located the missing photo, it will still appear in that collection, complete with its question mark badge. You

can remove that temporary collection from the Catalog panel at any time by right-clicking on it, and the missing photo question mark icons will automatically update when you switch to a different folder or collection.

I've renamed the files outside of Lightroom and now Lightroom thinks the photos are missing. Is it possible to recover them?

If you've renamed the files using other software, and Lightroom now thinks they're missing, you have a job on your hands.

If you have a copy of the files before they were renamed, maybe on a backup drive, you can move the renamed files, and put the originals in their place. Lightroom would then be able to find the original files—and you can rename again using Lightroom's rename facility if you need to do so.

Alternatively, if you wrote the settings to XMP, either manually or by having 'Automatically write changes into XMP' turned on in Catalog Settings, and the program you used to rename was XMP-aware (i.e., it renamed the XMP files to match), then you could just re-import the renamed files into Lightroom. You would lose anything that isn't stored in XMP, but you'll be back in business.

Other than that, you'll need to relink the files one by one, and remember not to do that again.

I've deleted some renamed photos. I do have backups but they have the original filenames, so Lightroom won't recognize them. Is it possible to relink them?

If you've deleted renamed files and your backup filenames don't match, you'll have to relink each photo in turn. That's a long job, but there may be a quicker way.

If your file naming structure is easily reproduced from the metadata, for example, a YYYYMMDD-HHSS filename, you could just import the

Also check...

"Which of Lightroom's data isn't stored in XMP?" on page 242

Also check...

"How do I rename one or more photos?" on page 166

Also check...

"How do I rename the files while importing?" on page 77 and "How do I back up Lightroom?" on page 222 backup photos into a clean catalog and rename the backups, and then put those backups back where the main catalog is expecting to find them. It's a good reason for using a naming structure that can be reproduced.

If the filename can't be reproduced from metadata, there's another possible option. Look in the Metadata panel, set to the 'EXIF and IPTC' view, and see if Lightroom still has the Original Filename. If it does, and that matches the names of your backup files, you can use dummy photos to reset Lightroom back to your original names and then relink them.

Lightroom will only rename photos if it has files to rename, but it's possible to trick it. As always, back up your catalog before you try any troubleshooting tips! Find some duplicate photos—you're going to delete them once we're done, so any files of the same format will do—and name them to the same names that Lightroom's expecting to see, either using an empty temporary Lightroom catalog or other renaming software. Obviously this is only quicker if you've used an easy naming format which can be batch renamed!

Now put those photos in the folder that should hold the missing photos, and restart Lightroom or click the question mark to link one of the missing files with the dummy file. The previews may start to update with the wrong photos, but just ignore that. Select all of the photos in Grid view, and go to Library menu > Rename Photos..., scroll down to Edit... and in the Filename Template Editor, change the naming tokens to Original Filename. Press OK so that the dummy photos are renamed.

By this point, all of the references in Lightroom should now be back to their original filenames, which should match your original filenames on your DVD, so you can close Lightroom, delete the dummy photos, and replace them with the original photos from the DVD. If you then open Lightroom, hopefully you'll be back to normal, and can rename the photos to your choice of filename.

Working with Catalogs

Many of Lightroom's features are dependent on its database backbone, and wouldn't be possible using a simple file browser. Amongst other things, Lightroom can create virtual copies, store extensive edit history for each image, and track information on settings for slideshows, prints and web galleries and their associated photos, all of which depend on the database. Searching image metadata (EXIF, keywords, etc.) is also much faster as a result of the database, and Lightroom can search for photos which are offline, as well as those currently accessible. Each catalog is a separate database containing all this information. Adobe produced Bridge for those who prefer a browser setup without these additional cataloging features.

MANAGING CATALOGS

When you first open Lightroom, it automatically creates a catalog for you to start working. You can move that catalog to a location of your choice, and you can also switch back and forth between multiple catalogs, although we'll come back to the pros and cons of multiple catalogs in a moment.

Also check...

"Should I use one big catalog, or multiple smaller catalogs?" on page 215

How do I create a new catalog and switch between catalogs?

If you hold down the Ctrl key (Windows) / Opt key (Mac) while opening Lightroom, a dialog will appear, asking you to open an existing catalog, or you can create a new catalog with the name and location of your choice.

If Lightroom's already running, you can also create a new catalog using File menu > New Catalog..., or open an existing catalog using File menu > Open Catalog...

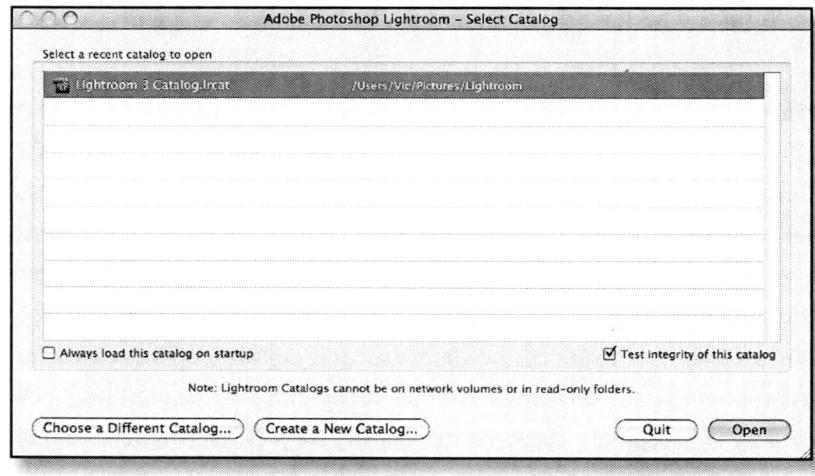

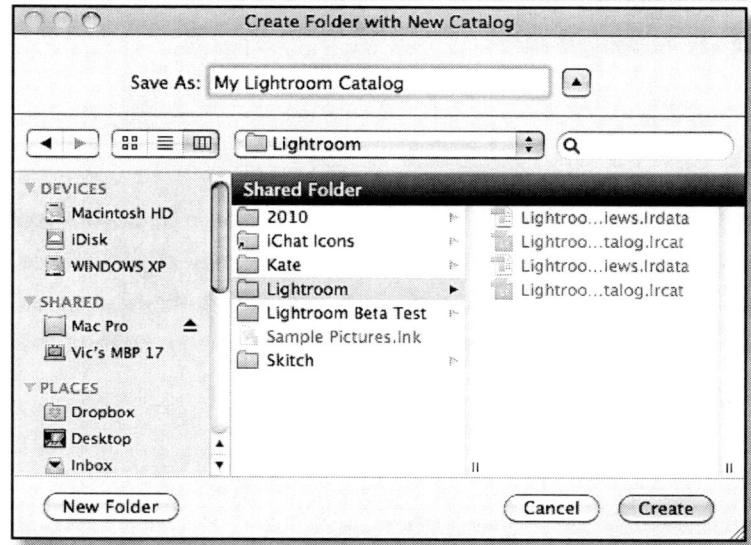

Why do I have a few different files for my catalog?

If you use Explorer (Windows) / Finder (Mac) to find view the catalog on your hard drive, by default in your My Pictures (Windows) / Photos (Mac) folder, you'll see a few different files.

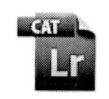

LR3 Catalog.lrcat

LR3 Catalog.Ircat.lock

- *.lrcat is the catalog/database which holds all of your settings.
- *.lrdata is the previews, which is made up of lots of little preview files, with multiple different size previews for each photo. On Windows, those previews are stored within a series of folders and subfolders, and on a Mac, they're within a package file.

If Lightroom is open, you may also have a couple of additional files.

- *.Ircat.lock is a lock file that protects the database from being corrupted by multiple users attempting to use it at the same time. If Lightroom is closed and the lock file remains, you can safely delete it, as it can sometimes get left behind if Lightroom crashes, and it will prevent you from opening the catalog again.
- *.lrcat-journal is a very important file that you never want to delete—it contains data that hasn't been written to the database yet, perhaps because Lightroom's crashed, so when Lightroom opens, the first thing it does is check for a journal file to update any incomplete records.

What does the catalog contain?

Let's start with what the catalog <u>doesn't</u> contain... it doesn't contain your photos. Remember, the photos are stored on your hard drives as normal image files. The catalog contains links to those image files and other metadata—that's information about the photos, including the EXIF data from the camera, any IPTC data, keywords and other metadata

you add in Lightroom, and also any Develop changes you make in Lightroom, all of which are stored as text instructions.

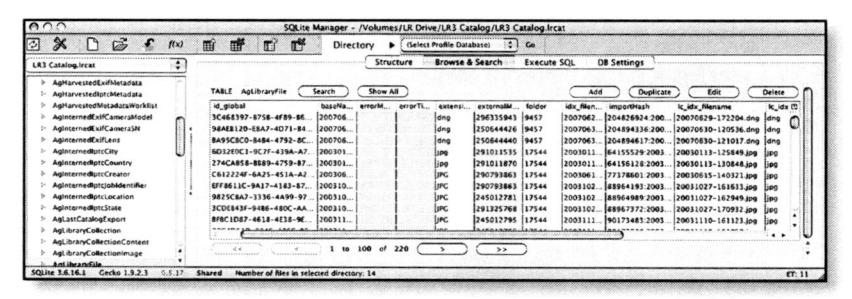

Is there a maximum number of photos that Lightroom can hold?

There's no known maximum number of photos you can store in a Lightroom catalog. Theoretically, your computer might run out of address space for your photos between 100,000 and 1,000,000 photos, although there are many users running catalogs of more than 100,000 photos, myself included.

If your catalog's stored on a FAT32 formatted hard drive, 2GB is the maximum file size allowable on that drive format, so your catalog could hit that limit, but then you could always move the catalog onto a drive formatted as NTFS on Windows or HFS on Mac.

Is there a maximum number of photos before Lightroom's performance starts to degrade?

There's no magic number of photos before performance declines—it depends on the computer specification. Many people are running catalogs of a few hundred thousand photos. Browsing or filtering the 'All Photographs' collection may be slower as it's searching a larger number of photos, but general browsing and work shouldn't be badly affected by the larger catalog size, as long as it's optimized regularly.

Is there a maximum image size that Lightroom can import?

The maximum image size that Lightroom 3.0 can import is 65,000 pixels along the longest edge, or up to 512 megapixels—whichever is smaller. A photo that is 60,000 x 60,000 is under the 65,000 pixel limit, but it still won't import as it's over the 512 megapixel limit. As most cameras range between 3-25 megapixels, that's only likely to become an issue for huge panoramic or poster shots created in Photoshop.

Can I move or rename my catalog?

You can move or rename the catalog in Explorer (Windows) / Finder (Mac) as if you were moving or renaming any other file, but don't forget to close Lightroom first.

Ideally you should also move or rename the previews folder so that it reflects the new name of the catalog too. If you don't rename the previews correctly, Lightroom will simply recreate all of the previews. No harm done except for the time involved, although if you have offline files, previews for those photos won't be recreated until they're next online. If Lightroom creates previews with a new name, you may want to delete the old previews file to regain the drive space.

So, for example:

Lightroom Catalog.lrcat —> New Name.lrcat
Lightroom Catalog Previews.lrdata —> New Name Previews.lrdata

When you next come to reopen Lightroom, hold down Ctrl (Windows) / Opt (Mac) to navigate to the renamed catalog. You may need to change the default catalog so it opens the correct catalog automatically in future.

How do I set or change my default catalog?

By default, Lightroom opens your last used catalog, however you can change that behavior in Lightroom's Preferences > General tab. You can

choose to open a specific catalog, open the most recent catalog, or be prompted each time Lightroom starts.

If you have it set to open a specific catalog, or the most recent catalog, you can override it and view the Select Catalog dialog by holding down Ctrl (Windows) / Opt (Mac) while starting Lightroom.

How can I remove everything I've done and start again?

If you're just getting started with Lightroom, you may be 'playing,' and then decide to start again with a clean slate for your primary catalog. Rather than deleting everything from the catalog, consider storing that catalog somewhere safe, in case you want to go back to it, and create a new catalog using File menu > New Catalog...

What general maintenance will keep my catalogs in good shape?

Under the File menu, you'll find 'Optimize Catalog', which was found in the Catalog Settings dialog in previous versions. That command checks through your catalog, reorganizing your database to make it run faster and more smoothly.

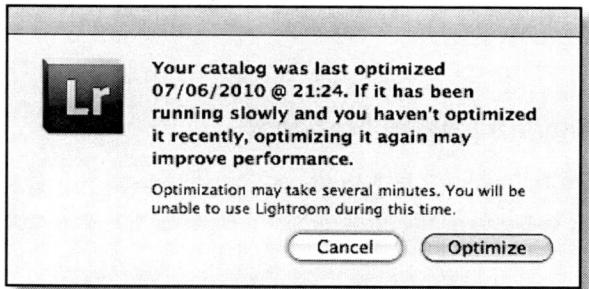

For the more technically minded, over the course of time, with many imports and deletes, the data can become fragmented and spread across the whole database, forcing Lightroom jump around to find the information it needs, so 'Optimize Catalog' runs a SQLite VACUUM command to sort it all back into the correct order, bringing it back up to speed.

'Optimize Catalog' is worth running whenever you've made significant database changes, such as removing or importing a large number of photos, or any time you feel that Lightroom has slowed down. You'll also find a checkbox in the Back Up Catalog dialog to automatically run the optimization each time you back up your catalog.

Why can't I open my catalog?

If you can't open your catalog, there are a few possible reasons. Firstly, Lightroom requires read and write access to the catalog file, so it may show an error message that says "The Lightroom catalog cannot be used because the parent folder ... does not allow files to be created within it" or "Lightroom cannot launch with this catalog. It is either on a network volume or on a volume on which Lightroom cannot save changes." If you see either of those errors, check your folder and file permissions as they're probably set to read-only. It may not be the catalog folder specifically that has the wrong permissions, but possibly a parent folder. Also check your catalog location—it can't be on read-only media, such as a DVD, a network drive, or an incorrectly formatted drive, such as

trying to use an NTFS drive on a Mac. On Windows Vista and 7, there are additional security layers which can cause similar issues.

If the file permissions are correct, check the catalog's folder for a *.lrcat.lock file. If Lightroom's closed, it shouldn't be there, so you can safely delete it. They sometimes get left behind if Lightroom crashes. Remember, if there's a *.lrcat-journal file, don't delete that journal as it contains data that hasn't been written back to the catalog yet.

Finally, Lightroom might give a warning about the catalog being corrupted. That can be a little more serious, so we'll cover that in more detail in the next section.

CATALOG CORRUPTION

Lightroom's catalogs are basic databases, so it is possible for them to become corrupted, even though it's relatively rare. You have nothing to fear from keeping all of your work in a single catalog, as long as you take sensible precautions.

How do catalogs become corrupted?

Generally speaking, corruption happens as a result of the computer crashing, kernel panics, or power outages, which prevent Lightroom from finishing writing to the catalog safely.

Catalogs also become corrupted if the connection to the drive cuts out while Lightroom is writing to the catalog, for example, as a result of an external drive being accidentally disconnected. Some external drives drop their connection intermittently for no known reason, so it's safest to keep your catalog on an internal drive if possible.

How can I keep my catalogs healthy and prevent corruption?

A little bit of common sense goes a long way in protecting your work.

Back up regularly, and keep older catalog backups.

- Always shut your computer down properly.
- · Don't disconnect an external drive while Lightroom is open.
- Keep the catalog on an internal drive if possible.
- Turn on 'Test integrity' and 'Optimize catalog' in the Backup dialog to run each time you back up.

Lightroom says that my catalog is corrupted—can I fix it?

If Lightroom warns you that your catalog is corrupted, it'll also offer to try to repair it for you. In many cases the corruption can be repaired automatically, but it depends on how it's happened. If the catalog repair fails, restoring a backup is your next step, which we'll cover in detail later in the chapter. You can also try moving the catalog to a different drive, which can solve some false corruption warnings.

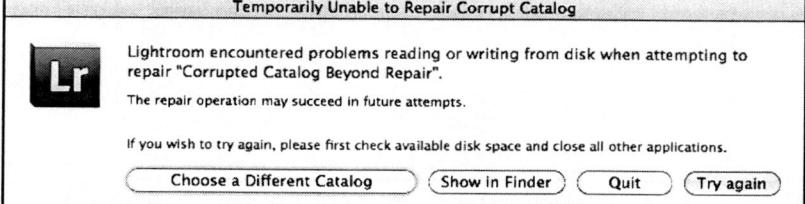

If you don't have a current backup catalog, there are a few rescue options you can try, which involve using Import from Catalog to transfer the uncorrupted data into a new catalog. Usually the corruption is

Also check...

"I have a problem with Lightroom—are there any troubleshooting steps I can try?" on page 457 and "How do I restore a catalog backup?" on page 228 confined to one or two folders that were being accessed when the catalog became corrupted, so working through methodically can usually rescue almost all of your data. It's worth a shot!

- Close Lightroom and duplicate the corrupted catalog using Explorer (Windows) / Finder (Mac) before you proceed with rescue attempts, just in case you make it worse.
- Create a new catalog, as we covered on the previous pages and then go to the Catalog Settings dialog and set the backup interval to 'Every time Lightroom exits'. You can change this back again later, but it saves you starting again from the beginning if you pull some corrupted data into the new catalog.
- Go to File menu > Import from Catalog... and navigate to the corrupted catalog. If it will get as far as the Import from Catalog dialog box, select just a few folders at a time to import the records into your new catalog.
- 4. Between imports, close and reopen Lightroom, so that a new backup is created, and the integrity check runs to ensure that your new catalog hasn't become corrupted.
- 5. Repeat the process until each of the folders are imported from the corrupted catalog. If you hit another corruption warning, go back a step, restore the previous backup, and make a note of the folders you had just imported, skipping them. If you were importing chunks of folders, you may be able to narrow it down to a single folder or even specific photo's records that contain the corrupted data.
- 6. Once you've finished, and you have a working catalog again, select all of the photos and go to File menu > Export as Catalog... and export the whole lot to a new catalog, which will help to clear any orphaned or unexplained data.

Of course, having current backups would have prevented all of this work, so you'll want to make sure that your backups are current in future!

SINGLE OR MULTIPLE CATALOGS

Since version 1.1, Lightroom has made it easy to create and use multiple catalogs, but the question is, just because you can, should you? We'll consider some of the pros and cons, and how to make it work if you do decide that multiple catalogs are right for you.

Should I use one big catalog, or multiple smaller catalogs?

There's no 'right' number of catalogs. As with the rest of your Lightroom workflow, it depends on how you work. So should you use multiple catalogs for your main working catalog, or should you split your photos into multiple catalogs? We're not referring to temporary catalogs which are created for a purpose, for example, to take a subset of photos to another machine before later merging them back in, but more specifically your main working or master catalogs.

The main benefit of keeping all of your photos in a DAM (Digital Asset Management) system is being able to easily search through them and find specific photos, but there are a few other pros and cons to consider.

Pros of Multiple Catalogs

- Smaller catalogs may be faster on lower spec hardware
- Multiple catalogs give a clear distinction between types of photography, i.e., work vs home

Cons of Multiple Catalogs

- Can't search across multiple catalogs
- Potential variation in metadata and keyword spellings
- · Harder to track backups
- Have to keep switching catalogs
- Some photos not in any catalog
- Duplicate photos in multiple catalogs by accident

There are few questions to ask yourself:

- How many photos are you working on at any one time? And how many do you have altogether?
- How fast is your computer—can it cope with a huge catalog at a reasonable speed? Or does it run much better with a small catalog?
- Do you want to be able to search through all of your photos to find a specific photo? Or do you have another DAM system that you prefer to use for cataloging your photos?
- If you decide to work across multiple catalogs, how are you going to make sure your keyword lists are the same in all of your catalogs?
- If you use multiple catalogs, is there going to be any crossover, with the same photos appearing in more than one catalog?
- · How would you keep track of which photos are in which catalog?
- Do you want to keep the photos in your catalog indefinitely or just while you're working on them, treating Lightroom more like a basic raw processor?
- How would you keep track of catalogs and their backups?

Your answers will likely depend on your reasons for using Lightroom. For some people, using multiple catalogs isn't a problem—they already have another system they use for DAM, and they want to use Lightroom for the other tools it offers. For example, some wedding photographers may decide to have a catalog for each wedding, and if they know that a photo from Mark & Kate's wedding is going to be in Mark & Kate's catalog, finding it really isn't a problem. But then, if you had to find a photo from a specific venue, or to use for publicity, you'd have to search through multiple catalogs.

Many high-volume photographers need the best of both worlds—a small fast catalog for working on their current photos, and then transferring them into a large searchable archive catalog for storing
completed photos. That's certainly another viable option, and a good compromise for many.

There are some easy distinctions, for example, you may also decide to keep personal photos entirely separate from work photos. Those kind of clear-cut distinctions work well, as long as there's never any crossover between the two. Keeping the same photo in multiple catalogs is best avoided, as it becomes very confusing! The more catalogs you have, the harder they become to track.

Can I search across multiple catalogs?

Lightroom doesn't currently allow you to search across multiple catalogs, or even have multiple catalogs open at the same time, so you would have to open each in turn. It's one of the biggest disadvantages to having multiple catalogs, so you might want to consider merging them back into one larger catalog if you often need to search through different catalogs.

How do I set default Catalog Settings to use for all new catalogs?

Certain settings are catalog-specific, primarily the Identity Plates, anything set in the Catalog Settings dialog, smart collections and keyword lists. Lightroom doesn't currently provide a way of making those settings available to new catalogs as templates, however there is a workaround. Set up a new empty catalog with the settings of your choice and save it somewhere safe. Whenever you need a new catalog with all of your favorite settings, simply duplicate that template catalog using Explorer (Windows) / Finder (Mac) instead of using File menu > New Catalog...

I seem to have 2 catalogs. I only use 1, so can I delete the other?

If you appear to have a spare catalog, it's probably a good idea to open it before you delete it, to check that you definitely don't want to keep it. To do so, either use File > Open Catalog... or double-click on the catalog in Explorer (Windows) / Finder (Mac). You can safely delete the spare catalog and its previews files as long as you're sure there are no settings in it that catalog that you need, or if in doubt, delete the previews (*.lrdata) and keep the catalog (*.lrcat) somewhere safe.

How do I split my catalog into multiple smaller catalogs?

If you need to split an existing catalog into smaller catalogs, you can use Export as Catalog.

 Select the photos in Grid view and go to File menu > Export as Catalog..., or right-click on a folder or collection and select that option from the context-sensitive menu.

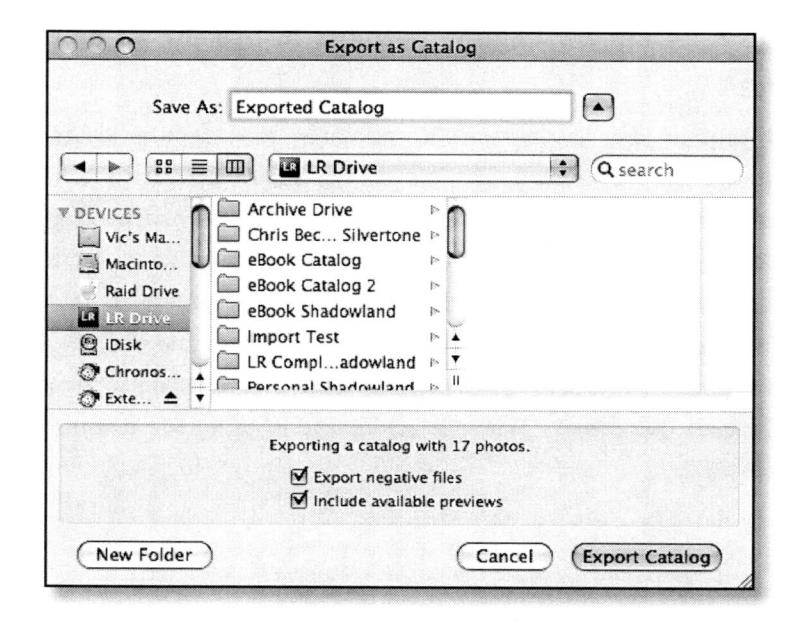

- Choose the name and location of the new catalog in the Export as Catalog dialog. We'll come back to the other checkboxes later in the chapter.
- 3. Once the export has completed, open that new catalog to check that everything has transferred as expected.
- 4. (Optional) Switch back to the original catalog and remove those photos from the catalog.

"How does Import from Catalog work?" on page 236

How do I merge multiple catalogs into one larger catalog?

If you want to merge your existing catalogs into one large catalog, it's simply a case of using Import from Catalog to pull the data into a new combined catalog.

- Select File menu > New Catalog... and create a clean catalog which will become your new combined catalog.
- 2. Go to File menu > Import from Catalog... and select one of the smaller catalogs.
- 3. Repeat the process for each of the other smaller catalogs until you've imported them all.
- 4. Keep the individual catalogs at least until you're sure that everything's transferred correctly.

Be careful if some of the same photos appear in more than one catalog. Choosing the 'Create virtual copies' option in the Import from Catalog dialog will create virtual copies of each of the different sets of settings, so you can go back through later and decide which to keep. We'll cover the Import from Catalog options in more detail in the Working with Multiple Machines section.

How do I transfer photos between catalogs?

It's just as easy to transfer photos between catalogs, for example, from a small working catalog into a large archive catalog.

Also check...

"Working with Multiple Machines" section on page 234

- Open your Archive catalog, or create one if you haven't done so already.
- Select File menu > Import from Catalog..., and navigate to the Working catalog. In the Import from Catalog dialog that follows, select the folders that you want to transfer into your Archive catalog, deselecting the others.
- 3. Import those folders into your Archive catalog and check that they've imported as expected.
- 4. Close your Archive catalog and open your Working catalog again.
- 5. Select the photos that you've just transferred.
- 6. Press the Delete key to remove those files from the Working catalog, being careful to choose 'Remove from the catalog' rather than 'Delete from the hard drive.'

Repeat the process whenever you want to transfer more photos into the Archive catalog.

When I used ACR I only kept the XMP files archived—can't I just do that?

If you've previously used ACR or another raw processor that created sidecar settings files, and you have another DAM system, then you do have the option of removing photos from the catalog and just keeping the XMP settings files instead. Not all of Lightroom's information is stored in XMP, as we'll discuss later in the chapter, so just double check that you won't be deleting

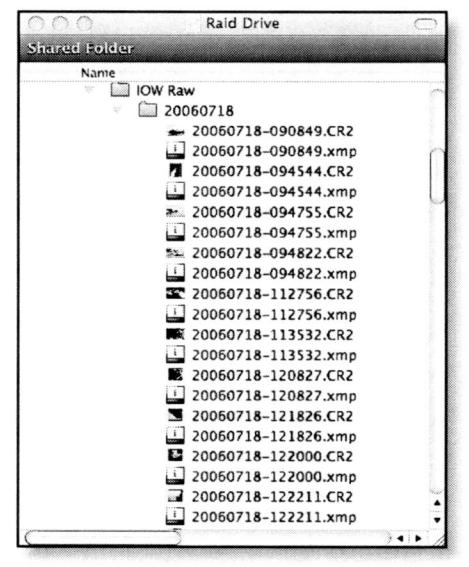

something you need. Don't forget, you will be missing out on the benefits of Lightroom's cataloging facilities.

Lightroom doesn't write to XMP by default, so you'll need to either enable 'Automatically write changes into XMP' in Catalog Settings > Metadata tab, or select all of the photos in Grid view once you've finished processing and press Ctrl-S (Windows) / Cmd-S (Mac) to manually write the settings to XMP.

BACKUP

We've already said that catalog corruption is always a risk with any database, so sensible backups are essential. Lightroom's own backup system can take care of versioned catalog backups, but there are other files that you'll also want to include in your backups, most notably the photos themselves.

When considering your backup system, don't limit the backups to attached hard drives, because viruses, computer malfunctions, lightning strikes, floods, and other similar disasters could wipe out all of your backups along with the working files. Online backups are an option if you have a fast internet connection, or there's always the lower tech solution of mailing a backup DVD to a friend or family member.

I run my own backup system—do I have to let Lightroom run backups too?

You don't have to let Lightroom run its own backups if you have a solid backup system, but be very careful if you choose to turn them off. Lightroom's own backups create versioned backups and are primarily protection against catalog corruption, whereas many backup programs just back up the latest version and could overwrite an uncorrupted copy with a corrupted one, which would defeat the object. Each time Lightroom backs up a catalog, it creates a folder named with the date

"Lightroom appears to be corrupting my photos—how do I stop it?" on page 108 and the time of the backup, for example, '2010-06-08 2100,' so previous backups aren't overwritten or automatically deleted.

Does Lightroom back up the photos as well as the catalog?

Lightroom's own backups are just a copy of your catalog, placed in a folder named with the date and time of the backup. The catalog only contains references to where your photos are stored, and information about those photos, so you definitely want to ensure that you're backing up your photos separately, including any derivatives edited in other software, for example, photos retouched in Photoshop. File synchronization software, such as Vice Versa (http://www.tgrmn.com/) for Windows or Chronosync (http://www.econtechnologies.com/) for Mac, makes it very easy to keep a mirrored backup on another drive without wrapping your photos up in a proprietary backup format. Many, including the 2 programs mentioned, can verify your data during the transfer, as most file corruption happens while copying or moving files between hard drives.

How do I back up Lightroom?

Ideally you'll be running a full system backup, but as far Lightroom is concerned, there are a few essentials to ensure you've included:

- The catalog(s) (*.lrcat extension)—holds all of the information about your photos, including all of the work you've done on the photos within Lightroom.
- The catalog backups—just in case your working catalog is corrupted.
- The previews (*.Irdata extension)—these would be rebuilt on demand as long as you have the photos, but if you have available backup space, you would save time rebuilding them. If you run a versioned backup system, which keeps additional copies each time a file changes, you'll want to exclude the previews as they change constantly and will rapidly fill your backup hard drives.

- The photos—in their current folder structure, in case you ever have to restore a backup. You'll want to include your edited files too.
- Your presets—includes Develop presets, Slideshow, Print and Web templates, Metadata presets, Export presets, etc.
- Your plug-ins—includes export plug-ins, web galleries and any other extensions that you may have downloaded for Lightroom.
- Your profiles—includes any custom camera profiles and lens profiles that you've created.
- The preferences file—includes last used catalogs, last used settings, view options, FTP settings for uploading web galleries, some plug-in settings, etc. The preferences could be rebuilt if necessary, but you would save yourself some time by backing them up and restoring them.

You'll find the default locations of all of those files in the Useful Information chapter at the end of this book. If you've saved all of those files and you ever have to restore from your backups, you can simply return those files back to their correct locations, open your catalog, and carry on working as if nothing has happened.

Matt Dawson's Config Backup plug-in makes it very easy to back up presets automatically, along with your catalog, and it's continuing to be developed, so other files such as custom camera profiles are likely to be added in the near future. You can download it from: http://thephotogeek.com/lightroom/config-backup/

I back up photos using the Import dialog—isn't that enough?

The 'Make a Second Copy' option in the Import dialog has improved in Lightroom 3—if you rename in the Import dialog, the backup copies will also now have those new names. The folder structure of those copies, however, won't match the folder structure within Lightroom, and any renaming or deleting that you later do within the Library module won't be updated in the backups either. Should you ever have to try to restore

Also check...

"Default File Locations" section on page 461 and "Where should I store my plug-ins?" on page 401

Also check...

"What does the 'Make a Second Copy' option do?" on page 75 from those backups, you'd have a very time-consuming job reorganizing all of the photos, which would be best avoided. It's safer to consider those 'Second Copy' backups as temporary backups while you make sure that the newly imported photos are added to your normal backup system.

How often should I back up my catalog?

You can change the backup interval in the Catalog Settings dialog. The interval between backups depends on how much you'd be willing to lose if something went wrong. If losing a week's work would be your worst nightmare, set it to back up every day, or even more often, for example, every time Lightroom exits. If, on the other hand, you only use Lightroom to edit a few photos every few weeks, a monthly backup interval may be better suited to your requirements.

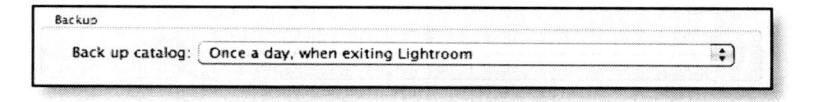

Where does Lightroom save the backups?

By default, Lightroom saves the backups in a Backups subfolder next to the original catalog. That's a fairly logical place, as long as those folders are also backed up to another drive by your primary backup system. However it won't help if those are your only catalog backups and your drive dies.

Also, because those backup catalogs have exactly the same name as their original, some people have opened one of the backup catalogs and accidentally start using that as their working catalog, ending up in a bit of a tangle. If you think that might happen to you, change the backup location to another drive, or another backup folder elsewhere on the same drive, so as to avoid confusion.

How do I change the backup location?

The backup directory is changed in the Back Up Catalog dialog, which appears when a backup is due to run. If you need to show the Back Up Catalog dialog to change the location, when a backup isn't normally due, you can run a backup on demand. To do so, go to Catalog Settings > General panel and change the backup frequency temporarily to 'Every time Lightroom exits'. Close Lightroom so that the backup dialog appears, and then you'll be able to change the backup location. Don't forget to change it back to your normal backup schedule.

Also check...

"What general maintenance will keep my catalogs in good shape?" on page 210

Should I turn on 'Test integrity' and 'Optimize catalog' each time I back up?

In the Backup dialog, there are two important checkboxes, which are worth leaving turned on. 'Test integrity' will check that the catalog hasn't become corrupted and attempts to repair any problems and 'Optimize catalog' tidies up and helps to keep your catalog running smoothly and quickly.

Can I delete the oldest backups?

You can safely delete all but most current backups if you wish, however it would be sensible to open the last couple of backups to ensure that they're not corrupted, before you delete the earlier versions.

Also check...

"How do I create a new catalog and switch between catalogs?"
on page 206

Alternatively you could zip them into compressed folders. They compress very well, massively reducing the file sizes, but if a zip file becomes corrupted, there's little chance of retrieving the catalog inside without corruption.

Is it safe to have Time Machine back up the catalog?

Due to way Time Machine works, trying to back up the catalog file while it's open could cause corruption. It is safest to exclude your Lightroom catalog from the Time Machine backups, or only turn on Time Machine with Lightroom closed.

You'll probably want to exclude the previews file (* Previews.Irdata) too, as that will take large amounts of storage because it's constantly changing, and those previews can always be recreated from the original files.

I'm worried about keeping all changes in one catalog—are there any other options?

As long as you're sensible about backups, then you have nothing to fear from keeping your data in a single catalog. However if, like me, you like a belt-and-braces approach to backup, you could also write most of your data to XMP, which is stored in the header of JPEG/TIFF/PSD/DNG files and in sidecar files for proprietary raw files. XMP doesn't hold all of the information that's stored in the catalog, but as the XMP is stored with the image files, it has been known to save the day on occasion. We'll come back to XMP in more detail.

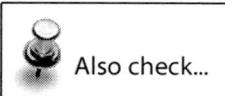

"XMP" section on page 241

I haven't got time to back up now—can I postpone the backup?

In the Back Up Catalog dialog, which appears when a backup is due to run, you have the options to either 'Skip Now,' which postpones the backup until the next time you close the catalog, or 'Backup tomorrow,'

or whatever other time period you've chosen for your backups. Don't be tempted to skip it too often, or you could find yourself without a recent backup.

Why does Lightroom say it's 'unable to backup'?

If Lightroom says it hasn't been able to back up your catalog, there are a few possibilities to check:

- Check the backup location—is that drive accessible and does that folder still exist?
- Check the folder permissions for the backup location—do you have write access?
- · Is there enough space on the drive?

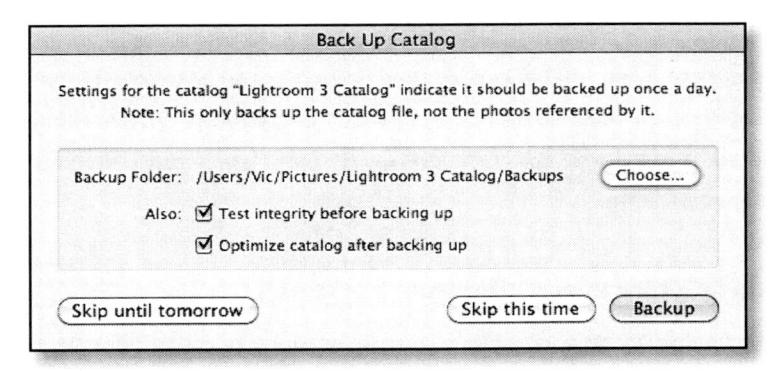

If everything looks correct, try changing the backup location, and if that works you can try changing it back again.

RESTORING BACKUPS

The true test of a backup system is how easily you can restore from those backups and continue working in the event of a disaster. Hopefully your only backup restores will be intentional, perhaps because of moving to a new computer or reinstalling the operating system.

"Lightroom says that my catalog is corrupted—can I fix it?" on page 213

How do I restore a catalog backup?

Lightroom's backup simply makes a copy of your catalog and places it in a dated subfolder, so restoring the catalog is simply a case of opening that backup file. Let's be a little more cautious though—you wouldn't want to risk damaging your last good backup.

First, if you're restoring a catalog after corruption, find your existing corrupted catalog and rename it, move it or zip it up somewhere safe. That's only the *.lrcat file at this stage. The previews may be unaffected, and if there are continued problems, then you can delete the *.lrdata previews file and they'll be rebuilt from the original files.

Now copy (not move!) your last good backup from the backups folder and paste it into the main catalog folder, so that the *.lrcat replaces the corrupted catalog that was there before.

Double click to open the backup, or hold down the Ctrl (Windows) / Opt (Mac) key to show the Select Catalog dialog. If everything's now working correctly, you can delete the corrupted catalog and you should be ready to continue working.

How do I restore everything from backups?

If you're having to do a complete restore, perhaps because your hard drive has died or you're reinstalling the operating system, then ideally you've got a solid backup system, and you can simply put the catalog, photos, and other files back exactly where they were, double-click on the catalog (*.lrcat file) to open it, and carry on working as before. We'll go into more detail on those options in the Moving Lightroom to a New Computer section.

If you don't have quite such a straightforward restore option, for one reason or another, then you'll need to restore as much as you do have backed up. Copy (not move!) the catalog and photos back to your computer from the backup drives, keeping an identical folder hierarchy for the photos if you possibly can. For example, if your photos were in

Also check...

"Moving Lightroom to a New Computer" section on page 232 dated folders, within year folders, and you put them back in a folder called Pictures, with subfolders for different people's names, you're going to have a long job ahead.

Now double-click on the catalog (*.Ircat file) to open it, and survey the damage! Are there question marks on any of the folders or photos? If so, those photos are no longer in the location that Lightroom is expecting, and you need to update the links to point to the new location, as we discussed at the end of the Library chapter. Once you've finished relinking any missing files, you can then get back to working normally.

If you're reading this before your hard drive dies, prevention is better than cure, so now is an excellent time to make sure that your backup system would be easy to restore in the event of a disaster.

If I'm restoring from backups, does the catalog or the XMP data take priority?

Even if you've written to XMP as a belt-and-braces backup, the catalog will always take priority, and the XMP will be ignored. Only if you import the photos into a new catalog, or you use the Metadata menu > Read Metadata from Files command, would the XMP metadata be used.

MOVING LIGHTROOM ON THE SAME COMPUTER

The time may come when you run out of space on your hard drive and need to move Lightroom to a new home on a bigger hard drive.

Before you do anything else, follow the backup procedures outlined in the previous sections, including backing up your catalog, presets, preferences and photos, and most importantly, setting up your catalog folder hierarchy. It'll save a lot of headaches. Having done so, it's time to transfer. If you're simply moving between hard drives in the same

"XMP" section on page 241

computer, your preferences and presets can stay in their current location, as they won't be affected.

How do I move only my catalog to another hard drive, leaving the photos where they are?

If only your catalog is moving, and the photos are remaining in their existing locations, you can close Lightroom and move your catalog using Explorer (Windows) / Finder (Mac). When Lightroom next launches, it won't be able to find the catalog, so select the 'Choose a Different Catalog...' button in the Select Catalog dialog, or double-click on the catalog (*.Ircat file) in Explorer (Windows) / Finder (Mac) to open it directly. As none of the file locations should have changed, you should be able to continue working without further issues.

How do I move only my photos to another hard drive, leaving the catalog where it is?

If you need to move photos to another hard drive, perhaps because you've outgrown your existing hard drive, there are a number of options, but these are the easiest:

Option One—move in Explorer/Finder and update Lightroom's links

- First follow the instructions in the Library chapter to show the folder hierarchy. That will make it easy to relink the files that will be marked as missing in the process.
- 2. Close Lightroom and use Explorer (Windows) / Finder (Mac) or file synchronization software to copy the files to the new drive.
- 3. Check the files have arrived safely, and then rename the original folder using Explorer (Windows) / Finder (Mac) temporarily, while you confirm that you've reconnected everything correctly.
- 4. Open Lightroom and right-click on the parent folder.

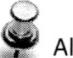

Also check...

"I have a long list of folders—can I change it to show the folder hierarchy?" on page 149

- 5. Select Find Missing Folder... or Update Folder Location... from the list, depending on which option is available.
- 6. Repeat the process for any other parent folders until all of the photos are shown as online, without question marks.
- 7. Once you've confirmed that everything has transferred correctly, you can safely detach the old hard drive or delete the files from their previous location using Explorer (Windows) / Finder (Mac).

Option Two—move the photos using Lightroom's Folders panel

- 1. Go to Library menu > New Folder...
- 2. Navigate to the new drive and create a new folder or select an existing folder where you plan to place the photos.
- 3. Drag the folders and/or photos onto that new location.
- 4. Check that the entire folder contents have copied correctly before deleting the originals, particularly if you're dragging and dropping the photos themselves, rather than the folders. Remember that Lightroom might not move/copy files that aren't currently in the catalog, such as text files, as Lightroom won't know that they exist.

Personally I prefer to use the first option when moving between hard drives, because file synchronization software, that we mentioned earlier in the backup section, allows me to verify that all of my files have moved correctly, byte-for-byte. File synchronization software will allow you to do a one-off copy, as well as proper drive synchronization.

How do I move my catalog & photos to another hard drive?

If you need to move both the catalog and the photos to a new hard drive, you can use the same steps as moving each individually. There's another option if you're moving both—you can use Export as Catalog to create a new catalog and duplicate photos on the other hard drive, and then delete the existing one, however there's a risk that, in the process,

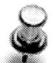

Also check...

"Lightroom thinks my photos are missing—how do I fix it?" on page 200

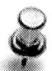

Also check...

"Backup" section on page 221 and "XMP" section on page 241

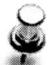

"How does Export as Catalog work?" on page 234 you could miss any files that aren't currently in Lightroom's catalog, such as text documents, so be careful if you choose that option. Also, your keyword list would only include keywords that have been used, and unused keywords would be purged. Export as Catalog is better suited to exporting work temporarily to another computer and then importing back into the main catalog later, rather than moving whole catalogs.

MOVING LIGHTROOM TO A NEW COMPUTER

When the time comes to move to a new computer or reinstall the operating system, it's essential that all of your files are backed up safely, as you wouldn't want to lose anything. Making a clone of the drive is always a good plan if you have that option, just in case you find that you missed files in your backups.

How do I move my catalog, photos and other Lightroom files to a new computer?

Firstly, you need to make sure that all of the essentials are backed up—the catalogs, photos, preferences, presets, plug-ins and any other related files. We covered these in more detail in the earlier Backup section. If you're wiping the hard drive in the process, rather than running both machines at the same time, it's even more important to make sure that you don't miss anything.

For extra security, you may choose to write most of your settings to XMP as well. To do so, select all of the photos in Grid view and press Ctrl-S (Windows) / Cmd-S (Mac). That stores your most crucial settings with the files themselves, and can be particularly useful if you make a mistake.

It's a good idea to make sure that Lightroom's Folders panel shows a tidy hierarchy before you back up the catalog. This makes it very easy to relink the files if the folder location, or the drive letter for an external drive, changes. We covered those instructions earlier in the Library chapter.

Also check...

"Backup" section on page 221, "Where should I store my plugins?" on page 401 and "I have a long list of folders—can I change it to show the folder hierarchy?" on page 149 Once everything's safely backed up, we're ready to set Lightroom up on the new computer. There's no need to install Lightroom from the CD and then run the updates, as the downloads on Adobe's website are the full program. You can just download the latest version or trial, and then enter your serial number(s). If your license is an upgrade version, you may need the serial number from an earlier version as well as the Lightroom 3 serial number.

Transfer the files—the catalog, the photos, preferences and so forth—and place them in their same locations as the old computer. The locations for the preferences, presets and profiles, are listed in the Useful Information chapter. If you're moving from Windows XP to Vista or 7, or from Windows to Mac or vice versa, some of the new file locations will change.

Then it's time to open the catalog. Double-click on the *.lrcat catalog file to open it, or hold down Ctrl (Windows) / Opt (Mac) to show the Select Catalog dialog when launching Lightroom and navigate to the catalog.

You might find that there are question marks all over the photos and folders because they're no longer in the same location, but don't be tempted to remove them and re-import, and don't try to relocate by clicking on a thumbnail question mark icon as you'll create a bigger job. Instead, right-click on the parent folder and choose Find Missing Folder... from the context-sensitive menu, and navigate to the new location of that folder. Relocate each top level folder in turn, until all of the photos are online.

Finally, you might find your plug-ins need reloading as the locations may

have changed in the move. Go to File menu > Plug-in Manager... and check whether all of the plug-ins have green circles, rather than red. If any plug-ins are incorrectly loaded, remove and add them again at their new locations.

on page 399

How do I move my catalog & photos from Windows to Mac or vice versa?

The process of moving your catalog cross-platform is exactly the same as moving to a new machine of the same platform. If you're transferring between platforms, it's even more important that you set Lightroom to show the folder hierarchy to make it easy to relink missing files, as Windows works with drive letters and Mac OS X works with drive names.

There's just one other main thing to look out for—the Mac OS can read Windows NTFS formatted drives, but can't write to them, and Windows can't read or write to Mac HFS formatted drives, so it's worth considering formatting transfer drives as FAT32 while doing a cross-platform transfer. That's most easily done using Disk Utility on the Mac.

WORKING WITH MULTIPLE MACHINES

Many photographers today are working between multiple computers, most often a laptop and a desktop. Lightroom isn't networkable, but it does allow you to split and merge catalogs to move parts of catalogs easily between computers, and it allows you to work with offline photos on the road too.

How does Export as Catalog work?

Export as Catalog allows you to take a subset of your catalog—perhaps a folder or collection—and create another catalog from those photos, complete with all of your metadata, and the previews and original files too, if you wish. You can then take that catalog to another computer, and merge it back in to your main catalog later.

To split your catalog using Export as Catalog, you first need to decide which photos you want to include in the export. You can export any selected photos using File menu > Export as Catalog, or a folder or collection from the right-click context-sensitive menu, using the Export

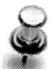

Also check...

"Should I use one big catalog, or multiple smaller catalogs?" on page 215 Folder/Collection as Catalog... commands, and in the Export as Catalog dialog, choose a location for your newly exported catalog.

You have the option to 'Include available previews', which will export the previews that have already been rendered. This is important if you're exporting a catalog subset to take to another computer, and you won't be taking the original files with you, otherwise you'll just have a catalog full of grey thumbnails.

The resulting catalog is a normal catalog, just like any other. If you've chosen to 'Export negative files', there will also be a subfolder called 'Images', containing copies of your original files, in folders reflecting their original folder structure. If you don't include the original files, and you take the catalog to another computer, there will be limitations, which we'll come back to in a moment.

You can transfer that catalog to any computer with Lightroom 3 installed, and either double-click on it, hold down Ctrl (Windows) / Opt (Mac) on starting Lightroom, or use the File menu > Open Catalog... command to open it.

Having finished working on that catalog, you can later use Import from Catalog to merge it back into your main catalog again.

What are the limitations of offline files?

If you choose not to take the originals when you're working on another machine, you'll still be able to do Library tasks as long as you have previews—labeling, rating, keywording, creating collections, etc., and you can also view slideshows and print, but only in draft mode. With those originals offline, you won't be able to do anything that requires the original files—working in the Develop module, exporting files, moving files between folders, and similar tasks—until the original files are available again. If you're going to want to zoom in on any of the photos, you'll need to render 1:1 previews before exporting the catalog, otherwise the previews may be too small.

How does Import from Catalog work?

Import from Catalog allows you to take a whole catalog, or part of it, and merge that into another existing catalog, enabling you to transfer photos between catalogs without losing any of your data. If you've taken part of your catalog out using Export as Catalog, it allows you to merge those changes back into your main catalog again.

First, open the target catalog that you want to merge into. Select File menu > Import from Catalog..., and navigate to the source catalog, from which you want to pull the metadata. Lightroom reads the source catalog and checks it against the target catalog, resulting in this Import from Catalog dialog:

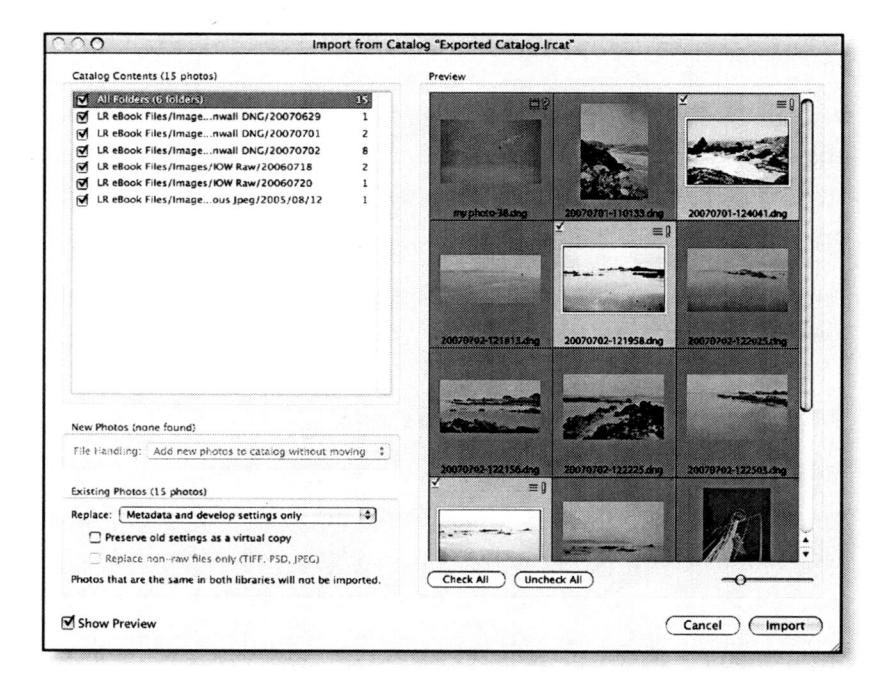

Depending on the choices you make, new photos are imported into the target catalog, either added at their existing locations if the original files are already on the same computer, or being copied to a folder of your choice in their current folder hierarchy.

Photos that exist in both catalogs are checked for changes, and only those that have updated metadata will be updated in the target catalog. Photos that are identical in both catalogs are dimmed, as you won't need to update those.

Lightroom can either replace just the metadata and settings, or replace the original image files too. You also have the option to replace originals on non-raw format only, as you may have done additional retouching on other formats. Unless you've worked on the files themselves in another program, for example, retouching in Photoshop, then you can usually just copy the settings.

If you're concerned about accidentally overwriting the wrong settings, Lightroom can create a virtual copy with your original settings as well as updating the settings on the master.

I need to work on my photos on my desktop and my laptop what are my options?

If you need to work on multiple machines, you have 3 main options:

- A single portable catalog—you place your catalog and photos on an external hard drive, and plug it into the machine that you're going to use at the time.
- Split and merge catalogs using Export to Catalog and Import from Catalog, ideally using one computer as a base (usually the desktop) and taking smaller catalogs out for use on the secondary computer (usually the laptop).
- Use XMP to transfer settings between computers—however some data isn't stored in XMP.

We'll consider the most common scenarios in greater detail...

Also check...

"Snapshots & Virtual Copies" section on page 308

Also check...

"How does Export as Catalog work?" on page 234 and "Which of Lightroom's data isn't stored in XMP?" on page 242

"Catalog Corruption" section on page 212

How do I use a portable catalog with originals, for example, the whole catalog on an external drive with the photos?

If you regularly work between different machines and your entire collection of photos is small enough to fit on a portable hard drive, then the simplest solution is to move your entire catalog and all of its photos onto a portable external hard drive, which you can then plug into whichever machine you want to use at the time.

It does have disadvantages, for example, external hard drive speeds are slower, so you'd want to choose a fast connection, such as eSATA or Firewire800 if possible. There's also a little more risk of corruption when the catalog is stored on an external drive, as they're more likely to become disconnected while you're working. You also need to consider your backup strategy, as external drives are at a higher risk of being lost, stolen, or dropped. If you work on multiple platforms, you may need to relink the files each time you switch computers.

How do I use a portable catalog without originals, for example, the whole catalog copied without the photos?

If your entire photo collection is too large to fit on an external drive, but you still want access to your catalog on multiple machines for metadata updates, moving only the catalog and its previews to the external drive is another possibility. Alternatively, you could copy the catalog onto the other computer, but if you have 2 working copies of the same catalog, it becomes a little harder to track. If you remember to copy the catalog back to the main computer before you swap machines, it works, or you can use Import from Catalog to merge the changes back again.

As the original files will be offline, the work you can do in Lightroom is more limited, but it works well for adding keywords or general browsing. You'll want to ensure that you've rendered at least standard-sized previews before copying the catalog, and if you plan on zooming in, you'll want 1:1 Previews.

Also check...

"What's the difference between Minimal, Embedded & Sidecar, Standard and 1:1 previews?" on page 253

How do I upload and start editing on my laptop, and then transfer that back to the main catalog?

If you choose to upload and start editing your photos while out on a shoot, it's simplest to create a new catalog on the laptop, just for those photos. When the time comes to merge those into your master catalog on your desktop, you can copy the catalog and the photos over to the desktop and use Import from Catalog to merge those photos into the main catalog. If your editing has been limited to ratings or other data stored in XMP, you could alternatively write the settings to XMP sidecars next to the original files, copy just the files back to the desktop, and import those photos as usual. We'll come back to the limitations of XMP later in the chapter.

"XMP" section on page 241

How do I export part of my catalog to another computer and then merge the changes back later?

Export as Catalog allows you to take a subset of your main catalog out with you, with or without the original files, and carry on working on the photos, merging the changes back into your main catalog later using Import from Catalog.

- Select the photos that you want to take with you, and use the File menu > Export as Catalog... command to create a smaller catalog of those photos. Exporting directly to a small external hard drive is usually the simplest solution.
- 2. Make sure you set it to 'Include available previews', and if you want to be able to work on the original files, for example making changes in Develop module, select 'Export negative files' too.
- 3. Moving to your laptop, plug in that external hard drive, open Lightroom, and open that new catalog that you've just created by double-clicking on the *.lrcat catalog file.
- 4. Work as normal on that catalog.

"How does Export as Catalog work?" on page 234 and "How does Import from Catalog work?" on page 236

- 5. When you get back to your desktop computer, connect the external hard drive, or transfer the catalog back to the desktop computer, and select File menu > Import from Catalog...
- 6. Navigate to the catalog you've been working on and the Import from Catalog dialog will appear.
- 7. As the photos will already be in your main working catalog, it'll ask you what you want to do with the new settings—you can choose whether to just update the metadata or, in the case of retouched files, copy those back too.
- 8. Once you've confirmed that the catalog has updated correctly, you can delete the smaller temporary catalog.

How can I use my presets on both computers?

Your presets, by default, aren't stored with the catalog, but you can transfer them manually so that they appear on each machine. It's easiest to allow file synchronization software to keep the entire Lightroom user settings folder synchronized between both computers. Using Dropbox (http://www.dropbox.com) and junctions (Windows) / symlinks (Mac) to keep the presets immediately updated on both computers works really well, particularly if those computers aren't on the same local network.

If you only have a single catalog that you use on multiple machines, perhaps on an external hard drive, there's also the 'Store presets with catalog' option in Preferences > Presets tab. This option allows you to store the presets alongside the catalog itself, for use with that specific catalog on any machine, however it does mean that the presets will not be available to other catalogs on either computer, and they may appear to go missing if that checkbox is unchecked, as it doesn't automatically copy the existing presets to the new location.

section on page 461

Can I synchronize two computers?

Synchronizing two computers isn't quite so simple. If only one person is using Lightroom, the Export as Catalog and Import from Catalog options work very well, as does having the catalog on an external drive that can be used by either machine. Two people using two entirely different sections of the catalog, and then merging those back into the main catalog works too.

The glitch comes if two people are trying to work on the same photos in two different catalogs at the same time—for example, one person is keywording and the other adjusting Develop settings. When those catalogs are merged, those settings won't be merged together, to get both the keywords and the Develop settings. Instead, you'll get whichever was the latest change to be made, so if the Develop changes on catalog B were done last, then catalog B's settings will be imported into the main catalog, and catalog A's keywords would be overwritten. In that case, you could set the Import as Catalog dialog to create virtual copies of any photos with different settings, so you would have a master photo with the Develop Settings from catalog B and a virtual copy with the keywords from catalog A, and you would need to copy the settings between photos manually. It's probably a situation best avoided!

XMP

In some of the previous questions we've mentioned XMP, which stands for Extensible Metadata Platform. It's simply a way of storing metadata, such as Develop settings, star ratings, color labels, and keywords, amongst other things, with the photos themselves. XMP is open source, which means that other companies can also write and understand that same format, making your data available to other image management software.

"I gave my photos different color labels in Lightroom—why are they all white in Bridge? Or I labeled my photos in Bridge—why isn't Lightroom showing my color labels?" on page 164 and "Backup" section on page 221

Why would I want settings written to XMP?

Any changes you make in Lightroom are stored within Lightroom's catalog, but that means that the changes aren't available to other programs, such as Bridge. If you want to make that data available to other programs, you need to write it to XMP.

Many use XMP data as an additional backup of settings in case your Lightroom catalog becomes corrupted, or more likely, you remove photos from the catalog by accident. If the data is written to XMP with the files themselves, Lightroom would then be able to read that data again when you re-import. It's also a handy way of transferring settings between catalogs, although not all data is stored in XMP.

Which of Lightroom's data isn't stored in XMP?

The XMP specification limits the data that can currently be stored in XMP. Flags, virtual copies, collection membership, Develop history, stacks, Develop module panel switches and zoomed image pan positions are currently only stored in the catalog itself, and not the XMP sections of the files.

Where are the XMP files for my JPEG/TIFF/PSD/DNG files?

Although many users are used to seeing .xmp sidecar files next to their raw files, those are only produced for proprietary raw as the raw files are undocumented and it wouldn't be safe to write back to the files themselves. The XMP for JPEG/TIFF/PSD/DNG is written to a section in the header of the file. Those changes don't affect the image data, and therefore it doesn't degrade the quality of the photo even if it's updated every time the metadata changes.

In Lightroom beta versions prior to the 1.0 release, XMP data was written to sidecar XMP files for JPEG/TIFF/PSD files, however that data couldn't be read by any other programs. The standard for interchangeable

metadata is that it's written back to the original file where possible, so Lightroom has followed that standard in the release versions.

How do I write settings to XMP?

If you want to write settings to XMP, select the files in Grid view and press Ctrl-S (Windows) / Cmd-S (Mac) or go to Metadata menu > Write Metadata to Files.

You can also turn on 'Automatically write changes into XMP' in Catalog Settings > Metadata tab, which will update the XMP every time a change is made to the photo.

Should I turn on 'Automatically write changes into XMP'?

There's an argument for leaving auto-write turned on, however there can be a slight performance hit due to the constant disc writes every time you make changes to a photo. That said, it's much less noticeable than it was in early releases as there's now a few seconds delay before writing. There's a slightly higher risk of corruption, although still minimal, if the files are being updated constantly.

If you do decide to turn it on, a few suggestions:

- Making changes to large numbers of photos (i.e., thousands) may be noticeably slower with auto-write turned on, due to the sheer volume of individual files that need to be written.
- Avoid turning auto-write off and on again too often, as every time you turn it on, it has to check every file for changes.

 When you first turn auto-write on, performance may drop considerably while it writes to XMP for all of the photos in the catalog. Once it's finished doing so, it should speed up again, so you're best just to leave it to work for a while.

If you do find it slows you down or you're concerned about potential corruption, then consider the alternative—leave it turned off, and then when you finish a session, select the photos in Grid view and press Ctrl-S (Windows) / Cmd-S (Mac) to write the metadata manually.

What's the difference between 'Write Metadata to Files' and 'Update DNG Preview & Metadata'?

In the Metadata menu, when DNG files are among the selected photos, are 2 different write options.

'Save Metadata to File' just updates the XMP metadata, as it would with any other kind of file.

'Update DNG Preview & Metadata' does the same, but it also updates the embedded preview in any DNG files, so viewing the DNGs in other programs will show the previews with your Lightroom adjustments applied, instead of the original camera previews.

Should I check or uncheck 'Include Develop settings in metadata inside JPEG, TIFF, and PSD files'?

There's an extra option in Catalog Settings > Metadata tab with regard to XMP, called 'Include Develop settings in metadata inside JPEG, TIFF, and PSD files'. It simply controls whether Lightroom includes your Develop settings when it writes the other metadata. It was originally designed to stop Bridge CS3 from opening those photos into the ACR dialog, although both Bridge and Photoshop now have a switch to prevent that.

Personally, I'd leave it turned on so that the data is stored with the files as well as in the catalog.

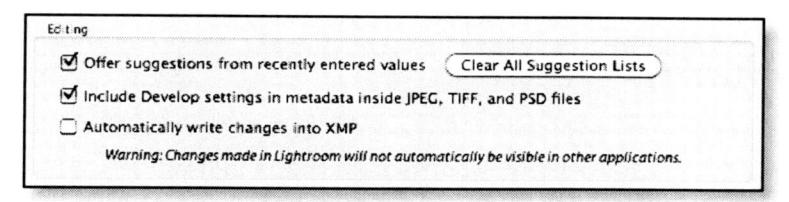

How do XMP files relate to the catalog?

All of the adjustments you make in Lightroom are stored in the catalog, and that database is always assumed to be correct, whether XMP settings exist or not. The XMP data is only read at the time of import, or when you choose to read the metadata using Metadata menu > Read Metadata from Files.

When you use that command to read the metadata from the files, you'll overwrite the information stored in the catalog with the information from the external XMP, and you can't do so selectively. If you're going to make changes to the XMP in another program, first write Lightroom's settings out to the XMP and then make the changes in the other software, so that when you read the metadata again later, Lightroom's settings are simply read back again, rather than being reset to default.

Can I view the content of my XMP sidecar files?

XMP sidecar files will open in any text editor in a readable format, but be careful that you don't corrupt them accidentally while editing. The data is stored in blocks that look like this:

```
Photo.xmp

xi:xmpmeta xmlns::x="adobe:ns:meta/" x:xmptx="Adobe xm2 core 4,2-c020 1.124078, Tue Sep 11 2007 23:21:40">
cmf:RDF xmlns::rdf="http://mww.w3.org/1999/02/22-rdf-syntax-ns#">
cmf:RDF xmlns::rdf="http://ms.m3.org/1999/02/22-rdf-syntax-ns#">
xmlns:tiff="http://ms.macobe.com/tiff/1.0/">
xtiff:Msdex-Commort/tiff:Msdex
ctiff:Model>Conon PowerShot (Go/tiff:Model)
xtiff:ImageWidth-4000-/tiff:ImageWidth-
xtiff:Image was the xmooth of xmooth
```

"Metadata Status Icon (6)" on page 129

XMP has been updated on another program or computer. Why don't the changes show in Lightroom?

Lightroom will always assume its own catalog is correct, and ignores any external metadata.

If you want to force Lightroom to read the data from the XMP, go to the Metadata menu > Read Metadata from Files, and it will ask you to confirm, as you'll be overwriting Lightroom's catalog with that external metadata.

If you've changed the XMP in another program, it should also show a 'metadata updated' icon, showing that the metadata in the XMP is newer than Lightroom's own catalog.

Clicking on this icon should request confirmation:

'Import Settings from Disk'—replace Lightroom's data with the external XMP metadata

'Cancel'—don't do anything

'Overwrite Settings'—replace the external XMP metadata with Lightroom's data

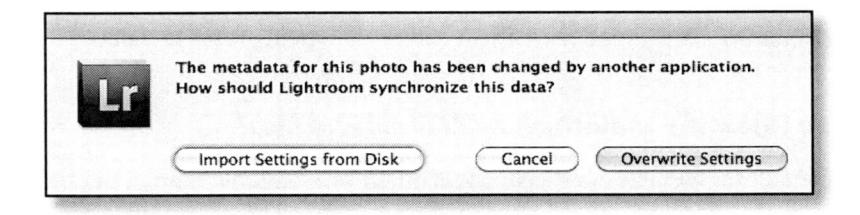

Lightroom says it can't write to XMP—how do I fix it?

If Lightroom says it can't write to XMP, check your operating system for the folder and file permissions—it's most likely that those files are read-only.

NETWORKING

Lightroom 3 doesn't have network or multi-user capabilities, other than accessing photos that are stored on a network.

The SQLite database format that Lightroom currently uses isn't well suited to network usage—the file would be too easily corrupted beyond repair by something as simple as the network connection dropping at the wrong moment. That's not just an oversight—SQLite was chosen for its other benefits, such as the simplicity for the user, cost, and most importantly, speed of access.

Those decisions may change in the future, but for now, let's consider some alternative solutions.

Can I share my catalog with multiple users on the same machine?

If you have multiple user accounts on the same computer, you can put the catalog and photos in a shared folder or on another drive that's accessible from both accounts, and all of the users will then be able to access that catalog. Only one user can have the catalog open at a time, so if you're using Fast User Switching, the previous user will have to close Lightroom before the next user can open it.

Can one catalog be opened simultaneously by several workstations across a network?

The catalog has to be on a local hard drive, not a network drive, and can only be opened by one user at a time. If more than one person needs access, the best solution currently is to temporarily split the photos that each user needs into a separate catalog using Export as Catalog, work on them elsewhere, and then merge their changes back into the master catalog using Import from Catalog once they've finished. It only works if they're all working on different photos.

Also check...

"Working with Multiple Machines" section on page 234

Is it possible to have the catalog stored on a Network Accessible Storage unit (NAS) but open it on a single machine?

Even single user network access is disabled as it's too easy to corrupt the catalog, so you can't work on the catalog while it's on the NAS. You could, of course, copy it to a local drive every time you want to work on it, and then copy it back again, but that's a lot of data to constantly move around the network.

The photos can be on your NAS or other network drive, but if you're putting the photos on your NAS, be aware that NAS file access can be slower than internal or even external drives, depending on the connection speed, so that may slow Lightroom down too.

Is it possible to use XMP files to allow some degree of sharing across the network?

Many people have asked whether it's possible to use XMP data stored with the files to allow basic sharing of settings across a network, so here's an overview of how it could work...

Each computer needs its own catalog, stored on a local drive, but the photos can be placed on a shared folder on the network in a few different configurations.

- The files are on Computer 1, and Computer 2 can access them.
- The files are on Computer 2, and Computer 1 can access them.
- The files are on networked storage that both computers can access.
- The files are on a server that both computers can access.

Import the photos into a catalog on each computer, with the Import dialog set to 'Add photos to catalog without moving.' This means that both computers are referencing exactly the same files.

On each computer, go to Catalog Settings > Metadata tab and turn on the 'Automatically write changes into XMP' checkbox. If 'Automatically write changes into XMP' is turned on, every time you make a change to the metadata of a photo, whether that's ratings, labels, Develop settings, etc., it gets written back to the XMP as well as to the catalog, but remember, certain data isn't stored in XMP. The write to XMP is usually delayed by about 10-15 seconds after the change to prevent unnecessary disc writes.

Now for the clever bit, when it comes to sharing files...

Added in version 1.1 was a metadata icon. This little icon changes direction depending on whether the metadata is most up to date in your Lightroom catalog or in the XMP section of the file.

Lightroom's catalog has updated metadata which hasn't been written to XMP, so you'd click on the icon to write to XMP. You shouldn't be seeing this icon, as you're automatically writing to XMP every time it changes.

Metadata in the XMP file has been updated externally and is newer than Lightroom's catalog, so click on the icon to read from XMP.

There's a metadata conflict, where both the XMP file and Lightroom's catalog have been changed. Click on the icon to choose whether to accept Lightroom's version or the XMP version.

The metadata is checked for updates whenever a file is made the active (most-selected) photo, or when you synchronize the folder, amongst other times.

So, 2 different scenarios...

Scenario 1...

Computer 1 & Computer 2 are both looking at the same folder of photos at the same time, working on rating the photos. As Computer 1 adds a 5 star rating to a photo, that's written to XMP after a slight delay. 2 minutes later, Computer 2 selects that photo, and after a few seconds,

Also check...

"Which of Lightroom's data isn't stored in XMP?" on page 242

"How does the Synchronize Folder command work?" on page 152 the updated metadata badge is displayed, showing that it's out of date. Click on that badge and choose 'Import Settings from Disc' to update Computer 2's view of that photo. It's not perfect—it's certainly not an instant solution—but it works for some people. Using Lightroom on the Computer 1, and viewing those photos in Bridge on Computer 2 (to view, not change, otherwise you hit the same delays), is another alternative.

Scenario 2...

Computer 1 & Computer 2 both have the same photos in their catalogs, but are working on different sets of photos. When the person operating each computer sits down to start a job, they first right-click on that job's folder and choose Synchronize Folder to retrieve the latest settings from XMP. As they work, the settings are written back to XMP, so that the XMP always has the most up-to-date information. It makes no difference which computer last used those files, as they read from XMP each time they start. Because you're not working on the same photos at the same time, it largely prevents conflicts.

And finally, in either scenario, when someone later comes along on Computer 3 and adds those files to their catalog (also referenced at their existing location), the metadata will be automatically carried across from the XMP.

A few warnings...

This isn't particularly supported by Adobe, and if you decide to try it, you do so at your own risk. There isn't any known risk to your files, but you can never be too careful!

- Fighting for the same files on the network will be slower than working from a local drive. Having 'Automatically write changes into XMP' turned on in Preferences can also decrease performance slightly.
- If you both write to XMP at the same time, one computer will overwrite the others settings.

 If Computer 1 writes to XMP, then Computer 2 makes changes to the same file and writes to XMP without first reading Computer 1's changes, then Computer 1's changes will be overwritten in the XMP. They don't merge.

OFFLINE ARCHIVES

As your collection of photos grows, your working hard drives may eventually start to overflow. So how do you transfer the photos to offline archives? And where should you keep the settings? Should you use Export as Catalog to store the settings on the same hard drive or CD/DVD as the photos?

If you move the photos to offline storage, they can remain in your main catalog, even though they'll be marked as missing. If you update the links to point to the new location, you can search through those offline photos along with the rest of your current photos, and it'll tell you where that photo is now stored. If you need to access the original file, perhaps to export a copy, you only need to plug that drive back into the computer and carry on working.

How do I archive photos to offline hard drives?

The easiest solutions for the working copy of your offline archives are external hard drives or NAS units, as they hold large amounts of data. Transferring photos to those offline hard drives is exactly the same as moving the files around on your computer, as we discussed earlier in the Moving Lightroom on the Same Computer section. Make sure you've rendered current previews before you disconnect the hard drive, so you can still browse with the photos offline. Once you disconnect those hard drives, the photos and their folders will be marked as missing with a question mark icon.

Also check...

"Moving Lightroom on the Same Computer" section on page 229

How do I archive photos to CD/DVD/Blu-Ray?

I would recommend that optical media only be used for a backup copy of your archived photos, and not your main working archive. Most optical media only has a lifespan of 3-10 years, they're limited in size, and it can become frustrating to keep swapping CD's or DVD's every time you need to use different files.

If you do decide to use CD's, DVD's or Blu-Ray, consider storing your photos in media sized folders from the outset, for example, if you're using DVD's, store the photos in folders of around 4.3GB. This concept is best-known as 'The Bucket System' created by Peter Krogh, and it makes it easier to track which photos are stored on which disc. If you're interested, you can find out more in his book.

To transfer photos to that optical media, the principle is the same as moving photos to another hard drive—in this case, burn the files to the disc and then update Lightroom's links. If you'll be wiping those photos from the hard drives, it's important to use burning software with verification, and to burn multiple copies.

When you're burning the discs, put the photos and/or their folders inside another parent folder, named with the disc's reference number. The Mac version will see each disc as a separate volume, whereas the Windows version will see them all under the same drive letter, making it difficult to work out which disc the photos are on.
Previews & Speed

Lightroom is a powerful program, offering far more than just basic raw processing, but that can also tax the most powerful of computer systems. Waiting for each photo to load before you can start working can be frustrating, so it's worth spending the time to set up your preferences in a way that will suit your own workflow.

PREVIEWS

We mentioned earlier in the Import chapter that Lightroom always creates its own previews, regardless of file type. Those previews allow you to apply Develop changes to the photos without affecting the original image data, and also allow you to view the photos when the originals are offline. Choosing the right preview settings for your own browsing habits is essential in keeping Lightroom running smoothly, so let's investigate the options.

What's the difference between Minimal, Embedded & Sidecar, Standard and 1:1 previews?

There are a number of options to choose from when importing your photos, and which you choose will depend on your own browsing habits.

Minimal shows the thumbnail preview embedded in the file. It's a quick option initially, but it's a very small low quality preview, usually with a black edging and about 160 px along the long edge, so you then have to wait to for previews to render as you browse. Minimal previews aren't color managed.

Embedded & Sidecar checks the files for larger previews (approx. 1024 px or larger), showing you the largest embedded preview. It's still just a temporary option—Lightroom will build its own previews as soon as it can.

Standard builds a standard-sized preview used for browsing through the photos. You set the size and quality of these previews in Catalog Settings > File Handling tab, and we'll come back to those options in the next question. Standard-sized previews are definitely worth building before you start browsing, if not directly at the time of import. It'll greatly speed up browsing performance if Lightroom isn't having to render previews on the fly.

1:1 previews are full resolution so they take up more space, but if you want to zoom in on your photos in the Library module, it will save Lightroom having to render 1:1 previews on the fly, which would slow your browsing experience. If you're concerned about the disc space that they take up, you can set in Catalog Settings for them to automatically delete after 1 day, 7 days, 30 days or Never, or you can discard 1:1 previews on demand by selecting the photos and choosing Library menu > Previews > Discard 1:1 Previews.

If you haven't rendered your chosen preview size at the time of import, or you want to refresh the previews as you've made Develop changes, select all (or none) of the photos in Grid view and choose Library menu > Previews > Render Standard-Sized Previews or 1:1 Previews. In early version 1 releases, rendering previews at the same time as importing was much quicker than rendering them later, but that no longer makes any difference, so you can render them at a time that suits you.

Also check...

"Why do I have to create previews? Why can't I just look at the photos?" on page 74

What size and quality should I set for Standard-Sized Previews?

In Catalog Settings > File Handling tab, you can set the preview size and quality. This is a per-catalog setting, so if you use multiple catalogs, you'll want to check each catalog.

The settings you use will depend on your general browsing habits and on your screen resolution. As a guide, choosing a size about the width of your screen is a good starting point, or slightly smaller if you always leave the panels open.

The quality setting is, as with most things, a trade-off. High quality previews take up more space on disc as they're less compressed, but higher quality previews also look better.

When I choose Render 1:1 Previews from the Library menu, does it apply to the entire catalog or just the selected photos?

When you choose Library menu > Previews > Render Standard-Sized Previews or Render 1:1 Previews, it gives you a choice:

- If you have no photos selected, or all photos selected, it renders
 previews for all of the photos in the current view, whether that's a
 collection, a folder, a filtered view, etc.
- If you have more than 1 photo selected in Grid mode, it assumes you just want to apply to the selected photos.
- If you have just 1 photo selected, it asks whether you want to render just that one preview, or previews for all photos in the current view.

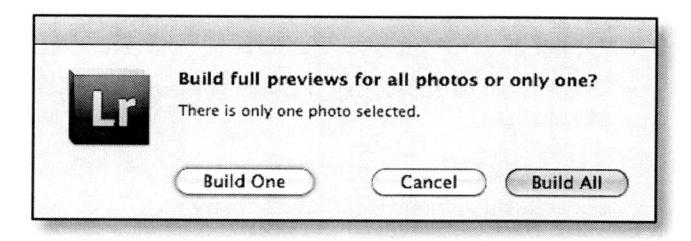

The previews folder is huge—can I delete it?

You can delete the previews without permanent damage, but Lightroom will have to rebuild the previews when you next view the photos, and if the files are offline, it will just show grey boxes until the files are next online and the previews can be rebuilt. If you find your previews are taking up too much space, consider using the Library menu > Previews > Discard 1:1 Previews command to throw away the largest preview size.

If I delete a photo, is the preview deleted too?

If you remove or delete a photo from within Lightroom, the preview will be deleted too. There's a slight delay in deleting the preview, just in case you undo that remove command. They usually disappear at the next relaunch, if not before.

If you delete a photo using Explorer (Windows), Finder (Mac), or other software, but if it's just marked as missing in Lightroom's catalog, the preview will remain until you remove the photo from the catalog.

I've discarded 1:1 previews—why hasn't the file/folder size shrunk?

If you discard previews, the *.lrdata previews folder doesn't get smaller right away because Lightroom has an undo feature, and it holds on to the previews for a little while, in case you choose to undo the discard operation. It usually shrinks the next time you relaunch Lightroom.

Lightroom only deletes 1:1 previews that are more than twice the size of your Standard-Sized Previews preference. For example, if your Standard-Sized Previews preference is set to 2048 and your 1:1 preview is 3036, Lightroom will keep the 1:1 preview, whereas if your Standard-Sized Previews preference is set to 1024, the 1:1 preview would be deleted.

Can I move the previews onto another drive?

Officially the previews have to be next to the catalog. That said, it's technically possible move the previews onto another drive using a Symbolic Link (not a standard alias or shortcut).

Sean McCormack wrote instructions for the Mac version at: http://lightroom-blog.com/2007/09/moving-the-preview-folder-mac-osx.html

If you do put the previews on another drive, make sure it's a fast drive, as you'll need good read speeds. Disk read speed makes a big difference when switching from one photo to the next, so avoid keeping previews on a network drive, and if they'll fit on an internal drive rather than an external hard drive, that'll help a bit too. And remember, this isn't an Adobe supported suggestion.

PREVIEW PROBLEMS

Viewing accurate previews of your photos is essential, however problems do sometimes occur, so you'll need to know how to fix them, even if they're not Lightroom's fault.

Why do I just get grey boxes instead of previews?

If there's a question mark in the corner of the thumbnail in Grid view as well as grey thumbnails, Lightroom simply hasn't been able to build

the previews. The original file may have been renamed or moved outside of Lightroom, or the drive was disconnected before Lightroom was able to create the previews. If you reconnect the drive or update the link to the file, the previews should update.

If there aren't question marks in the corner of the thumbnails in Grid view, a corrupted monitor profile is the most likely cause, or the graphics

Also check...

"Lightroom thinks my photos are missing—how do I fix it?" on page 200 card driver may need updating. We'll discuss corrupted monitor profiles in more detail in the next 2 questions.

It's also possible that the preview cache is corrupted, particularly if your catalog has been upgraded from an earlier version. If the previews show up in some views and not in others, that's a likely suspect. To check that theory, move or rename the previews folder (*.Irdata) and restart Lightroom. Lightroom will have to rebuild the previews, but they should rebuild correctly.

Everything in Lightroom is a funny color, but the original photos look perfect in other programs, and the exported photos don't look like they do in Lightroom either. What could be wrong?

Strange colored previews that don't match the exported photos in color managed programs are usually caused by a corrupted monitor profile. Lightroom uses the profile differently to other programs (perceptual rendering rather than relative colorimetric), so corruption in that part of the profile shows up in Lightroom even though it appears correct in other programs. It often happens with the canned profiles that come with many monitors.

The easiest way to tell that Lightroom's displaying incorrectly is to check the Histogram on a grayscale photo. It should be neutral but corrupted profiles can create some weird color casts which also show on the Histogram. (Obviously you can't see the cast in the greyscale copies of this book, but you know what a color cast looks like.)

Ideally you should recalibrate your monitor using a hardware calibration

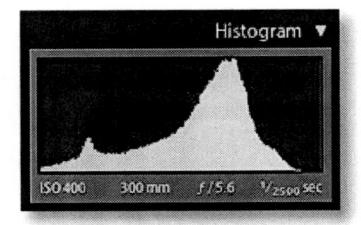

device. If you don't have such a tool, put it on your shopping list, and in the meantime, remove the corrupted monitor profile to confirm that is the problem.

How do I change my monitor profile to check whether it's corrupted?

Windows XP

- 1. Close Lightroom.
- 2. Go to Start menu > Control Panel > Display.
- 3. Click the Settings tab.
- 4. Click the Advanced button.
- 5. Click the Color Management tab.
- 6. Click the Add... button.
- 7. Choose a standard sRGB color profile, such as sRGB IEC61966 2.1.
- 8. In the 'Color profiles currently associated with this device' field, select that sRGB profile.
- 9. Click the Set As Default button.
- 10. (Optional) Select the old profile and click the Remove button.
- 11. Click the OK button.

Windows Vista or 7

- 1. Close Lightroom.
- 2. Go to Start menu > Control Panel > Color Management.
- 3. In the 'Profiles associated with this device' field, select the default monitor profile.
- 4. Click the Advanced tab.
- 5. Select any existing profile and click the Remove button.
- 6. Change the device profile to a standard sRGB color profile, such as sRGB IEC61966 2.1.

Mac OS X

- 1. Close Lightroom.
- 2. Go to System Preferences > Display.
- 3. Select the Color tab.
- 4. Press the Calibrate... button and follow the instructions.
- 5. Turn on the Expert Options and calibrate to gamma 2.2.

Remember this is only a temporary measure—sRGB isn't an accurate profile for your monitor, and calibrating the monitor with a hardware calibration device is the only way of building an accurate monitor profile.

How should I calibrate my monitor?

The only real way of calibrating a monitor is with a hardware calibration device. Software calibration is only ever as good as your eyes, and everyone sees color differently, but calibration hardware, such as the Eye One Display2, is now very inexpensive, and an essential part of every keen digital photographer's toolkit.

Most calibration software offers an advanced setting, so if it gives you a choice, go for a brightness of around 100-120 cd/m2, native white point for LCD monitor, and most importantly, an ICC2 matrix profile rather than an ICC4 or LUT-based, as those more recent profiles aren't compatible with many programs yet.

The previews are slightly different between Library and Develop and Fit and 1:1 views—why is that?

The previews you see are rendered differently between the Library and Develop modules. Library, and the other modules, use pre-rendered Adobe RGB compressed JPEGs for speed, so there may be slight losses compared to Develop, particularly if your previews are set to Medium or Low Quality. Develop module, on the other hand, renders a preview from the original data and then updates it live as you make adjustments.

There's also a difference in the resampling methods used in the 2 modules, which can result in a significant difference in the preview display at less than 1:1 view. The Library module takes the largest rendered preview it has available, and resamples that preview to show smaller zoom ratios, whereas Develop works on the full resolution raw data. Remember that lower zoom ratios aren't 100% accurate, and high sharpening and noise reduction values can be wildly inaccurate.

Then comes a difference between the sharpening and noise reduction. Because there have been significant changes to the Sharpening, Noise Reduction and Fill Light algorithms in Lightroom 3, Adobe introduced a new concept—a Process Version, often shortened to PV. PV2003 is for photos that were already in your catalog, and it uses the old algorithms. PV2010 uses the new rendering. We'll go into more detail in the Develop chapter, but as far as previews are concerned, there's a difference in the preview rendering depending on that Process Version setting, as well as whether the file is rendered (JPEG/TIFF/PSD) or raw.

	PV2003	PV2003	PV2010	PV2010
	Sharp	Noise	Sharp	Noise
Library Fit Rendered	no (except no (except no (except			
	low res)	low res)	low res)	yes
Library Fit Raw	no	no	no	adaptive
Develop Fit Jpeg	no	no	yes	yes
Develop Fit Raw	no	no	adaptive	adaptive
Library 1:1 Jpeg	yes	yes	yes	yes
Library 1:1 Raw	yes	yes	yes	yes
Develop 1:1 Jpeg	yes	yes	yes	yes
Develop 1:1 Raw	yes	yes	yes	yes

In summary:

- In all modules, 1:1 view will show the sharpening and noise reduction, but lower zoom ratios vary
- In Library, PV2003 won't show sharpening or noise reduction unless there are 1:1previews rendered
- In Library, PV2010 won't show sharpening unless there are 1:1 previews rendered, but may show noise reduction
- In Library, rendering 1:1 previews will also apply the sharpening and noise reduction to smaller previews
- In Develop, PV2003 won't show sharpening or noise reduction at less than 1:1 view
- In Develop, PV2010 can show sharpening and noise reduction on all rendered files at less than 1:1 view, but adaptively on raw files, depending on how likely you are to see the noise.

My photos have imported incorrectly rotated and distorted—how do I fix it?

Odd rotations and distortion appear from time to time, primarily with photos that have been rotated in other programs.

If it doesn't correct itself automatically, select all of the affected photos in Grid view and write your current settings to XMP using Metadata menu > Write Metadata to Files or the shortcut Ctrl-S (Windows) / Cmd-S (Mac) so you don't lose them. Then read from XMP again using Metadata menu > Read Metadata from Files. If you then ask Lightroom to render updated previews using Library menu > Previews > Render Standard-Sized Previews, it fixes the majority of cases.

SPEED TIPS

Working with Lightroom isn't like working with Photoshop or Elements, and the hardware requirements are different. In Photoshop or Elements, you'll usually be working with one or a few photos at a time, whereas with Lightroom, you work with much larger numbers. Besides buying a fast new computer, there are some other speed tips which can help Lightroom run much more smoothly.

"How do I convert to DNG?" on page 97

How can I get Lightroom to import faster?

Lightroom's import speed depends on two things—where the files are coming from, and the settings you choose in the Import dialog.

Importing using a card reader is usually faster than importing directly from the camera, particularly if you buy a good quality card reader with a fast connection. Importing directly from the hard drive is obviously faster still.

Setting the Import dialog to 'Add photos to catalog without moving' will be quicker than one of the Copy options, as Lightroom's not having to duplicate the files, but be careful to only use Add for files on your hard drive, and not those on memory cards.

If you usually convert to DNG while importing, but you're in a hurry, you can import the proprietary format initially and then run the conversion to DNG later when you have more time, swapping the proprietary raw files for DNG files automatically. Turn back to the DNG section in the Import chapter for those instructions.

How can I speed up browsing in Library module?

If you're browsing in the Library module, your choice of pre-rendered preview size can make major improvements in the speed. There's a big difference between rendering previews that have never been built or that need updating, and loading those ready-built previews from disc.

Also check...

"What size and quality should I set for Standard-Sized Previews?" on page 255 If the 'Loading...' overlay stays on the screen for a long time, Lightroom's likely rendering a preview for the first time, updating an old existing preview, or building a larger preview for your current zoom ratio—and you're having to wait for it!

Loading...

Either set Lightroom to render the previews when it imports, by selecting your chosen preview size in the Import dialog, or switch to Grid view, select the photos and go to Library menu > Previews > Render Standard-Sized Previews or Render 1:1 Previews, and leave it until it's finished. It'll skip any that already have current previews, and you'll find browsing much quicker once it's finished rendering.

If you need to zoom into 1:1 view in the Library module (not Develop), and you're still seeing the 'Loading...' overlay for a long time, then you'll need to render 1:1 previews rather than Standard-Sized previews, either in the Import dialog or using the menu command noted above. If you rarely zoom in Library module, you're better off using Standard-Sized previews, as they'll take up less disc space and be slightly quicker to read from the preview cache.

Each time you make Develop changes, the previews have to be updated. If you've made Develop changes to the photos, for example, by applying a preset, and you don't want to wait for the previews to update one at a time as you browse through them, use the same Library menu > Previews > Render Standard-Sized Previews command to update all of the previews in one go.

"How do I move or copy photos between folders?" on page 167

How can I speed up moving files between folders?

If you're frustrated by the speed of moving photos, select them and start them moving as you would usually, but then select a folder which contains no photos, and wait for the move to complete before switching back. The file move will run much quicker because Lightroom won't be constantly redrawing the continually changing Grid view.

It's taking forever to delete photos—should it really take this long?

Deleting files within Lightroom can take a bit longer than deleting directly in Explorer (Windows) / Finder (Mac), while it finds and deletes previews and updates the catalog too, but it shouldn't be a vast difference. If you're finding it slow, there are a few things you can do to help.

Empty your Recycle Bin (Windows) / Trash (Mac) regularly, as that's been known to slow deletion significantly, particularly on Windows.

If you installed the unsupported Microsoft Raw Viewer add-on for XP, which adds raw viewing capability to Explorer and Windows Picture and Fax Viewer, try uninstalling it. There's a known bug with that add-on that can cause file deletion issues with various programs, not just Lightroom.

As with moving photos, it can help to click on another empty folder or collection as soon as you've started the delete, as it saves Lightroom constantly having to redraw the Grid view to show the changes.

If you're trying to delete photos that you don't want to keep, rather than doing them one at a time, consider marking them with a reject flag instead, so you can delete them all in one go without interrupting your workflow.

And finally, if it still doesn't work, rebooting solves most slow delete issues.

How can I speed up browsing in Develop module? And what are these Cache*.dat files?

We've mentioned before that there's a difference between the way that the Library and Develop modules display previews. Library shows you lower quality previews from the previews cache. Develop, on the other hand, assumes you need an accurate, rapidly changing view, so it first shows you the preview from the preview cache, then does a quick read of the raw file, and then finishes loading properly, before it turns off the

Also check...

"The previews are slightly different between Library and Develop and Fit and 1:1 views—why is that?" on page 260

'Loading...' overlay. You don't have to wait for the overlay to disappear before starting work on the photo. If you find the overlay distracting, you can turn it off going to the View menu > View Options > Loupe tab and turning off the 'Show message when loading or rendering photos' checkbox.

Particularly with the size of camera sensors today, there's a lot of raw data to load and process each time you switch photos. Have you ever noticed, though, that when you adjust a photo in Develop module, move to other photos, and then come back to that first photo again, it loads much quicker than it did the first time? If you've only just viewed the photo, it may still be stored in RAM, but once it's disappeared from RAM, the Camera Raw cache, also known as the ACR cache, comes into its own.

When Lightroom reads the data the first time, it adds it into the shared Camera Raw cache in a partially processed state, with the initial demosaic and other background work already done. Those are the Cache*.dat files that you might see appearing. When you load a photo into the Develop module, it will first check that cache to see if the data is already there to reuse, which is much quicker than reading and processing the original raw file data.

By default, that Camera Raw cache is only 1GB in size, and when new data gets added, the oldest data is removed. With only 1GB of space, that happens quite quickly, so you're not seeing the benefit if you're processing large raw files. If you go to Lightroom's Preferences > File Handling tab, you can change the cache size to suit—up to a maximum of 200GB. If you have spare hard drive space available, bigger is better! You can also change the location of that cache, but make sure it's on a fast hard drive. The Camera Raw cache settings that you change in Lightroom also apply to ACR in Bridge/Photoshop, and can also be changed in

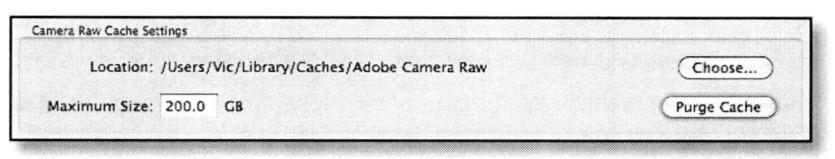

the ACR Preferences dialog.

Once that data is cached. it's much faster moving between photos in the Develop module — almost instantaneous high end machines. Of course, that's only helpful when Lightroom has recently read the raw file, and added it to the cache.

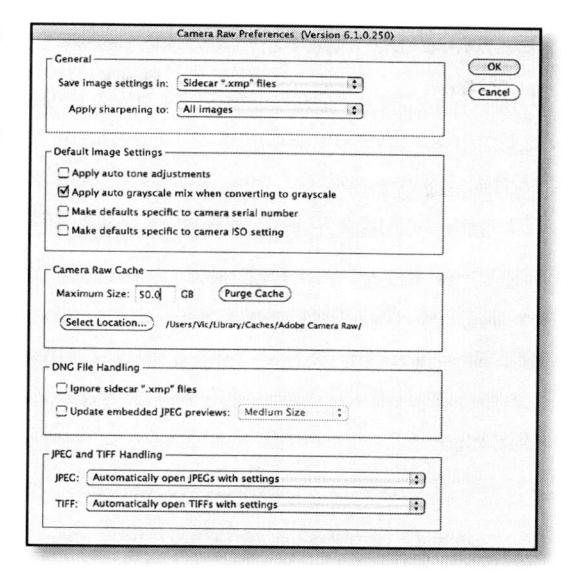

and there isn't currently a menu command to pre-load the Camera Raw cache. All is not lost!

There's a trick to pre-loading the Camera Raw cache. In addition to actually viewing the photo in the Develop module, there's another obvious time when Lightroom has to read, and therefore caches, the raw data—namely, when rendering previews. If you haven't already rendered previews for your photos, simply using the Library menu > Render Standard-Sized Previews command will also pre-load the photos into the Camera Raw cache. If, however, you already have current previews, you can force them to re-render by making a minor or reversible Develop adjustment to the photos (i.e., by using a Quick Develop button) and then using the Render Standard-Sized Previews menu command. Leave it to finish, and by the time you come back, even the Develop module should be moving through the photos at a much more comfortable speed.

Also check...

"What general maintenance will keep my catalogs in good shape?" on page 210 and "Should I turn on 'Automatically write changes into XMP'?" on page 243

Are there any other Lightroom tweaks to make it run faster?

If you find Lightroom is feeling a little sluggish, select the File menu > Optimize Catalog command to perform database optimization. It's worth doing regularly, and any time you make significant database changes like importing or removing large numbers of photos.

The more things that Lightroom has to update, the more work it has to do, and therefore the slower it becomes. Closing the Histogram and Navigator panels can help a little if you're struggling for speed, as can turning off the badges in the Grid view under View menu > View Options.

On older machines particularly, tools such as AutoSync force Lightroom to update all of the selected thumbnails every time you make a change, whereas using Sync to apply all of the changes in one pass only has to update the thumbnails once.

Auto Mask on the Adjustment Brushes is another heavily processor intensive task, which can bring even fast machines to a crawl if used extensively.

Also, although it's improved greatly since the early Lightroom releases, 'Automatically write changes into XMP' in Catalog Settings does slow Lightroom down a little as it constantly writes to the external metadata. If you want to write to XMP but are concerned about the speed hit, wait until you've finished editing and then write to XMP manually.

Are there any hardware or operating system tweaks to make Lightroom faster?

There's no question, Lightroom loves good hardware, but it can still run on lower specification machines too. Always make sure you're running the latest stable Lightroom release as performance improvements have been made to most updates.

The system requirements have increased for Lightroom 3. They're now listed as Intel Pentium 4 or equivalent (i.e., a processor with the SSE2

instruction set or later), with 2GB of RAM and 1GB of hard drive space. On a Mac, the old PowerPC processors are no longer supported, so it's Intel only, with Leopard (10.5.6 or later) or Snow Leopard.

Let's be clear—those are minimum system requirements. It'll run—well, it'll walk! If you start trying to feed 21mp files into Lightroom using an old computer, don't expect it to be fast. If you're going to spend money on the latest cameras, bear in mind that your computer hardware may also require a helping hand to work with those new super-size files.

If you're working with existing hardware on Windows, check your graphics card. You don't need an expensive gaming graphics card to run Lightroom, but you will benefit from the latest drivers that are available from the graphics card manufacturers. If you haven't checked recently, that's your first port of call for a free and easy performance fix.

If you have an older nVidia graphics card on Windows, some have found that adjusting some of the settings in the drivers can make a difference to Lightroom's speed, particularly for sticky sliders, slow preview refreshes, and Adjustment Brush problems. Most notably, disable the nView software which is sometimes installed along with nVidia drivers, as there are known conflicts. Other nVidia tips can be found on these blog and forum posts: http://www.thejohnsonblog.com/2008/09/06/lightroom-2-and-nvidia-performance/ and http://www.flickr.com/groups/adobe_lightroom/discuss/72157607074073712/

Hard drives are another obvious place to look. For a start, you'll want plenty of space on your hard drives, particularly the boot drive, as your computer will get slower as you start to run out of space. While you're tidying up, make sure the Recycle Bin (Windows) / Trash (Mac) are emptied regularly as they can slow some Lightroom functions even if they're not overflowing. If you're on Windows, defragment your hard drives too.

Slow hard drive connections can also affect Lightroom's performance, due to the amount of data transfer when working with large files.

Internal drives will usually be fastest. If you have to work from external drives, eSata and Firewire800 will be much faster than Firewire400 or USB.

In an ideal setup, your catalog (and the previews alongside) should be on a different physical drive to the image files themselves—not just another partition of the same drive.

If you're looking for new hardware, you may be wondering if Lightroom can make use of multiple cores—and yes it can. Processor intensive functions such as import, export, creating previews and making Develop adjustments, amongst other things, can use up to 8 cores.

Lightroom also loves plenty of RAM, but bear in mind that you'll need a 64-bit operating system to really take advantage of large amounts of RAM. You're most likely to see improvement in the responsiveness of the Develop module when using the 64-bit version.

You can't change Lightroom's memory settings as you can in Photoshop, however you don't need to, as the technology is much newer. Lightroom doesn't have a separate virtual memory manager, but uses the operating system instead. You can increase the Windows page file and restart the computer to minimize memory fragmentation—if Lightroom shows 'Out of Memory' errors, it's running out of contiguous memory.

And finally, a little logic. Virus protection constantly scanning the same files that Lightroom's trying to use will slow you down. Consider excluding the catalog (*.lrcat), the previews file (*.lrdata next to the catalog), and the ACR Cache (check the Lightroom Preferences dialog for the location) from the live scan, and perhaps the photos themselves.

The less you have running in the background, the better, particularly on older slower machines, and that includes those little system tray or menu bar programs that load on startup.

Develop Module

When you're ready to start Developing your photos, stop. Take some time first to evaluate what the photo actually needs. Is it too dark? Too light? Perhaps it's a little cold and blue? Is it flat and lacking in contrast? Is there noise that needs attention? Was your sensor dusty? Does the blue of the sky need enhancing slightly? Would it look better cropped? Would it be a stronger photo in black & white?

Once you've finished evaluating the photo, then you're ready to start Developing. Don't try to do too much. One of the identifying marks of a new photographer is over-processing, which can distract the viewer from the photo itself. Just because sliders exist doesn't mean you have to adjust every single one.

RAW FILE RENDERING

In the Import chapter, we mentioned that some preferences, such as Auto settings or Import presets, can change the Develop settings of photos when they're imported. Those factors can apply to any type of file, whether raw or rendered, but there's another issue which only applies to raw files.

"Why is Lightroom changing the colors of my photos?" on page 109

Also check...

"Calibration Profiles & Styles" section on page 329 and "DNG Profile Editor" section on page 330

Why do my raw photos change color? When the first preview appears, it looks just like it did on the camera—how do I stop it changing?

A raw file isn't an image file like a JPEG or a TIFF. You can't look at it—there's nothing to see. You need some software to process it into a photo, and that software is called a raw converter. The initial preview you see in Lightroom is the JPEG preview embedded in the raw file by the camera. That JPEG preview has the manufacturer's own processing applied in-camera, just as if you would set your camera to shoot a JPEG rather than a raw file format.

The camera manufacturer's don't share their processing secrets, so each raw converter creates its own interpretation of the sensor's data. There is no right or wrong—it's just different. Lightroom builds its own preview to show you how it will process your photo using its current settings.

So how do you get your file in Lightroom to look like that original camera JPEG preview? One of the major benefits of shooting in your raw file format is that you can tweak the photo to your own taste, rather than being tied to the manufacturer's rendering, but Adobe listened to the user's cries and created a new profiling system which allows greater flexibility.

The DNG Profile Editor allows the creation of much more detailed profiles than have ever been available to ACR (Adobe Camera Raw) and Lightroom before. As well as being able to create your profiles, Adobe have created ready-made profiles to emulate the most popular in-camera JPEG rendering for many Pro-level SLR's. Although the name 'DNG Profiles' makes it sound like they're limited to DNG files, these profiles can actually be used on proprietary raw files too.

You'll find those profiles in the Profile pop-up menu in the Calibration panel, installed automatically with each Lightroom update, and you can add your own profiles too. If you find a profile that you'd prefer to use as a starting point for all of your photos, you can also set it as the default,

so that your newly imported photos automatically use that profile. Many choose to set 'Camera Standard' as their default profile, so that the initial preview is closer to the camera rendering. We'll come back to creating your own profiles and setting default settings later in the chapter.

I set my camera to black & white. Why is Lightroom changing them back to color?

Only the manufacturer's own software, or those using the manufacturer's SDK, can understand and use many of the in-camera settings. We covered some of those settings earlier in the Import chapter. The data is stored as color raw data, without additional processing, such as black & white applied.

The only parameter that is recognized and interpreted by all converters is white balance. If you had set your camera to 'Cloudy' and have your raw software set to 'As Shot' it would use the white balance set in the camera, but this is still an interpretation by the software programmers. Lightroom doesn't know if you had your camera set to black & white.

The beauty of shooting raw is that you have the ability to make the decisions later, without any reduction in quality. If you do need a record of what you were thinking at the time of shooting, shoot Raw+JPEG and import both photos into Lightroom. The JPEG will show the black & white or other picture style applied in the camera, and you can then adjust the raw file to match if you want to do so.

How do other programs like iView, PhotoMechanic, Apple's Preview, Windows Explorer, Breezebrowser, etc., get it right?

If other programs show the same rendering as the manufacturer, it's because they're either showing the preview which is embedded in every raw file, or they're using the manufacturer's SDK (Software Development Kit) to process the raw data.

🌳 Also check...

"Defaults" section on page 306 and "Why is Lightroom showing different Kelvin values than I set in my camera custom white balance?" on page 278

Also check...

"If I shoot sRAW format, can Lightroom apply all the usual adjustments?" on page 64 Lightroom could use the manufacturer's SDK rather than its own ACR engine, but then it would only have very basic controls, and it wouldn't be possible to add the other tools, such as the Adjustment Brush, that we now have available in Lightroom. It's all or nothing.

There are some hot pixels on my sensor in other programs, but I can't see them in Lightroom. Where have they gone?

If you're wondering where your hot pixels on your camera's sensor have gone, Lightroom automatically maps out hot pixels, as does ACR, however it only works on standard raw or DNG files, not sRAW.

PROCESS VERSIONS

There have been significant changes under the hood of Lightroom 3 to improve the image quality that it can produce.

The initial demosaic algorithms have been rebuilt to extract more detail from the raw data and produce an artifact-free file that will respond better to noise reduction. That happens behind the scenes with all photos, so you might find your existing photos show a little more noise and sharpness than previous releases, and you may want to increase the Luminance Noise Reduction by 20-25.

There have also been significant changes to the Noise Reduction, Capture Sharpening and Fill Light too. If your photos with existing Noise Reduction, Sharpening and Fill Light settings had these new changes automatically applied, the photos would render significantly differently, and you would have to process them all again.

To avoid this situation of significantly different rendering, Lightroom 3 has introduced Process Versions named 2003 and 2010, often shortened to PV2003 and PV2010. That simply refers to the date that each process engine was introduced.

Any photos set to Process Version 2003 will use the old Noise Reduction,

Also check...

"The previews are slightly different between Library and Develop and Fit and 1:1 views—why is that?" on page 260 and "Detail—Sharpening & Noise Reduction" section on page 314

Sharpening and Fill Light algorithms, so will look very similar to the Lightroom 2 rendering, apart from the new demosaic. They'll show a warning exclamation mark in the lower right hand corner of the preview area in the Develop module. Any photos set to Process Version 2010 will use the new improved Noise Reduction, Sharpening and Fill Light.

As we mentioned in the previous chapter, there have also been changes to the way the different Process Versions preview in the Develop module, with sharpening now being applied to Process Version 2010 previews even at less than 1:1, and noise reduction being intelligently applied at less than 1:1 on the noisiest images.

Which settings are affected by the Process Version?

The Process Version you select currently only affects Sharpening, Noise Reduction and Fill Light. Everything else is independent of the Process Version.

Which Process Version should I use?

PV2003 is only there for legacy reasons. New photos default to PV2010, which has the better image quality, and you can upgrade existing photos to PV2010 when you have time to tweak their settings.

How do I switch between PV2003 and PV2010?

To update from PV2003 to PV2010, you can simply click on the warning exclamation mark to the lower right of the preview in Develop. That shows a dialog asking whether to review the changes with a before/after preview. It also gives you the option of updating all of the photos currently in the filmstrip, which are those in the same folder or collection that aren't hidden by a filter.

If you decide to update your entire catalog, selecting 'All Photographs' with filters disabled and then clicking that 'Update All Filmstrip Photos' button will update all of the photos in one go.

Also check...

"Can I synchronize my settings with other photos?" on page 352 and "History & Reset" section on page 312 If you choose the before/after preview, and you decide you want to stick with the PV2003 rendering for now, you can revert using Ctrl-Z (Windows) / Cmd-Z (Mac) or by selecting the previous state in the History panel.

There are a few other options for updating or reverting the Process Version. You will find it under the Settings menu > Process in Develop module, and in the Calibration panel, where Sync and AutoSync can apply your choice to multiple photos in one go. You'll find it in the Library module too, under the context-sensitive right click menus in the Develop Settings section.

Why are my new imports set to Process Version 2003?

If the newly imported files already have settings—for example, as a result of XMP sidecar files with settings from a previous Lightroom or ACR version, or a preset with the Process Version checked being applied—then they will be marked as Process Version 2003.

WHITE BALANCE

The White Balance sliders adjust for the color of the light in which the photo was taken. Our eyes automatically adapt to the changing light, but cameras don't, which can result in a color cast on your photos. You don't necessarily want to neutralize the white balance on every photo though. If you look outside on a cold winters day, the light is cool and blue, but during a beautiful sunset, it's warm and orange. If you neutralize those photos, you lose the atmosphere.

If the photo is too yellow or warm, you move the Temperature slider to

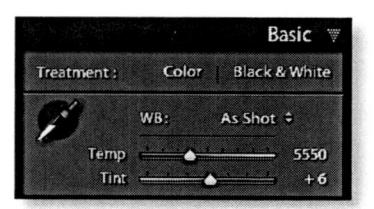

the left to compensate, and if it's too blue or cold, you move the slider to the right. The Tint slider adjusts from green on the left to magenta on the right. The White Balance Eyedropper will allow you to click on a neutral point in the photo to automatically neutralize any color cast, and you can tweak the sliders to taste from that starting point. As you float over the photo with the Eyedropper selected, watch the Navigator panel. The preview will automatically update to show you a preview of your white balance adjustment.

Where should I be clicking with the White Balance Eyedropper?

To set the white balance using the Eyedropper, ideally you want to click on something that should be light neutral, which may have a color cast if the white balance is incorrect. Clicking with that Eyedropper tool attempts to neutralize that point.

You need to choose something bright for the best accuracy, but don't choose something so bright that any of the channels are clipped. Specular highlights, which are highlights with no detail, are no good either, however nice and white they look! If any channels are clipped, you will get a weird result, if it works at all.

You need to be careful about the color that you choose. Remember that white objects will take on a color cast if they get reflected light from another object—so a glossy white hat outdoors under a clear blue sky should probably look slightly blue, not white. Inside, paintwork that should be white often goes slightly yellow over time, so making that neutral may make the rest of the photo a little too blue.

Having set the white balance in the right ballpark, you may then need to tweak it further using the sliders.

The White Balance Eyedropper disappears every time I click anything—how do I keep it turned on?

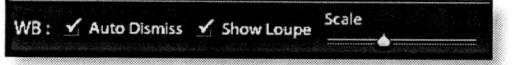

While you have the White Balance Eyedropper

active, there's a check box for 'Auto Dismiss' in the toolbar. With that checkbox unchecked, the Eyedropper will remain on screen until you

intentionally dismiss it by pressing W or returning the Eyedropper to its base. If you can't see the toolbar beneath the photo, press T.

Why don't the Temp and Tint sliders have the proper white balance scale when I'm working on JPEGs?

When working on rendered files, such as JPEGs, you'll notice that the White Balance sliders no longer show Kelvin values. That's because they wouldn't mean anything. On JPEGs, Lightroom is just shifting colors from a fixed point, as the white balance has already been set and applied in camera. Raw files can use a Kelvin scale as you're actually shifting the white balance setting that is being applied to the raw data.

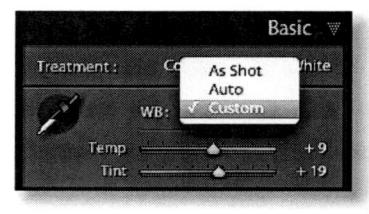

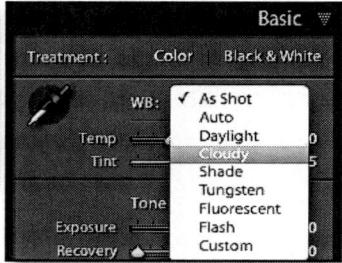

Where have the other White Balance presets gone, such as Cloudy and Flash?

When working with raw files, there are a number of White Balance presets for common lighting conditions. These aren't available for other file formats, such as JPEG, as the white balance has already been set and applied in camera.

Why is Lightroom showing different Kelvin values than I set in my camera custom white balance?

If you set a custom white balance in the camera of 5000k, that same As Shot white balance may show in Lightroom as 5200k Temp and -5 Tint. That's not a bug, and Lightroom is respecting your custom white balance, but the numeric values may differ. Most cameras store white

balance values as the camera color space co-ordinates rather than as a Kelvin value, and the resulting Temperature and Tint numeric values will depend on the profile and raw converter used. The appearance of the color temperature is matched, not the numeric Kelvin value.

Also check...

"DNG Profile Editor" section on page 330

Can I change the eyedropper averaging?

When the White Balance tool is active, the Loupe previews the pixels that will be used in calculating the white balance. Changing the Scale slider on the toolbar changes the number of pixels that are averaged when calculating the white balance, so on a noisy photo, you may need to increase the number of pixels sampled.

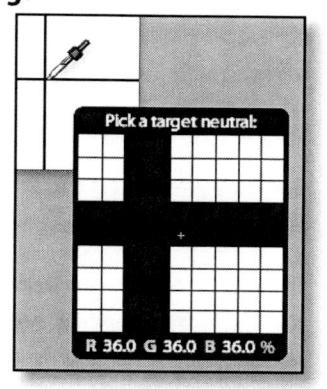

How do I adjust for an extreme white balance, under 2000k or over 50000k?

Lightroom's White Balance sliders only run from 2000k to 50000k Temp and -150 to 150 Tint. Usually that will be a large enough range, but some extreme lighting or infrared shots can fall outside of that range. If you open the DNG Profile Editor, which we'll come back to at the end of the chapter, you can create custom profiles for those extreme white balances.

BASIC ADJUSTMENTS

The Basic panel is where you make the major tonal adjustments to your photos. Most of the sliders are familiar to those who have used post-processing software, and obvious to newer users, so we'll primarily concentrate on the questions that are asked regularly on the forums. To cover all of the possibilities in detail would fill another book, but

if this whets your appetite and you'd like more information, I highly recommend Jeff Schewe's *Real World Camera Raw* book.

Exposure—sets the white point where the highlights start to clip

Recovery—where a channel is clipped, it uses the information from the other channels to create detail

Fill Light—brings detail back into the shadows and dark midtones without affecting the highlight tones

Blacks—sets the black point where the shadows start to clip

Brightness—affects the brightness of the midtones while protecting the

highlights and shadows from clipping

Contrast—applies an S-curve, leaving the extreme shadows and highlights alone

Clarity—increases midtone contrast

Vibrance—increases the saturation of unsaturated colors more than heavily saturated colors, and protects skin tones

Saturation—increases the saturation of all colors equally

What's the difference between Exposure and Brightness?

Both Exposure and Brightness lighten or darken the photo, but they do so in different ways. Exposure sets the white point whereas Brightness primarily affects the midtones. For an average photo, you would use the Exposure slider to set the white point to just before the highlights starts clipping or losing detail, and then use the Brightness slider to adjust the overall brightness.

If you hold down the Alt (Windows) / Opt (Mac) key while moving the Exposure slider, you'll see a temporary clipping warning. It's ok for some parts of the photo to clip, for example, if you're taking a photo inside, a window in the background may be blown out without detail. You don't want important detail, such as a bride's wedding dress or the detail on someone's face to clip.

You can do some useful things by balancing the two sliders, for example, on a photo of a wedding dress, a lower Exposure and higher Brightness setting will brighten the photo without clipping the dress detail.

Why does the Recovery slider add a colored tint?

When one or more channels are clipped, Lightroom uses the information from the remaining channels to recover as much detail as it can. That can result in hue shifts in the highlights, usually adding a pink tone. It's a very clever tool, but don't push it too far. If your photo is overexposed, pull back the Exposure slider first, until the highlights are no longer clipping, and then adjust the Brightness slider to bring the midtones back up to brighten the photo overall. Then you can tweak the Recovery, Fill Light and Blacks sliders to balance off the detail without flattening the contrast too much or pulling in significant hue shifts.

Fill Light creates halos and drops the contrast too far—is there an easy solution?

Fill Light builds a blurred mask of the image to concentrate its adjustments on the shadow tones, but that can lead to visible halos on high contrast edges, so don't push it too far. They have improved in Lightroom 3, but Fill Light still works best at low-medium values.

Using too much Fill Light can also drop the contrast, so you may need to increase the Blacks slider or tweak the Tone Curve to compensate. That will offset the drop in contrast without making the lighter areas too bright, whereas increasing the Contrast slider will affect the higher midtones too.

What does the Clarity slider do?

Clarity, which was originally known as 'Punch,' is an effect similar to a low-amount high-radius USM in Photoshop. It adds local area contrast, concentrating primarily on the midtones, which helps to lift the photo off the page or screen.

As a general rule, it's best to use a low setting for portraits, as it can accentuate lines and wrinkles, but higher values are brilliant on architecture and landscapes. Set to a negative amount, it adds a gentle softening effect, which is particularly useful on close-up portraits.

In this screenshot Clarity is set to 100, just to show the effect, but you probably won't want it that high on most photos:

Here Clarity is set to -100. The same image is used to show the difference, however negative values work best on faces:

What's the difference between Vibrance and Saturation?

Saturation is quite a blunt instrument which adjusts the saturation of all colors equally, which can result in some colors clipping as they reach full saturation.

Vibrance is far more useful as it adjusts the saturation on a non-linear scale, increasing the saturation of lower-saturated colors more than higher-saturated colors, which also helps to prevent skin tones from becoming over saturated.

"Moving Sliders" section on page 136

WORKING WITH SLIDERS & TARGETED ADJUSTMENT TOOL

We've already mentioned some of the slider adjustment options earlier in the Workspace chapter, for example, you can drag the panel to become wider, which will lengthen the sliders, making them easier to adjust. There are a few more tips that only apply in the Develop module.

The slider movements are too coarse—how can I adjust them?

If you hover over the slider without clicking, you can use the up and down keys to move the slider. Adding Shift moves in larger increments or Alt (Windows) / Opt (Mac) decreases the increments.

If you click on a slider label, that slider becomes highlighted, and using the + / – keys adjust that slider. Adding Shift or Alt (Windows) / Opt (Mac) changes the increments. The ; key resets that slider to its default position at the Exposure slider, and , and . move up and down through the sliders, selecting each in turn.

For speed, I choose to use a Wacom Graphics Pen in one hand to float over the sliders, and a Contour Shuttle Pro 2 dial (http://www.contourdesign.com/) programmed to up/down keys when I turn the dial, with the buttons programmed to other useful shortcuts.

You can download my settings from: http://www.lightroomqueen.com/lr3bookdownloads.php This is my current Shuttle setup for speedy Develop processing:

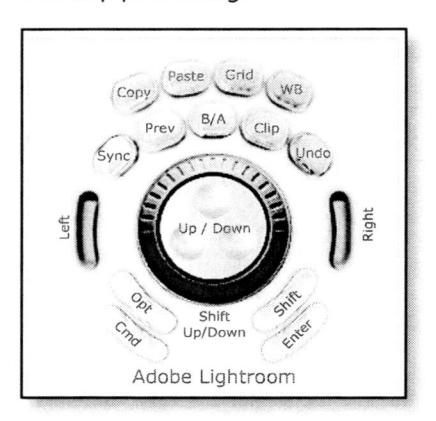

How do I apply Auto settings to individual sliders?

Holding down Shift and double-clicking on the slider label sets the slider to its Auto position without adjusting the other sliders. You'll also find an Auto button in the Basic and B&W panels, and an Auto Tone command under the Settings menu with the shortcut Ctrl-U (Windows) / Cmd-U (Mac). The Auto controls often produce a good starting point, more so on raw files than JPEGs.

That's great if you're working on one photo at a time, but how do you apply that to multiple photos?

You could switch to the Grid view, select the photos, and press the Auto button in the Quick Develop panel, and then apply a preset to reset some sliders back to their default settings, but there's an easier way. You can create a preset which only applies one or more of the Auto settings, and you can even edit existing presets to do the same.

First, create a Develop preset by clicking the + button on the Presets panel, giving it a name such as 'AutoBlacks' and check only the Auto Tone checkbox. We'll come back to customized Presets in more detail later in the chapter.

"Presets" section on page 300

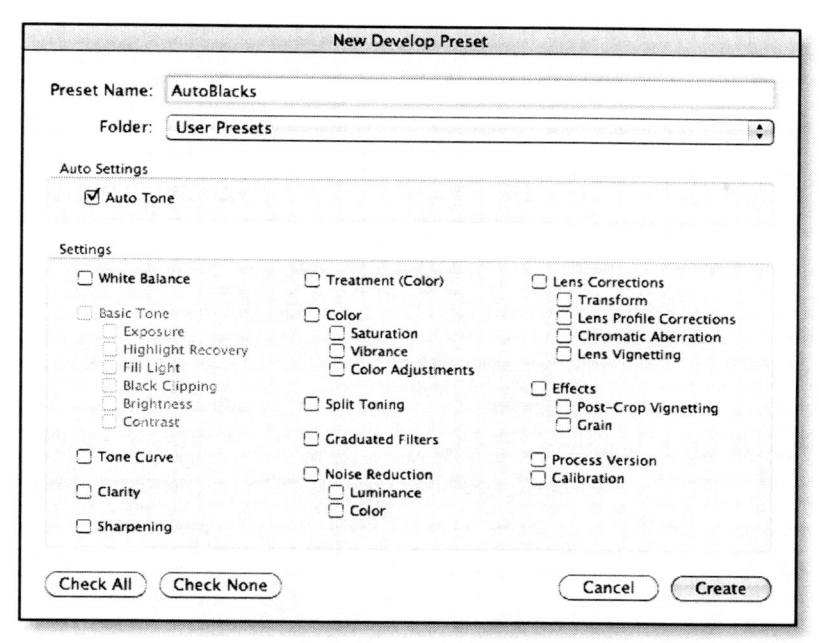

Now right-click on the preset and choose Show in Explorer (Windows) / Show in Finder (Mac) to find the preset on your hard drive, and open it with a plain text editor, such as Notepad (Windows) / TextEdit (Mac). To create an AutoBlacks preset, for example, you need to remove the AutoBrightness, AutoContrast, AutoExposure and AutoTone lines, and change the AutoShadows line from false to true. Don't change anything else.

Now save the text file, restart Lightroom, and then apply it to a photo to check it's working. You now have an AutoBlacks preset, and the same

principle applies to any of those other auto settings, so you could create a whole set of Auto Presets or add that same line into any of your other favorite presets.

```
s = {
    id = "13BF7AA3-9408-4D2D-8507-F624D2DA275C",
    internalName = "Test preset",
    title = "Test preset",
    type = "Develop",
    value = {
        settings = {
            AutoBrightness = false,
            AutoExposure = false,
            AutoExposure = false,
            AutoTone = true,
        },
        uuid = "5D3A2AE9-C144-4080-A618-BE4ED80007A8",
    },
    version = 0,
}
```

Also check...

"Calibration Profiles & Styles" section on page 329

Does it matter in which order I apply sliders?

You can tweak sliders in whichever order suits you, and they'll always be applied in an independent order behind the scenes.

As a rule of thumb, working roughly from top to bottom will usually work well. The one exception is the Profiles in the Camera Calibration panel, which are worth selecting before you start developing your photo, as they will significantly change the look of the photo.

You may find yourself skipping around the Basic panel sliders. If your photo is very over or underexposed, you'll need to roughly adjust the Exposure slider before you can set the white balance, and once you've got the white balance right, you may then need to go back and adjust the exposure of the photo further, as an incorrect white balance can shift the highlight clipping considerably.

If you're converting a photo to black & white, first set the white balance while it's still in color, as an incorrect white balance can create a muddy black & white.

How do I use the TAT, or Targeted Adjustment tool?

Appearing in the Tone Curve, Hue, Saturation, Luminance and B&W panels, the Targeted Adjustment tool, or TAT for short, allows you to directly control the sliders by dragging on the photo itself. It means you can concentrate on the photo itself rather than the sliders. This rather unobtrusive little tool is a real gem!

"What is the HSL panel used for?" on page 289 If you select the TAT tool from the Tone Curve panel, and click and drag upwards on an area of the photo, that area will get lighter, as the Tone Curve for that particular spot on the histogram is affected. If you prefer, rather than clicking and dragging, you can float over an area on the photo, and use the Up/Down keys to make adjustments. Once you've finished, just press Escape or return the tool

to its base.

Whichever your preference, this little TAT tool enables you to adjust the photo while focusing on the photo itself, rather than what the sliders are doing. Particularly when adjusting HSL or B&W, it saves you having to work out which sliders you need to adjust for a specific color.

TONE CURVES

Tone Curves are primarily used for adjusting contrast in specific tonal ranges. The steeper the curve, the higher the contrast becomes. For example, the most popular shape curve is an S shape, which increases contrast by lightening the highlights and darkening the shadows. The area in the middle becomes steeper and higher contrast, and the highest highlights and darkest shadows become shallower, holding some of the detail.

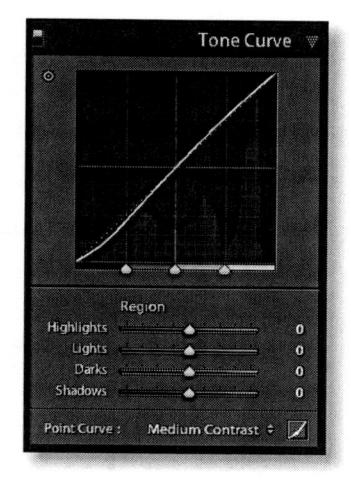

How do I use the standard Parametric Tone Curve?

The Parametric Tone Curve is the default view, and it allows you to adjust the curve of the photo while still protecting the photo from extremes. You can drag the curve itself, move the sliders, or use the TAT tool to adjust the curve while concentrating on the photo itself. As you drag each area, the grey highlighted section shows the limits of movement of that slider.

What do the three triangular sliders docked at the base of the Tone Curve do?

The three triangles at the bottom of the Parametric Tone Curve adjust how much of the tonal range is affected by each of the sliders for Shadows, Darks, Lights and Highlights. Double-clicking on any of those triangular sliders resets the slider to its default position.

How do I use the Point Curve?

Lightroom 3 sees the introduction of the custom Point Curve interface for advanced users, which allows much more extreme curves. Press the small button next to the Point Curve pop-up menu and you can edit the Point Curve directly, creating some of the weirdest curves imaginable.

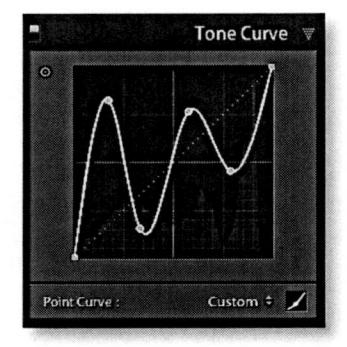

The TAT tool allows you to create

additional points on the Point Curve, and dragging those points on the Point Curve interface adjusts them. You can't use the keyboard to adjust the points, but if you hold down the Alt (Windows) / Opt (Mac) key while moving the points, it allows you to adjust with much finer movements.

Where have the Tone Curve sliders gone?

If you're missing the Tone Curve sliders, you're viewing the Point Curve interface, so press the 'Point Curve' button to return to the Parametric Curves.

HSL, COLOR, B&W & SPLIT TONING

The HSL, Color, B&W and Split Toning sliders can look slightly daunting to start with, as there are a multitude of sliders. They allow for much finer adjustments of specific colors in your photos and creative monochrome effects too. Often a color in your photo will be affected by more than one slider, so try experimenting with the TAT tool and see how they interact.
What is the HSL panel used for?

H stands for Hue, which is the color. S stands for Saturation, which is the purity or intensity of the color. L stands for Luminance, which is the brightness of the color.

The HSL panel allows you to adjust the colors in your photo, and the tinted sliders show which way the colors will shift. For example, if you have some grass in your photo, moving the Green slider to the left will make that grass more yellow, without affecting the reds significantly. If someone's skin is too pink, and the rest of the photo is perfect, you may need to adjust a few of those sliders, including the Magenta and Red sliders. Rather than having to work out which colors to shift, the TAT tool allows you to drag directly on the photo and it will choose which sliders need to be adjusted.

My favorite use of the TAT tool and the HSL panel is for a quick blue sky fix. When brightening a photo causes those beautiful blue skies and white fluffy clouds to become too light, try setting the HSL panel to Luminance, selecting the TAT tool, and dragging downwards on the blue sky to darken the sky and maybe then switch to Saturation to increase the blue too. Don't go too far, as you'll start to introduce noise, but it's a very quick fix.

Also check...

"How do I use the TAT, or Targeted Adjustment tool?" on page 286

What's the difference between the HSL and Color panels?

There is no difference in the functionality of the HSL and Color panels—they're the same tools laid out differently.

How do I create a Black & White photo?

If you just want an idea of how your photo would look in Black & White, press the V key on your keyboard, which toggles between the Color and Black & White choices at the top of the Basic panel. If you like it, then you can start adjusting the way the colors are mixed. In the B&W panel, the sliders are set to Auto positions by default, and those are often a good starting point. You can adjust those sliders manually, or you can pick up the TAT tool and start dragging different areas on the photo to make them darker or lighter. For example, dragging that TAT tool downwards on the sky will darken the blue tones, giving a more dramatic contrast against the clouds. You may also want to switch back to the Tone Curve panel and adjust the curve to increase the contrast. Some photos look far better in black & white than they do in color, and photos that are very underexposed or overexposed often can be rescued by black & white conversion.

How do I use the Split Tone panel?

The Split Tone panel is primarily designed for effects such as softly toned black & whites and cross-processed looks. There are 2 pairs of Hue and Saturation sliders—one for the Highlights and one for the Shadows. If you click on the color swatch, you can also select your tint from the Color Picker, and you'll see both sliders move to match your selected tint. The slider in the middle balances the effect between the Highlights and the Shadows. If you're just starting to experiment with cross-processing and toned black & whites, there are many free presets that may give you a few ideas.

Split Tone is also really useful when correcting color casts on rendered files, for example, you may have corrected the overall white balance

"Where can I download Develop presets?" on page 300 with the Temperature and Tint sliders, but a green cast may remain in the shadows, which can easily be corrected by using a slight magenta shadow in the Split Tone panel.

How do I create a Sepia photo?

To create a great sepia or softly-toned black and white photo, you again use the Split Tone panel. A hue of around 40 to 50 gives a lovely soft brown tone, and then adjusted the saturation slider in that panel to increase or decrease the strength of the effect.

ADJUSTING MULTIPLE PHOTOS

One of Lightroom's greatest strengths is its ability to batch process photos quickly, copying settings across multiple photos. Even if the photos are not identical, synchronizing a custom white balance across photos taken in similar lighting can give you a good starting point and helps to keep the processing consistent across the whole batch.

How do I copy or synchronize my settings with other photos?

As with most things, Lightroom gives a number of different options, so you can choose the one that suits you best at the time:

Copy/Paste option

Copy and Paste allows you to select which settings to copy to the new photo, and they stay in memory until you copy different settings or close Lightroom, so you can apply the same settings to other photos later.

- Adjust the first photo, which will become the source of your settings.
- Press Ctrl-Shift-C (Windows) / Cmd-Shift-C (Mac) to show the Copy Settings dialog, or use the 'Copy...' button at the bottom of the left hand panel in the Develop module.

- 3. Select the checkboxes for the slider settings that you want to copy to the other photo.
- 4. Move to the target photo.
- 5. Press Ctrl-Shift-V (Windows) / Cmd-Shift-V (Mac) to paste those settings onto the selected photo, or use the 'Paste' button at the bottom of the left hand panel.

Previous option

The Previous option copies all of the settings from the most recently selected photo to the next photo you select.

- 1. Adjust the first photo.
- 2. Move on to next photo.
- 3. Press Ctrl-Alt-V (Windows) / Cmd-Opt-V (Mac) to apply all of the settings from the previous photo, or use the 'Previous' button at the bottom of the right hand panel.

There's one exception—if you're moving from a photo with no crop, to a photo with an existing crop, the crop will not be reset. If you use 'Previous,' watch out for Red Eye Reduction and other local adjustments which are copied over too, as they can end up being small dots in strange places if the photos aren't identical.

Sync option

Sync uses the data from the most-selected or active photo, and pastes it onto all of the other selected photos. That's why there are 3 different levels of selection, as we mentioned early in the Workspace chapter.

- 1. Adjust the first photo, which will be the source of the settings.
- 2. Keeping that photo active (most-selected), also select the other photos by holding down Ctrl (Windows) / Cmd (Mac) or Shift key

while clicking directly on their thumbnails, rather than the cell borders.

3. Ctrl-Shift-S (Windows) / Cmd-Shift-S (Mac) shows the Sync Develop Settings dialog so you can choose which settings to Synchronize, or use the 'Sync...' button in the Develop module or 'Sync Settings' in the Library module to do the same.

Holding down the Alt (Windows) / Opt (Mac) button while pressing the 'Sync' button, or using Ctrl-Alt-S (Windows) / Cmd-Opt-S (Mac), will synchronize the settings but bypass the dialog. If you're bypassing the dialog, make sure you've got your chosen settings checked the first time, as it'll use the last used checkbox settings.

AutoSync option

or Straighten tools.

The AutoSync behavior matches the behavior of ACR—when you have multiple photos selected, any slider adjustments are applied to all of the selected photos. It can be slow for large numbers of photos, particularly when used with the Crop

- 1. Select multiple photos.
- Toggle the switch next to the 'Sync' button so that the label changes to 'AutoSync.'
- 3. As you adjust the photos, all of the selected photos will update with any slider adjustment at the same time.

AutoSync is powerful but dangerous, as it's easy to accidentally apply a setting to multiple photos without realizing that they're all selected. It gets particularly confusing if you often switch between standard Sync and AutoSync, so you may find it easiest to leave it turned on at all times, or at least leave the Filmstrip visible so you can see the number of photos that are selected.

When you have AutoSync turned on, you can still use the keyboard shortcuts for the other sync options such as Previous, Paste or standard

"White Balance" section on page 276

Sync, but they will apply to ALL selected photos, not just active (most-selected) photo, as AutoSync will still be active.

Why won't my white balance sync?

The white balance is perfect on photo A, so you sync the settings to photo B... but it doesn't change. So you try it again... and it still doesn't change. Why?

'As Shot' is the key. If photo A is set to 'As Shot' white balance, photo B will also be set to 'As Shot,' not the same numerical values. To solve it, select 'Custom' from the white balance pop-up, or shift the values slightly, and then sync with photo B, and your numerical values will be copied.

What does 'Match Total Exposure' in the Settings menu do?

Match Total Exposure is intelligent adjustment of the exposure value on a series of photos. Where photos were shot in the same lighting, but on Aperture Priority/AV, Shutter Priority/TV or Program, it results in varying camera exposure settings. This clever command calculates and adjusts the exposure on all selected photos to end up with the same overall exposure value. It doesn't adjust for the sun going behind a cloud though!

To use it, correct a single photo, then select other photos taken at the same time. In the Develop module, go to Settings menu > Match Total Exposure, and the photos will all be adjusted to match the overall exposure of the active (most-selected) photo, taking into account the variation in camera settings. You'll also find it in the Library module under Photo menu > Develop Settings.

Can I make relative adjustments, for example, brighten all selected photos by 1 stop?

You can't make relative adjustments directly within the Develop module, but you can do so using the Quick Develop panel in the Library module, which we mentioned in that earlier chapter.

Select the photos and make sure you're viewing the Grid view, so that your changes apply to all selected photos. Press the buttons in the Quick Develop panel and the photos will change relative to their existing settings, rather than Sync, which would set everything to the same fixed slider value.

"Quick Develop" section on page 198

BEFORE / AFTER VIEWS

There's nothing better than seeing the results of your hard work, so Lightroom offers before and after previews to compare your photo with an earlier rendering.

Can I see a Before / After preview?

If you press the \ key, the preview toggles between a before/after view of the whole photo. When you click the 'Before / After Previews' button in

the toolbar—the one with a Y on it—you'll see other options, such as side-by-side, top-and-bottom and split-view previews. Logically

the keyboard shortcuts for those previews are all variations on the letter Y too, and you'll find those listed in the Keyboard Shortcuts chapter.

Can I change the 'Before' state to something other than the Import state?

By default, the 'Before' view is last 'Read from Metadata,' which is usually when the photo was imported, but you can choose any history step or

"History & Reset"
section on page 312
and "Snapshots &
Virtual Copies" section
on page 308

snapshot to be the 'Before' view. Right-click on the history step or snapshot, and choose 'Copy History

Step Settings to Before' or 'Copy Snapshot Settings to Before.'

If you want to update a whole set of photos to show their current state as 'Before', but don't want to do it by hand on every photo, there's a quicker solution...

- 1. Go to Grid view.
- 2. Select the photos, and press Ctrl-S (Windows) / Cmd-S (Mac) to write the settings to the files. If you have 'automatically write to XMP' turned on in preferences, you can skip this step.
- 3. Once it's finished, with those photos still selected, select Metadata menu > Read Metadata from Files.
- That automatically updates the 'Before' state to the current settings, but it only works with master photos and not virtual copies.

Can I turn off the effect of a whole panel's settings, to see the preview with and without those settings?

Most Develop panels have a toggle switch to the left of the panel label,

which allows you to temporarily disable any panel for that specific photo only, without resetting the slider values. That also applies to the Spot Removal, Red Eye Correction, Graduated Filter and Adjustment Brush tools, which have a switch at the bottom left of their options panel.

HISTOGRAM & RGB VALUES

A Histogram, shown in the top right panel, is a bar graph showing the distribution of tonal values. It runs from the blackest shadow on the

on page 137

left to the brightest highlight on the right, and vertically it shows the number of pixels with that specific tonal value.

There's no such thing as a 'correct' histogram, but an average photo with a wide range of tones will

usually fill the whole width, so understanding how to read it can help you set the exposure, especially on the back of the camera.

A photo that is primarily light, for example, a white dog against snow, will show most of the data on the right hand side of the histogram. That's entirely normal, just as a photo taken in fog is unlikely to have any dark black pixels.

On the other hand, if you have an average photo, where you'd expect to have tones running from pure white to pure black, and you find the histogram stops half way across, then you know the photo is underexposed and lacking in contrast.

You can click and drag directly on the Histogram to move those tones to the right, and the Exposure slider will move as you do so. If the last pixel on the left or the right spikes, it means that those pixels are no longer holding detail in your photo. Those are called clipped highlights or shadows, or you may hear them referred to

skin, you'll need to pull that back the other way.

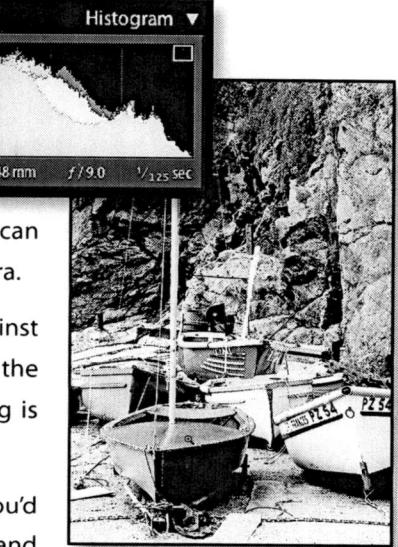

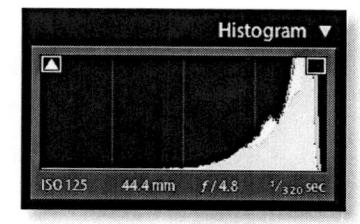

Is it possible to see clipping warnings? Or, why are there red and blue areas on my photos?

The triangles in the top-left and top-right corners of the histogram turn the clipping warnings on and off, and also change color when a channel is clipped. Clipping means that there's no detail in that channel at that value.

They're turned on and off by clicking directly on those triangles, or by

using the keyboard shortcut 'J' to turn both on and off at the same time. They can also be accessed temporarily by holding down the Alt (Windows) / Opt (Mac) key while dragging the Exposure, Recovery or Blacks sliders.

Why does the Histogram look different when I open the exported sRGB photo in Photoshop? Why are my highlights clipping in Photoshop but not in Lightroom?

The histogram in Lightroom, and therefore the clipping, is working in the internal MelissaRGB color space, which is a much larger color space than sRGB. A color which is still within gamut in MelissaRGB or ProPhotoRGB, may therefore have slipped out of gamut when changing to a small space, such as sRGB, resulting in clipping. We'll come back to color spaces in the Export chapter.

To see this in practice, take one of the photos, and open it in ACR. Set the color space to the largest available—ProPhoto RGB in ACR—and look at the histogram and clipping. And now change it to sRGB and look at the histogram. Can you see how it's changed? You'll most often notice it when the red channel is close to clipping in Lightroom, and then blows when you convert to a smaller color space.

Let's illustrate with this fire truck... the saturated reds make it clear to see the difference.

"Color Space" on page 375

First we have the ProPhoto RGB version, with clipping warnings turned on, and the image is unclipped as expected. This is very close to Lightroom's histogram.

And then we have the sRGB version, with clipping warnings turned on, and it's clear to see, both from the clipping warning and the histogram, that the red channel is clipped.

If you must use sRGB, for example, for the web, just be aware that certain colors, particularly skin tones on highly saturated photos, may clip when sending to sRGB, so don't push them quite as close to the end when you're editing.

Can I view RGB values using a normal 0-255 scale?

Underneath the Histogram, Lightroom shows the RGB values for the pixel beneath the cursor. Those are shown in percentages, rather than a 0-255 scale, because 0-255 is an 8-bit scale and Lightroom works in 16-bit. As in the 0-255 scale, equal numbers are neutral, so 50% 50% 50% is neutral grey.

PRESETS

A Develop preset is simply a combination of Develop settings saved for use on other photos, and a whole community has sprung up, sharing and selling Lightroom Develop presets. They can offer a good starting point for your post-processing, or more often, some weird and wonderful effects. Some examples are included by Adobe, and you'll find them in the Presets panel on the left of the screen.

Where can I download Develop presets?

There are many sources of free and commercial presets, or you can create your own.

These are the most well-known free preset websites:

http://www.inside-lightroom.com/

http://www.ononesoftware.com/photopresets-wow.php

http://www.lightroomkillertips.com/

There's a regularly updated list of free presets at:

http://www.prophotoshow.net/blog/2007/11/09/

lightroom-presets-the-ultimate-free-list/

And the Lightroom Exchange is a great place to find all sorts of new plug-ins, presets and other goodies: http://www.adobe.com/cfusion/exchange/index.cfm?event=productHome&exc=25

How do I install Develop presets?

If you're installing presets from a single folder, the automatic method is quick and easy. If you're installing lots of presets in one go, perhaps because you've bought a whole set, and they're organized into multiple folders, then the manual installation may be quicker.

Automatic installation

- Unzip the presets if they're zipped.
- 2. Go to Develop module Presets panel, right-click the 'User Presets' folder and choose Import...
- 3. Navigate to the folder of presets, select them and press the Import button.

Manual installation

- 1. Unzip the presets if they're zipped.
- Find the Develop Presets folder in Explorer (Windows) / Finder (Mac) by going to Preferences > Presets panel and choosing the 'Show Lightroom Presets Folder...' button.
- 3. Drag the presets into that folder, still in their folders if you'd like to keep them organized in the same way.
- 4. Restart Lightroom.

How do I preview and apply presets to my photos?

If you want to see what your preset will look like, without having to apply it to a photo and then undo it again, you can watch the Navigator panel as you float over the presets in the Presets panel. The small Navigator preview will update with your preset settings, allowing you to easily find the effect you're looking for.

To apply your preset in the Develop module to the currently selected photo, you can just click on the preset in the Presets panel. To apply it to multiple photos, it's easiest to select all of the photos in Grid view and

Also check...

"The default location of the Presets is..."

on page 463

Also check...

"Can I synchronize my settings with other photos?" on page 352 and "Quick Develop" section on page 198 choose your preset from the Quick Develop panel or from the right-click > Develop Settings menu. Anything you

do in Grid view applies to all of the selected photos. If you want to stay in Develop module, you can apply the preset with AutoSync turned on, or you can apply to one photo and then use Sync to copy the settings to the rest of the photos.

How do I create my own Develop Presets?

To create your own preset, adjust a photo to the settings that you want to save as your preset. Press the + button on the Presets panel to show the New Develop Preset dialog.

Check or uncheck the sliders you want to save in your preset. If a checkbox is unchecked, that unchecked slider won't be affected when you apply your preset to another photo. For example, if your preset is just for Calibration settings, uncheck the other checkboxes, otherwise you may accidentally change the exposure and other settings.

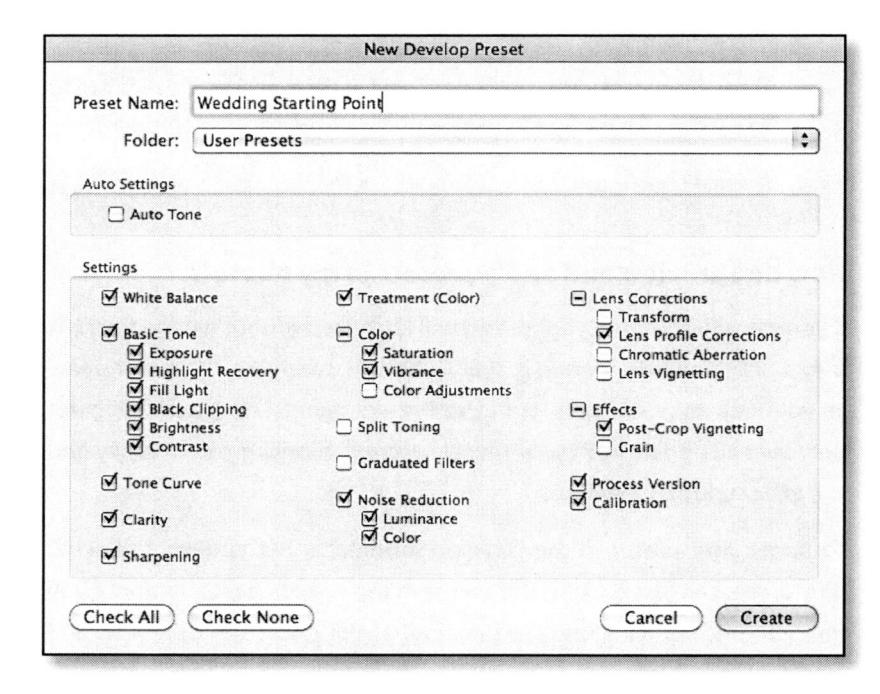

Name the preset and choose a folder to group similar presets together, and then press the Create button. Your preset will now appear in the Presets panel for use on any photos.

If you later need to update a preset, repeat the process, but instead of pressing the + button to create a new preset, right-click on an existing preset and choose 'Update with Current Settings.'

How can I organize my presets into folders or groups?

Many users are now overflowing with presets that they've created or downloaded, and it can be difficult to find the one you're looking for. You can create folders for the presets by right-clicking on any existing user preset or preset folder and choosing New Folder. Once you've created folders, it's simply a case of dragging and dropping the presets into a logical order. If you have hundreds of presets, you might find it useful to group your most often used presets in a single folder, rather than having to scroll through them all.

How do I rename Develop presets?

To rename a preset, go to the Presets panel, right-click on the preset and select 'Rename...' Renaming the preset file manually in Explorer (Windows) / Finder (Mac) doesn't work because the preset name is embedded in the file itself. It's possible to edit the preset with a text editor, but a minor error could corrupt the preset, so be careful!

How do I remove the default Develop presets?

The default presets included with Lightroom are embedded in the program files. If you don't want to use them, just close the folder and ignore them, rather than digging around in the program files to try to find them.

"The default location of the Presets is..." on page 463

How do I uninstall Develop presets?

To delete a preset, go to the Presets panel, right-click on the preset and choose 'Delete.' You can also navigate directly to the Develop Presets folder via the Preferences dialog > Presets tab > 'Show Lightroom Presets Folder...' button, and delete/move multiple presets in one go, and then restart Lightroom. I keep a 'Spare Develop Presets' folder next to the main 'Develop Presets' folder for the presets I uninstall but may want to reinstall in future, which helps to reduce the clutter.

Where have my presets gone?

If you have 'Store Presets with Catalog' checked in the Preferences dialog > Presets tab, your presets are stored in a folder next to the catalog rather than in the global location. That means that they're only available to that single catalog.

That option works well if you use a single catalog, and that catalog is used on multiple different machines, as your presets will always go with you. It's also useful if you do 3 very different styles of photography, each with their own catalog, and your presets are specific to that particular style of photography.

That preference also causes some complications. The presets are not copied to or from that location automatically by checking or unchecking that checkbox, so you have to transfer them manually. Also, if your preferences get corrupted, reverting to the unchecked state, or you switch language, your presets can appear to have mysteriously gone missing. Also, the 'Show Lightroom Presets Folder...' button always points to the global location, rather than any presets stored next to the catalog.

If there isn't a specific reason why you need the presets stored with the catalog, I'd recommend leaving it unchecked. If you want the presets synchronized with multiple computers, file synchronization software or Dropbox (http://www.dropbox.com/) are a good alternative.

Can I apply multiple presets to the same photo, layering the effects?

Presets only move a slider to a new position, and they don't calculate relative to the current slider settings. If Preset A only adjusts, for example, the Exposure and Brightness sliders, and Preset B only adjusts the Vibrance slider, then they can be applied cumulatively. If the presets change the same sliders, for example, Preset A sets the Exposure to -1 and then Preset B sets the Exposure to 0, then the changes made by the first preset will be overwritten by the second preset.

I have some Develop presets that I use in ACR in CS4—can I use them in Lightroom?

Lightroom's presets are saved in a Lightroom-only format (*.Irtemplate), so they're not directly interchangeable. If you want to be able to use an ACR preset in Lightroom, apply that preset to a raw file, and then import that raw file into Lightroom. Once in Lightroom, you can save the settings as a Lightroom Develop preset for future use. The same works in the opposite direction, sharing Lightroom presets with ACR, and it's quicker than writing down all of the settings and entering them manually.

Why do my presets look wrong when used on JPEG/TIFF/PSD files, even though they work on raw files?

The processing on JPEG/TIFF/PSD files is completely different from the processing on a raw file, as raw files are linear and rendered files aren't. JPEGs start at 0 and are set to Linear for the Tone Curve, whereas raw files start with 50 Brightness, 25 Contrast, 5 Blacks, a Medium Contrast

"How do I use the Painter tool to quickly add metadata?" on page 163 Tone Curve and some Sharpening and Noise Reduction too. That means that the presets can have a different effect, for example, a preset that sets the Tone Curve to Strong Contrast will be much stronger on a JPEG than it will on a raw file.

Your best option is to create two sets of presets which give a similar result if you use those specific sliders—one set for raw files, the other set for everything else.

Is there a way to add a keyboard shortcut to a preset?

You can't apply presets using a keyboard shortcut, but you can use the Painter tool to apply Develop presets quickly, which we covered in the Library chapter.

If you're a high volume user who is particularly keen on using keyboard shortcuts for as many commands as possible, including applying presets and other commands for which standard keyboard shortcuts aren't available, you could consider RPG Keys, a commercial product designed specifically for Lightroom. I have no affiliation with the company, however it does fill a need for some users, so you can decide whether it's for you. The website is: http://www.rpgkeys.com/

DEFAULTS

Default settings are automatically applied whenever you import photos. Adobe set default settings, but you can change those to suit your own taste. The defaults you set in Lightroom are also used for ACR, and vice versa.

Why would I change the default settings instead of using a preset?

You can set new default settings for your photos, and those settings will automatically apply to any newly imported photos that don't have

Also check...

"What Develop settings, metadata and keywords should I apply in the Import dialog?" on page 75

existing settings stored in XMP. It won't overwrite any existing settings stored in the files, whereas a preset would reset those existing settings.

The default settings will also apply any time you press the 'Reset' button. The defaults can be set either by camera model or ISO, or by both combined too.

How do I change the default settings?

Go into Preferences > Presets panel and decide whether you want 'Make defaults specific to camera serial number' and 'Make defaults specific to camera ISO setting' turned on or off.

- 1. Select a photo and set your new settings.
- 2. Go to Develop menu > Set Default Settings...
- 3. Press 'Update to Current Settings'.
- Repeat with a sample photo from each camera, and each combination of ISO/Serial Number if those options were selected in Preferences.

Although that dialog gives the warning that the changes aren't undoable, you can return to that dialog at any time to restore the Adobe's own default settings.

Why would I want different defaults for each ISO and serial number combination?

Lightroom always sets defaults for the camera model and file type combination, and it shows that combination in the Set Default Develop Settings dialog. In Preferences dialog > Presets tab, there are additional checkboxes to make defaults specific to the camera serial number or ISO too. For example, you might like to use different ISO defaults to apply different noise settings for different ISO ratings. Serial number might be used for different sharpening for different cameras, because the lens you always use on one body is softer than the other identical model, or something along those lines.

Why don't all of the sliders default to 0?

The slider values are just arbitrary numbers. The number 0 doesn't mean anything. 25 for Contrast, 50 for Brightness, Medium Contrast for Tone Curve, 25 for Sharpening, and so forth, have always been the default in ACR since the early releases, and that's carried over into Lightroom. Those settings are a good starting point. The default is 0 for JPEGs, but they've already had some processing in-camera, whereas raw files benefit from the additional contrast and brightness.

What settings should I use as the defaults?

Your default settings are a matter of personal taste, but Adobe's own defaults are a good starting point for most people. You might prefer a different camera profile, or a higher contrast or sharpening setting, but you can choose, and if you change your mind, you can always change your defaults again.

SNAPSHOTS & VIRTUAL COPIES

If you wanted to try a different version of a photo in a pixel editing program, such as Photoshop, you'd have to duplicate that photo on the hard drive, taking up more space on your hard drive. Lightroom offers 2 virtual options that don't require their own copy of the original file. Those options are virtual copies, often shortened to VC's, and snapshots, and there's a crossover in the 2 concepts, so you can decide which works best for you.

To create a virtual copy, you can right-click on a photo and choose Create Virtual Copy from the menu or use the Ctrl-' (Windows) / Cmd-' (Mac) shortcut. It will appear as a separate photo, and you can filter to

find those virtual copies using the Attribute filters on the Filter bar. You can also create virtual copies when you're creating a collection—select the photos and create a new collection,

and in the dialog you'll find a 'Make new virtual copies' checkbox.

To delete a virtual copy, you just press Delete, like any other photo.

To create a snapshot, click on the + button on the Snapshots panel and give it a name, and like presets, you can update it with the current settings from the right-click menu.

Why would I want to use virtual copies?

A virtual copy is a duplicate of an existing photo, but it's virtual—it doesn't take up additional space on the hard drive, with the exception of the preview.

You can do almost anything to a virtual copy that you can do to a master photo, for example, you can give it a different star rating, label, keywords, or other metadata. Virtual copies are treated as if they're separate photos, so they will show in Grid view alongside the master and any other virtual copies. Most use virtual copies to keep variations of photos—perhaps a color version, a black and white version, a special effect version, and a few different crops.

"Sorting, Filtering & Finding Photos" section on page 187

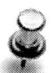

"Which of Lightroom's data isn't stored in XMP?" on page 242 Information about virtual copies is only stored in the catalog and not in XMP, so if you need image variations that are stored in XMP, consider snapshots as an alternative.

When would I use a snapshot instead of a virtual copy?

A snapshot is a special history state, which captures the slider settings at the moment of its creation. You can make changes to your photo, save it as a snapshot, make more adjustments, and then easily go back to the earlier snapshot state, even if you clear the History panel.

A photo can only be in a single snapshot state at any one time, and is treated as a single photo, unlike virtual copies, where each copy is treated as a separate photo. A photo with multiple snapshots will only appear as one photo in Grid view, and there's no way of telling that there are multiple versions from the Grid view.

Snapshot states are saved in XMP, but virtual copies are not. If you create a snapshot on a virtual copy, that snapshot is available to the master and the other virtual copies, but unlike virtual copies, snapshots are also written to XMP.

Can I rename virtual copies?

If you rename a virtual copy, the name of the master will change too—after all, it's virtual. When you export the virtual copies, they can have different

names from the originals as if they're individual

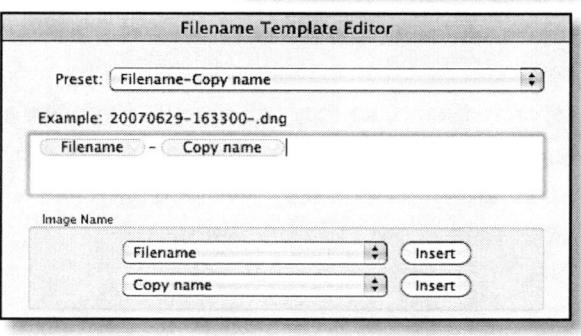

"How do I change the filename while exporting?" on page 370 photos, and you have some control over that naming while still in the Library module.

In the Metadata panel of a virtual copy is a 'Copy Name' field, which defaults to 'Copy 1,' but you can change to an alternative name of your choice, for example 'Sepia.' You can update a series of photos in one go by first selecting them and then editing that field.

If you've updated the copy name on your virtual copies, you can use that copy name when you export. You'll find 'Copy Name' as an option in the Filename Template Editor. For example, if you've set 'Sepia' in the 'Copy Name' field, you could use 'Original Filename_Copy Name' tokens to create 'IMG_003_Sepia.jpg.'

Can I turn virtual copies into snapshots and vice versa?

Although there's a crossover in the 2 concepts, there isn't a really easy way to switch between the two.

If you're viewing a virtual copy, creating a snapshot will make that snapshot available to all of the other versions of that photo, and it will be written to XMP. That can be time consuming if you need to create snapshots for lots of photos, but Matt Dawson's Snapshotter plug-in can automate the process. http://thephotogeek.com/lightroom/snapshotter/

If you're viewing a snapshot, creating a virtual copy will take that snapshot state.

Can I swap virtual copies for masters and vice versa?

If you need to swap a single virtual copy for its master, you can select 'Set Copy as Master' from the Library menu. If you want to do a whole batch of photos, it's not quite so simple. The closest you'll get to batching that process would be to export the virtual copies to another folder, with the file format set to 'Original,' and then import those new files into your

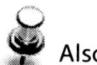

"How do I copy or synchronize my settings with other photos?" on page 291 catalog. You'd only have data that's stored in XMP, but it may be a good compromise in some circumstances.

What do Sync Copies and Sync Snapshots do?

Under the Settings menu, there are two additional sync options which apply to virtual copies and snapshots. 'Sync Copies' and 'Sync Snapshots' allow you to sync settings from your current rendering to all of that photo's virtual copies or snapshots in one go. For example, if you've created different versions for different crop ratios, and then you update the Process Version or change the sharpening, you might want to update all of your other versions of that photo too.

HISTORY & RESET

Thanks to its database, Lightroom is able to keep a list of all of the steps you've taken to get to the current settings. Unlike Photoshop, that history remains in the catalog indefinitely, even if you close Lightroom. You can come back months later and pick up where you left off, or go back to an earlier history state and carry on processing from there.

There will also be times when you want to remove the Develop adjustments and start from scratch, so there are reset options for individual sliders, panels, and all settings too.

How do I reset a single slider or panel section to its default setting?

To reset a single slider to its default setting, double-click on the slider label. If you want to reset a whole section within a panel, hold down Alt (Windows) / Opt (Mac) and the panel label will change to a 'Reset Section' button, or double-clicking on that same panel label without holding down the Alt (Windows) / Opt (Mac) buttons will do the same.

Reset (Adobe)

How do I reset photos back to their default settings?

To reset all of the settings back to default, press the 'Reset' button at the bottom of the right hand panel in the Develop module. You'll also find it in the Library module in the Quick Develop panel and the right-click menu, which allows you to easily reset multiple photos in one go, or you can reset one and sync that across the rest of the photos.

If you've change the default settings, you can reset the photo to Adobe's default settings by holding down Shift to change the 'Reset' button to 'Reset (Adobe).'

If I don't like the last adjustment I made, can I just undo that step, rather than resetting everything?

You can press Ctrl-Z (Windows) / Cmd-Z (Mac) multiple times to step back through each and every action. That affects most actions, not just the history states for the currently selected photo, so it will step back through module changes, selecting photos, etc. There are a few actions that can't be undone using those shortcuts, such as deleting photos from the hard drive, but the dialogs always warn if an action is not undoable using that shortcut.

The History panel contains a record of the changes you've made to each

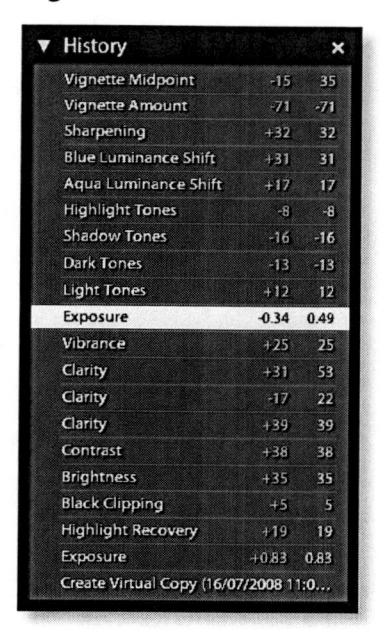

individual photo, so you can go back to an earlier point when you were happy with the settings. You can try different settings without worrying, and then return to your earlier state if you don't like the result of your experiment. Just click on the history state that you were happy with,

"Which of Lightroom's data isn't stored in XMP?" on page 242 and continue editing—a new history will be written from that point on, replacing the steps that followed.

How long do the adjustments stay in the History panel?

The list of history states stay in the History panel for as long as the photo stays in the catalog and you don't press the Clear button, which is the X in the corner of the History panel. It doesn't matter if the photo is shown as missing and then you relink it, as long as you don't remove it from Lightroom's catalog. History states can't be saved to XMP—only the current settings are saved—so if you remove the photo from the catalog, the history of Develop changes will be lost.

DETAIL—SHARPENING & NOISE REDUCTION

Most digital photographs require some degree of sharpening, and although camera sensors are improving, most high ISO photos also benefit from noise reduction. Lightroom 3 benefits from improved sharpening and has new noise reduction algorithms that can now compete with specialized noise reduction software, such as Noise Ninja and Neat Image.

Why are my pictures softer and noisier than other programs?

When Lightroom's sharpening and noise reduction sliders are at 0, those tools are turned off completely, whereas many other programs apply additional sharpening and noise reduction behind the scenes, even with their tools set to 0.

What is multiple pass sharpening?

Lightroom's sharpening is based on Bruce Fraser's multiple pass sharpening techniques. You can read more about his techniques at http://www.creativepro.com/article/out-gamut-two-pass-approach-

sharpening-photoshop and http://www.creativepro.com/article/out-of-gamut-thoughts-on-a-sharpening-workflow

Sharpening in Lightroom's Develop module is designed to be Capture sharpening, intended to offset the inherent softness caused by digital capture and the demosaicing that's done by the raw converter.

Creative sharpening is usually applied to specific parts of the photo, for example, the eyes in a portrait. The Clarity slider may be described as creative sharpening, although the effect is global rather than localized. The sharpening in the Local Adjustments would also be classed as creative sharpening.

Output sharpening is the last stage, depending on whether the photos will be viewed on screen, inkjet print, photographic print or a variety of other presentation options. The sharpening applied in the Export dialog or Print module would be classed as output sharpening, as it's calculated based on the output size and type.

How do the sharpening sliders interact?

Amount is quite logically the amount—like a volume control. It runs from 0-150, with a default of 25. The higher the value, the more sharpening

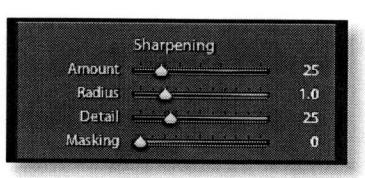

that is being applied. You won't usually want to use it at 150 unless you're combining it with the masking or detail sliders which suppress the sharpening.

Radius affects the width of the sharpening halo, as it would for USM (Unsharp Mask in Photoshop). It runs from 0.5-3, with a default of 1.0. Photos with fine detail need a smaller radius, as do portraits, but a slightly higher radius can look good on landscapes.

Detail allows you to suppress the halos and concentrate on edge sharpening. It runs from 0-100, with a default of 25. 100 behaves in a similar way to USM, sharpening everything equally. As you increase

"Which Print
Sharpening option do I
choose?" on page 441

Adobe Lightroom 3 - The Missing FAQ

Detail, you'll usually need to turn the Amount slider down, and vice versa. A low setting is ideal for portraits, whereas you may want a slightly higher setting for landscapes or other shots with lots of fine detail.

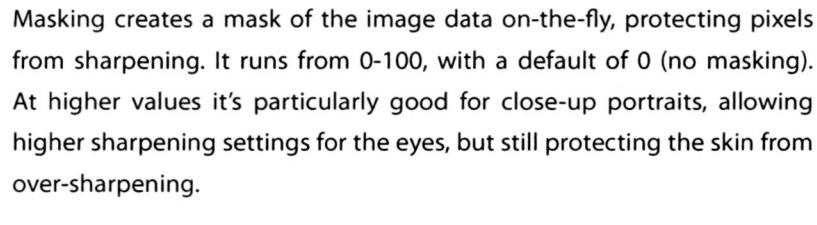

Holding down the Alt key (Windows) / Opt key (Mac) while moving the sharpening sliders shows a grayscale mask of the effect, which can help you determine the best value for each slider individually, for example, when using the Masking slider, the white areas of the mask will be sharpened and the black areas won't.

Can I apply or remove sharpening selectively?

Sharpening is one of the controls available in the Adjustment Brush, which gives you the ability to 'paint in' sharpening over a selected area, such as the eyes in a portrait. We'll come back to the Adjustment Brush later in the chapter.

0 to -50 on the Local Adjustment sharpening reduces the amount of sharpening applied by that global sharpening. Beyond -50 starts blurring the photo with an effect similar to a lens blur, but that is very processor intensive, so don't be surprised if Lightroom starts to slow down.

The Local Adjustment sharpening is directly tied to the sharpening sliders in the Detail panel, so the Radius, Detail and Masking settings from the Detail panel are combined with the Amount set in the Brush options panel. This also gives you the ability to remove sharpening that's been applied by the main sharpening Amount slider in the Detail panel.

How do I use the different Noise Reduction sliders?

Just because there's now an array of noise reduction sliders doesn't mean you need to use them on every photo. Most photos will only require the Luminance and Color sliders. The other sliders are there for more extreme

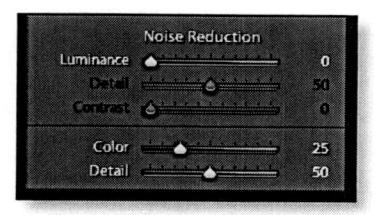

cases, and can be left at their default settings most of the time.

The Luminance slider controls the amount of luminance noise reduction applied, moving from 0, which doesn't apply any noise reduction, through to 100 where the photo has an almost painted effect. The Color slider tries to suppress color noise blobs without losing the edge detail.

The other sliders will only make a real difference to extremely noisy images, such as those produced by the highest ISO rating that your camera offers, or where a high ISO file is extremely underexposed. You're unlikely to see a difference at lower ISO ratings, for better or for worse, so in most cases you won't need to change those settings from their defaults.

The Luminance Detail slider sets the noise threshold, so higher values will preserve more detail but some noise may incorrectly be identified as detail. The Luminance Contrast slider at 0 is a much finer grain than 100. Higher values help to preserve texture, but can introduce a mottling effect, so lower values will usually be preferred. The Color Detail slider refines any fine color edges. At low values it reduces the number of color speckles in those edges but may slightly desaturate them, whereas at high values, it tries to retain the color detail but may introduce color speckles in the process.

If you're looking for an Auto setting, 25 on both the Luminance and Color sliders, with the other sliders at their defaults, will often be a good balance between detail and noise. The values automatically adapt depending on the camera and ISO rating when used with raw files. It's a matter of personal taste, so you might prefer a different value.

"How do I switch between PV2003 and PV2010?" on page 275

I've turned sharpening and noise reduction right up to the maximum, but it doesn't seem to be doing anything—why not?

There's a small Detail Preview 1:1 view in the Detail panel, and by selecting the icon in the top left hand corner of that panel and clicking on the main preview, you can choose which part of the photo to show in that Detail Preview. This means that you can watch the 1:1 view of a particular area of the photo—perhaps an eye in a portrait—while viewing another area in the main preview.

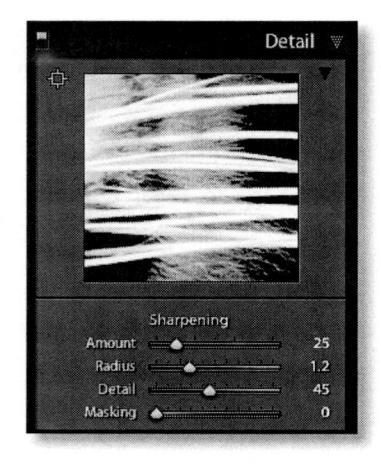

There's a difference in the way sharpening and noise reduction are previewed, depending on whether the photo is set to PV2003 or PV2010. Turn back to the Previews chapter if you need a reminder. In short, if your photo is still using the PV2003 rendering, you have to zoom in to 1:1, by clicking on the photo, to view the effect of the sharpening or noise reduction, but if you update the photo to PV2010, sharpening and some noise reduction will be previewed in Fit view as well as 1:1 view, but remember it's not completely accurate unless you're viewing the 1:1 view.

Also check...

"Process Versions"
section on page 274
and "The previews
are slightly different
between Library and
Develop and Fit and
1:1 views—why is
that?" on page 260

Why is the Noise Reduction sometimes visible in Fit View and other times only visible in 1:1?

Applying noise reduction for raw files is very processor intensive and can result in slow performance, so Lightroom shows some intelligence. At less than 1:1 view, it applies the noise reduction to all rendered files (i.e., JPEGs) but only raw files that are likely to show noise, depending on the camera model and ISO rating.

LENS CORRECTIONS

Camera lenses can show different defects at different settings, including vignetting around the corners, barrel and pincushion distortion and chromatic aberration. Lightroom 3 now has lens correction tools to correct for those defects, as well as new perspective corrections.

How do I apply lens corrections to my photo?

Applying lens corrections in Lightroom is often as simple as checking the 'Enable Profile Corrections' checkbox in the Lens Corrections panel. Lightroom will check the EXIF data in the file and try to identify the lens. If it finds the right profile, the pop-up menus below will automatically populate, and you're done. If Lightroom can't find the right profile, then you can help by selecting the lens details in the pop-up menus below.

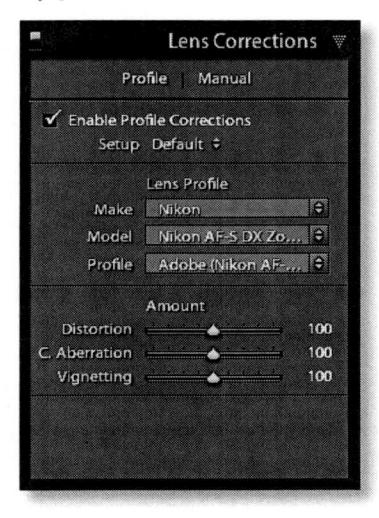

Why is the lens profile not selected automatically?

The EXIF 2.3 official standard for recording lens information in the metadata is only just starting to come into effect, and therefore it isn't always clear which lens was used. Lightroom uses all of the information available to make an educated guess, but if it's not sure it leaves you to select the profile. Once you've chosen the lens, you can set that as a default for that camera/lens combination, so you don't have to select it on every photo in future.

How do I set a default lens profile?

If your lens isn't automatically recognized by Lightroom, you'll need to set a default lens profile. That default will include the lens details selected in the pop-up menus and the Amount sliders below.

- 1. Open a photo taken with the camera/lens combination.
- 2. Go to the Lens Correction panel and check the 'Enable Profile Corrections' checkbox.
- 3. Select the lens make, model and profile from the pop-up menus.
- 4. (Optional) Adjust the Amount sliders.
- Go to the Setup pop-up menu and select 'Save New Lens Profile Defaults.'

In the Setup pop-up menu, what's the difference between Default, Auto & Custom?

'Auto' leaves Lightroom to search for a matching profile automatically. If it can't find a matching profile, either because the profile doesn't exist yet, or because it doesn't have enough information in the photo's EXIF data, then it will show an error saying 'Unable to locate a matching profile automatically.'

'Default' does the same, but also allows you to customize the settings for specific lenses. For example, if 'Auto' can't find a lens because it doesn't have enough information, you can select the correct profile from the pop-up menus below and save it as a default for the future. From that point on, whenever you select 'Default' for a photo with that camera/ lens combination, it will apply your new default lens setting. It's also useful if you have multiple profiles for a lens—perhaps one provided by Adobe and one you've created yourself—and you want to automatically select one of those profiles.

'Custom' shows that you've manually changed the profile or one of the Amount sliders.

How do the Amount sliders interact with the profile?

The Amount sliders below the profiles act as a volume control, increasing or decreasing the amount of profiled correction that's being applied. 0 doesn't apply the correction at all, 100 applies the profile as it was created, and higher values increase the effect of the correction.

Can I use the profiled lens corrections to correct the chromatic aberrations without removing the distortion?

There are some situations where you might want to use some of the profiled correction, but not all of it. For example, with a fisheye lens, you might want to remove the chromatic aberration automatically, but keep the fisheye effect. To do so, reduce the Distortion Amount slider to 0 but leave the Chromatic Aberration Amount slider at 100.

Why have the lens corrections created new chromatic aberration and vignetting instead of fixing it?

If you're working on existing files, you may have previously fixed Chromatic Aberration or Vignetting manually, and applying a profiled lens correction doesn't reset any existing manual settings. Switch to the Manual tab and reset those settings or create a Develop preset to reset them to 0.

Can I correct multiple photos in one go?

You can synchronize or copy and paste lens correction settings just like any other Develop sliders, and you can save them in presets and defaults.

Can I turn on the lens corrections by default?

If you want the profiled lens corrections applied to all of your newly imported photos automatically, first set your photo to its normal default settings, and then check the 'Enable Profile Corrections' checkbox and make sure the Setup pop-up menu is set to 'Default.' Finally, go

Also check...

"How do I copy or synchronize my settings with other photos?" on page 291 and "Defaults" section on page 306 to Develop menu > Set Default Settings... to set the default for that specific camera.

You only to set these defaults once per-camera, unless you have it set to use different defaults for each ISO/Serial Number set in Preferences. Turn back to the Defaults section if you need more information on changing default settings.

It's crucial that you set the Setup pop-up menu to 'Default' rather than 'Custom' when setting defaults. If you have it set to 'Custom' and you use a Canon 24-105mm profile when you create the Develop default, it will mistakenly apply that Canon 24-105mm profile to any photos shot with that camera. If you correctly choose 'Default,' Lightroom will automatically load your per-lens default, even when you switch lenses.

What are my options if my lens profile isn't available?

If your lens doesn't appear in the Lens Profile pop-up menus, you have 4 options:

- Switch to the Manual tab and adjust the sliders manually.
- Wait for Adobe to create a profile for that lens—lens profiles will be added gradually, likely at the same time as new camera support.
- If you have Photoshop CS5, you can open the photo into Photoshop, go to Filters menu > Lens Correction and click the button to search the Adobe Server to download communitycreated profiles, which will then also be available in Lightroom after restarting.
- You can build your own profiles using the free Adobe Lens Profile
 Creator tool. We'll come back to that option a little later.

What do the Manual Lens Corrections sliders do?

The Distortion slider corrects for barrel or pincushion distortion if you don't have a profile for that lens.

"How do I create a Lens Profile using the Lens Profile Creator?" on page 326

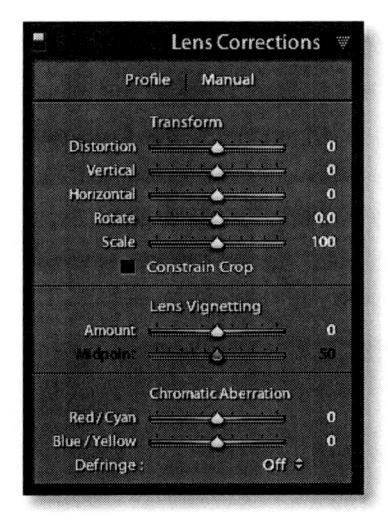

The Vertical and Horizontal sliders adjust for perspective.

The Rotate slider adjusts for camera tilt.

The Scale slider interpolates the data to pull back pixels which have been pushed out of the frame or remove blank areas of the photo caused by the previous corrections.

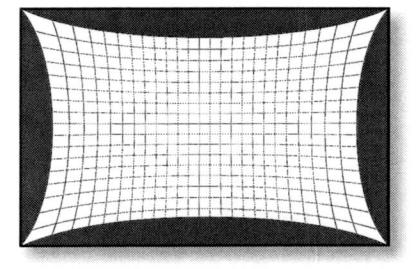

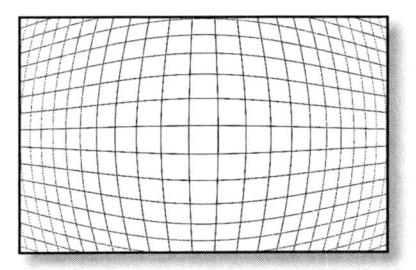

How is the Rotate slider different from Straighten in the Crop options?

The Rotate slider in the Manual Lens Corrections is applied at a much earlier stage in the processing than the crop, with a different result. Rotate pivots on the center of the uncropped photo instead of the center of the crop. In the attached screenshot, the same grid was rotated using the Rotate slider and the Straighten slider and the same -100 Vertical transform applied, but then a small crop was taken from a corner, and you can see the difference.

The detail to remember is that if you're using the Manual Lens Corrections to correct perspective, and your camera wasn't level, use the Rotate slider in the Manual Lens Corrections to level the camera, rather than Straighten in the Crop tool.

"Cropping" section on page 336

How is the Scale slider different to cropping?

If one of your perspective adjustments has pushed some of the photo out of the frame by your Lens Correction adjustments, the Crop tool can't bring those pixels back. The Scale slider adjusted to the left can bring back that pixel data and adds grey padding for blank areas. Scale also interpolates data to match your original pixel dimensions, whereas the Crop tool only crops away existing pixels.

What does the 'Constrain Crop' checkbox do?

The 'Constrain Crop' checkbox in the Lens Corrections panel > Manual tab and the 'Constrain to Warp' checkbox in the Crop options panel both do the same thing—they simply prevent you from including blank grey pixels in your crop. It means that you can crop your photo without having to be too careful to avoid including blank areas. If you uncheck those boxes, it doesn't reset the crop automatically.

Why doesn't the Lens Correction Vignette adjust to the Crop boundaries?

The vignette in the Lens Corrections panel is for correcting lens vignetting, not for effect, and therefore isn't affected by the cropping, however in the Effects panel there is a Post-Crop Vignette with additional options.
How do I fix Chromatic Aberration?

Chromatic aberration refers to the little fringes of color that can appear along high contrast edges, where the color wavelengths have hit the sensor at different points. It's most noticeable around the corners on photos taken with lower quality lenses. They can be corrected as part of the profile lens corrections, or by using the Chromatic Aberration sliders in the Manual tab. If you're manually fixing the chromatic aberration, zoom in on the photo to see it clearly and drag the sliders to realign the color channels until the fringes disappear. The 'All Edges' option in the Defringe pop-up menu can work quite nicely if you're having problems removing the chromatic aberration properly, as it slightly desaturates the edges.

Purple fringing, or blooming, isn't a lens problem, but a sensor problem. It occurs when too much light hits the sensor and that affects the surrounding pixels too. It usually shows up against the edges of specular highlights, and the Defringe controls can help to reduce that problem too.

Can I save Manual lens corrections as defaults for lenses?

If you've used the Manual Lens Corrections to correct a lens that doesn't have a profile, you can save those settings as a standard Develop preset in the Presets panel.

When in my workflow should I apply lens corrections?

It doesn't make any difference to the end result, whether you apply Lens Corrections before or after other settings, as they still go through the processing pipeline in their normal order, rather than the order that vou've moved the sliders.

There can be noticeable differences in UI (user interface) response speeds, particularly when combining Lens Corrections with the Spot Removal or Local Adjustment tools, which may affect the order in which

Also check...

"How do I create my own Develop Presets?" on page 302

you choose to apply settings, although you'll probably need to adjust the crop after applying Lens Corrections.

How do I turn off the grid overlay?

You can't turn the lens correction grid off, but it only appears when you float over the Lens Corrections sliders.

How do I create a Lens Profile using the Lens Profile Creator?

If your lens isn't currently supported by Adobe, you can build your own profile using the free Lens Profile Creator tool which you can download from Adobe Labs: http://labs.adobe.com/technologies/lensprofile_creator/ There's extensive instructions that come with it, so we won't go into detail, but the idea is simply that you print the target and then photograph it in different positions on the sensor with different combinations of settings, for example, different focal lengths for zoom lenses. The target needs to be flat, but the Lens Profile Creator tool can compensate for variations in positioning and lighting, so you don't have to have a studio setting or perfect alignment. You then feed those sets of files into the Lens Profile Creator and it will create a profile automatically. If Adobe later create a profile for your lens, both will be shown in the pop-up menus.

Does it matter which camera body is used when creating a lens profile?

When creating a lens profile, use the largest sensor size available, for example, if you have a Canon 5D with a full frame sensor and a Canon 50D with a cropped sensor, use the full frame. The lens profiles can compensate for smaller sensor sizes but can't create data for larger sensors, and other differences between camera bodies have a minimal effect on the lens profiles.

EFFECTS—POST-CROP VIGNETTE & GRAIN

Vignetting is the darkening or lightening of the corners of a photo. Although traditionally it's caused by the camera lens, it's become popular as a photographic effect. Lightroom 3 has moved some of the

sliders between panels, so the lens correction vignette, which is designed for fixing those lens issues, has moved to the new Lens Corrections panel, and the post-crop vignette is now in the Effects panel.

Lightroom 3 also introduces a new Grain effect, designed to simulate traditional film grain, which is much more natural than digital noise.

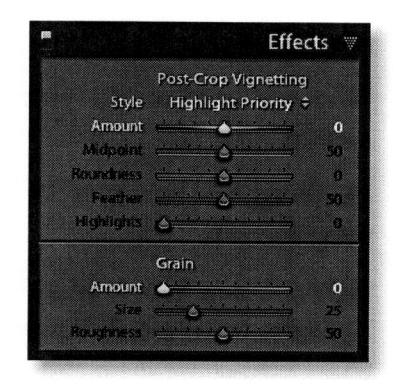

What's the difference between Highlight Priority, Color Priority and Paint Overlay?

The pop-up menu in the Effects panel gives a choice of 3 different postcrop vignettes, which all fit within the crop boundary, rather than the original lens correction vignette which is designed for correcting lens problems.

Highlight Priority is the default and imitates a traditional lens vignette with the colors remaining heavily saturated throughout.

Color Priority retains more natural colors into the vignette, with smoother shadow transitions.

Paint Overlay is the post-crop vignette from Lightroom 2, which adds a plain black or white overlay.

How do the Post-Crop Vignette sliders interact?

Amount logically affects the amount, with -100 being very dark and +100 being very light.

Midpoint controls how close to the center of the photo the vignette affects, ranging from 0 affecting the center and 100 barely touching the sides.

Roundness runs from -100 which is almost rectangular, to +100 which is circular.

Feathering runs from 0 to 100, with 0 showing a hard edge, and 100 being very soft.

Highlights runs from 0, which has no effect, to 100, which makes the highlights under a dark vignette brighter, allowing you to darken the edges without the photo becoming too flat and lacking in contrast.

How do the Grain sliders interact?

Amount obviously affects the amount of grain applied. The noise is applied equally across the photo, giving a much more film-like quality than digital noise, which tends to be heavier in the shadows.

Size affects the size of the grain, just as grain on film came in different sizes, and it gets softer as it gets larger.

Roughness affects the consistency of the grain, so 0 is even across the photo, whereas higher values become rougher.

Why does my grain not always look exactly the same in the exported file as in the Develop preview?

Grain is very sensitive to resizing, sharpening and compression, so you'll need to view it at 1:1 view in Develop to see an accurate preview.

"The previews are slightly different between Library and Develop and Fit and 1:1 views—why is that?" on page 260

CALIBRATION PROFILES & STYLES

In the Camera Calibration panel, you'll notice a 'Profile' pop-up menu. It contains the profiles that we mentioned in the Raw File Rendering section at the beginning of the chapter.

The Adobe Standard profiles are the new default profiles and replace the

old ACR X.X profiles. The Camera Style profiles emulate the manufacturers own standard rendering and Picture Styles, giving a close match to a camera JPEG file. There is no right or wrong rendering. It's down to personal choice, and may vary depending on the photo.

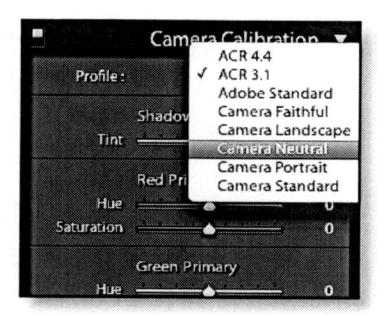

"DNG Profile Editor"

section on page 330

How do I install and use the profiles?

The profiles are automatically installed with each Lightroom update. Once installed, the profiles appear in the Profile pop-up menu in the Camera Calibration panel, ready for you to select on each individual photo.

Which are the profiles for my camera?

Any of the profiles in the Profile pop-up menu are the correct profiles for your camera. It won't show you profiles for other cameras.

ACR 4.4

✓ ACR 3.1

Adobe Standard

Camera Faithful

Camera Landscape

Camera Neutral

Camera Portrait

Camera Standard

They use standard names such as 'Camera Standard' so that you can save them in presets which can be applied to multiple different camera models. Your camera model might use a slightly different naming system, but 'Camera Standard' is the camera's

default picture style, and others such as 'Portrait' and 'Landscape' are options on most cameras.

Also check...

"If I can use all of Lightroom's controls on JPEG files, why would I want to shoot in my camera's raw file format?" on page 62

Why does my Nikon D300 have D2X profiles?

Nikon cameras other than the D2X may also show D2X Styles in the Profiles pop-up menu. That simply refers to their D2X 'style,' not the camera of the same name. It's Nikon's naming convention!

Why does the profile pop-up menu just say 'Embedded'?

Camera profiles are only available for raw files, so JPEG/PSD/TIFF format files will only show 'Embedded' in the list of profiles.

Why do I only have Matrix listed?

If the only option in your Profile pop-up menu says 'Matrix,' it means that all of the other profiles are missing from your system, and it's reverted to the old ACR X.X profiles. Reinstalling Lightroom or ACR should also reinstall the profiles.

The ACR version number in the Calibration section is an old version—how do I update it?

Older numbers, such as 3.1, are the version of ACR that was current when the camera support was officially released.

If there's a newer version listed in the Calibration Profile pop-up menu, you can select that instead, however be aware that your Develop settings may render differently with the alternative Camera Profiles.

DNG PROFILE EDITOR

Everyone has their own preferences for raw conversion. Some like the manufacturer's own rendering and others like a variety of different raw

converters. Often you hear people say 'I prefer the colors from XXX raw converter' or 'Why doesn't my raw file look like the camera rendering?'

In the past, there was no way of accurately replicating a look from another manufacturer, but that's now changed. Using the free standalone DNG Profile Editor, it's possible to create complex profiles that can closely match the color rendering of any camera manufacturer or raw converter using Lightroom, while enjoying all of the other tools that Lightroom has to offer.

"Raw File Rendering" section on page 271

Why is the DNG Profile Editor better than the Calibration sliders?

The original Calibration sliders didn't allow for different adjustments for different saturations of the same color, so when you adjusted, for example, the reds, you affected all of the reds in the photo. The new DNG Profile Editor allows you to separate those saturation ranges, adjusting each in a different direction.

For example, reds with low saturation values, such as skin tones, may be too red and the reds with high saturation values, such as a fire truck, may be too orange. That couldn't be corrected with any combination of the previous sliders, and yet can be easily adjusted with the DNG Profile Editor.

Can I use the profiles on proprietary raw files, not just DNG?

It's called the DNG Profile Editor because the profile format is described in the new DNG specification. The DNG Profile Editor itself only reads DNG files, but the resulting profiles can be used on any raw file format.

Why doesn't it use ICC profiles?

The DNG Profiles are much newer technology than ICC profiles, and offer a better result. They're much smaller than full ICC profiles, which allows for multiple profiles to be embedded in DNG files without noticeable

file size increases, which could otherwise quickly add up over a volume of files. They also allow two calibrations to be included, interpolated by color temperature, which ICC profiles can't do.

Where do I download the DNG Profile Editor?

The DNG Profile Editor is officially still in beta, and is therefore hosted on Adobe Labs, however it's as stable and 'finished' as a final release. You can download it from the Adobe Labs website at: http://labs.adobe.com/wiki/index.php/DNG_Profiles:Editor

How do I use the DNG Profile Editor? It looks complicated!

Adobe isn't expecting everyone to use the DNG Profile Editor to create their own profiles, but the facility is available for those who do wish to use it. It's far easier than it looks.

There's a comprehensive tutorial with the download, so we'll just go through the basic idea, and a few extra tips:

- Correct the white balance before you start, if you haven't done so already. A right-click switches the cursor from a standard Eyedropper to the White Balance Eyedropper, and the white balance values will be shown in the photo window title bar.
- If you have a ColorChecker Chart, you might like to use that as
 a starting point. Using the Chart tab, you can run an automatic
 profile creation. The settings created automatically from your
 24-patch ColorChecker Chart will appear as if you had created
 the color control points manually. You can either accept these

adjustments and save the profile, or you can go on to tweak further. It also allows you to shoot 2 different lighting conditions (2850K and 6500K) and create a

- single profile with both sets of adjustments, ready for interpolation between the two.
- You can create additional color control points by clicking on the photo or on the Color Wheel. You can use color control points to fix specific colors to stop that color from changing, as well as creating color points to shift the colors.

- 4. The color control points then appear in the Color List Box to the right of the Color Wheel.
- 5. The checkbox to the left of your new color rectangle enables and disables the adjustment, showing as black when enabled. It's useful for previewing the changes to specific colors.

- 6. The—icon to the right of the color rectangle removes that color control point, as does Alt-clicking (Windows) / Opt-clicking (Mac) on the color control point on the Color Wheel. You can select a different color control point by either clicking directly on the point on the Color Wheel, or by clicking on the color rectangle in the Color List.
- Adjust the sliders below the Color Wheel, and you'll see the photo
 preview update live based on your adjustments. You'll also see
 the color rectangle in the Color List Box split in half, showing the
 before and after color.
- 8. In addition to adjusting the colors on the Color Wheel, you can also adjust the other panels such as the Tone Curve. The Tone

- Curve adjustments will be relative to the base tone curve you select. You won't usually need to use the Color Matrices panel.
- 9. Once you've finished, save your Profile Recipe by selecting File menu > Save Recipe... That doesn't create the profile—it just saves your current list of changes so that you can come back and change it again later without having to start again.
- 10. When you're ready to save your profile, use File menu > Export Profile... Profiles will be saved with a .dcp extension, and are usually camera-specific. Save the profile into the Camera Profiles directory, and then you'll need to restart Lightroom/ACR before the new profile will be become available for use.

A few other quick hints:

- You can have multiple photos open at the same time, and the previews will all update, so you can see how your changes will affect a variety of different photos.
- If you have multiple photos from different cameras open at the same time, both photos will still update based on your current profile settings. You can save the profile for use with both cameras—the File menu > Export Profile... command is updated to the name of the currently selected photo (i.e. Export Canon EOS 5D Profile...)
- You can load any other profile as a starting point, including the camera emulation profiles, and then tweak to your taste, or you can start from a blank canvas. To load another profile as a starting point, select your profile from the Base Profile pop-up menu, and all adjustments will be made relative to that profile.

Is there a simpler way of creating a DNG Profile for my camera?

If you have a 24-patch ColorChecker Chart, there's a Lightroom export plug-in which can automatically create a DNG Profile, without you having to even open the DNG Profile Editor. You can download the

Also check...

"The default locations of the Adobe Camera Raw & Lens Profiles are..." on page 464 and "Your custom Camera Raw & Lens Profiles can also be installed to the User folders..."

ColorChecker Passport plug-in from http://www.xritephoto.com/ after filling out their free website registration form.

CROPPING

In an ideal world, you'd have the time to make sure a photo was perfectly composed in the camera at the time of shooting. Unfortunately, very few of us live in an ideal world all of the time, and by the time you've perfected the shot, you'll have missed the moment. Many photos benefit from cropping and straightening during post-processing, so Lightroom provides the tools to do so, without having to switch to a destructive editor such as Photoshop.

You can go directly to the Crop tool from any module by pressing the R key, or you'll find it in the Tool Strip beneath the Histogram. You can either drag the edges or corners of the crop bounding box or select a preset crop ratio from the Crop options panel.

Why does the crop go in the wrong direction when I try and move the grid around?

Lightroom's crop is completely opposite to Photoshop's crop. It does take some getting used to, but most seem to feel it's actually better once you do get used to it. Unlike Photoshop, when you rotate the crop, the resulting cropped photo remains level instead of having to turn your head to see how the photo will look once it's cropped.

Think of it as moving the photo underneath the crop overlay, rather than moving the grid. And you can turn the grid off by pressing O if you find it distracting.

How do I crop a vertical portion from a horizontal photo?

The change the crop orientation, drag the corner of the crop diagonally until the long edge becomes shorter than the short edge and the grid flips over, or just press the X key.

Alternatively, unlock the ratio lock in the Crop options panel and adjust to the crop of your choice. You can also drag a crop freehand, as long as any existing crop has been reset, just as you would in Photoshop.

Can I zoom while cropping?

You can't zoom while in Crop mode, but if you need a larger preview, select the Crop tool and then press Shift-Tab to hide all of the side panels. It's particularly useful when straightening a photo.

How can I change the default crop ratio?

You can't change the default crop ratio, but there are two easy workarounds. Either go to Grid view, select the photos and choose the ratio you want from the Quick Develop panel, or crop the first photo in normal Crop mode, and synchronize that with all of the other photos. Either way, it's intelligent enough to rotate the crop for the opposite orientation photos, but beware, as either option will reset any existing

crops. Once you've done that, your chosen ratio will already be selected in the Crop options panel and you can go through the photos and adjust the crop as normal.

How do I set a custom crop aspect ratio?

In the Aspect pop-up menu, which you'll find in the Crop options under the Tool Strip, you can select 'Enter Custom...' and choose your own fixed crop ratio, or you can unlock the crop ratio by clicking on the padlock icon and draw a custom crop.

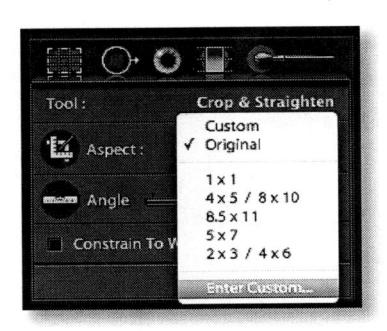

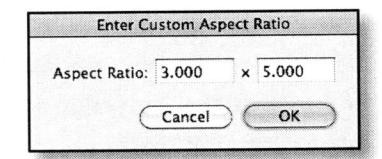

How do I delete a custom crop aspect ratio?

You can't delete custom crop ratios manually, but they work on a rolling list of 5, so only your most recent 5 custom ratios remain in the list, and as you add a new one, the oldest one is removed from the list.

How do I set my crop grid back to thirds or bring the Crop Overlay back when it goes missing?

Press O to cycle through a variety of useful overlays—Grid, Thirds, Diagonal, Triangle, Golden Ratio and Golden Spiral—and Shift-O to change the orientation of the overlays.

Is it possible to change the Crop Overlay color?

You can't change the Crop Overlay color, but you can enter Lights Out mode by pressing the L key twice to get a better view of the crop as you adjust it. Press L again to switch back to the normal view.

How do I straighten or rotate a photo?

With the Crop tool selected, click on the Straighten tool in the Crop options panel under the Tool Strip. You can also access it by holding down the Ctrl key (Windows) / Cmd key (Mac) while the Crop tool is selected. Click on the horizon and still holding down the

mouse button, drag along the line of the horizon. Lightroom will automatically rotate the photo to straighten the horizon line you've just drawn.

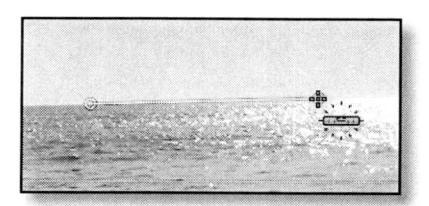

Also check...

"Tethered Shooting & Watched Folders" section on page 111 and "Loupe View, Info Overlay & Status Overlay" on page 124

Can a crop be saved in a preset?

You can't save a crop in a preset, but there are a couple of alternatives—select the photos in Grid view and choose your crop ratio in Quick Develop to apply it to multiple photos, or for tethering, applying the crop to one photo and then using the 'Previous' setting, as we mentioned in the Import chapter.

Is there a way to see what the new pixel dimensions will be without interpolation?

If you go to View menu > View Options..., you can set the Info Overlay to show 'Cropped Dimensions,' which is the cropped pixel dimensions without any resampling. Every time you let go of the Crop edge, the dimensions will update.

SPOT REMOVAL—CLONE & HEAL TOOLS

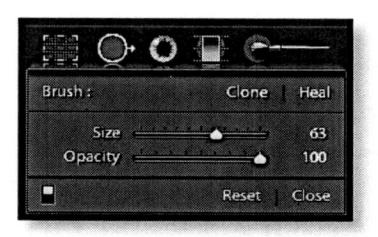

The Spot Removal tools are called spot removal for a reason. It is possible to do fairly complex retouching with multiple overlapping spots, but that's not what it was designed for. As Lightroom is a metadata editor, it has to constantly re-

run text instructions, so it gets slower with the more adjustments that you add. The tools are designed for removing spots such as sensor dust,

and detailed retouching is quicker and easier in a pixel editing program, such as Photoshop or Elements.

How do I retouch a spot?

To use the Spot Removal tools, select it from the Tool Strip beneath the Histogram. In the options panel below, you'll note that you have a choice of Clone or Heal. Heal works like the Healing Brush in Photoshop, intelligently blending the pixels, and Clone works like Photoshop's Clone tool, picking up the pixels and dropping them in another location.

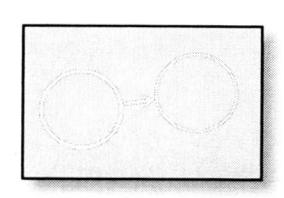

For most spots, the Heal option works best, particularly in clean areas such as sky. If you're trying to retouch a spot along an edge in the photo, for example, a roofline against the sky, the Heal tool can smudge, in which case the Clone option may work better.

If you click once on the photo, Lightroom will intelligently search for the most suitable source of replacement pixels. If you want to choose the source yourself, click on the spot and drag to that chosen source without letting go of the mouse button.

If you zoom into 1:1 view to do retouching, start in the top left corner and then you can use the Page Down key to work through the photo. It divides the photo up into an imaginary grid, and when you hit the bottom of the first column, it automatically returns to the top of the photo and starts on the next column. By the time you reach the bottom right corner, you'll have retouched the entire photo without missing any spots.

How do I adjust the brush size or the size of an existing spot?

In the Spot Removal options panel under the Tool Strip is a brush size slider, or you can use the [and] keyboard shortcuts or your mouse scroll wheel to adjust the size. You can readjust

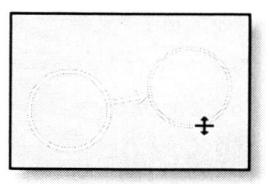

an existing spot by clicking on it to make it active and using those same controls. Alternatively, if you hover over the edge of an existing spot, the cursor will change and you can then drag that edge to adjust the size.

How do I adjust the opacity of an existing spot?

If you click on the spot to select it, and then adjust the Opacity slider in the Spot Removal options panel, you can fade the effect of the retouching.

How do I move or delete an existing spot?

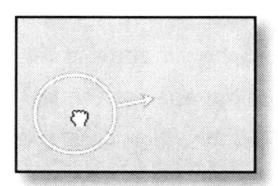

When you hover over the center of an existing spot or retouching source spot, the cursor will change, and you can then drag to move that spot. If you need to delete a spot, click on it to make it active, and then press the Delete key on your keyboard.

Can I copy or synchronize the clone/heal spots?

You can copy or synchronize clone/heal spots in the same way as you synchronize any other settings, using Copy/Paste or Sync, that we covered earlier in the chapter. This is particularly useful when using the spot tools to remove sensor dust in a clear area of sky, as it's intelligent enough to adjust for orientation.

Also check...

"Can I synchronize my settings with other photos?" on page 352

RED EYE REDUCTION TOOL

Red eye in photography is caused by light from a flash bouncing off the inside of a person's eye. Although many cameras now come with red eye reduction, those pre-flashes tend to warn people that you're about to take a photograph, and can lose any spontaneity. Lightroom's Red Eye tool can fix red eye very easily, so you can safely turn that camera setting off.

How do I work the Red Eye Reduction tool?

To remove red eye, select the Red Eye Reduction tool from the Tool Strip beneath the Histogram and drag from the centre of the eye, to encompass the whole eye. It will automatically search for the red eye within that area and once it locks, you can adjust the sliders to change the pupil size or darken the retouching.

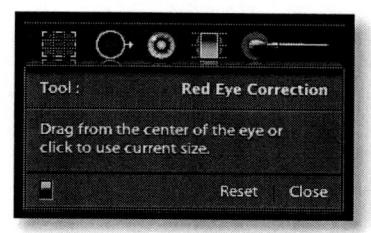

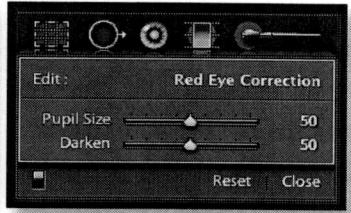

Lightroom's Red Eye Reduction tool can't lock on to the red eye—is there anything I can do to help it?

If the Red Eye Reduction tool can't lock on to the red eye, try temporarily

increasing the red saturation in the HSL panel and try again. Once it locks, you can set the HSL panel back to its previous settings.

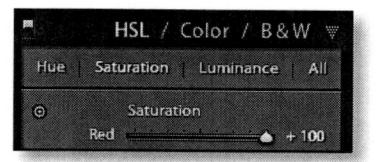

Why doesn't the Red Eye Reduction tool work properly on my dog's red eye?

Animals have different colored red eye, so the tool can't find the red it's looking for. As an alternative, try the Adjustment Brush, set to lower exposure and a suitable color.

LOCAL ADJUSTMENTS—GRADUATED FILTER & ADJUSTMENT BRUSH

Most of Lightroom's controls are global, which means that they affect the entire photo. The Local Adjustments allow you to paint a mask on

the photo, either by means of a brush or gradient, and apply adjustments just to that masked area.

The Local Adjustments can make localized changes to Exposure, Brightness, Contrast, Saturation, Clarity, Sharpness, or apply a Color Tint. For example, the Exposure adjustment is similar to dodging and burning in Photoshop or in a traditional darkroom. Settings such as Sharpness and Clarity can be used for softening skin on portraits. Color is useful when

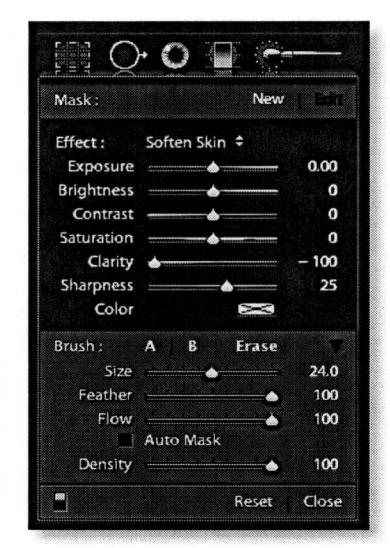

adjusting for mixed lighting situations. Settings can be combined, so a combination of perhaps Exposure, Saturation, Clarity and a blue tint can make a dull sky much more interesting. If you regularly use the same combination of sliders, you can save their settings using the pop-up menu in the options panel.

Why would I use the Graduated Filter & Adjustment Brush rather than editing a photo in Photoshop?

When you edit a photo in Photoshop, you have yet another large photo file to store, whereas using Lightroom's Local Adjustments stores the adjustment information nondestructively in metadata. That leaves you with a tiny amount of text information which is stored as part of the catalog, and you can always go back and change your adjustments without damaging the original file.

This doesn't mean that Lightroom entirely replaces Photoshop—there are still many pixel based adjustments that would require Photoshop—however it does mean that you can make many more adjustments within Lightroom's own interface and save them nondestructively without vast storage requirements.

Because Lightroom has to constantly re-run text instructions, rather than applying them destructively to the original pixels immediately, it can be slower when there are lots of adjustments, so there's a fine line, depending largely on your computer hardware.

How do I create a new brush mask?

When you select the Adjustment Brush, it will automatically be ready to start a new mask. Select your brush characteristics and the effect you want to apply then simply start painting!

For example, the following screenshots show the Amount set to Exposure. +4.0 brightens the exposure by +4.0 as in the white screenshot, +1.0 brightens the exposure by +1.0 as in the grey screenshot, and -4.0 darkens the exposure by -4.0, as shown in the black screenshot.

In some cases, you may find it helpful to paint with the slider turned up higher than your intended result, or with the mask overlay turned on (press O), in order to clearly see where you're painting, and then turn it down again when you've finished painting. Holding down the Shift key whilst you paint will draw the stroke in a straight vertical or horizontal line.

What do Size and Feather do?

Size logically affects the size of the brush, and Feather is the hardness of the brush edge. You can see the effect of the feathering set to 0 (top, hard), 50 (center), and 100 (bottom, soft).

Also check...

"How do I show the mask I've created?" on page 350

The brush cursor changes depending on the size of the brush and the amount of feathering, with the cursor screenshot at the top showing feathering at 0, and the cursor screenshot below showing the same size brush but with the feathering setting at 100.

You can also use the [and] keys to increase and decrease the size of the brush, and Shift-[and Shift-] keys to increase and decrease the feathering.

What's the difference between Flow & Density?

Flow controls the rate at which the adjustment is applied.

With Flow at 100, the brush behaves like a paintbrush, laying down the maximum effect with each stroke. You can see this in the screenshot, where the effect is applied equally with each stroke.

With Flow at a lower value such as 25, the brush behaves more like an airbrush, building up the effect gradually. Each stroke adds to the effect of the previous strokes, giving the effect shown in the screenshot, where areas that have multiple brushstrokes are stronger than those with a single stroke.

Density controls the maximum strength of the stroke. Regardless of how many times you paint that stroke or the settings used, it can never be stronger than the maximum density setting. In the screenshot, the

top line—the one that you can't see—is set to 0. The center line is set to 25 and the bottom line is set to 100. Unless you need the Density control for a specific purpose, I would suggest leaving it set at 100.

To fully understand these controls, try creating a single 50% grey file and testing different combinations of sliders. It's easier to see the differences when you're not distracted by an image.

Is the Adjustment Brush pressure sensitive when used with a graphics pen tablet?

The pressure sensitivity on your graphics pen tablet controls the opacity of the stroke.

What does Auto Mask do?

Auto Mask confines your brush strokes to areas of similar color, helping to prevent your mask spilling over into other areas of the photo. It's very performance intensive so it may slow Lightroom down, and it can also result in some halos, for example, trying to darken a bright sky with a silhouette of a tree in the foreground may leave a halo around the edge of the tree.

Why are there speckles in the brushed area?

If you find speckles or dots in the brushed area, try turning off Auto Mask and painting the area again. Auto Mask can miss some odd pixels resulting from noise in the photo.

How can I tell if I'm applying a color tint when using the Adjustment Brush?

When no is tint being applied, the Color icon changes and shows a cross instead of a color.

Can I select a color tint from the photo itself?

To select a color tint from the photo, first click on the Color icon to bring up the Color Picker. Click in the Color Picker and while holding the mouse button down, drag the cursor onto the photo itself. As you drag across

the photo, Color Picker will update live to reflect the color beneath your cursor. When you release the mouse button, the color under the cursor will be selected in the Color Picker.

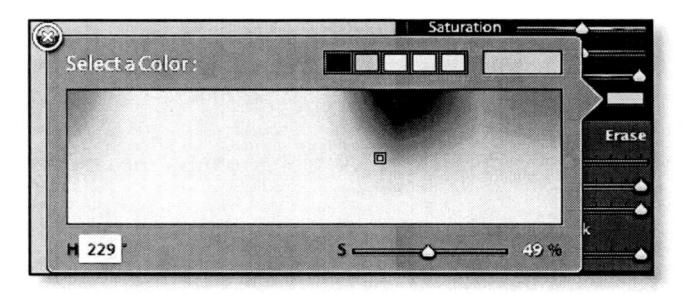

To find a complimentary color to remove a tint, select the color as above, but then click in the Hue field in the Color Picker and type a value 180 degrees from the current value, keeping within the limits of 360 degrees. For example, if the current value is 30, adding 180 will make it 210, but if the current value is 330, you would have to remove 180 to make it 150.

Can I brush on a lens blur effect?

If you set the Sharpening slider to between -50 and -100, it applies a blur similar to a lens blur. It is very processor intensive, so it can be slow.

If I apply sharpening using the Adjustment Brush, where do I adjust the Radius, Detail and Masking?

The Adjustment Brush sharpening is now tied to the main settings in the Detail panel, so the Radius, Detail and Masking settings will be identical across the photo. The amount of sharpening is still independent for the Adjustment Brush, allowing you to apply global sharpening using the Detail panel, and then applying heavier sharpening using the Adjustment Brush, or vice versa.

"Detail—Sharpening & Noise Reduction" section on page 314

Where have my mask pins gone?

Under View menu > Tool Overlay, you have the option to 'Auto Show' which only shows the pin when you float the mouse nearby, as well as 'Always Show,' 'Show Selected' and 'Never Show'. You'll also find those options on the toolbar while the Adjustment Brush is active.

As a quick shortcut, the H key hides the pins, so press H again to return them. It toggles between 'Auto Show' and 'Never Show'.

How can I tell whether I'm creating a new mask or editing an existing mask?

When you select the Adjustment Brush or Graduated Filter tool, Lightroom will automatically be ready to start a new mask, so to edit an existing mask you must first click on the mask pin.

You can check whether you're in New or Edit mode by looking at the top of the Adjustment Brush options panel or by checking which pin is currently selected.

How do I reselect and edit an existing mask?

The mask pins have 2 states—selected or not selected, or active and inactive. Not selected is shown by a white pin, and clicking on the pin will select that mask, turning the pin black. Once your existing mask is reselected, you can adjust the sliders to change the effect, or go back and edit the mask itself.

If you select an existing pin, the Adjustment Brush options panel will automatically switch into Edit mode and you can make additional brush strokes, erase existing brush strokes, and adjust the effect. You can temporarily switch to the Erase tool by holding down the Alt (Windows) / Opt (Mac) button while you paint.

How do I create a new gradient mask?

When you select the Graduated Filter tool, it will automatically be ready to start a new mask. Select the effect you wish to apply, click at your gradient starting point, and drag to your gradient end point before releasing the mouse button.

You can hold down the Shift key while creating the gradient to constrain it to a 90 degree angle, and holding down the Alt (Windows) / Opt (Mac) key will start the gradient from the middle instead an edge.

Having created the gradient, you can go back and adjust both the rotation and length of the gradient, as well as the effect that you're applying.

How do I adjust an existing gradient?

To adjust an existing gradient, re-select it by clicking on the pin, just as you would with a brush mask. The gradient lines will appear, allowing you to make adjustments. You'll find you have more control if you move to the outer ends of the lines.

When you float over the central line—the one with the pin—the cursor will change to a double-headed arrow, enabling you to adjust the rotation of the gradient.

How do I show the mask I've created?

Making sure the mask is selected, press the O key to toggle the mask overlay on and off, or float over the pin and the mask overlay will appear.

Can I change the color of the mask overlay?

To change the mask overlay color, first press O to show the overlay, and then press Shift-O to cycle through a series of different overlays (red, green, lighten and darken) until you find an overlay that can be clearly seen against your photo.

How do I fade the effect of an existing mask?

Clicking the disclosure triangle to the right of the Presets pop-up menu, you can switch between a basic Amount slider and the more advanced slider mode.

The Amount slider increases or decreases the strength of all of the adjustments on the selected mask, so

if you adjust the Amount having made adjustments to multiple sliders, all of the sliders will be adjusted by the same percentage of change. When applied to multiple sliders, you could call it a 'Fade' slider.

You can access the same Amount control without having to switch back to that basic mode—simply click on the pin and while holding the mouse button down, drag left and right and you'll see all the sliders move.

Can I layer the effect of multiple masks?

You can create as many different masks as you like, and they can be overlapped and layered, with the effect being cumulative.

Also check...

"How do I copy or synchronize my settings with other photos?" on page 291

Can I invert the mask?

You can't invert the mask in Lightroom 3, however you can use a large brush to paint over everything, and then use a small brush to erase from that mask. For example, you can paint the entire photo using a -100 Saturation brush to make it Black & White and then erase to show a small amount of the original color photo below.

Can I synchronize my settings with other photos?

You can copy or synchronize Local Adjustments in the same way as you synchronize any other settings.

Can I save my Adjustment Brush strokes in a preset?

If you've created, for example, a brushed edge effect, you may want to apply that later to other photos. Lightroom doesn't allow you to save brush strokes in a preset, but you can sync the settings across multiple photos. If you keep a folder of plain grey JPEGs, for example, they can be used to store those brushed vignettes to sync to other photos in the future, and they're easily identified without having to search through all of your photos.

Editing in Other Programs

Lightroom is a parametric editor, which means that it runs text instructions rather than directly editing the pixels. It's designed for the management and processing of large numbers of photos, and not as a replacement for Photoshop. Lightroom can do spot removal and localized tonal adjustments, but pixel editors, such as Photoshop and Elements, are still better suited to more detailed retouching. Lightroom integrates with both Photoshop and Elements, as well as other image editing software.

EDITING IN OTHER PROGRAMS

Using the Edit in... commands in the right-click menu, you can open the photo directly into Photoshop when using a matching version of ACR, or by means of an interim TIFF or PSD file for Elements or other software.

How do I change my Edit in... file settings?

Your External Editor settings are chosen in the Preferences dialog > External Editing tab. In that dialog, you choose the file format, color space, bit depth, resolution and compression, as well adding additional External Editors. We'll come back to some of those choices in more detail in the Export chapter.

"Export" chapter on page 367

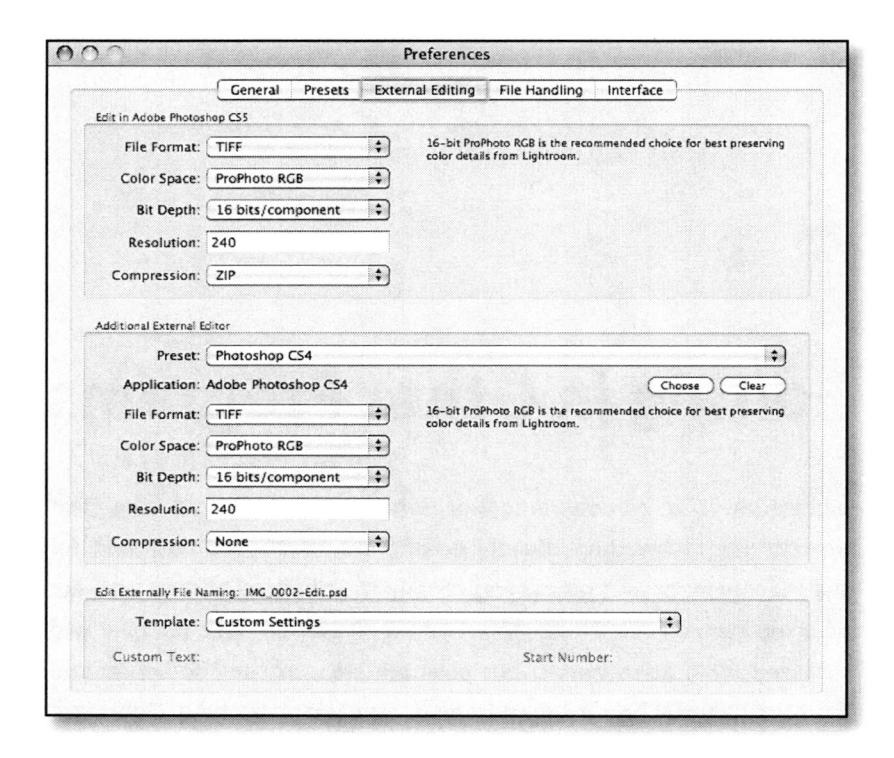

In the Edit in... options, should I choose TIFF or PSD?

In terms of functionality, there's no longer a difference between the TIFF and PSD formats—you can save everything to a TIFF that you can to a PSD. TIFFs are more efficient when updating metadata and they're compatible with a wider range of software, so Adobe are generally recommending TIFFs now, but both are lossless formats, so it's largely down to personal choice.

Can I have more than two External Editors?

While there are only two main External Editors, you can create additional presets using the same Preferences > External Editing dialog.

The Primary External Editor automatically selects the most recent full version of Photoshop, or if it can't find Photoshop, then it selects the

latest version of Elements. It takes the main shortcut Ctrl-E (Windows) / Cmd-E (Mac).

You can create as many Additional External Editors as you like, and they will appear in the Edit in... Menu. Simply press the Choose button in the Additional External Editors section, navigate to the program you want to use, and select the exe file (Windows) / application (Mac). Choose your other settings, and then select 'Save Current Settings as New Preset' from the pop-up menu. They'll then appear in the Edit in... menu, ready to use.

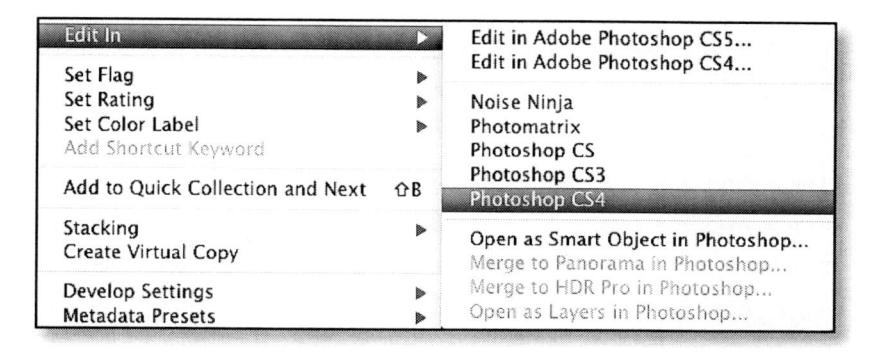

The preset you currently have selected in that dialog will become the main Additional External Editor shown at the top of the list, and assigned the secondary keyboard shortcut, which is Ctrl-Alt-E (Windows) / Cmd-Opt-E (Mac).

How do I get Lightroom to use a different version of Photoshop?

If you have multiple versions of Photoshop installed, Lightroom should use the most recent full version of Photoshop. For example, if you had Photoshop CS4 installed, and then you install Photoshop CS5, Lightroom will update to show Photoshop CS5 as its primary external editor.

If you want to use a different version, for example, the 32-bit version on Windows, you can just make sure your chosen version is already open when you select Edit in Photoshop. Lightroom won't open the 64-bit

version if the 32-bit version is already in use, which is useful if some of your Photoshop plug-ins haven't updated to 64-bit yet.

You can also set older versions of Photoshop as Additional External Editors.

Lightroom can't find Photoshop to use Edit in Photoshop—how do I fix it?

When Lightroom starts up, it checks to see whether Photoshop or Photoshop Elements are installed, and if it can't find them, then the Edit in Photoshop menu command is disabled. If, for example, you install Photoshop CS5 and then decide to uninstall Photoshop CS4, the link can get broken.

Uninstalling and reinstalling Photoshop will usually fix it, or you can fix it by editing the registry key (Windows) or deleting Photoshop's plist file (Mac). There's more information on the official tech note at: http://go.adobe.com/kb/ts_kb401629_en-us

Of course, you could just take the easy course and add it as an Additional External Editor, however you would be missing out on some of the direct integration.

Can I open the raw file into another raw processor?

Lightroom sends TIFF/PSD files to its Additional External Editors, rather than the raw data, which is ideal for most pixel editing software, but there may be occasions when you want to open a photo into another raw processor. On those occasions, you can right-click on the photo, choose Show in Explorer (Windows) / Show in Finder (Mac) and then open into your raw processor, or you can export as 'Original' format, with the raw processor set as the Post-Processing Action, however the latter will result in an additional copy on your hard drive.

John Beardsworth has made it far easier with his Open Directly plug-in, which takes the original file and opens it into the software of your

choice. http://www.beardsworth.co.uk/lightroom/open-directly/ It will pass the original file to any other software, so it's not just limited to raw processors, but can be used for passing video files to video editing software too.

Why isn't Lightroom creating a TIFF or PSD file according to my preferences?

If you open a photo directly into Photoshop when it's set as the Primary External Editor, allowing ACR to process the file, then the file won't be saved until you choose to save it. If you choose not to save the file, you don't have to worry about going back to delete the TIFF or PSD.

When you do press Ctrl-S (Windows) / Cmd-S (Mac) in Photoshop, or go to File menu > Save, it will create the TIFF or PSD file according to your Lightroom preferences. You don't need to use 'Save As' to create the TIFF/PSD file.

How do I open my layered file back into Photoshop without flattening it?

Lightroom doesn't understand layers because it's not designed as pixel editing software. That means that when you apply Develop changes to a layered photo, that layered photo must be flattened to apply the changes, losing your layers in the process, but of course, that doesn't have to be done until the final export.

If you need to open the photo back into Photoshop to make further adjustments to the layers, perhaps for additional retouching, choose the 'Edit Original' or 'Edit a Copy' options, rather than 'Edit a Copy with Lightroom Adjustments.' That will open the original layered file into Photoshop without your Develop adjustments, and when you bring the file back into Lightroom, your Develop adjustments will still be laid nondestructively over the top.

"Managing Videos" chapter on page 186 and "Raw Files" diagram on page 365

Also check...

"Rendered Files (JPEG/ TIFF/PSD)" diagram on page 364

What's the difference between 'Edit Original,' 'Edit a Copy,' or 'Edit a Copy with Lightroom Adjustments'?

If you're passing a rendered file to Photoshop—a TIFF, a PSD, or a JPEG—then there will be a dialog asking how you want to handle that file.

'Edit Original' opens the original file into Photoshop.

'Edit a Copy' creates a copy of the original file, in the same format, and open that into Photoshop.

'Edit a Copy with Lightroom Adjustments' passes the image data and the settings to ACR to open directly into Photoshop, or creates a TIFF/PSD if you're using Elements. If there's a mismatch in ACR versions, it shows the same ACR Mismatch dialog as a raw file, with the same results. We'll go into those mismatches in further detail in the next section.

What do the other options in the Edit in... menu do?

Using Edit in Photoshop as the primary External Editor, you can open the file or multiple files directly into Photoshop CS3 10.0.1 or later without first saving an interim TIFF or PSD file, although you may get unexpected results if you're not using a fully compatible version of ACR, which we'll discuss in the next section.

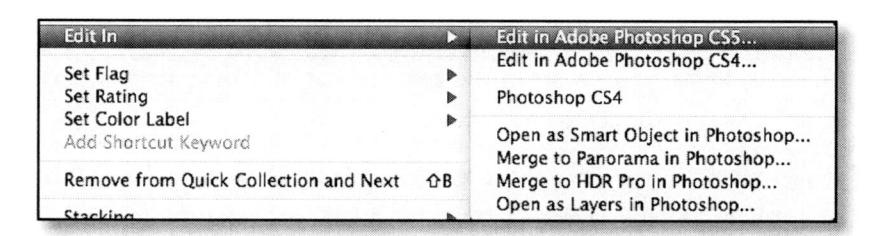

'Open as Smart Object in Photoshop' logically does exactly what it says. In the case of a raw file, this means that you can go back and edit the raw file settings in ACR while in Photoshop, although those Develop settings won't then be updated on the original raw file in your Lightroom catalog, but will remain with the edited copy.

'Merge to Panorama in Photoshop' and 'Merge to HDR in Photoshop' only become available when you have multiple photos selected. 'Merge to Panorama' opens the files directly into the Photomerge dialog in Photoshop allowing you to create panoramic photos, and 'Merge to HDR' opens the files directly into the Merge to HDR dialog in Photoshop to create HDR photos. The resulting photos are automatically added to your Lightroom catalog when you save them.

And finally, 'Open as Layers in Photoshop' also only becomes available when you have multiple photos selected. It opens the files directly into Photoshop and places those photos into a single document as multiple layers, which is particularly useful if you've created different renderings in Lightroom that you want to merge in Photoshop.

If you're using Photoshop Elements, those additional direct integration options will be unavailable, but Matt Dawson's Elemental plug-in adds similar functionality for Elements 6 or later, and is available from: http://thephotogeek.com/lightroom/elemental/

ADOBE CAMERA RAW COMPATIBILITY FOR PHOTOSHOP

ACR, or Adobe Camera Raw, is the processing engine which allows Adobe programs to read raw file formats and convert them into image files. It's available as a plug-in for Adobe Bridge and Photoshop, and that same backbone is built directly into Lightroom itself.

Updates are released every 3-4 months to add new camera support, with separate downloads for the plug-in and for Lightroom. Lightroom runs as a standalone program, without any need for Photoshop, but if you do want to use the two together, it's important to update both at the same time to make sure the ACR versions are fully compatible, or at least ensure that you understand the implications of a mismatch.

Also check...

"How do I update Lightroom with the latest version of ACR?" on page 473

How do I check which Lightroom and ACR versions I have installed?

Every time a Lightroom update is released, there's a matching ACR plugin update, and for full compatibility those versions need to match.

You can check both your Lightroom version number, and the matching ACR version, by going to About Adobe Photoshop Lightroom 3 under the Help menu (Windows) / Lightroom menu (Mac).

To check your ACR version, open any raw photo into ACR using Bridge or Photoshop, and you'll see the number on the ACR dialog title bar.

Which ACR version do I need for the settings to be fully compatible?

At the time of release of Lightroom 3.0, the matching ACR version is 6.1. They're both released at the same time, so in the future, 3.2 is likely to match 6.2, 3.3 should match 6.3, and so forth.
ACR 6.x is only available for CS5 and Elements 8, but Adobe don't force you to upgrade Photoshop every time you upgrade Lightroom. If you're using Elements, CS4, or another earlier release, Lightroom will still work correctly, but you'll miss out on some of the cross-application support when using the Edit in Photoshop tools.

What happens if I'm still using an older version of ACR and Photoshop?

If you're using a mismatched version of ACR, it may not understand all of Lightroom 3's new settings, and therefore the rendering may be different. Besides the new camera support, there are a few other changes involved, depending on the version number. In recent years, there have been changes to the demosaic, new sliders added such as Grain, existing sliders redesigned resulting in the introduction of Process Versions, and now the new lens corrections too.

The demosaic, in basic terms, is the initial translation of the raw data into an image, which applies to all of the photos regardless of your Process Version setting. ACR 5.6 and earlier use an older demosaic, whereas Lightroom 3 and ACR 5.7 and higher all use the new demosaic. The visible difference is an increased amount of detail in the newer demosaic, which can affect the amount of sharpening and noise reduction you choose to apply. If you open a Lightroom 3 photo into a version of ACR with the old demosaic (5.6 or earlier), for example, opening a photo directly into CS3 with ACR 4.6, then it will appear softer and less detailed than Lightroom 3, even if you've used sliders that it understands.

There are also new sliders which older ACR versions may not understand, for example, Grain and the post-crop vignette Highlight Priority and Color Priority options, are understood by 5.7 but no earlier. The original post-crop vignette, local adjustments, and camera profiles are understood by 4.6 but no earlier.

Further down the line are the processing algorithms, including Fill Light, Noise Reduction and Sharpening, which have changed so significantly

"Process Versions" section on page 274 and "Can I open a raw file directly into the ACR dialog?" on page 363

Also check...

"Detail—Sharpening & Noise Reduction" section on page 314 and "Lens Corrections" section on page 319 this time that they now come in 2 different versions – Process Versions 2003 and 2010, more often shortened to PV2003 and PV2010. We discussed those in more detail in the Develop chapter.

And of course, last but not least, there are the new lens corrections which require ACR 6.1 or later.

Here's a quick reference of the most recent ACR versions for each Photoshop release, and the differences you're likely to see if you leave ACR to process your files.

	Demosaic	PV2003	PV2010	New	Lens
				Sliders	Correct
CS3 / 4.6	Mismatch	Close	Mismatch	Mismatch	Mismatch
CS4 / 5.7	Match	Close	Close	Close	Mismatch
			(no UI)	(no UI)	
CS5 / 6.1	Match	Match	Match	Match	Match

There's an additional dialog which often appears when the ACR version is mismatched, offering you the choice of 'Render Using Lightroom' or 'Open Anyway'.

"Raw Files" diagram on page 365 and "Rendered Files (JPEG/ TIFF/PSD)" diagram on page 364

What's the difference between 'Render Using Lightroom' and 'Open Anyway' in the ACR mismatch dialog?

If you're working with a mismatched ACR version, you should see the ACR Mismatch dialog, which allows you to choose how to handle the file. There's a diagram of the options and their results on the following pages.

'Render using Lightroom' uses Lightroom's own processing engine to render a new file which is then automatically opened into Photoshop. This does mean that an additional TIFF or PSD file is created, depending on your preferences, however all of your Lightroom adjustments will be applied correctly.

'Open Anyway' ignores the mismatch and passes the image data and settings to Photoshop for ACR to process, which may produce something close to the correct rendering or may be completely different, depending on how great the mismatch is, and which sliders you've used. It doesn't save the TIFF/PSD until you choose to save the changes.

If you choose 'Open Anyway' but support for your camera was added after that ACR version, Photoshop will open but the photo won't open, as Photoshop won't know what to do with it.

Can I open a raw file directly into the ACR dialog?

You can't open a photo into the ACR dialog directly, but then, why would you want to, as all of the controls are available in Lightroom anyway.

If you do want to open into the ACR dialog, you have a couple of options. You can select the file and press Ctrl-S (Windows) / Cmd-S (Mac) to save the settings to XMP. Having done so, you can either browse to the file in Bridge or Photoshop and open in those programs, or right-click on the file in Lightroom and choose Show in Explorer (Windows) / Finder (Mac) will take you directly to the file for you to double-click to open in Photoshop, saving you browsing to find it.

If you have CS3 or later, you can use 'Open in Photoshop as Smart Object' and then double-click on the Smart Object to open that into ACR. Be aware that any Develop settings you change will not be reflected in Lightroom if you do that though, and unless you're running a matching ACR version, as we discussed in the previous question, the photo will render differently.

Rendered Files (JPEG/TIFF/PSD)

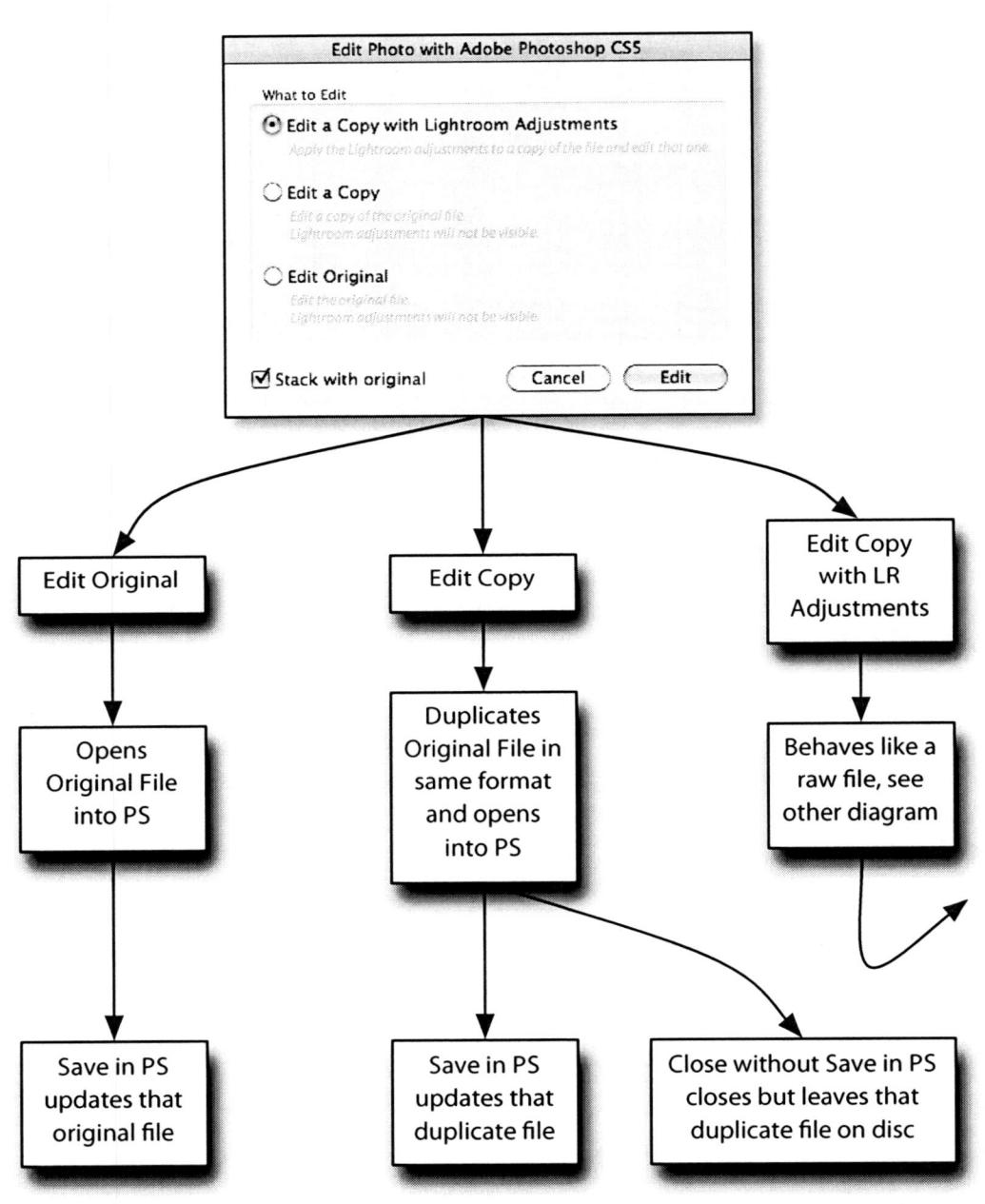

Raw Files

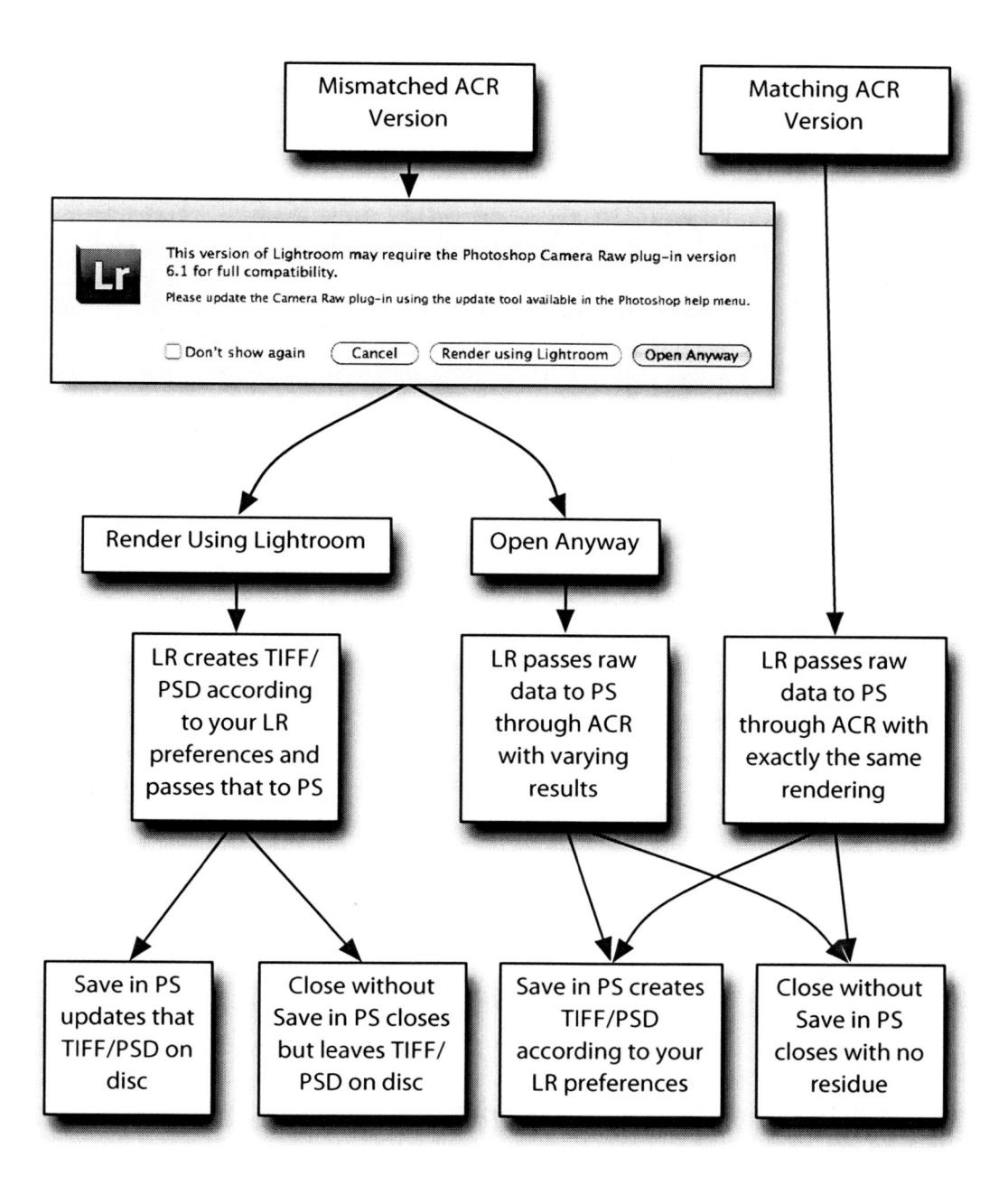

If I use ACR to convert, having created XMP files, will the result be identical to Lightroom?

If you're using a fully compatible version of ACR in Photoshop or Bridge, the results will be identical to Lightroom 3, as it uses exactly the same processing engine.

I'd prefer to let Bridge run the conversion to JPEG using Image Processor to run an action. Is it possible?

You can use Lightroom to work through your photos, and then save the settings to XMP, browse to them in Bridge, and convert the photos using Image Processor. It would allow you to run an action on the photos at the same time as converting them, but you can do the same using droplets from Lightroom, which we'll cover in more detail in the Export chapter. Using Image Processor to convert does tie up Photoshop, whereas Lightroom would run in the background while you continue working on other photos unless you were also using a droplet to run a Photoshop Action, and don't forget that you'll need a fully compatible ACR version in order to get the same results.

Why is Bridge not seeing the raw adjustments I've made in Lightroom?

The adjustments you make to your photos in Lightroom are stored in Lightroom's own catalog, and other programs such as Bridge can't read that catalog. In order for Bridge to read the settings, you need to write to XMP by selecting the photos in Grid view and pressing Ctrl-S (Windows) / Cmd-S (Mac).

If you've written to XMP and the XMP files are correctly alongside the raw files, then you may find that Bridge hasn't yet updated its previews. You can force Bridge to update its previews by going to Tools menu > Cache > Build and Export Cache..., or Purge Cache in that same menu if it still doesn't work.

"Post-Processing Actions & Droplets" section on page 394

Export

As Lightroom works nondestructively, applying your settings to your photos involves exporting them to new files, in the size and format suited to the purpose.

To export photos, select them and go to File menu > Export..., use the shortcut Ctrl-Shift-E (Windows) / Cmd-Shift-E (Mac), or you'll also find it in the right-click menu. Right at the top of the dialog, there's a pop-up menu that's usually set to Hard Drive for normal exports, but also allows writing the exported files to CD/DVD or exporting to specific plug-ins. Leave that on Hard Drive for the moment and we'll investigate some of the other options later.

EXPORT LOCATIONS & FILE NAMING

The first thing that you need to choose in the Export dialog is the location for your exported files, and also their filenames if you want to rename while exporting.

Can I set Lightroom to automatically export back to the same folder as the original?

In the Export dialog you can set Lightroom to export the photo to either a 'Specific folder' or 'Same folder as original photo,' and place them either

directly within that folder or within a named subfolder of your choice. If the original photos are in different folders, 'Specific folder' will group all of the exported photos in one place, whereas 'Same folder as original photo' will result in the exported photos being placed with their original files, so they may be spread across variety of different locations.

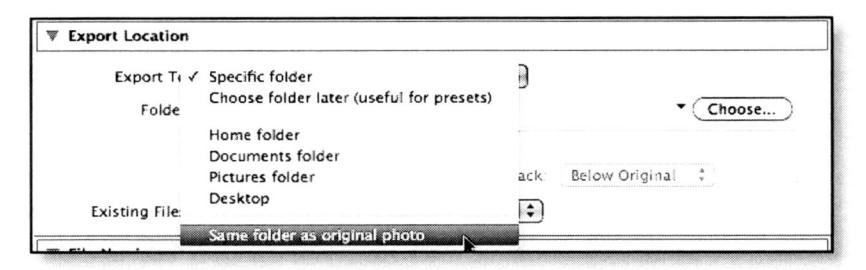

If you need to replicate your folder structure during an export, for example, a wedding that's grouped into folders for each stage of the day, LR/TreeExporter plug-in can save you doing so manually. http://www.photographers-toolbox.com/products/lrtreeexporter.php

Can I set Lightroom to automatically re-import the exported files?

There's an option in the Export dialog to automatically add the exported photos back into your catalog, bypassing the Import dialog. If the exported files have been exported to the same folder as the original photos, you can also automatically stack them.

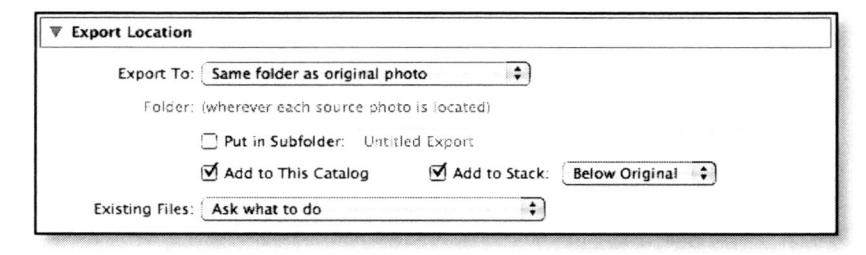

Why is the 'Add to Stack' checkbox unavailable?

Stacking is only available when photos are in the same folder, so the 'Add to Stack' checkbox is only turned on when you have the export set 'Same folder as original photo,' and not into a subfolder.

Can I set Lightroom to overwrite the original when exporting?

Lightroom shouldn't allow you to overwrite the source file, as it goes against its philosophy of nondestructive editing. Overwriting the originals is like throwing away the negatives once you've made a print that you like! If you attempt to overwrite the source files that you're exporting, it should ask whether to skip them or use unique names. There's a bug that's appeared intermittently at various times in Lightroom's development, where Lightroom gets stuck in a loop—trying to read the original source file but having already overwritten the part it needs, resulting in corrupted files. At the time of writing, it's working correctly, but it's worth avoiding trying to overwrite originals, just in case it returns in the future.

Can I stop Lightroom asking me what to do when it finds an existing file with the same name?

In the Export dialog you can set a default action, so that when it finds existing files, it doesn't stop and wait for your decision. You can choose to allow it to adjust the filename, overwrite the existing file, skip exporting the conflicted file, or ask you what to do.

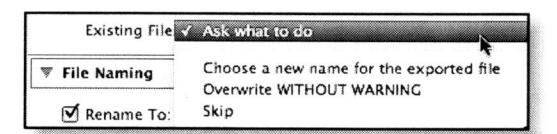

How do I burn the exported files to CD or DVD?

Lightroom has limited support for burning exported photos to CD or DVD directly from the export dialog. At the top of the export dialog,

Also check...

"Stacking" section on page 158

Also check...

"How do I rename the files while importing?" on page 77 and "How do I rename one or more photos?" on page 166 change the pop-up menu which usually says 'Hard Drive' to 'CD/DVD,' and it should prompt for optical media. The support is limited—there are no suitable drivers for the 64-bit versions of Windows, and it's available only for convenience, so more advanced users may prefer to export to their hard drive and use standalone software to burn instead.

How do I change the filename while exporting?

Rather than having to rename and then export the files, or vice versa, you can use the File Naming in the Export dialog. This won't affect the original photos in your catalog—it will only change the names of the exported photos.

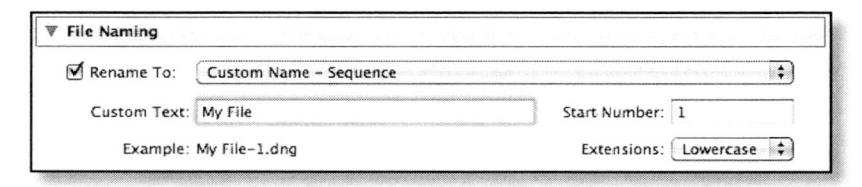

The dialog used for the File Naming Template is the same dialog that is used both for renaming while importing and later in the Library module.

FILE SETTINGS

The next section in the Export dialog is File Settings, where you select the file format, quality and color space. We'll come back to color space in the next section.

The file format you select will depend on the purpose of the photo. JPEG is an excellent choice for email or posting on the web, but it's a lossy format, whereas PSD and TIFF allow you to save Photoshop's layers

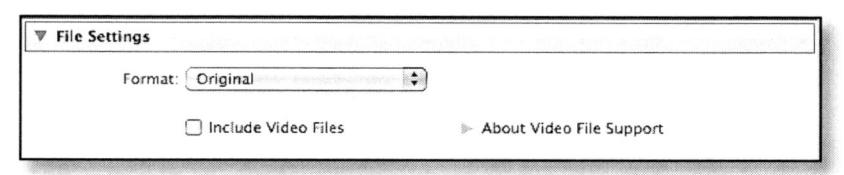

and they're lossless. The 'Original' option exports in the original format, creating a duplicate of the original file but with updated metadata.

What's the equivalent of JPEG quality...?

If you've used Photoshop, you'll notice that Lightroom uses a different scale (0-100 rather than 0-12) for JPEG quality. There isn't a direct equivalent, but as a rough guide:

Photoshop quality 8—approx. 65 in Lightroom Photoshop quality 10—approx. 80 in Lightroom Photoshop quality 12—100 in Lightroom

Visit http://regex.info/blog/lightroom-goodies/jpeg-quality for a detailed explanation of the different quality ranges.

How do I set Lightroom to a JPEG level 0-12 so that Photoshop doesn't ask me every time I save?

As Lightroom doesn't save a 0-12 quality tag in the file, whenever you try to resave a JPEG in Photoshop, it'll ask you for the quality. That's fine for individual files, but becomes irritating on a batch process. You can automatically set the quality rating for the whole batch by including a 'Save As,' with the same name and location, in your action rather than a standard 'Save'. Even if you override the save location when setting up the batch, it'll still use the quality tag that you used when setting up the action. As this is a Lightroom book, rather than a Photoshop book, we won't go into any more detail, but you'll get the general idea from the Post-Processing Actions & Droplets section later in the chapter.

If a photo is imported as a JPEG, and it's not edited it any way, is what I am exporting identical to what I imported?

If you choose 'Original' as the File Format in the Export dialog, you'll create a duplicate of the original file. The file size may be slightly different as Lightroom will update the metadata, unlike an operating

"Can I run a Photoshop action from Lightroom?" on page 395

"Why can't CS2 save as JPEG when I've used Local Adjustments on the photo?" on page 404 system duplication, but it won't re-compress the image data, so the quality won't be reduced. If you select 'JPEG' as the output format, the file will be re-compressed.

Why won't Photoshop allow me to save my Lightroom file as a JPEG?

If you open a 16-bit file into Photoshop, either via Edit in Photoshop or after exporting, you can't save it as a JPEG. CS5 now automatically converts to 8-bit when you try to save a JPEG, but earlier versions require you to make a

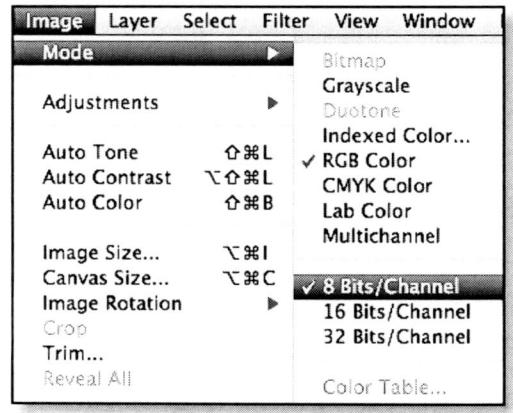

decision. You can either convert the photo to 8-bit, in which case you can save as a JPEG, or you can save your 16-bit photo as another format such as TIFF or PSD. If you want to convert from 16-bit to 8-bit to save it as a JPEG, go to Photoshop's Image menu > Mode > 8 bits/Channel.

Should I choose 8-bit or 16-bit?

16-bit ProPhoto RGB is the officially recommended choice for best preserving color details from Lightroom, but what does that actually mean?

Every photo is made up of pixels. In an RGB photo, each pixel has a Red, a Green and a Blue channel, and in an 8-bit photo, each of those channels has a value from 0-255. That means that a 3-channel 8-bit photo can mix those channels in a possible 16.7 million combinations, resulting in a potential 16.7 million different colors—256x256x256 = 16.7 million.

That sounds like a lot, but come back to those 256 levels per channel a moment. What happens if you need to make any significant tonal

changes? You've only got maximum of 256 levels per channel play with. Perhaps you've significantly underexposed photo, and all of the detail is in the first 128 levels. You can stretch the detail out to fill the full 0-255 range, but you can't create data, so you end up with gaps in the histogram like this: Those gaps may not notice on your average photo, but are more likely to notice as banding on photos with smooth gradients, such as a sky at sunset. A 16-bit photo, on the other hand, has 65,536 levels per channel, so you can manipulate it without worrying about losing too much data.

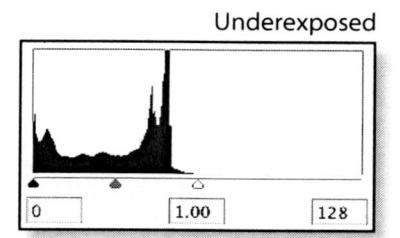

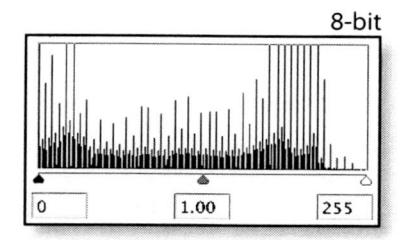

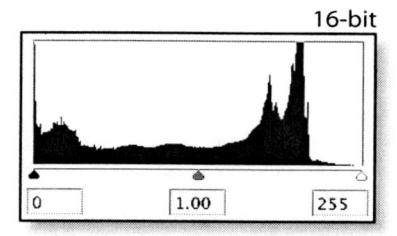

The downside to 16-bit is that all that extra data takes up more space on your hard drive, so in the real world, it's not always quite so clear cut. 16-bit files can only be saved at TIFF or PSD, not JPEG, and the file sizes are much bigger than an 8-bit quality 12 JPEG, often with very little, if any, visible difference to the untrained eye on a small print. A Canon 5D file would be around 73MB for a 16-bit TIFF, but less than 3.5MB for a quality 12 8-bit JPEG. That's a big difference on a large volume of files!

So the reality is you may want to weigh it up on a case-by-case basis. If you're producing a fine art print, 16-bit would be an excellent choice to preserve as much detail as possible. If you're going to take a file into Photoshop and make massive tonal changes, 16-bit would be an excellent choice, giving greater latitude for adjustments.

On the other hand, if you're processing a series of 1000 photos for a wedding, you're making your tonal changes within Lightroom using the

full range of 12-bit or 14-bit raw data captured by the camera, before converting down to 8-bit, and they're only going to be small photos in an album with no major additional changes to be made, 8-bit JPEG could be a far more efficient choice. You can always re-export from Lightroom as a 16-bit file if you find a photo which would benefit, such as a photo exhibiting banding in the sky, or suchlike.

I am a high volume photographer (weddings, etc.)—do I have to convert to PSD or TIFF for light retouching, or can I use JPEG?

As with the 8-bit vs. 16-bit debate, there's no fixed answer on whether to use JPEGs for your working files—it depends on your situation.

JPEG is a lossy format, which means that if you open, re-save, close and repeat that process enough times, you will eventually start to see the compression artifacts. TIFF and PSD, on the other hand, are lossless formats.

Some high volume photographers, such as wedding photographers, are using 16-bit TIFFs for everything, simply because they've been told that's best. And technically, that is absolutely true. However we live in the real world, and, as with everything, there is a trade-off—TIFF and PSD formats are much larger than JPEGs. High volumes of these files will rapidly fill your hard drive, and they will take longer to open and save due to the larger file sizes. If you're dealing with a small number of photos, that's not a problem, but for photographers working with thousands of photos every week, it becomes a question of ultimate quality vs. real-world efficiency.

So, some questions to consider...

What are you doing to these files once they've left Lightroom?
 Major color/density shifts? Or a little light retouching before printing? If you're doing major adjustments, a 16-bit TIFF or PSD will be the best choice, but ideally you would be making those

adjustments within Lightroom using the raw data.

- Do you want to keep layered files? If so, you could consider using TIFF or PSD for your working files, and then converting to high quality JPEG once you're ready to archive.
- How big are the photos going to be printed? A photo which is going to be printed as a poster-size fine art print will be best as a 16-bit TIFF or PSD, whereas you may choose to compromise and use JPEGs on photos that are only going to appear as smaller photos in an album or on the web.
- How often are you going to need to re-save this file? Are you
 going to keep coming back to it and doing a bit more retouching,
 or will it just be re-saved once or twice? If you're just opening it
 once, doing a little retouching, saving and closing, there's very
 little visible, real-world difference to the untrained eye—and the
 space savings are HUGE.

Test it for yourself—how many times can you open a file/save/close/ reopen and repeat before you can find any visible differences? At quality 12? Even at quality 10? Will your customers see it? Don't take someone else's word for it—check it for your own peace of mind. You can save as many times as you like while the file remains open in Photoshop, without any additional compression, as the original data remains in the computers memory—it's only saving the file after closing and reopening that will re-compress it.

Only you can decide whether you're comfortable with that compromise in specific situations, having checked the facts for yourself.

COLOR SPACE

When it comes to the color space, there's lots of confusion. Should you choose sRGB because it's common? But you've heard ProPhoto RGB is better because it's bigger, so should you choose that one? Let's investigate the options...

Which color space should I use?

Color management is a huge subject in its own right, so we won't go into detail here. If you'd like to learn more, Jeffrey Friedl wrote an excellent article on color spaces, which you will find at: http://regex.info/blog/photo-tech/color-spaces-page0/

In short, we've already said that photos are made up of pixels, which each have number values for each of the color channels. For example, 0-0-0 is pure black. 255-255-255 is pure white. The numbers in between are open to interpretation—who decides exactly what color green 10-190-10 equates to? That's where color profiles come in—they define how those numbers should translate to colors.

Lightroom is internally color-managed, so as long as your monitor is properly calibrated, the only times you need to worry about color spaces are when you're outputting the photos to other programs. That may be passing the data to Photoshop for further editing, passing the data to a printer driver for printing, or exporting the photos for other purposes, such as email or web.

When considering the size of color spaces, imagine you're baking a cake, and you need to mix the ingredients. ProPhoto RGB is a big enough mixing bowl that it won't overflow in the process, whereas sRGB is like the cake tin that just about fits the cake when you've finished, but will overflow and lose some of your cake mixture if you try to move it around too much. You use the right bowl for the job.

sRGB is a small color space, but fairly universal. It can't contain all of the colors that your camera can capture, which will result in some clipping. As it's a common color space, it's a good choice for photos that you're outputting for screen use (web, slideshow, digital photo frame), and many non-pro digital print labs will expect sRGB files too.

Adobe RGB is a slightly bigger color space, which contains more of the colors that your camera can capture, but still clips some. Many pro digital print labs will accept Adobe RGB files. It's also a good choice for setting on your camera if you choose to shoot JPEG rather than the raw file format, if your camera can't capture in ProPhoto RGB.

ProPhoto RGB is the largest color space that Lightroom offers, and it's designed for digital photographers. It can contain all of the colors that today's cameras can capture, with room to spare. The disadvantage is that putting an Adobe RGB or ProPhoto RGB file in a non-color-managed program, such as most web browsers, will give a flat desaturated result. That makes it an excellent choice for editing and archiving, but a poor choice when sending photos to anyone else.

So your chosen color space will depend on the situation. You don't need to worry while the photo stays in Lightroom, as all of the internal editing is done in a special large color space known as Melissa RGB. When the photo leaves Lightroom, then you need to make a choice. If you're sending a photo to Photoshop using the Edit in... command, ProPhoto RGB will often be the best choice, retaining as wide a range as possible. ProPhoto RGB doesn't play well with 8-bit though, because you'd be trying to jam a large gamut into a small bit depth, which can lead to banding, so stick with 16-bit while using ProPhoto RGB. Once you've finished your editing, and you want to export the finished photo for a specific purpose, then you can choose a smaller color space.

Whichever color space you choose to use, always embed the profile. A digital photo is just a collection of numbers, and the profile defines how those numbers should be displayed. If there's no profile, the program has to guess—and often guesses incorrectly. Lightroom always embeds the profile, but Photoshop offers a checkbox in the Save As dialog, which you need to leave checked.

Why do my photos look different in Photoshop?

A mismatch in colors between Lightroom and Photoshop is usually due to either a corrupted or incompatible monitor profile or incorrect color space settings. For example, a ProPhoto RGB photo mistakenly rendered as sRGB will display as desaturated and flat.

"Editing in Other Programs" section on page 353 ProPhoto RGB photo correctly displayed as ProPhoto RGB:

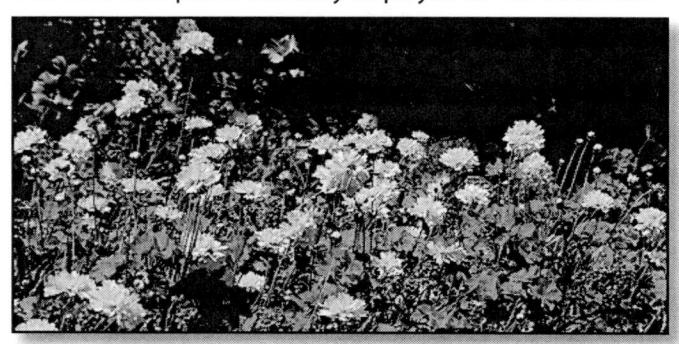

ProPhoto RGB photo incorrectly displayed as if sRGB:

The corrupted monitor profile is very easy to check, and we covered that in the earlier Previews & Speed chapter. We'll also need to confirm that the color spaces match across the 2 programs. The same principles will also apply to opening photos in other software, not just in Photoshop.

First, check your color settings.

In Photoshop, go to Edit menu > Color Settings to view the Color Settings dialog.

The RGB Working Space is your choice, but whichever you choose to use, you're best to set the same in Lightroom's External Editor preferences and Export dialog. We'll come to that in a moment.

Selecting 'Preserve Embedded Profiles' and/or checking the 'Ask When Opening' for Profile Mismatches in that same dialog will help prevent any profile mismatches. 'Preserve Embedded Profiles' tells Photoshop to

Also check...

"Which color space should I use?" on page 376 and "How do I change my monitor profile to check whether it's corrupted?" on page 259 use the profile embedded in the file regardless of whether it matches your usual working space. 'Ask When Opening' for profile mismatches shows you a warning dialog when the embedded profile doesn't match your usual working space, and asks you what to do.

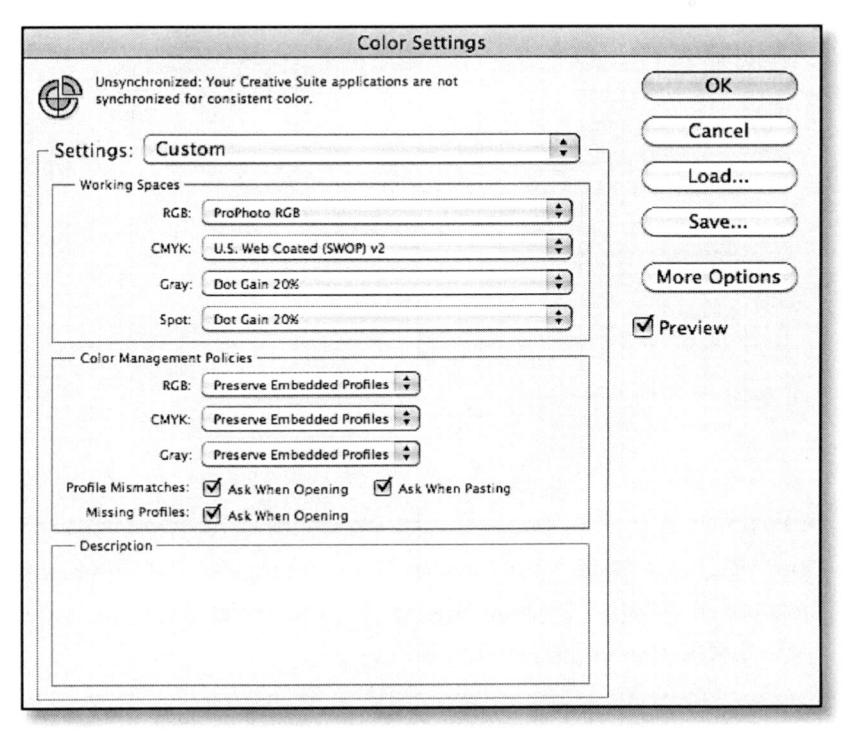

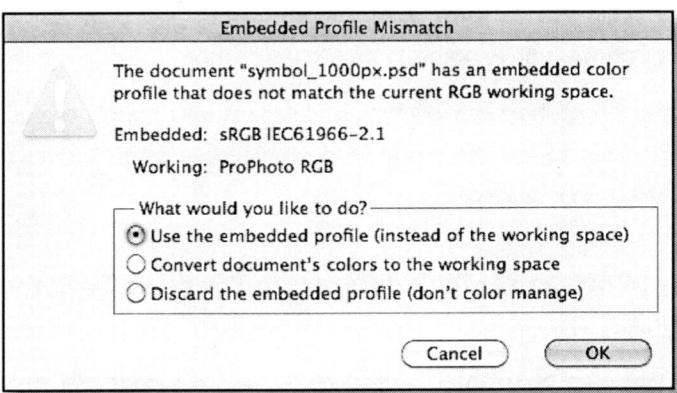

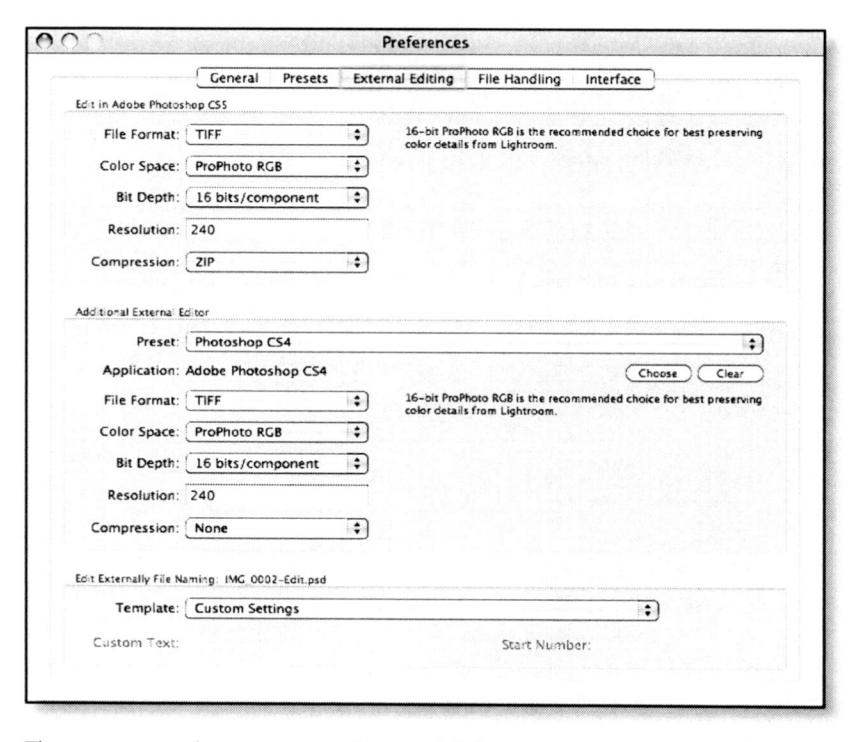

Also check...

"Everything in
Lightroom is a funny
color, but the original
photos look perfect
in other programs,
and the exported
photos don't look like
they do in Lightroom
either. What could be
wrong?" on page 258

Then you need to set your External Editor settings in the Lightroom Preferences dialog > External Editing tab, and select the same color space that you've selected in Photoshop.

You'll also want to check the color space that you're using in the Export dialog, and again, if passing those photos to Photoshop, select the same color space for photos you're going to edit in Photoshop.

As long as your Photoshop and Lightroom color settings match, or you have Photoshop set to use the embedded profile, your photos should match between both programs.

Why do my photographs look different in Windows Explorer or on the Web?

Having checked your Photoshop color settings, you may still find that your photos look incorrect in other programs such as web browsers. This is because most web browsers, and many other programs such as Windows Photo Viewer, aren't color managed by default, if at all. If anything, they assume that your photos are sRGB, resulting in an incorrect appearance for Adobe RGB or ProPhoto RGB tagged photos.

Photos destined for the web or other screen display should usually be exported as sRGB, unless you know that they're going to a fully color managed environment. sRGB isn't actually 'better'—the color space is actually smaller—but it will ensure that the rendering in non-color-managed programs will be at least as close as possible to the photo you're viewing in Lightroom.

Can I export with a custom ICC profile?

Selecting 'Other' in the Export dialog Color Space pop-up menu will bring up a dialog box allowing you to choose which other custom ICC profiles will be available in the Color Space pop-up menu. These might include profiles for digital print labs or other printers. The only restriction is that the profiles have to be RGB, rather than CMYK or other color spaces.

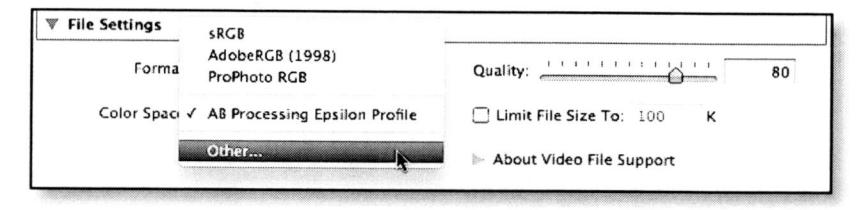

SIZING & RESOLUTION

Resizing the original photos would go completely against Lightroom's nondestructive editing, after all, there's nothing more destructive than deleting pixels. Instead, you crop to a specific ratio in the Develop module and then set the actual size in the Export dialog.

What's the difference between Width & Height, Dimensions, Longest Edge & Shortest Edge?

Width & Height behaves like Fit Image and Image Processor in Photoshop. It fits the photos within a bounding box in their current orientation. This setting is width/height sensitive—settings of 400 wide

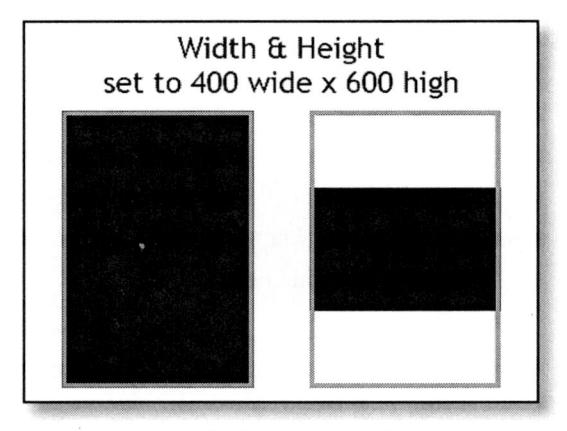

by 600 high will give a 400×600 vertical photo, but only a 400×267 horizontal photo. To create photos of up to 400×600 of either orientation, you would have to enter a square bounding box of 600×600 .

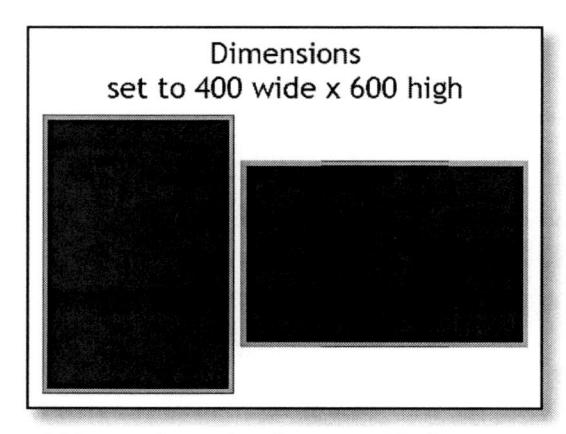

Dimensions works slightly differently. It still fits your photo within a bounding box, but it's a little more intelligent. It takes into account the rotation of the photo, and it will make the photo as big as it can

within your bounding box, even if it has to turn the bounding box round to do so. The Dimensions setting isn't width/height sensitive, so settings of 400 wide by 600 high will give a 400×600 or 600x400 photo. If your photo is a different ratio, it will still make it as big as it can within those boundaries. To create photos of up to 400×600 of either orientation, you would simply enter 400x600.

Longest Edge sets the length of the longest edge, as the name suggests. A setting of 10 inches long would give photos of varying sizes such as 3"×10", 5"×10", 7"×10", 8"×10", 10"×10".

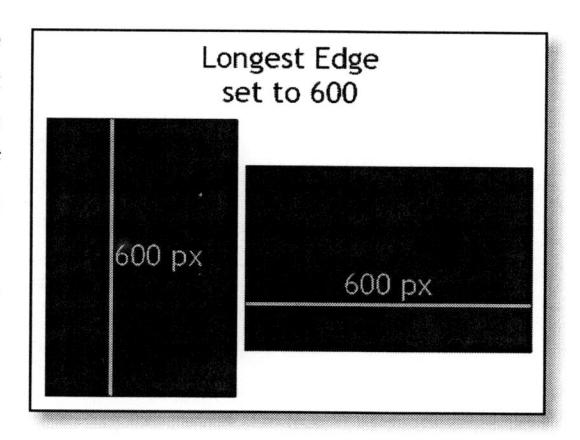

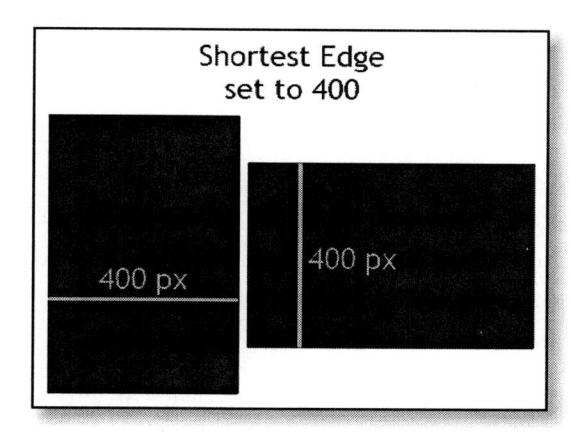

Shortest Edge sets the length of the shortest edge, again as the name suggests. A setting of 5 inches along the shortest edge would give varying sizes such as 5"×5", 5"×8", 5"×10", 5"×12".

Bear in mind that these measurements do still fall within the ACR limits of 65,000 pixels along the longest edge and 512MP, so if your photo will fall outside of this range according to the measurements you've set, Lightroom will simply make the photo as big as it can.

When I enter 4x6 as my output size, why do the vertical photos become 4x6 but the horizontal photos become 2.5x4?

If you're ending up with photos that are smaller than expected, you've got Export Resizing set to 'Width & Height,' which fits the photo within a bounding box without rotating. Change it to 'Dimensions' and it will work as you're expecting.

What does the 'Don't Enlarge' checkbox do?

The 'Don't Enlarge' checkbox will prevent small photos from being upsized to meet the dimensions you've set, while still downsizing photos which are too large to fit your chosen dimensions.

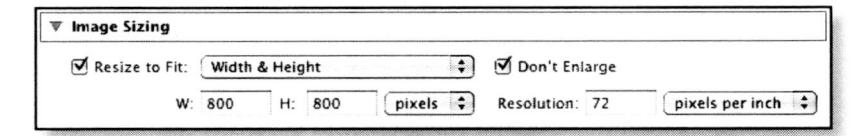

What PPI setting should I enter in the Export dialog?

The PPI (Pixels Per Inch) setting, or Resolution, is generally irrelevant as long as the overall pixel dimensions are correct. As a side point, DPI refers to Dots Per Inch, which doesn't apply to digital images until they're dots on a piece of paper.

We won't go into a lot of detail as a web search on 'ppi resolution' will produce a multitude of information, but you're simply defining how to divide up the photo. When you're talking in pixel dimensions, it doesn't mean anything. It's only useful when combined with measurements.

Imagine you've finished baking your cake—you can divide it into 4 fat slices, or 16 narrow slices, but the overall amount of cake doesn't change. Your photo behaves the same way. The PPI setting just tells other programs how many slices you think the photo should be divided into, but there's the same amount of data overall.

The PPI setting becomes more useful when resizing in inches or cm rather than in pixels, as it saves you calculating pixel dimensions. For example, creating a small image of $0.5" \times 0.5"$ at 300ppi will give you $150px \times 150px$. That tiny image will look good when printed in that small size, but if you try to spread those same pixels over a larger area, for example, $3" \times 3"$ at 50ppi which is also $150px \times 150px$, then the result will be lower quality and pixelated. To create a good quality print in the

larger size, you'd need more data, so you'd need a larger number. If your image was 900px x 900px, or 3" x 2" at 300ppi, you'll see less pixelation.

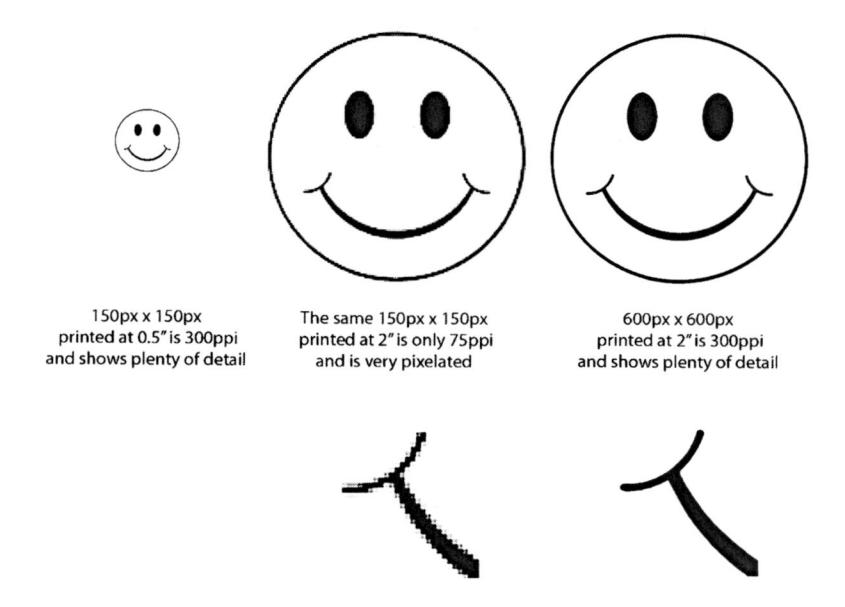

Moving on from smiley faces, when sending photos to a lab for printing, you may decide against sending them the full resolution file, and choose to downsize to a smaller file size for faster upload. As a rule of thumb, about 250-300ppi, with the correct print dimensions in inches or centimeters, is a good trade-off for printing. Selecting a photo size of 4"x6" at 300ppi, or the equivalent pixel dimensions of 1200x1800, is plenty for most labs to print a good quality 4"x6" print. On the other hand, using 4"x6" at 72ppi will give pixel dimensions of just 288x432, which will be pixelated and low quality.

If you're just starting out, here are some sample export settings for different uses:

Email—Longest Edge 800px, and you can ignore the resolution as we're specifying the size in pixels. Format JPEG, quality 60-80.

 $4" \times 6"$ digital print—Dimensions $4" \times 6"$ at 300ppi. Format JPEG, quality 80-100.

8" x 10" digital print—Dimensions 8" x 10" at 300ppi. Format JPEG, quality 80-100.

Full resolution master—uncheck the 'Resize to Fit:' checkbox. Format TIFF/PSD or JPEG quality 100.

I set the export PPI to 300—why is it 72ppi when I open it in Photoshop?

If you specifically need the resolution tag, don't check the 'Minimize Embedded Metadata' checkbox in the Export dialog as it wipes that tag. 'Minimize Embedded Metadata' only keeps the copyright and color profile tags.

When I crop to 8x10 in Lightroom and then open in Photoshop, why is it not 8"x10"?

When you're cropping in Lightroom, you're cropping to a ratio rather than a fixed size. Because you're not throwing away pixels in your nondestructive Lightroom workflow, that crop can be output to a number of different sizes—for example, your 8x10 crop could also be output as 16"x20", 8"x10", 4"x5" or 400x500 pixels for the web, amongst others, all without having to go back and re-crop the photo.

When you come to export, you then define the size that you wish to export, either as pixel dimensions or as inches/cm combined with a resolution setting.

Is it better to upsize in Lightroom or in Photoshop?

When Lightroom resizes, you don't have a choice of interpolation method, unlike Photoshop which offers Nearest Neighbor, Bilinear, Bicubic, Bicubic Smoother and Bicubic Sharper. Instead, Lightroom uses an intelligent adaptive bicubic algorithm which will automatically adjust for the increase or decrease in size. Either program will resize your photo well, but Lightroom will automatically choose the best option, whereas Photoshop expects you to make the decision.

Can I export to a specific file size?

Because Lightroom's working on a lot of files, rather than Photoshop's one file, it doesn't give you a preview of the resulting file size when you adjust the quality. If you're uploading the photos to a website with a specific file size limit, it can be time-consuming to repeatedly export the photos, changing the quality setting to check that they fall inside of the limit of, for example, 70kb. If you check the 'Limit File Size To:' checkbox and enter a limit, Lightroom will do that work for you, however the export can take longer than a standard export.

Lightroom only adjusts the quality setting automatically, and not the pixel dimensions, so attempting to export a full resolution photo under 50k would compress the photo beyond recognition and will show an error message warning you that it can't be done. Make sure you choose reasonable pixel dimensions for the file size.

Also check...

"Detail—Sharpening & Noise Reduction" section on page 314 and "Presets" section on page 300

OUTPUT SHARPENING

Once you've set the sizing, the sharpening is next in line. That output sharpening may only have 2 pop-up menus, but it's far more powerful than it looks.

Why does the Export Sharpening only have a few options? How can I control it?

Lightroom's sharpening controls are based on Bruce Fraser's multiple pass sharpening methods, as we mentioned earlier in the Develop chapter.

The output sharpening found in the Export, Print and Web modules is based on the complex algorithms created by the team at Pixel Genius, who created the well-known Photoshop plug-in PhotoKit Sharpener.

Based on the size of the original file, the output size and resolution, the type of paper, and the strength of sharpening you prefer, it automatically adjusts the sharpening to create the optimal result.

To get the best out of the automated output sharpening, you do need a properly capture sharpened photo, so the sharpening settings in the Develop module are still essential.

Which Export Sharpening setting applies more sharpening—screen, matte or glossy?

The difference between Matte and Glossy is barely noticeable on screen, but there is a difference between each of the settings. At a glance you'll see that the Screen setting sharpens the high-frequency details less than the Matte or Glossy settings, but there are a lot more technicalities behind that.

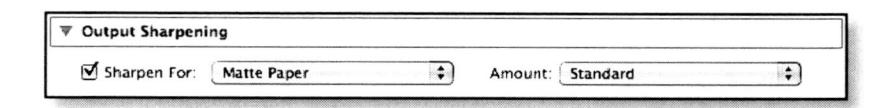

As a general rule, pick the right paper type, and you'll be about right. Sending matte sharpening to a glossy paper will look worse than sending glossy sharpening to matte paper. Screen sharpening may look a little soft on CRT monitors as it's optimized for LCD screens. Avoid oversharpening in the Develop module, otherwise the Export Sharpening will make it look a lot worse.

COPYRIGHT & WATERMARKING

The Watermarking tool is designed as a very easy way to apply a simple watermark to your photos, rather than as a replacement for the popular, but complex, LR/Mogrify plug-in.

How do I create a basic watermark?

Go to Edit menu (Windows) / Lightroom menu (Mac) and select Edit Watermarks... The Edit Watermark dialog, where you set up your watermarks, is shown on the following page.

If you want to add a text watermark, select the New Text Watermark option and then enter your text in the text field beneath the preview image. If you want to add a © copyright symbol, hold down Alt and type 0169 (Windows) / Opt-G (Mac).

The options on the right allow you to choose the font and size of your watermark. The alignment buttons in the Text Options panel apply to the text alignment within the bounding box and they only come into effect when you have multiple lines of copyright text. The Shadow options in the Text Options panel are currently Mac only, as they use features that are part of the operating system.

If you would prefer a graphical watermark, press the Choose button in the Image Options panel and navigate to the JPEG or PNG file of your choice. Once you've found your watermark, you can adjust the size using the bounding box on the preview or you can change it in the Watermark Effects panel.

Also check...

"Plug-ins" section on page 399

"Saving Presets in Pop-Up Menus" on page 138 To move the watermark around on the image, you can't drag it, but you can use the Watermark Effects panel to lock it to the center, a corner, or an edge of the photo, and add additional spacing to distance it from the edge of the photo too.

Once you're happy with your watermark, use the pop-up menu at the top of the dialog to save it ready for use on your photos.

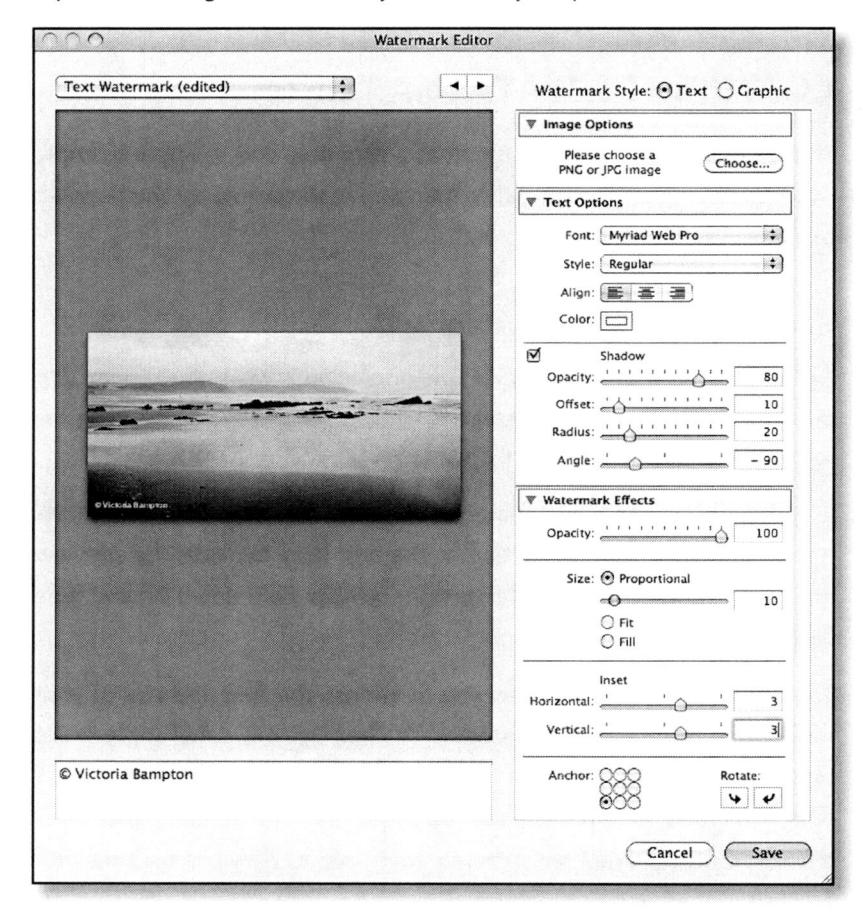

Are the watermarks intelligent for vertical and horizontal images?

The sizing of the watermark is proportional to the size and orientation of the exported photo, and you can decide whether to Fit the watermark within the short edge, Fill the long edge, or keep it Proportional to the current orientation.

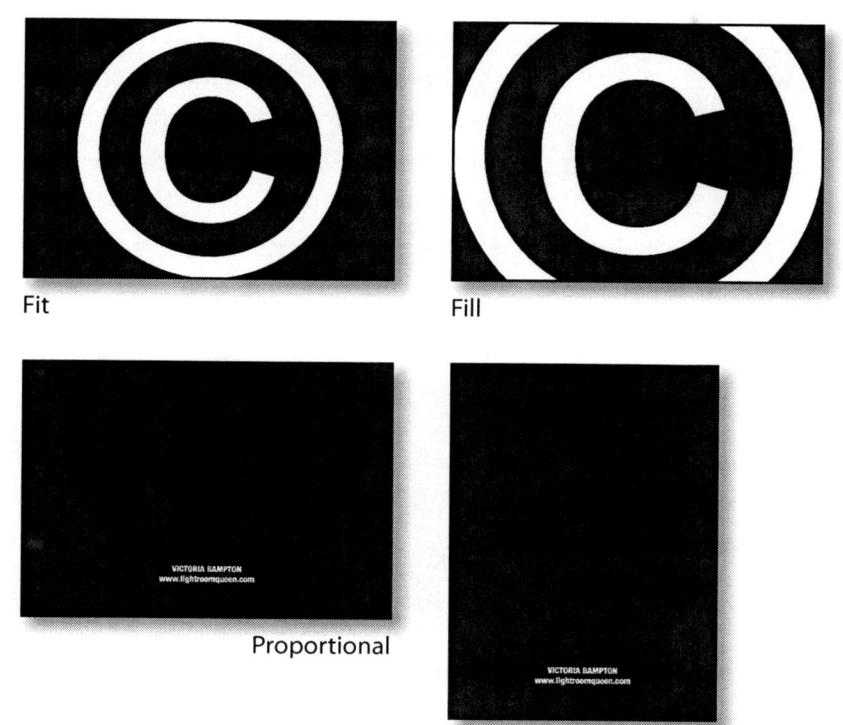

Which file formats can I use for the graphical watermark?

You have a choice of JPEG or PNG formats for the watermarks. The PNG format has the advantage of allowing transparency, or semi-transparency—for example, you may want a large © symbol across your photo, but you don't want a large white square showing.

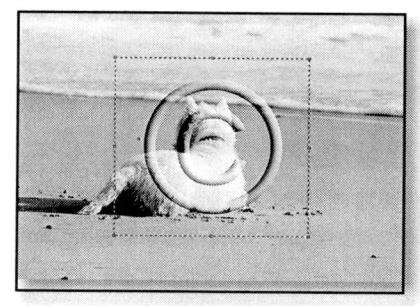

To create a transparent PNG, you'll need pixel editing software such as Photoshop. Create a new layer and drag the background layer to the trash, so that you can see the grey and white checkerboard underneath. Anywhere that you see that grey and white checkerboard is going

to be transparent, and you can also apply blend modes to the watermark to give it additional depth. In the Save or Save for Web dialog, select the PNG format.

You can download some of my favorite watermarks from: http://www.lightroomqueen.com/ lr3bookdownloads.php

Can I overwrite an existing watermark?

As with many of the pop-up menus that we discussed in the Workspace chapter, if you've selected an existing watermark and then edited it, the

name in the pop-up menu will add '(Edited)' to the end, and an 'Update Preset' option will appear in the menu, allowing you to overwrite.

What is 'Simple Copyright Watermark' in the watermark menu?

Simple Copyright Watermark refers to the original copyright watermark, which takes its data from the Copyright metadata field. It's a small plain

"Renaming, Updating and Deleting Presets in Pop-Up Menus" on page 138 text watermark in the lower right corner of a photo. You can add that Copyright data using the Metadata panel in Library module.

Where can I use my watermarks?

The watermarks are available as an option in the Export dialog for standard exports, the Publish Services settings for synchronized photo sharing, and also in the Slideshow, Print, and Web modules.

How do I change the watermark placement for each photo?

The Watermark tool's purpose is to apply a watermark to large numbers of photos in the same size and position, so there isn't an interface for moving the watermark on individual photos, unless you want to keep returning to the Edit Watermark... dialog every time you export. Using the Identity Plate and Print to JPEG, which we'll cover in the Print module, may be a better workaround if you need to carefully position a watermark on each individual photo.

Can I create more complex watermarks, such as text and a graphic?

Using Lightroom's watermark feature, you can only add either a text or a graphical watermark—not both. If you want greater control over the watermarking, and you're willing to experiment to get your perfect result, the LR/Mogrify plug-in offers extensive options for adding multiple lines of text, multiple graphics, as well as borders. You can download it as donationware from:

http://www.photographers-toolbox.com/products/lrmogrify2.php

Also check...

"How do I add metadata to multiple photos at once?" on page 170

Also check...

"How can I overlay
a graphic such as
a border onto my
print?" on page 438

POST-PROCESSING ACTIONS & DROPLETS

Finally, Lightroom can pass your exported photos automatically to other programs when it's finished exporting, using the Post-Processing pop-up menu. Scroll down to the bottom of the dialog to find the Post-Processing options.

How do I get Lightroom to attach the exported files to an email?

There are numerous email programs available—far too many for Adobe to support—but the most popular already have options for automatically attaching exported photos.

Windows:

For Windows, Steve Sutherland has written MapiMailer, which is an Export plug-in which passes exported photos to any default email program. You can download this donationware plug-in from his website at: http://www.sbsutherland.com/ and he's included full installation instructions.

Mac:

To attach files to a new email on the Mac version of Lightroom, you need to select 'Open in Other Application...' in the pop-up menu and navigate to Applications folder and select Mail.app. It should create a new email and attach your exported photos. It works for most Mac email applications, except Thunderbird which doesn't have the necessary hooks to pass data in the same way.

Gmail:

If you use a webmail email account, your automated options are more limited. Timothy Armes has written an export plug-in called LR/Gmail which sends photos directly from Lightroom to Gmail. You can download it as donationware from:

http://www.photographers-toolbox.com/products/lrgmail.php

Can I run a Photoshop action from Lightroom?

Lightroom's not designed to be a file browser, so it doesn't work quite like Bridge, but it's still possible to run Photoshop actions on your exported photos without user intervention. The solution involves creating a droplet in Photoshop from an existing action, and then telling Lightroom to run the droplet after exporting the photos.

Create the Action

In Photoshop, you need to have already created an action—if you're not familiar with creating Photoshop actions, there are plenty of web resources which will take you through step-by-step.

If you're going to run the action on JPEGs, it must include a 'Save As' step to set the JPEG quality, otherwise it'll ask for a quality setting for each and every photo, defeating the object of automating it! To do so, in the Save As dialog, just press OK without changing the filename or location, and make sure you choose your quality setting—you'll override the location in the Create Droplet dialog.

The resulting Action will look something like this simple 're-save as quality 12' action.

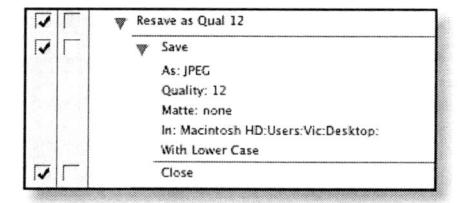

Create the Droplet

Go to File > Automate > Create Droplet to view the Create Droplet dialog.

Save your droplet somewhere safe with a logical name, and make sure you've set the save location to 'Save and Close' to overwrite the exported file, and tick the 'Override save location' box. If you don't want to overwrite the exported file when running the droplet, set your destination folder instead. Click OK to create your droplet.

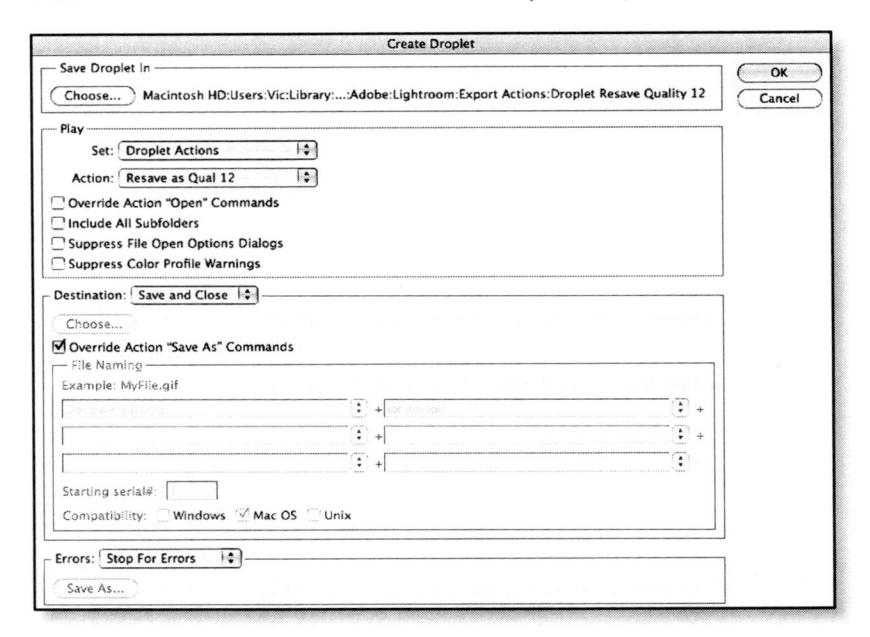

Add the Droplet to Lightroom

Open Lightroom, select a photo, and go to the Export dialog. At the bottom of the dialog, you'll see the Post-Processing pop-up menu. Click 'Go to Export Actions Folder Now' at the end of the pop-up menu to show you that folder in Explorer (Windows) / Finder (Mac). Drop a shortcut/alias to your droplet in the folder which appears, or move the droplet itself, and then close the Export dialog box.
Export Actions

When you reopen the Export dialog box to export your photos from Lightroom, your droplet will appear in the Post-Processing pop-up menu. Export your photos from Lightroom, with your new droplet selected in that pop-up menu, and once the photos have finished exporting they should automatically open Photoshop and run your action.

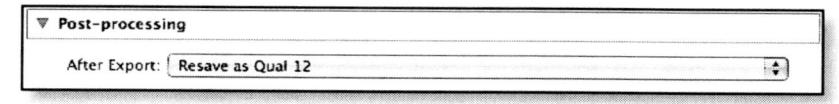

The droplet runs, but it doesn't save—what have I done wrong?

If you can see that Photoshop is opening the photos and running the action correctly, but simply isn't saving the changes, you've probably correctly checked the 'Override Action "Save As" Commands' checkbox in the Droplet dialog, but your action didn't include a 'Save As.' Alternatively, you might find that you set your droplet or action up to save to another location. Either way, try creating your action and droplet again!

The droplet runs, but it keeps asking what JPEG compression to use—what have I done wrong?

If Photoshop keeps asking for the JPEG compression, you forgot to include a 'Save As' in your action to set the JPEG quality, so just re-create the action and droplet again.

The droplet doesn't run at all—why not?

If the droplet doesn't run, the problem is likely with the droplet itself. You can check whether the droplet works by dropping files directly onto the droplet icon—that was their original purpose, and excludes Lightroom from the problem briefly. If it doesn't run, try re-creating your action and droplet, following the instructions carefully. If it still doesn't run when dropping files directly onto the droplet, it would suggest that you have

a problem with your Photoshop installation, and reinstalling Photoshop should fix it.

The droplet only works on some of the photos and then stops—what's wrong?

When Lightroom tells Photoshop which files to run the action on, it passes it a string of file paths which looks something like: 'C:\Documents and Settings\username\Desktop\image1.jpg; C:\Documents and Settings\username\Desktop\image2.jpg;' The maximum allowable length of that string is limited.

If the files you're sending are buried deep in the folder structure, you'll use up the available string length far quicker than a short file path such as: 'D:\image1.jpg, D:\image2.jpg' Don't be fooled into thinking that 'Desktop' or 'My Pictures' are short length paths—on both Windows and Mac operating systems, they're actually shortcuts to folders buried much deeper in the folder structure. Droplets aren't ideal for huge numbers of photos, but if you find it's cutting out too early, you could try exporting to a root level folder to keep that string as short as possible.

In my droplet I used a 'Save for Web' instead of a standard 'Save As'—why won't it overwrite the original file?

'Save for Web' isn't a standard Photoshop save—it's an Export Action, so any overrides such as 'Save Location' in the Create Droplet dialog won't have any effect. If you want to use 'Save for Web,' set your droplet to 'Save for Web' as part of the action, sending to a standard location (maybe a 'Droplet' folder on your desktop), don't put any other 'Save As' in the action, and set the Droplet Destination to 'None.' You'll have to delete the files created by the Lightroom export once the action has completed, as they won't have been overwritten by your 'Save for Web' photos, but all of the 'Save for Web' photos will appear in your 'Droplets' folder.

PLUG-INS

Plug-ins allow third-party developers to add additional functionality to Lightroom. They're written in Lua, and the SDK (Software Development Kit) is freely available from:

http://www.adobe.com/devnet/photoshoplightroom/

What plug-ins are currently available?

There is a wide variety of plug-ins now available, and not all are confined to Export. Below are some of the most popular, and my favorites...

Timothy Armes has been writing numerous Lightroom plug-ins which are available from: http://www.photographers-toolbox.com/

- · LR/Mogrify—borders & copyright watermarks, etc.
- LR/Enfuse—blending multiple exposures, creating HDR-type photos
- LR/Transporter—imports, modifies and exports metadata from text files
- LR/TreeExporter—exports files in your folder hierarchy
- · LR/Blog—export directly to your blog
- · LR/Gmail—send photos via your Gmail account

Jeffrey Friedl is also a prolific plug-writer, and his are available from: http://www.regex.info/blog/lightroom-goodies/

- Zenfolio, SmugMug, Flickr, Picasa Web, Facebook and Kodak Gallery uploads
- · Metadata Wrangler—choose which metadata to strip or include
- GPS Support & GPS Proximity Search—geo-encoding
- Focal-length Sort & Megapixel Sort—adds additional options to Metadata Filter bar
- · and much more besides

John Beardsworth has joined in too, with my favorites being available from: http://www.photographers-toolbox.com/

- Open Directly—opens an original file directly into other software
- Search & Replace—searches the catalog, finding and replacing metadata
- Big Note—adds a large text field to the Metadata panel for your quick notes on each photo

Matt Dawson http://thephotogeek.com/lightroom/ has been busy with plug-ins including:

- Elemental—brings the additional Edit in Photoshop options such as Merge to Panorama to Photoshop Elements
- · Config Backup Plugin—quickly backs up all of your presets
- Snapshotter—makes snapshots out of virtual copies, which can then be written to XMP

Also available is LRSaver http://www.lrsaver.com/ which can read your Lightroom catalog and use its previews as a screensaver.

If you're searching for duplicate photos that you've imported into your catalog, try the Duplicate Finder plug-in from: http://www.lightroom-plugins.com/DupesIndex.php

The list of plug-ins is growing all the time—a simple Google search will bring up many new options, and the Lightroom Exchange is a great place to find all sorts of new plug-ins, presets and other goodies: http://www.adobe.com/cfusion/exchange/index.cfm?event=productHome&exc=25

How do I install Export plug-ins?

Having downloaded the plug-in of your choice, you need to install it. If the plug-in has a .zip extension, double-click to unzip it, and store it

"The default location of the Presets is..." on page 463 somewhere safe. Then to install it, go to File menu > Plug-in Manager... to show the Plug-in Manager dialog. Click on the Add button in the lower-left corner, and navigate to the 'Irplugin' or 'Irdevplugin' folder for the plug-in you would like to install. On Windows, you need to select the folder, rather than its contents, whereas it's a single package file on Mac.

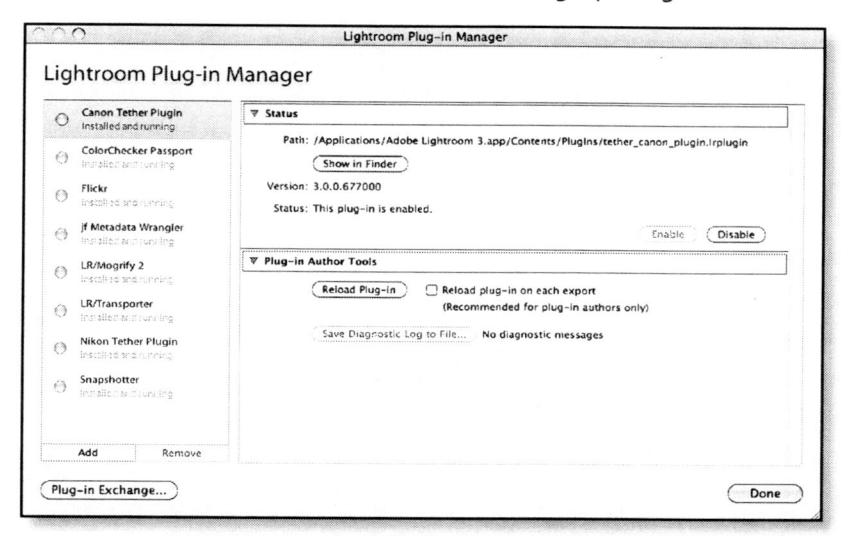

Where should I store my plug-ins?

It's a good idea to keep all of your plug-ins in one place, to make them easy to find, update, transfer, back up or delete. Creating a Plug-ins folder alongside the other presets folders would be an ideal place, and you can find that folder easily by going to Preferences dialog > Presets tab and clicking the 'Show Lightroom Presets Folder...' button.

Why can't I remove this Export plug-in?

To remove any plug-ins that you've installed by means of the Add button, simply select the plug-in in the Plug-in Manager dialog and press the Remove button. That Remove button isn't available for plug-ins stored in Lightroom's own Modules folder, such as the Tether plug-ins, in case you want to reinstall them later.

How do I use Export plug-ins?

Once you've installed the Export plug-in, it's ready to use. The way you access it depends on the individual plug-in, but each developer should provide instructions.

Some plug-ins that export directly to a different destination, such as Jeffrey's popular Flickr plug-in, show in the pop-up menu at the top of the Export dialog, which usually says 'Hard Drive.' They create their

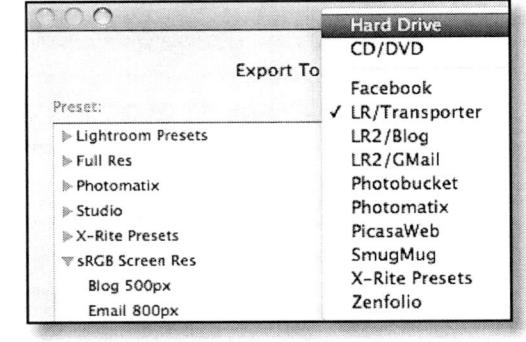

own panels in the Export dialog.

Some, such as LR/Mogrify and Metadata Wrangler, appear in the Post-Process Actions section of the Export dialog, below the Export Presets. From there, you can choose which options you want to make available for your current export, for example, on LR/Mogrify, a single border. The plug-in panels that you choose then appear beneath the normal export panels.

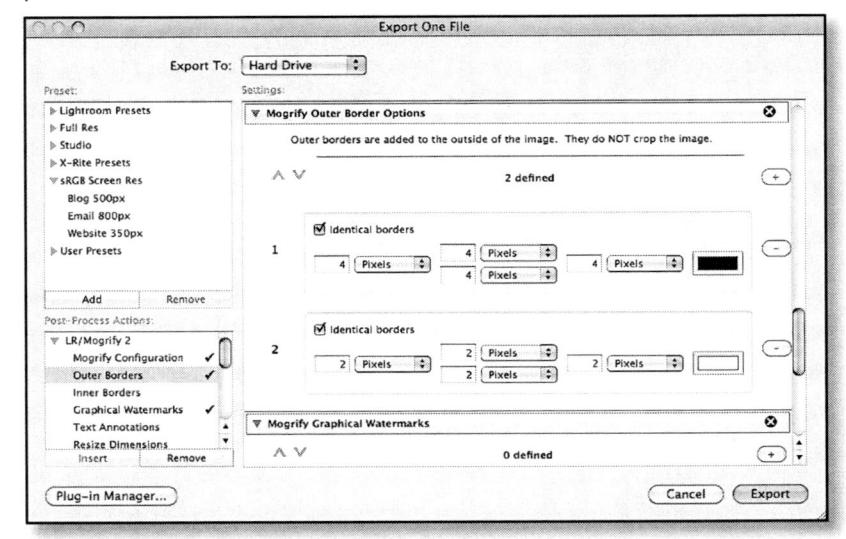

Certain other Export Plug-ins, such as LR/Transporter have a menu listing under the File menu or Library menu in the Plug-in Extras section instead, and many of the plug-ins store additional information under that menu too.

Can I export directly to an FTP server?

download the If you plug-in SDK (Software Development Kit), there's а sample plug-in for uploading to a FTP server. It's not as complicated as it sounds—just go http://www.adobe.com/devnet/photoshoplightroom/ and download the SDK zip, unzip it, and look in the Sample Plug-ins folder. There should be a folder called 'ftp_upload.lrdevplugin' which you can install using the instructions on the previous pages.

OTHER EXPORT QUESTIONS & TROUBLESHOOTING

Having chosen all of your settings in the Export dialog, you can save them as a preset for easy access next time.

Can I save my Export settings as a preset?

A few Export presets are already included by default, but it's useful to save your own settings for easy access. Set up your Export options, and then press the Add button in the Presets panel of the Export dialog to save the settings for future use. As with other presets, you can organize them into folders for easy access, and update them when your settings change. You might choose to create presets for regular

exports, such as email, blog, printing at a lab, archiving full resolution, and so forth.

Do I have to use the Export dialog every time I export?

If you've set up Export presets, you can easily access these through File menu > Export with Preset, or through the right-click context-sensitive menu for any photo.

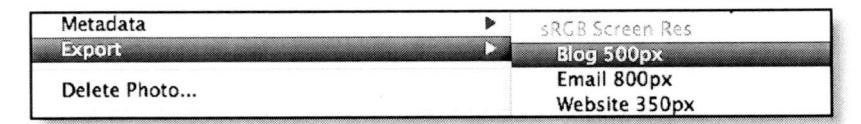

Can I strip the metadata from my files, like Save for Web in Photoshop?

The 'Minimize Embedded Metadata' checkbox in the Export dialog will strip most of the metadata from the exported file, leaving the copyright information and color space tag.

If you want to be a little more selective, Jeffrey Friedl's Metadata Wrangler Export Plug-in allows you to choose which metadata to remove and which to keep. You can download it from:

http://www.regex.info/blog/lightroom-goodies/

Why can't CS2 save as JPEG when I've used Local Adjustments on the photo?

If you edit a file in Lightroom using the Gradient tool or Adjustment Brush, open that file in Photoshop CS2, and then try to save it as a JPEG, Photoshop will show an error message which says 'Could not complete your request because of a program error.' Why?

Ok, it's a bug... but it's not a Lightroom bug. Photoshop CS2 trips up on some perfectly legitimate metadata that Lightroom saves into the files when you've used local adjustments. CS3 and later behave correctly

with this metadata, but CS2 is no longer updated and so the bug will never be fixed. So what can you do about it? You have a few options:

- Upgrade to CS3 or later. (While we're on the subject of CS2 and upgrades, CS5 is the last upgrade that CS2 users can buy at an upgrade price. Once CS6 is available, CS2 users will have to pay the full price to upgrade, as only the previous 3 releases qualify for the discounted upgrade pricing.)
- Check the 'Minimize Embedded Metadata' checkbox in the Lightroom Export dialog, which will strip ALL of the metadata. It solves the problem, but leaves you short of any metadata in your files.
- Use Jeffrey's Metadata Wrangler to strip just the problem metadata from the file, which is by far the best option.

To use Jeffrey's Metadata Wrangler Export plug-in, you'll first need to download it and install the plug-in from:

http://regex.info/blog/lightroom-goodies/metadata-wrangler

Select the plug-in in the lower left of the Export dialog, and you'll see the additional section appear in the main Export options panel—scroll down if you can't see them.

The only part you need to remove is the 'crs' block marked in red -- all of the rest of the metadata can stay. The 'crs' block is the Camera Raw Settings metadata, better known as the Develop settings, and photos exported with that block removed will quite happily save as a JPEG, even with Photoshop CS2.

Remove	Preserve	XMP Blocks (Remove ○ Preserve ○) The XMP block consists of many sub blocks, the arrangement of which is an utter mess, with related information scattered across unrelated blocks, and unrelated information crammed together into the same block. Click the link at right to visit a page that provides more information
•	0	XMP "crs" block (develop adjustments, local corrections,)
0	•	XMP "tiff" block (basic things like Arcist, copyright, date, size,)
0	•	XMP "exif" block (repeats many Exif items; see "remove with prejudice" below)
0	\odot	XMP "de" plack (basic publishing: date, identifier, rights, title,)
0	\odot	XMP "iptecore" block (creator, location)
0	\odot	XMP "photoshop" block (location, history, credit)
0	\odot	XMP "xmp" block (rating, label, modify date,)
0	\odot	XMP "aux" block (lens id, camera serial number,)
\circ	•	XMP "xmpRights" block (rights url, owner, rights usage terms)
\circ	\odot	XMP "Ir" block (hierarchical keywords)

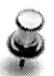

Also check...

"Lightroom thinks my photos are missing—how do I fix it?" on page 200

It gives an error message—'Some export operations were not performed. The file could not be written.' or 'The file could not be found.' What went wrong?

If Lightroom says it couldn't export the files, press the 'Show in Library' button to view an 'Error Photos' temporary collection, so you can see the photos in question.

If the error says 'The file could not be found,' then some of the selected photos are missing because you've moved or renamed them with other software, or the drive is offline. Click on the question mark on the thumbnail and locate the original file, and run the export again.

If the error says 'The file could not be written,' check the permissions on the export folder or parents of that folder, because they're probably read-only, or you're running out of disc space on that drive.

The files appear in the export folder and then disappear again. Why is Lightroom deleting them?

If the files seem to appear in the Export folder and then immediately disappear again, it's because Lightroom isn't able to write to that folder.

The most likely reason is that you've run out of hard drive space, or are at least running very low. Try exporting to another hard drive or clearing some space, perhaps emptying the Recycle Bin (Windows) / Trash (Mac).

Publish Services

Publish Services is another way of sharing your photos. It does a two-way synchronization between your Lightroom catalog and other locations—at this stage primarily photo-sharing websites. As you make changes within Lightroom, those changes can be updated on your photo-sharing website, and depending on the service used, some updates such as comments made on the website can be transferred back to your catalog.

SETTING UP YOUR PUBLISH SERVICES

To get started with Publish Services, look at the Publish Services panel in the Library module. By default, you'll see at least 2 Publish Services—Hard Drive and Flickr. There may also be others, depending on the plug-ins you have installed.

Why is Flickr the only website? Where's my favorite photo sharing website?

The Flickr plug-in's just a starting point. It was chosen because it's the most popular photo sharing website among Lightroom users, it has a good range of features and a stable API (Application Programming Interface) to build on.

"What plug-ins are currently available?" on page 399 Jeffrey Friedl, for one, has already started adding Publish Services integration into his well-known Export plug-ins. Each of the services will have slightly different limitations, dependent on the photo sharing website facilities and API, but the basic setup will be the same as the Flickr integration.

What can I use the Hard Drive option for?

The Hard Drive facility isn't the primary purpose for Publish Services, but it has its uses. You can create a folder on your hard drive for your Publish collections, and any changes you make within your catalog will automatically be exported to that folder hierarchy.

For example, maybe you like to keep photos on your iPad, so you could have an iPad collection which updates the photos in a folder ready to be transferred by iTunes next time you sync your iPad.

Perhaps you like to have your screensaver showing your latest photos, so a smart collection sending your last month's photos to your screensaver folder would be useful.

If you're using album design software, it's also a convenient way of making changes to the individual photos in Lightroom, and then being able to keep the exported versions updated in the album design.

How do I set up my Publish Services accounts?

When you first look at the Publish Services panel, there are two buttons— Hard Drive and Flickr. Click on one to show the Lightroom Publishing

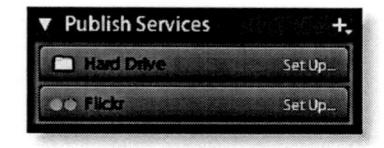

Manager dialog. We'll use Flickr for this example.

Give your account a name and then press the 'Log In' button and it will ask you to authorize access to that account.

When you press Authorize, it will open Flickr's website, where you'll be asked to confirm that you want to allow Lightroom access to your Flickr account.

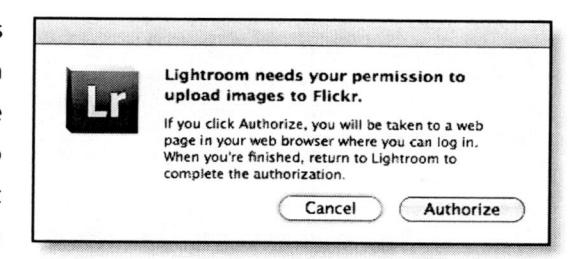

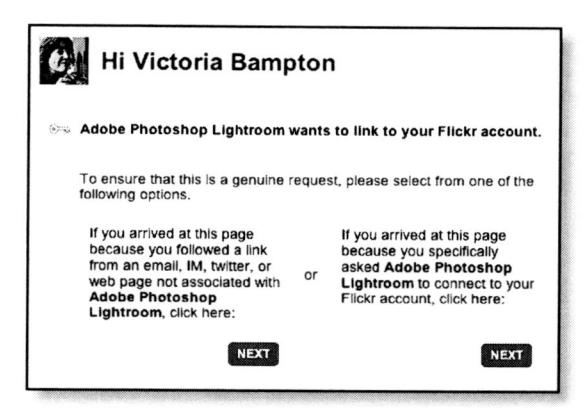

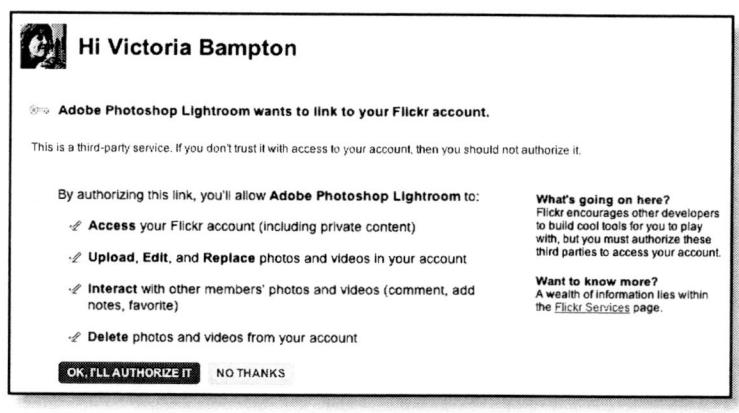

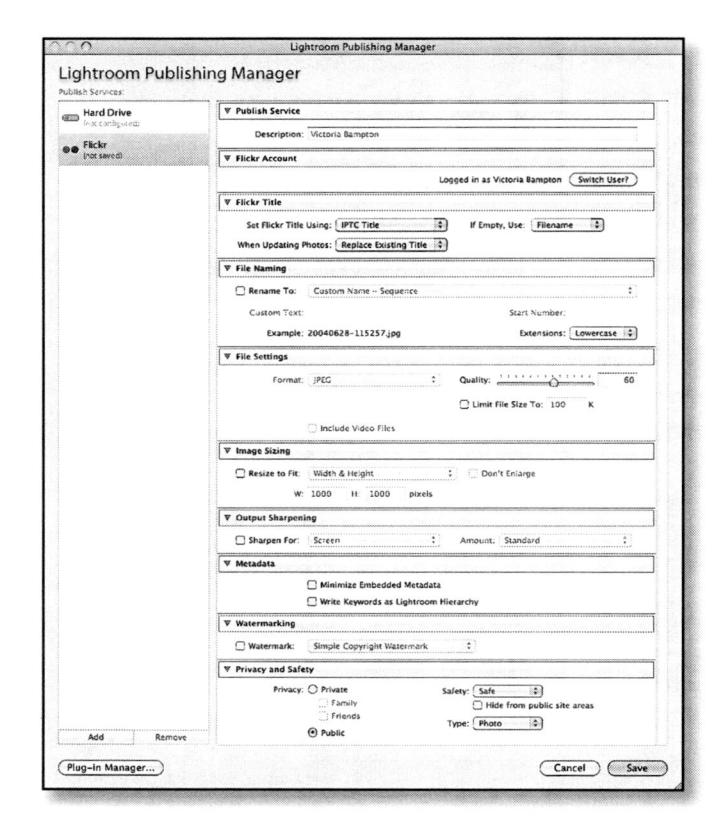

Once Lightroom has been granted permission, you can start setting up your preferences. The options will be familiar from the Export dialog, which we covered in the previous chapter.

Once you've finished with your preferences, press 'Save' and you'll be ready to start setting up your Publish Collections.

Can I choose the size of the photos to upload?

The Publishing Manager dialog gives you all of the controls that would usually be available in the Export dialog, including image sizing, sharpening and watermarking. If you need to upload different sizes, you'll need to set up 2 separate Publish Services accounts as the settings are per-service, but they can both link to the same Flickr account online.

"File Settings" section on page 370

How do I prevent it uploading a particular version of a photo?

Only add photos that you want to upload to your Flickr photoset, or if there's a particular version you would like to upload, use a virtual copy. Anything you add to those photos will be published.

How do I control which keywords are visible on my published photos?

If you go to the Keyword List panel and right-click on the keyword, you can uncheck the 'Include on Export' checkbox in the Edit Keyword dialog. Doing so will exclude that keyword from all exports, so it's particularly useful when using parent keywords like 'Place' in a keyword hierarchy. If you only want to exclude the keyword from Flickr, use a virtual copy without that keyword applied, or select 'Minimize Embedded Metadata' in the Publishing Manager dialog to strip all of the metadata from all of the photos you're uploading.

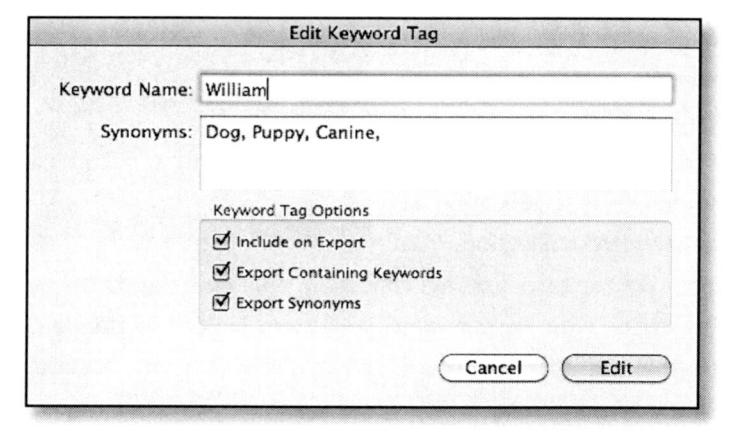

Which settings should I use for Privacy & Safety?

At the end of the Lightroom Publishing Manager dialog is the Privacy & Safety section. 'Privacy' controls who can view your photos, so they can be set to 'Public' to be visible to everyone or limited to your friends and family. 'Safety' controls Flickr's own content filters, rating the photos as

"Snapshots & Virtual Copies" section on page 308

"Keywording" section on page 173 safe for anyone to view through to restricted which are unsuitable for some audiences, just like movie parental guidance ratings.

CREATING COLLECTIONS & PHOTOSETS

You're not limited to putting photos directly into the Photostream for Flickr or a single folder for Hard Drive. You can organize your photos into groups, creating photosets for Flickr or a hierarchy of folders and subfolders for the Hard Drive.

Can I divide my photos into different sets?

The Flickr Photostream collection will automatically appear in the Flickr section of the Publish Services panel when you create a Flickr Service. You can add photos to that collection as if it was a standard collection. You

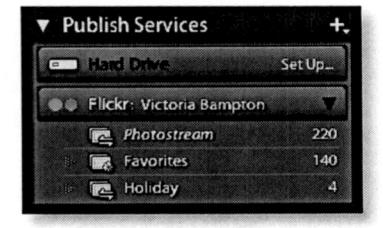

can also right-click to create another collection, only here they're called Photosets to match with Flickr's name. You're not limited to standard collections—you can also use smart collections which will become additional photosets on Flickr.

How do I add photos into a photoset that already exists on Flickr?

If you create photosets within your Flickr Publish Service in Lightroom, and name them using precisely the same name as your photoset on Flickr, photos in those collections in Lightroom will get added to the corresponding photoset on Flickr.

I didn't mean to remove a photo from a photoset—how do I restore it?

If you accidentally remove a photo from a photoset, just drag it back again. If you haven't run a 'Publish Now,' nothing will change on Flickr and it will move back into the 'Published photos' section. If the photo has been deleted from Flickr, it will be uploaded again.

SYNCHRONIZING CHANGES

Once you've set up your Publish Service, chosen your photos, and grouped them, you're then ready to synchronize that with the other service, whether that's a website or a hard drive location.

How do I publish to Flickr or my hard drive?

Once you've created your collections/photosets, right-click on each and choose 'Publish Now'. The photos will start to upload which, depending on the dimensions chosen and your internet connection upload speed, could take a while!

If you only want to limit your upload to specific photos temporarily, select them and then hold down the Alt (Windows) / Opt (Mac) key and the 'Publish' button at the bottom of the left hand panel will change into a 'Publish Selected' button.

Does it automatically publish changes I make to my photos?

Lightroom waits for you to right-click on the photoset and choose 'Publish Now,' rather than automatically uploading, otherwise it would be constantly uploading every time you made a change to a photo.

How do I update Flickr or my hard drive with the changes I've made to my photos?

When you come back to one of those collections or photosets later, having made changes the photos, Lightroom will have divided it into different sections—'New photos to publish,' 'Deleted photos to remove, 'Modified photos to republish' and 'Published photos.' To update Flickr with your changes, right-click on the photoset and choose 'Publish Now.'

How do I remove photos from my Lightroom catalog without removing them from Flickr?

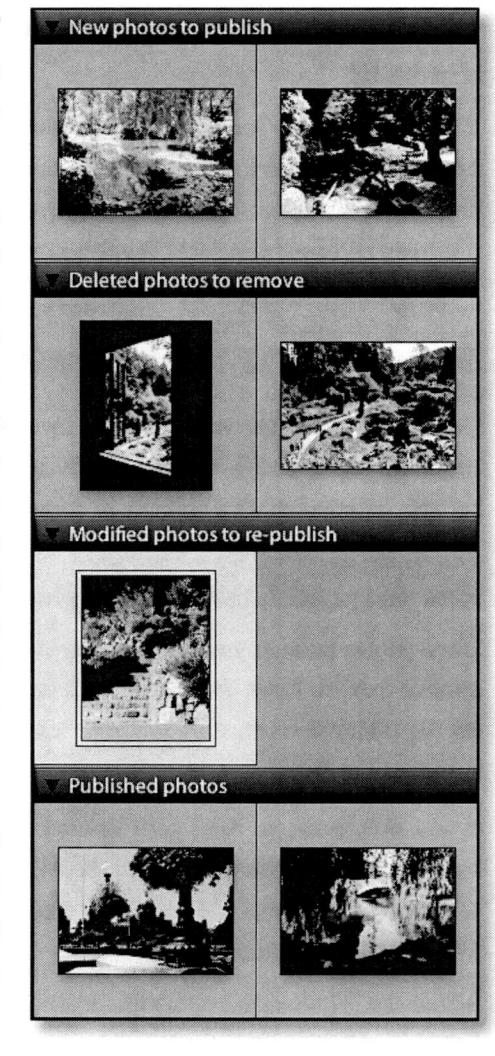

If you remove a photo from your catalog or from your computer, but you want it left on your Flickr account, don't press 'Publish Now' again, because it'll also be removed from your Flickr account. It doesn't work the other way round, so you can safely delete photos from your Flickr account without them being deleted from your catalog.

I deleted a photo on the Flickr web interface—how do I upload it again?

If you delete a photo on the Flickr website, Lightroom won't know, and it'll remain in Lightroom's 'Published Photos' section. If you want to upload it again, right-click on the photo and choose 'Mark to Republish' and when you next select 'Publish Now,' that photo will be re-uploaded.

"How does Export as Catalog work?" on page 234

What happens if I rename a photo and then republish it?

If you rename a photo in Lightroom and then click 'Publish Now,' the Free account will ignore the change of name, but the Pro account will update the existing Flickr photo to show its new name.

Can I use Export as Catalog to transfer my Publish collections between catalogs?

Publish collections/photosets are tied to one specific catalog, and aren't carried over when using Export as Catalog, unlike normal collections, so be careful to set it up in your master catalog rather than a temporary catalog.

FLICKR ACCOUNT QUESTIONS

Although the following questions refer specifically to Flickr accounts, many of the principles will also apply to other photo sharing websites.

What are the limitations of the Free vs. Pro Flickr accounts?

The limitations of a free Flickr account are listed on their website here: http://www.flickr.com/help/limits/#28

As far as Lightroom's integration is concerned, the Free account can republish photos, but in doing so it removes the previous one and uploads a new one, so any links referring to the original photo are broken and changes made on the web interface are lost. The Pro account

is able to replace photos in place, without breaking the links to the page, although the links to the photos themselves do get broken as a result of limitations in the Flickr API.

How do I upgrade Lightroom to a Pro account?

Lightroom only checks whether you have a Pro or Free account when you set up the Publish Service in Flickr. If you start out with a Free account, and then later decide to upgrade to a Pro account, you'll need to revoke the permissions and re-establish the connection again.

Open the 'Your Account' page on the Flickr website, go to the 'Extending Flickr' tab, and click on 'Edit.' You'll see Lightroom in the list of 'Account Links'. Click 'Edit' at the end of that line, then 'Remove Permission' on the following page, and finally confirm that you're revoking Lightroom's permissions. Switch back to Lightroom, right-click on the Flickr Service to go to the Publishing Manager dialog and click 'Log In' to go through the Authorization steps again, as if you were setting the account up for the first time.

Can I have more than one Flickr account connected to my catalog?

To connect multiple Flickr accounts to the same catalog, right-click on the Flickr Publish Service, select 'Create Another Flickr Connection,' and go back and set it up as an additional account in the Publishing Manager dialog. You can also connect the same Flickr account to the same catalog multiple times, perhaps to use different upload settings for specific photos.

Can I have the same Flickr account connected to multiple catalogs?

You can have the same Flickr account connected to multiple catalogs, but there are limitations. You can't transfer your collections/photosets

"Should I use one big catalog, or multiple smaller catalogs?" on page 215 between catalogs, even using Export as Catalog, and Lightroom won't know about anything that's already on your Flickr account or in your other catalog.

How do I disconnect Lightroom from my Flickr account?

If you want to disconnect a Publish Service from your Flickr account, right-click on it and choose Delete. Nothing will be deleted from Flickr by doing this, but Lightroom will no longer have a record of which photos were uploaded, so if you decide to reconnect your Flickr account in the future, you would have to set up those photosets again.

I accidentally revoked the authorization on Flickr's website how do I fix it?

If you accidentally revoke the authorization on Flickr's website, editing the settings in the Publishing Manager dialog will allow you to log in and re-authorize Lightroom's access.

PUBLISH SERVICES TROUBLESHOOTING

And of course, no chapter would be complete without a few hiccups that can occur along the way!

Why is the new Comments panel unavailable?

The Comments panel is designed to work with the Publish Services, synchronizing comments with supported photo sharing services, so it's

"How do I install Export plug-ins?" on page 400 only available when you have a Publish collection selected. If someone comments on one of your photos on the Flickr website, those comments will be retrieved when you next publish that collection. There isn't currently an easy way of finding out which photos have comments.

Why is there a question mark on my Flickr service?

The Flickr Publish Service is just a plug-in which can be enabled and disabled using the Plug-in Manager. Go to File menu > Plug-in Manager and check that the plug-in has a green circle against it, and if it hasn't, select it and press the Enable button.

What does 'Flickr API returned an error message (function upload, message Not a Pro Account)' mean?

The Free account is more limited than a Pro account, and any error messages that say 'Not a Pro Account' are a result of trying to use a facility that isn't available with the Free account. For example, trying to upload a video which is longer than the 90 second Free account limit can cause such error messages. To avoid those limitations, you can upgrade to a Pro account.

Slideshow Module

The Slideshow module isn't designed to replace specialized slideshow software, so it does have some limitations, but it's a great way of showing your photos to friends, family and clients. If they're sat next to you, the slideshow can run directly within Lightroom with background music to set the atmosphere, or you can export your slideshow to PDF or movie format to share with others. If you prefer to use other slideshow software, to set different transitions and timings for each slide, you can still use Lightroom's slide design tools to create beautiful slides and then export them to JPEG format.

STYLES & SETTINGS

Lightroom's slideshows aren't limited to just showing the photo full screen. You can design the slides with background images and tints, add borders and drop shadows to lift the photos off the screen, and include metadata describing the photos.

How do I create my first slideshow?

Lightroom comes with a few templates to get you started. As you hover the mouse over the templates in the Template Browser panel, the Preview panel above will show you a small preview of that template, so find one you like and click on it.

The 'Default' template is a good starting point, but you might like to customize it further, so start exploring the panels on the right. With the default black background, a white stroke around the edge of the photo can help to lift it, so go to the Options panel and click to show the Color Picker for the 'Stroke Border' setting. If you find the margin guides distracting, you can turn them off by unchecking 'Show Guides' in the Layout panel.

At the bottom of the right hand panel are the 'Preview' and 'Play' buttons, which allow you to check your slideshow. 'Preview' shows you the slideshow within the normal content preview area, whereas 'Play' will show it full screen. To go back to the slide editing mode at any time, just press Escape on your keyboard.

If you're going to show your slideshow to other people, it's wise to do a full dry run first, to make sure that your previews are fully rendered and everything behaves as you expect.

How do I add my Identity Plate to my slideshow?

Your Identity Plate is tucked away in the corner of that 'Default' template, but if you click on it, you can resize or move it, or switch to a different one using the Overlays panel. It's a great way of personalizing your slideshow, adding your name or logo, but it doesn't have to stay in that corner. You might like to place it below the photo in the center, in which case you'll probably need to adjust the bottom margin by dragging that guideline or changing the slider in the Layout

panel. If all of the guidelines move at the same time, uncheck the 'Link All' checkbox in the Overlays panel.

How do I adjust the anchor point?

As you move the Identity Plate around on the slide, you'll see a small fly-out anchor point which snaps to the corners and edges of the photo or screen. That locks the relative position of the Identity Plate, and it also works on the text overlays that we'll consider next. If you want the Identity Plate below the photo in the center, pick up the yellow anchor point and drag it to the bottom center of the screen, rather than the photo, so that it doesn't jump around as you go through each slide. If you'd prefer to use it as a signature, lock it to the bottom right corner of the photo instead. You can check how it will look on other photos by clicking on them in the Filmstrip. It's worth testing both horizontal and vertical photos to see whether your layout will work well with both orientations.

How do I add captions to the slides?

If you press the 'ABC' button on the toolbar, you can add captions to the slides. The 'Custom Text' option, which is selected by default, only creates a static line of text which is the same on each slide. If you'd like to add a different caption to each slide, perhaps telling the story behind each photo, you first need to add the caption for each photo in the Metadata

"Using Tokens in Dialogs" on page 139 panel in the Library module. To show that caption in the slideshow, press the 'ABC' button on the toolbar as before, but this time choose 'Caption' from the pop-up menu. That will only show text on photos which have a caption in the metadata, and others will be blank.

You're not limited to only adding captions. You might like to add the camera EXIF data if you're

presenting your photos to the local camera club, or show the filename and your star rating if you're presenting to a client. If you select 'Edit...' in that pop-up menu, you can use tokens to create your own combination of data in the Text Template Editor dialog.

How do I change the font on my text overlays?

If you click on a text overlay to make it active, indicated by the bounding box around the text, then you can change the font and text color for that specific overlay using the Text Overlays controls in the Overlays panel. If you have more than one text overlay, you have to change each in turn. To change the font size, click and drag the edges of the bounding box. It's the vertical height that you need to get right, as the width will automatically adjust according to the text.

How do I remove the quotation marks when a caption is blank?

If you create a slideshow using the 'Caption & Rating' slideshow template which comes installed with Lightroom, the caption is shown in quotation marks, such as "Mount Rushmore," but when the caption field is empty, those quotation marks still show as "" which can look quite odd. You could check all of your photos to ensure they all have entries in the Caption field, or you could just remove the quotation marks. To do so, click on the bounding box which says "" on the preview and then select 'Edit...' from the pop-up menu on the toolbar. In the Text Template Editor dialog, remove the quotation marks and press Done. You might want to save your settings as a new 'Caption & Rating' template for use

again in the future, so we'll come back to saving templates later in the chapter.

How do I change the background?

Personally I like the clean black background, as it doesn't distract from the photos themselves, but if you scroll down to the Backdrop panel, you can choose a different background color, add a gentle gradient, or even a background photo or texture. If you do add a background photo, I'd suggest setting the background color to white, and dropping the opacity of the background photo so that it doesn't compete for your attention.

What does 'Zoom to Fill Frame' do?

The 'Zoom to Fill Frame' checkbox in the Options panel fills the entire aperture with the photo, making them all an identical orientation and ratio. If you have any panoramic or vertical photos, they can look odd cropped tight, so I usually leave it unchecked.

Can I add Intro and Ending slides?

If you want to build the anticipation and stop your guests from viewing the first slide, you can check the Intro and Ending Screen checkboxes in

the Titles panel, and they can include an Identity Plate to personalize it. If you'd like more complicated title pages, you can design them in Photoshop and save them as an image format (i.e., JPEG). You'll then be able to import them into Lightroom and place them at the beginning and end of your slideshow.

When you're setting up your slideshow, press Play, but then immediately press the Spacebar to pause the slideshow on that Intro slide. When you're ready to play, just press the Spacebar again.

Can I advance the slides manually, but still have them fade from one to the next?

If you advance to the next slide manually by pressing the left and right arrows on the keyboard, Lightroom assumes that you don't want to wait for the set slide duration, and therefore you also don't want to wait for the fade either, so at this point in time it's not possible to manually advance with the fade.

Can I rate photos while a slideshow is running?

"Rating & Labeling" section on page 160

You can use the 0-5, 6-9 and P, U, X shortcut keys to mark the photos with star ratings, color labels or flags while the slideshow is running. Even if you don't have those markers showing as captions on your slideshow, the new rating will appear briefly in the lower left corner of the screen so you can check the rating you've just applied.

How do I make the slideshow display on my second screen?

If you have more than one screen attached to your computer, they both appear in the Playback panel, and you can click on whichever screen you want to use to display the slideshow. Your chosen screen will be marked with a triangle—a 'play' icon.

MUSIC

Lightroom allows you to add a music track to your slideshow, which adds to the atmosphere. You'll find the controls in the Playback panel.

How do I select or change the music track?

To select your music track, check the 'Soundtrack' checkbox and press the 'Select Music' button to navigate to the track of your choice. The

name of the track will appear above, along with the track length.

Which music formats can Lightroom play?

Lightroom can play MP3 or AAC files, as long as they're DRM free.

How do I adjust the slide timings to fit the length of the music track?

Once you've chosen the photos and music track, you can select the fade timing of your choice in the Playback panel, and then press the 'Fit to Music'

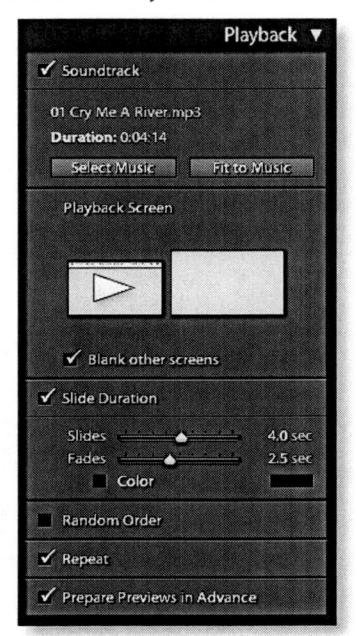

button. You'll see the slide timings automatically adjust to fit, and you can then press 'Preview' to test your settings. If the slide duration and fade duration aren't well balanced, you can adjust the fade timing and press 'Fit to Music' again. You don't have to fit the slideshow to your chosen music track, but if the slideshow finishes before the music, the music will also stop mid-song.

Why can't Lightroom find my iTunes playlists?

Lightroom no longer looks for the iTunes library on the Mac version, bringing the behavior of the Mac version in line with the Windows version. Instead, you select a specific track to play as your slideshow soundtrack.

How do I play multiple different music tracks during my slideshow?

Playing multiple music tracks during a slideshow is missing from Lightroom 3 because the addition of Export to Video has created some additional limitations for the time being. Hopefully it will return in the future.

In the meantime, if the track ends while the slideshow is still running, the music track will loop back to the beginning and play again, or you can join multiple tracks into a single long music file using audio editing software, and then set Lightroom to play that long combined track.

SAVING & EXPORTING SLIDESHOWS

Having set up your slideshow just the way you want it, you'll need to save those settings for later, both as a collection for those specific photos, and as a template to apply to other photos.

Being able to play your slideshow in Lightroom is great if the people are sat next to you, but Lightroom can also export the slideshow to other

formats to send to your viewers. You have a choice of export options, including JPEG slides for use in other software, PDF format without music, or MP4 Video format with the music and transitions.

Can I save my settings for a specific slideshow?

If you create a slideshow from an existing collection, or you create a collection in the Slideshow module, your slideshow settings will be stored with that collection, including the sort order, slide design, background colors, music choice, and so forth.

When you return to that collection later, all of that collection's slideshow settings will be applied, regardless of what you've done using other photos in the Slideshow module since.

If you create the collection using the Collections panel in the Slideshow module, the collection will show a Slideshow collection icon, and if you're viewing another module, double-clicking on the Slideshow collection will take you directly to the Slideshow module.

How do I save my settings as a template for use on other photos?

To reuse those slideshow settings on another set of photos, you can save them as a template by clicking on the + button on the Template Browser panel, just as you would with Develop presets. Name your template, and place it in the User Templates folder or another folder of your choice. As with all presets, you can update your templates at any time by changing your settings and then right-clicking on the template and choosing 'Update with Current Settings.'

Template Browser

▼ Lightroom Templates

☐ Caption and Rating

☐ Crop To Fill

丽 Default

User Templates

Exif MetadataWidescreen

■ My Slideshow Template

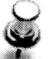

Also check...

"Web Module" chapter on page 447

Can I export my slideshow to run in a DVD player?

The slideshow export options available at this point in time, in addition to running the slideshow using Lightroom itself, are 'Export to PDF,' 'Export to JPEG' and 'Export to Video.' If you need to create a DVD slideshow specifically, the 'Export to JPEG' option does give you the possibility of designing the bordered slides in Lightroom, exporting them to JPEG format, and then using those slides in other software which is specifically designed to create DVD slideshows—your CD/DVD burning software may have that capability.

Can I export my slideshow for viewing on the web?

If you export using the new 'Export as Video,' you can host that MP4 file on your own website or blog, YouTube, Facebook, and other video hosting websites. If you would prefer a Flash slideshow for your website, they can be created in the Web module using the standard Flash gallery, or some of the third-party web gallery plug-ins, such as 'SlideShowPro' (http://www.slideshowpro.net/products/slideshowpro/#ssplr) or 'TTG Monoslideshow 2' (http://lr.theturninggate.net/flash-galleries/ttg-monoslideshow-2/).

Can I export the slideshow with the music?

'Export to PDF' doesn't include music, but 'Export to Video' does. Alternatively, if you own Adobe Acrobat Pro™, it would be possible to embed the soundtrack into the PDF file once it's been created by Lightroom, along with other security features limiting access to the PDF.

Where has the 'Export to JPEG' option gone?

The 'Export to JPEG' option is still available in the Slideshow menu, but its button has been taken over by the more popular 'Export to Video' option. The button's still there, but it's now hiding under the 'Export to PDF' button—hold down the Alt (Windows) / Opt (Mac) key and it will change it temporarily back into an 'Export to JPEG' button.

I exported to PDF, but it doesn't automatically start the slideshow when I open the PDF. Why not?

If you check the 'Automatically show full screen' checkbox in the Export Slideshow to PDF dialog, it will automatically run as a full screen slideshow when opening the PDF, but only in certain PDF software, for example, a current version of Adobe Reader.

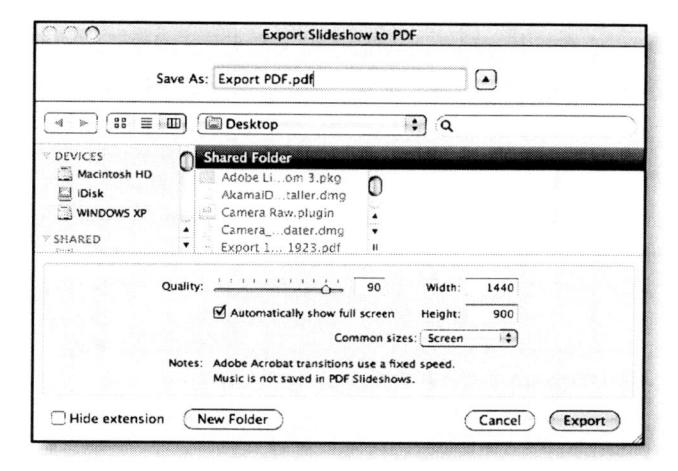

Which movie size option should I choose?

Adobe's recommendations are:

320 x 240—smallest file size, suited to email, compatible with Quicktime, iTunes, Adobe Media Player, Windows Media Player 12, etc.

480 x 320—ideal for mobile devices such as iPhone, iPod Touch, Android, etc.

720 x 480—small handheld devices, email, web

960 x 540—home media display i.e. AppleTV

720p—medium size HD for online sharing, YouTube, Facebook, blip.tv, and for home media/entertainment such as iPad, AppleTV or Windows Media Center

1080p—high quality HD video

Also check...

"Previews" section on page 253

ERRORS

Of course, problems can occur, but there are a few things you can do to fix them.

Why does it stall part way through the slideshow or go much slower than the times I'd chosen?

If the previews aren't rendered in advance, or are too low in quality, Lightroom will be working hard to render the previews to show in the slideshow. This can create delays, so there's a 'Prepare Previews in Advance' checkbox in the Playback panel which makes sure the previews of the whole slides, including their backgrounds and borders, are rendered before starting the slideshow. If you choose to uncheck this box, or press Escape when the preview rendering dialog shows, the slideshow will start playing but it may stall or show lower quality previews, particularly on slower hardware.

Everything appears to be running correctly, then the screen just goes plain grey or black when I try to running the slideshow. Why?

Problems with the slideshow not running are usually an issue with the graphics card driver, so check with the card's manufacturer for an updated driver. Selecting a lower screen resolution can help when the graphics card is struggling.

Why is my noise reduction and sharpening not applied to my slideshow?

Noise Reduction and Sharpening are only applied to 1:1 Previews, not Standard-Sized Previews. Select the photos in Grid view and choose Library menu > Previews > Render 1:1 Previews and wait for it to finish. Once the previews have been rendered, run the slideshow again and your noise reduction and sharpening should have been applied.

"The previews are slightly different between Library and Develop and Fit and 1:1 views—why is that?" on page 260

Print Module

Although most photos today start out as digital files, at some stage you're likely to want to print them. Exporting the photos and sending them to a digital lab is an easy option, but Lightroom also offers a Print module which allows you to build contact sheets and lay out multiple photos on a page for printing to a local printer.

LAYING OUT YOUR PHOTOS

Lightroom offers 3 different options for printing, which you select in the Layout Style panel.

- Single Image/Contact Sheet = a single photo or different photos all the same size, laid out as a grid
- Picture Package = the same photo in different sizes, laid out fixed to grid lines
- Custom Package = different photos in different sizes, laid out freeform

How do I set up a single borderless print, for example, a 4x6 snapshot?

To create a borderless print, you first need to click on the Page Setup button at the bottom of the left panel and set your printer paper size to borderless because Lightroom won't allow you to reduce the borders past the printer setting. Those options are limited to paper sizes that your own printer driver offers. If you have 'Page Bleed' checked in the

Guides panel, you'll see the minimum margins marked in grey. If you set your paper size to borderless, those grey borders will disappear and you can adjust the margins to 0 in the Layout panel.

How do I change the page size?

If your 'Print to:' setting in the Print Job panel is set to 'Printer,' then the printer driver is setting the paper size, and you must go Page Setup to change that paper size. If you're printing to JPEG format, you can set customer file dimensions in the Print Job panel.

How do I create a contact sheet?

If you're just getting started, there are a number of default contact sheet templates in the Template Browser panel to get you started. You can either pick one of those and adjust it to your taste, or start from scratch.

If you're starting from a clean page, first set the page size and orientation in the Page Setup dialog. In the Layout Style panel, select 'Single Image/ Contact Sheet,' and then moving down to the Layout panel, choose the numbers of rows and columns that you want on your contact sheet and adjust the spacing between the cells. You may need to go back to the Image Settings panel to turn off 'Rotate to Fit' if you have a mixture of horizontal and vertical photos.

We'll come back to other design customization such as background colors and text information later in the chapter.

"Why can't I drag and drop into a custom sort order or User Order?" on page 188
How can I change the order of contact sheet photos?

The contact sheet photos will display in the current sort order, so if you rearrange the sort order in Grid view or Filmstrip, the contact sheet will automatically update to show your new sort order.

If you're going to need to reprint the contact sheet again later, you may decide to save the photos in a collection, as the collection will retain the sort order, in addition to your Print module settings.

How do I use Picture Package?

The Picture Package enables you to print multiple versions of the same photo in varying sizes, for example, printing 2 small copies for your wallet, and a larger copy for a frame.

There are some default Picture Package templates, for example '(1) 5x7, (4) 2.5x3.5,' or you can create your own package using the Cells panel.

Clicking any of the size buttons in the Cells panel will create a cell of that size, and the buttons have a pop-up menu allowing you to create buttons for custom sized cells. Holding down Alt (Windows) / Opt (Mac) while dragging an existing cell will duplicate that cell.

If you want to resize an existing cell, you can use the sliders in the Cells

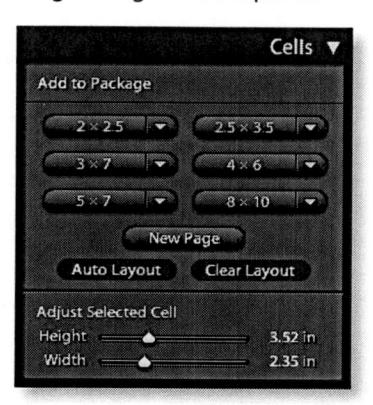

panel, or drag the edges of the bounding box. Holding down the Shift key while resizing the bounding box will constrain the ratio of the cell, and holding down Alt (Windows) / Opt (Mac) resizes from the center point instead of the corner, just like in the Crop tool.

Clicking the Auto Layout button will arrange the cells on the page to waste as little paper as possible, or you can drag and drop them into a layout that you like.

What does the exclamation mark in the top right corner mean?

If the photos are overlapping in the Picture Package, an exclamation mark will show in the top right corner of the preview to warn you. If you ignore that warning, they'll print in the overlapping layout you've designed.

How do I create a Custom Package?

The Custom Package enables you to print any photos in a mixture of sizes to avoid wasting paper, so you have 2 choices—either you place the cells first and then drop the photos into those cells, or you drop the photos directly onto the page and their cells will be automatically created, ready for you to resize.

As in the Picture Package, holding down Alt (Windows) / Opt (Mac) while dragging an existing cell will duplicate that cell, and you can resize it using the sliders in the Cells panel or by dragging the edge of the bounding box. Again, holding down the Shift key while resizing the bounding box will constrain the ratio of the cell, and holding down Alt (Windows) / Opt (Mac) resizes from the center point instead of the corner, just like in the Crop tool.

What's a pinned or anchored cell?

If you right-click on a cell in the Custom Package and choose Anchor Cell, that cell and its contents will be placed on each page in exactly the same place, and moving or deleting it on one page will do the same on the other pages. It's particularly useful for adding a logo onto each page.

How do I replace a photo in an existing cell?

To change a photo, just drop another photo on the existing cell, and it will automatically be replaced.

How do I see the cell size?

If you click on a cell, the cell dimensions are available in the Cells panel, but if you turn on the Dimensions checkbox in the Rulers, Grid & Guides panel, they'll also appear in the top left corner of any cell

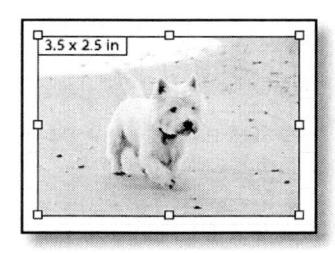

containing a photo. They update live as you resize each cell, and in that Rulers, Grids & Guides panel, you can choose whether to show the sizes in inches, centimeters, or a variety of other units.

How can I stop the photos being cropped by the cells?

If you want to do a one-off resize to fit the cell to the photo's aspect ratio, right-click on the photo and choose Match Aspect Ratio. The cell will then be adjusted to fit, but it's not locked to that ratio, so any further resizing could alter the ratio again, whereas the Lock to Photo Aspect Ratio checkbox in the Cells panel will force all of the cells on the page to match the aspect ratio of the photos they contain.

How do I rotate a photo within a cell?

You can't manually rotate a photo within a cell—just the cell itself—but if 'Rotate to Fit' is checked in the Image Settings panel, the photo will automatically rotate within the cell to best fit your chosen crop.

How do I move a photo within a cell?

If the cell doesn't match the aspect ratio of the photo, for example you have a standard ratio photo in a long thin cell, you can hold down the Ctrl (Windows) / Cmd (Mac) key while dragging the photo to move it around within the cell. The movement is limited to moving up and down the short edge of the cell, so if you need a specific crop, it's better do the crop first in the Develop module.

"Cropping" section on page 336

How do I scroll through custom package pages?

There's a button in the Cells panel to create a new page, or dropping another photo on a page that's already full will automatically create another page.

The first 6 pages you create are all shown on screen at the same time, and then as you start adding additional pages, the arrow buttons on the toolbar become available to scroll through each following set of 6 pages.

The page previews do get a bit small once you have 6 pages, and there

isn't currently a way to zoom in on just one page, so custom packages needing detailed alignment may be best created one or two pages at a time unless you have a very large monitor.

Can I use the Print module to design albums and books?

The Print module isn't designed as a page layout tool for designing albums or books, at least at this point in time. There are limited options, for example, laying photos out on the page and adding basic strokes around the photos, but more extensive work would be better carried out in specialized software. It's a popular request, so it may make an appearance in the future, but for now, the Publish Services tool can help by keeping exported files updated with any Develop changes, so you can use album design software to create your finished article.

"What can I use the Hard Drive option for?" on page 408

STYLES & SETTINGS

Having laid your photos out on the page, you may want to add additional details to the page, such as filenames in the case of a contact sheet, or your logo or other personalization.

How do I add the filename and watermark to my contact sheet?

At the bottom of the Page panel there's a 'Photo Info' checkbox—if you check it and choose 'Filename,' that information will show beneath each photo. You're not just limited to the filename. If you select Edit... from the pop-up menu, you can combine tokens to create your own combination of metadata, using a dialog which is similar to the Filename Template Editor dialog used when renaming photos.

To protect your photos, particularly for contact sheets, you might also want to add the watermark that we created earlier in the Export chapter. You'll find the Watermarking checkbox and pop-up menu in that same Page panel.

Page

Page Background Color

Override Color

Victoria Bampton

✓ Identity Plate

"Using Tokens in Dialogs" on page 139

Is it possible to personalize my print by changing the background color?

You can change the page background color at the top of the Page panel, but it's automatically limited to neutral shades to avoid clashing with your photos. A black page background combined with a narrow white stroke, which you'll find further up in the Image Settings panel, can look striking and makes a change from a traditional white background.

While you're personalizing your contact sheet or print, you can also add your logo using the Identity Plate, also found in the Page panel. You may need to change the page margins to leave space for your Identity Plate, which you can do by dragging the margin guide if you have the guide lines set to show, or by using the sliders in the Layout panel.

Also check...

"Identity Plate / Activity
Viewer" on page
118 and "Copyright
& Watermarking"
section on page 389

How can I overlay a graphic such as a border onto my print?

Lightroom isn't currently designed to overlay graphical borders, however there's a popular workaround using Identity Plates or the new Watermarking feature.

Make a series of PNG border files using Photoshop—in the Lightroom community they're known as TPI's or Transparent PNG Images—and then save these as Identity Plates or Watermarks. You can download

examples from:

http://www.lightroomqueen.com/lr3bookdownloads.php

Although the Identity Plate dialog says it requires a maximum height of 57 pixels, this doesn't apply to Identity Plates that you'll use for overlaying on photos. These need to be the correct ratio for the prints you'll use them on, and if you're going to use them for printing, they'll need to be high resolution. You can have several Identity Plates or Watermarks saved, and then just choose the one you want to overlay.

Here's an example of one of the possibilities for framing photos using a soft edge. On the PNG file the black areas are transparent, however I've made the transparent areas black so you can see them.

With 1 photo on a sheet, I can place the Identity Plate anywhere on the photo. Is that possible for multiple photos?

If you print one photo per page, you can reposition the Identity Plate, or rotate it as needed, and adjust the opacity too. If you're printing multiple photos on the same page, you can't reposition it, but you can still adjust the size and opacity. If you're using the Watermarks feature instead of the Identity Plate, you have to set the position and size in the

Watermark Template Editor, rather than directly in the Print module, but the watermark can be saved in any position on the photo, rather than just being placed centrally, and will appear in that relative position on each of the photos.

I have the Rulers and Grid checked in the Rulers, Grid & Guides panel—why can't I see them?

If your guidelines are missing, make sure you haven't unchecked View menu > Show Guides, as that will hide the lines regardless of your Rulers, Grid & Guides panel settings.

How can I save my Print settings for later?

If you want to save your settings for use on a variety of different photos, for example, your personalized contact sheet, save them as a template. The printer settings from the Page Setup and Print Settings dialogs are also saved as part of the template. Having arranged the Print settings to suit, use the + button on the Template Browser panel, just as you would with Develop presets, and name your template and place it in a folder so you can easily find it again later. That template will then appear in the Template Browser panel for use on any photos in the future.

As with all presets, you can update your User Templates at any time, by changing the settings and then right-clicking on the template and clicking 'Update with Current Settings.'

If you want to save the Print settings for specific photos, place those photos in a collection, and the Print module settings will be saved as part of that collection. As in the Slideshow module, creating the collection from the Print module will give it a Print collection icon and double-clicking on that collection will take you directly to the Print module. It

only saves one set of Print settings per collection, so you'll need separate collections for different settings.

PRINTING

Lightroom's Print module allows you to print to a local printer, or output those files to JPEG format to send to an offsite lab.

Why do Page Setup, Print Settings and Print buttons show the same dialog?

Some driver/operating system combinations show the same dialog when you press the 'Page Setup...,' 'Print Settings...,' and/or 'Print...' buttons, while other combinations show different dialogs. This means that none of the buttons can be removed, even though they may not be needed for your setup.

Where different dialogs are shown for the different buttons, generally the Page Setup dialog allows you to set paper size, orientation and margins, whereas Print Settings sets up paper type, quality, color management and other printer-specific settings.

The 'Page Setup...' and 'Print Settings...' buttons on the left panel allow you to set up and save your settings as part of a template without using the 'Print...' button on the right panel to actually queue up a print job.

Which Print Sharpening option do I choose?

As in the Export dialog, if you select the correct paper type and the strength of sharpening you prefer, Lightroom will work out the sharpening automatically, based on the size of the original file, the output size and resolution, and the type of paper.

Also check...

"Why does the Export
Sharpening only have
a few options? How
can I control it?" on
page 388 and "Which
Export Sharpening
setting applies more
sharpening—screen,
matte or glossy?"
on page 388

When should I turn on 16-bit printing?

The '16 Bit Output' checkbox in the Print Job panel sends 16-bit data to the printer driver, which can help with banding in gentle gradients. It does require 16-bit printer drivers provided by your printer manufacturer, which are currently limited to high end printers, and it's also currently limited to the Mac OS. If you send 16-bit data to a printer that doesn't support it, printing will be slower than normal.

What is 'Draft Mode Printing'?

The 'Draft Mode Printing' checkbox in the Print Job panel allows you to print a photo using Lightroom's JPEG preview if the original file is offline.

How do I set up my printer to match the preview I see on screen?

Setup for each printer is different, so we'll just run through the basic guidelines. If you need help with your specific printer, it's best to drop by one of the Lightroom forums for one-to-one assistance.

Option 1—Lightroom manages color

In the Print Job panel in Lightroom, find the Color Management section and select the correct ICC profile from the pop-up menu for your printer/ink/paper combination.

In the Printer dialog, select the correct paper type and quality settings, and

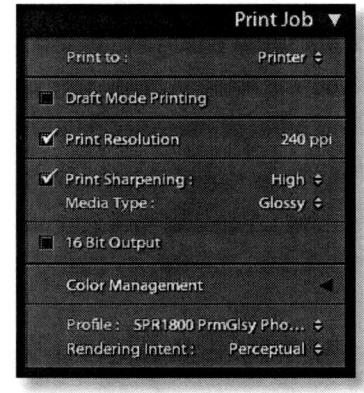

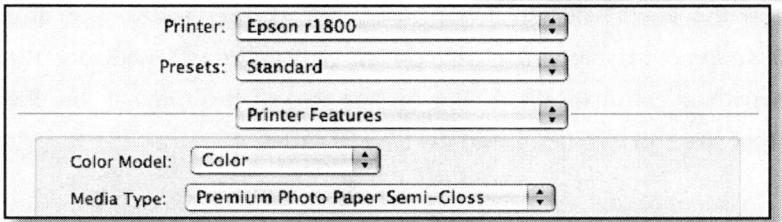

set the Color Management section to 'No Color Adjustment'. The Printer dialog will vary depending on the operating system and printer model, so these screenshots are just a guide.

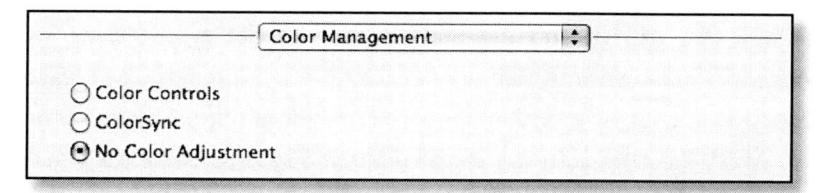

Option 2—Printer manages color

In the Print Job panel in Lightroom, find the Color Management section and select 'Managed by Printer' from the pop-up menu.

In the Printer dialog, select the correct paper type and quality settings and select the correct ICC profile in the Color Management section. As in option 1, the Printer dialog will

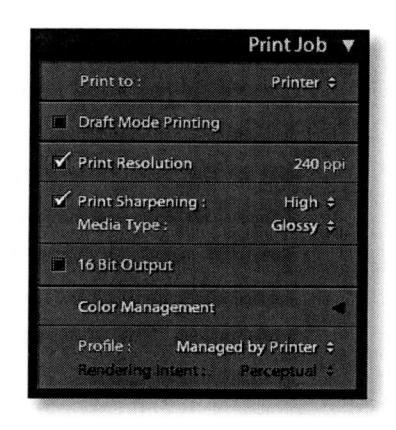

vary depending on the operating system and printer model, so these screenshots are just a guide.

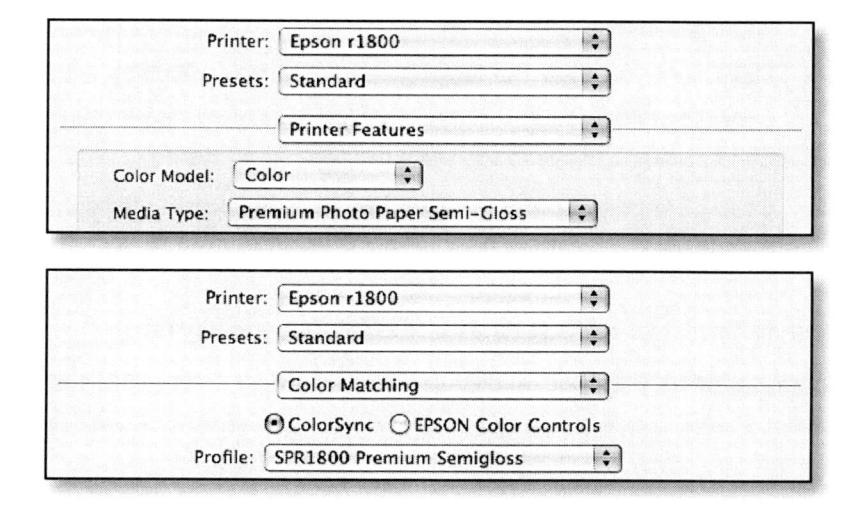

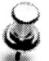

Also check...

"Everything in
Lightroom is a funny
color, but the original
photos look perfect
in other programs,
and the exported
photos don't look like
they do in Lightroom
either. What could be
wrong?" on page 258

Why do Lightroom's prints not match the preview on screen?

Printing correctly should be a science, but there are so many variables, between the operating system, the drivers, the printer manufacturers, the inks, the papers, and the profiles, that it's not always quite so simple. The same settings that print correctly in one program, can react differently in another program, simply as a result of using a newer print path which links the software to the operating system. There are a few things to double check if you're having problems.

- Calibrate your monitor using a hardware calibration device, otherwise you have no way of telling whether you're seeing an accurate preview on screen. Most monitors are too bright straight out of the box. They're set up to be bright and punchy, but that doesn't match printed output. Ideally you want to calibrate your monitor using a hardware calibration device and adjust the luminance to about 110-120 cd/m2, depending on your viewing conditions. This may be under the 'advanced' section of your calibration software.
- Use the correct ICC profile for your printer/ink/paper combination, because printer profiles aren't one-size-fits-all. If you're not using the manufacturer's own ink and paper, or other properly profiled combinations, you will need some trial and error to create prints vaguely matching your screen.
- Make sure you have the latest printer drivers, particularly with Snow Leopard (Mac) and some 64-bit versions of Windows which need updated drivers to use the newer operating systems.
- Check your print settings in Lightroom. You either want Lightroom to manage the colors, or your printer to do so, but not both.

How do I print to a file such as a JPEG to send to my lab?

Lightroom offers full Print to JPEG facilities, enabling saving JPEGs of contact sheets, bordered photos and a whole host of other ideas, so

you can send them to a photographic lab rather than printing them on a desktop printer.

To print to a JPEG file from the Print module, select JPEG File from the Print Job panel. In that panel, you can select a custom file size (currently only available in inches), the file resolution (PPI), JPEG quality, sharpening settings and the ICC profile.

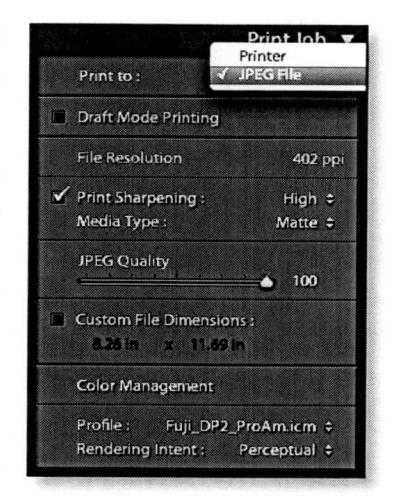

When you press the 'Print to File...'

button, it'll ask you for a filename. If you're just printing a single page, it'll just use that filename, but if you're printing multiple pages, it'll create a folder with that name, and put the pages inside that folder with a sequence number on the end of the filename. For example, if you give it the name 'Test,' it will create a 'Test' folder and create files called 'Test-1. jpg,' 'Test-2.jpg' and so forth. It doesn't currently have the option to use the name of the photo that you're printing, as you may be printing more than one photo per page.

How do I get Lightroom to see my custom printer profile?

To add custom printer profiles, you first need to install them in the operating system, and then restart Lightroom.

You can usually install them in the operating system by placing the profiles in the following folders...

Windows XP/Vista/7:

Place the profile in C:\Windows\system32\spool\drivers\color. It may be a hidden folder.

Mac:

Place the profile in Macintosh HD/Users/[your username]/Library/

ColorSync/Profiles, or the global ColorSync folder if multiple users will need access to it.

Once the profiles are installed and you've restarted Lightroom, you can select the Profile pop-up menu and choose 'Other...' to view a list of all available profiles. Putting a checkmark next to a profile adds it to the main Profile pop-up menu, allowing you to select it as your output profile.

Why does my custom ICC printer profile not show in Lightroom's list of profiles?

If your profile doesn't show in the Choose Profiles dialog which is shown when you choose 'Other...,' it may be a CMYK profile, and Lightroom isn't designed to output CMYK. If you have access to a Mac, you can open the profile in ColorSync Utility to check—the color space is recorded in the profile info.

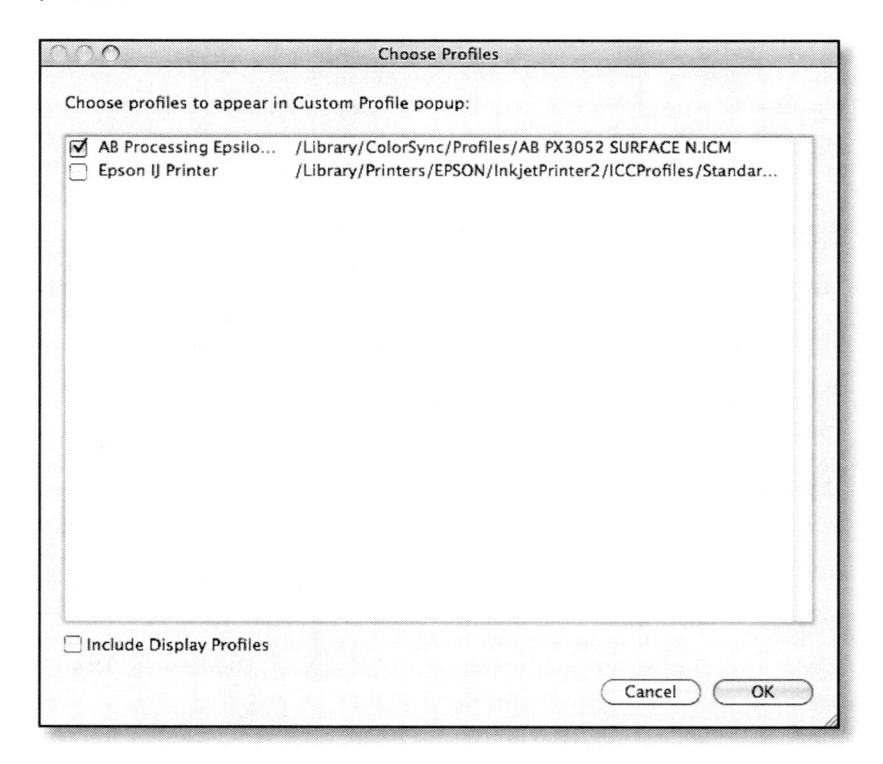

Web Module

The Web Module allows you to create beautiful galleries of your photos for displaying on the web, and you don't need any web design experience to create them.

STYLES & SETTINGS

Lightroom comes with 5 different web gallery styles, including basic HTML and Flash galleries, and additional web galleries can be downloaded too. You can then customize them further, adjusting the colors, styles and layouts to suit your taste.

How do I create my first web gallery?

Adobe have provided a whole selection of pre-built web templates in different colors and styles to get you started, and as you float over those templates in the Template Browser panel, the preview appears in the Preview area above. Click on one you like, and then start exploring the options in the panels on the right. You can add gallery titles and contact information in the Site Info panel. The Color Palette and Appearance panels allow you to change the colors of various elements and change the layout of the pages, and as you change those options, the preview of the gallery updates in the main preview pane. In the Image Info and Output Settings panels, you can choose to add metadata such as

the filename or caption, set the quality and sharpening for the large photos, and most importantly if you're putting photos on the web, add watermarking too. Having adjusted those settings, you're ready to upload your web gallery, which we'll come back to in a moment.

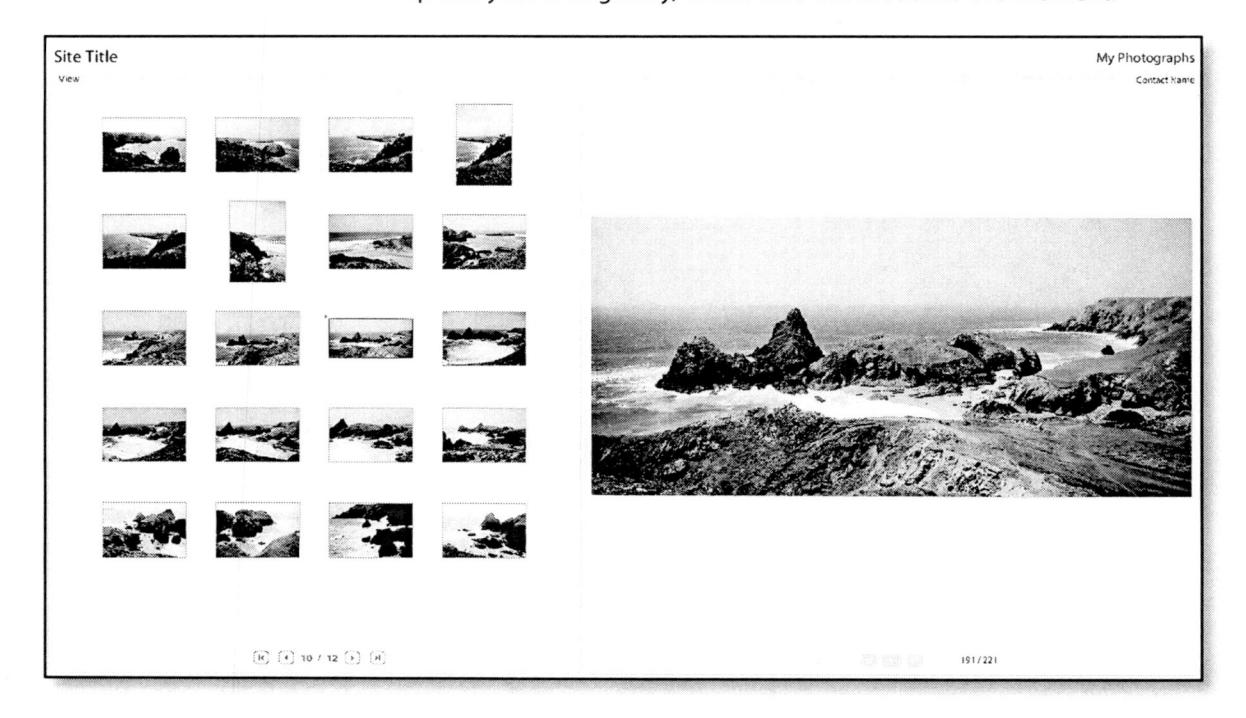

How can I change a web gallery I've already created?

If you use a collection when you create a web gallery, or you create a collection in the Web module, your web gallery settings are stored in that collection along with the photos. When you go back to that collection later, you can add or remove photos, change the sort order, update the photos and change the gallery settings, and then re-export or re-upload the gallery.

How do I save my settings as a template for use on other photos?

To reuse those web gallery settings on another set of photos, you can save them as a template by clicking on the + button on the Template Browser panel, just as you

would with Develop presets. Name your template, and place it in the User Templates folder or another folder of your choice. As with all presets, you can update your templates at any time by changing your settings and then right-clicking on the template and choosing 'Update with Current Settings.'

The default flash gallery appears to be capped at 500 photos—how do I increase the number of photos it can hold?

The default flash gallery is capped at 500 photos. If you need to include more photos, consider splitting them across multiple galleries, or using one of the third party galleries which can be added to Lightroom. If you still want to use the default flash gallery, it's possible to change that limit, but it involves digging in the program files to duplicate the gallery, so take care! Duplicating the gallery means that you won't need to repeat the process every time you install a dot release update (i.e., 3.1).

Windows:

- Find the following folder: C:\Program Files\Adobe\Adobe
 Photoshop Lightroom 3.0\shared\webengines\default_flash.
 Irwebengine\
- 2. Copy that default_flash.lrwebengine folder your user Web Galleries folder. You may have create Web Galleries folder in the following locations: Windows XP—C:\Documents and Settings\[your username]\

- Application Data\Adobe\Lightroom\Presets\Web Galleries\
 Windows Vista or 7—C:\Users\[your username]\AppData\
 Roaming\Adobe\Lightroom\Presets\Web Galleries\
- 3. Ensure that you have read/write access to the folder and files.
- 4. Inside that folder is a file called galleryInfo.lrweb, which you need to open in a basic text editor such as Notepad.
- 5. Find the line that says "maximumGallerySize=500," and increase the value.
- 6. Save and close the file.
- 7. Restart Lightroom and check that your gallery will now allow larger numbers of photos.

Mac:

- 1. Go to Applications folder
- 2. Right-click on Adobe Lightroom 3.app and select 'Show Package Contents'
- 3. Navigate to Contents > Plug-ins > Web.lrmodule
- 4. Right-click on Web.lrmodule and select 'Show Package Contents'
- 5. Navigate to Contents > Resources > Galleries
- Copy that default_flash.lrwebengine folder to your user web galleries folder. You may have to create the Web Galleries folder at: Macintosh HD/Users/[your username]/Library/Application Support/Adobe/Lightroom/Presets/Web Galleries/
- 7. Ensure that you have read/write access to the folder and files.
- 8. Inside that folder is a file called galleryInfo.Irweb, which you need to open in a basic text editor such as TextEdit.
- 9. Find the line that says "maximumGallerySize=500," and increase the value.
- 10. Save and close the file

11. Restart Lightroom and check that your gallery will now allow larger numbers of photos.

Is it possible to add music to the galleries?

Some third party galleries, such as 'SlideShowPro' (http://www.slideshowpro.net/products/slideshowpro/#ssplr) or 'TTG Monoslideshow-2' (http://lr.theturninggate.net/flash-galleries/ttg-monoslideshow-2/), allow you to add a music track to your web gallery.

Why do my galleries show stray white pixels on some photos?

There's an old Internet Explorer 6 bug which causes some mystery white pixels to appear on some photos on some galleries. Update to a modern web browser and the white pixels will disappear.

ADDITIONAL GALLERIES

Although Lightroom comes with 5 galleries by default, many web designers have created additional web galleries for use in Lightroom. They offer a huge range of different styles and functions, including adding additional text to create a whole website, adding PayPal links for customers to purchase photos, and slideshows with music too.

Where can I download additional web galleries?

The most popular galleries can be found at:

http://lightroom.theturninggate.net/

http://www.lightroomgalleries.com/

http://lightroom-blog.com/category/web-gallery/

http://www.photographers-toolbox.com/

http://www.slideshowpro.net/

And the Lightroom Exchange is a great place to find all sorts of new galleries, plug-ins, presets and other goodies:

http://www.adobe.com/cfusion/exchange/index.cfm?event=productHome&exc=25

Are there any web galleries with download links or an integrated shopping cart such as PayPal?

The TTG Client Response gallery allows your clients to select photos and email you a list automatically, but it doesn't include payment facilities. http://lr.theturninggate.net/html-galleries/ttg-client-response-gallery/

TTGHighslideProoffersfullshoppingcartfacilities, including paymentlinks. http://lr.theturninggate.net/html-galleries/ttg-highslide-gallery-pro/

The LRG Complete and LRG Total galleries from Lightroom Galleries (http://www.lightroomgalleries.com/) both offer shopping cart facilities, although you have to dig through the main blog posts to find the example galleries.

Those galleries also offer optional full resolution downloads too.

How do I install new web galleries?

Most web galleries are zipped, so double-click to unzip it, and then copy the resulting folder to the Web Galleries folder. If the Web Galleries folder doesn't already exist, you may need to create it. The file locations are:

Windows XP—C:\Documents and Settings\[your username]\Application Data\Adobe\Lightroom\Presets\Web Galleries\

Windows Vista or 7—C:\Users\[your username]\AppData\Roaming\ Adobe\Lightroom\Presets\Web Galleries\

Mac—Macintosh HD/Users/[your username]/Library/Application Support/Adobe/Lightroom/Presets/Web Galleries/

"The default location of the Presets is..." on page 463 Don't put it in the Web Templates folder instead of the Web Galleries folder, as there is a difference. Web Templates are the settings you store in the Template Browser panel, whereas Web Galleries are the engines that appear in the Layout Style panel.

Restart Lightroom and your new galleries should appear in the Layout Style panel.

When using some third party galleries, the panels are clipped—can they be resized?

If the panel contents are clipped under the edge of the panels, drag the left edge of the panel to the full width and then restart Lightroom, and they will appear correctly.

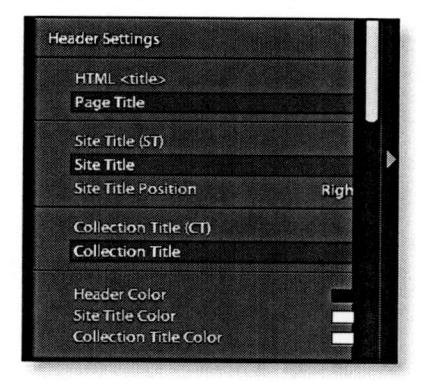

EXPORTING & UPLOADING

Once you've finished creating your web gallery, it's time to upload it to your web space. You can either let Lightroom upload the files using its built-in FTP client or export the gallery to your hard drive and use your own dedicated FTP software.

How do I upload my gallery?

Once you've set up your gallery, go to the Upload Settings panel and select your FTP Server from the pop-up menu if you've already set it up,

or select 'Edit...' to show the Configure FTP File Transfer dialog. Enter the details for your website, including the FTP server address, username, password and server path. You may need to check with your web host for the details. Save the details as a preset for next time, and press OK to return to the Lightroom interface.

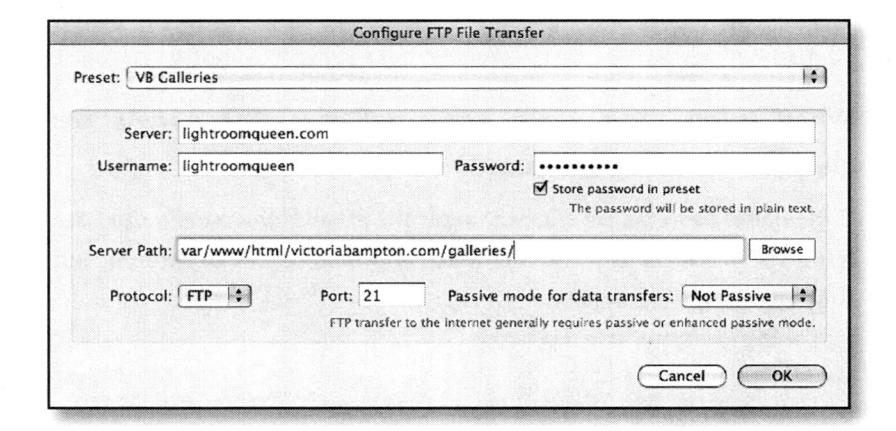

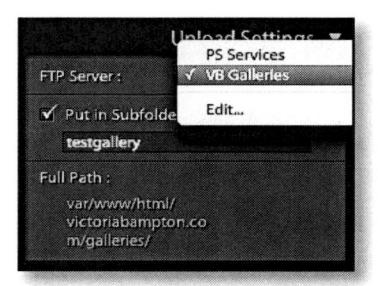

Back in the Upload Settings panel, enter a subfolder name, otherwise any further galleries that you upload could overwrite your existing galleries. Be careful—if you don't select a subfolder in the 'Put in Subfolder:' field, you could overwrite your home page. Then

you can press 'Upload' and leave it to work. You can carry on working in Lightroom while the upload runs in the background, and you can check the progress in the Activity Monitor in the top left hand corner of the

screen. The upload speed, once it's created the gallery, depends on your internet connection.

Alternatively, you could use the 'Export...' button to export your gallery to your hard drive, and then upload to your server using your normal FTP software. That's my preferred option, because if the upload fails, you don't then have to start again.

Why doesn't the FTP upload work—it says 'Remote Disc Error'?

Lightroom's FTP facility is there for convenience, but it's not quite as robust as dedicated FTP software. Check your FTP settings, because they may be incorrect, and you could also try with and without the 'Passive' setting checked in the Configure FTP File Transfer dialog. Large uploads may time out, depending on your web server.

If it still doesn't work smoothly, export directly to your hard drive using the 'Export...' button rather than the 'Upload' button, and then use standard FTP software to upload instead. If you don't already have FTP software, you can download free FTP clients, such as Filezilla for Windows (http://filezilla-project.org/download.php?type=client) or Cyberduck for Mac (http://cyberduck.ch/).

Why are my FTP settings not saved in the templates?

Lightroom saves your upload settings within a collection as it assumes that you'll want to upload those same photos to the same place, whereas templates are used when selecting a new set of photos, so you're likely to change the upload location each time you use the template otherwise you would overwrite the previous gallery.

Can I have multiple galleries on my website?

If you want to put multiple galleries on your website, just put each gallery in its own subfolder on your web server, and add an index page. Some third party galleries, such as TTG AutoIndex by The Turning Gate, can automatically create index pages for many third party galleries. You can download it from: http://lightroom.theturninggate.net/special-purpose-templates/ttg-auto-index/

Is it possible to embed a web gallery into an existing website or webpage?

If you want to embed a web gallery into an existing website, the easiest option is to place the gallery in a subfolder and link to it, as in the previous question. If you want to embed a gallery into an existing page, it is possible, but requires some web design skills. An HTML iframe is the easiest way of integrating into an existing page.

I changed an existing gallery—why hasn't it changed on the website?

If you change a web gallery within Lightroom, you then have to upload those changes to your website. There is no automatic link between the two, unlike Publish Services. It's often quicker to export the gallery to the hard drive and then use FTP software to intelligently upload the files that have changed, instead of letting Lightroom upload the full gallery again.

Troubleshooting & Useful Information

Being at only version 3, Lightroom is still in early stages of development, unlike Photoshop which is now on version 12. Hiccups do occur, so we'll cover some of the most useful troubleshooting steps, as well as more general information on installing and upgrading Lightroom in various languages and formats.

TROUBLESHOOTING STEPS

As with all computer software, problems can occur with Lightroom, so it's useful to have some simple troubleshooting steps to try before you need to ask for additional help.

I have a problem with Lightroom—are there any troubleshooting steps I can try?

On the following pages are some standard troubleshooting steps for the most frequent issues, but as always, make sure you have backups before you try any troubleshooting steps.

- 1. Restart Lightroom.
- 2. Restart the Computer.
- 3. Make sure you're running the latest updates, both for Lightroom and for your operating system.

Also check...

"How do I check which Lightroom and ACR versions I have installed?" on page 360

Adobe Lightroom 3 - The Missing FAQ

Also check...

"What general maintenance will keep my catalogs in good shape?" on page 210, "Lightroom says that my catalog is corrupted—can I fix it?" on page 213, "How do I create a new catalog and switch between catalogs?" on page 206 and "The default location of the Presets is..." on page 463

- Optimize the Catalog.
 Go to File menu > Optimize Catalog and wait for it to tell you it's completed before moving on.
- 5. Delete the Preferences file. Close Lightroom and find the Preferences file. The Preferences may be in a hidden folder on some systems, which you may need to show. You could move or rename that Preferences file, rather than deleting, and if it doesn't solve the problem, you can put it back.
- 6. If your catalog won't open, check for a *.lock file alongside your catalog file, and delete it, and then try to restart. The lock file can get left behind if Lightroom crashes, preventing you from opening the catalog. If you find a *.lrcat-journal file, do not delete that as it contains important information.
- 7. Create a new catalog to rule out catalog corruption. Restart Lightroom while holding down Ctrl (Windows) / Opt (Mac). Select Create New Catalog. Import some photos into that new catalog to check everything is working as expected. If this works, the problem is with the catalog, possibly corruption. (Don't panic, that can usually be fixed!)
- 8. Move all user presets to another location in case a corrupted preset is causing the problem.
- Update drivers on your machine, particularly the graphics card drivers. If you have a nVidia Graphics card, turn off the nView software as it's known to cause conflicts.
- Damaged RAM can also cause some odd problems Lightroom will find dodgy memory quicker than almost any other program. Run software such as Memtest to check your memory.

If none of those troubleshooting steps solve the problem, post a description at http://www.lightroomforums.net/ and we'll help you figure it out!

How do I delete the Preferences file?

Deleting Lightroom's Preferences file can solve all sorts of 'weirdness,' so it's always a good early step in troubleshooting.

On Windows, it's a hidden file by default. The easiest way to find it is to go to Lightroom's Preferences dialog > Presets tab and press the 'Show Lightroom Presets Folder...' button. Once you've found that folder, close Lightroom. In that folder will be a Lightroom 3 Preferences.agprefs file—move it to another folder or delete it, and then restart Lightroom.

On Mac, you'll find com.adobe.Lightroom3.plist with the other Preferences files at Macintosh HD/Users/[your username]/Library/ Preferences/. As with Windows, close Lightroom and move it to another folder or delete it, and then restart Lightroom.

Moving or renaming that preferences file, rather than deleting it, does mean that you can put it back if it doesn't solve the problem, to save you recreating your preferences again.

What is deleted when I delete my Preferences file?

When you delete your Preferences file, the obvious settings that you lose are those in the Preferences dialog, but it also includes other details such as your View Options settings, last used catalogs, last used settings, FTP server details, some plug-in settings, etc.

Your original photos, Develop settings, collections, presets and suchlike aren't affected by deleting the Preferences file.

I installed Lightroom, but it says 'An error occurred while attempting to change modules'. How do I fix it?

If Lightroom says 'An error occurred while attempting to change modules', a few things could be going wrong. The standard troubleshooting steps apply—corrupted catalogs, preferences and presets have been known to cause similar problems. If that doesn't work, reinstall the latest Lightroom release—there have been some cases of the installation not

Also check...

"The default location of the Preferences is..." on page 462

Also check...

"The default location of the Presets is..." on page 463 copying across all of the necessary program files, or certain software removing those files.

If you're seeing that error message having just installed Lightroom, try installing into a clean user account. There's a mysterious problem that shows up intermittently with the installer, but it can't be reproduced on demand, which makes it difficult to fix. It appears to be a file permissions issue. If the clean user account works, you can then transfer the Application Data (Windows XP) / AppData (Windows Vista/7) / Application Support files (Mac) back to your normal user account—they're listed on the following pages under Preset locations. If it still doesn't work, try copying the catalog and preferences over from the clean account too.

It says 'There was an error working with the photo' or there's an exclamation mark in the corner of the thumbnail and a small fuzzy preview. What's wrong?

Unfortunately files can become corrupted. It usually happens while importing, as a result of a damaged card reader or cable, but there are various possible causes, and as we discussed in the Import chapter, severely corrupted photos often don't even pass the import stage.

If you can see a preview but it has a black line around it, that's the camera's embedded preview. If there's a little more data available, Lightroom may try to read the full file, in which case you'll see a colorful pattern instead. Try opening the photo in the Develop module, and if the file's corrupted, it should warn you that it can't be opened. You can double check by converting it using another raw processor—simply

"Lightroom appears to be corrupting my photos—how do I stop it?" on page 108

viewing it in a program that shows the embedded JPEG won't be enough, as the embedded JPEGs often escape the corruption

The file appears to be unsupported or damaged.

Unfortunately, either way the data is not readable, so you'll need to redownload the file from the memory card or replace it with a backup.

PREFERENCES & SETTINGS

A few of the menu commands are in different locations on Windows and Mac, depending on the operating system standard. Rather than repeating the long list every time I refer to Preferences or Catalog Settings, here's a quick reference:

Lightroom Preferences & Catalog Settings are...

Windows—under the Edit menu Mac—under the Lightroom menu

Photoshop Preferences are...

Windows—under the Edit menu Mac—under the Photoshop menu

Photoshop Color Settings are...

Windows—under the Edit menu Mac—under the Edit menu

DEFAULT FILE LOCATIONS

If you need to find Lightroom's files at any time, you'll need to know where to look, so here are the most popular Lightroom file locations.

By default, the boot drive is C:\ on Windows and Macintosh HD on Mac. If your operating system is installed on a different drive, you may need to replace the drive letter/name on the file paths that are listed below.

[your username] refers to the name of your user account, for example, mine is called Vic.

The default location of the Lightroom catalog is...

Windows XP—C: \ Documents and Settings \ [your username] \ My Documents \ My Pictures \ Lightroom \ Lightroom 3 Catalog.lrcat

Windows Vista or 7—C: \ Users \ [your username] \ My Pictures \ Lightroom \ Lightroom 3 Catalog.lrcat

Mac—Macintosh HD / Users / [your username] / Pictures / Lightroom / Lightroom 3 Catalog.lrcat

The catalogs are fully cross platform, and the catalog file extensions are:

- *.lrcat is version 1.1 onwards.
- *.lrdb was version 1.0.
- *.aglib was the early beta.

The default location of the Preferences is...

Windows XP—C: \ Documents and Settings \ [your username] \ Application Data \ Adobe \ Lightroom \ Preferences \ Lightroom 3 Preferences.agprefs

Windows Vista or 7—C: \ Users \ [your username] \ AppData \ Roaming \ Adobe \ Lightroom \ Preferences \ Lightroom 3 Preferences.agprefs

Mac—Macintosh HD / Users / [your username] / Library / Preferences / com.adobe.Lightroom3.plist

Preference files aren't cross-platform.

It's a hidden file on Windows, but to find it easily, go to Preferences > Presets tab and press 'Show Lightroom Presets Folder...'

The default location of the Presets is...

Windows XP—C: \ Documents and Settings \ [your username] \ Application Data \ Adobe \ Lightroom \

Windows Vista or 7—C: \ Users \ [your username] \ AppData \ Roaming \ Adobe \ Lightroom \

Mac—Macintosh HD / Users / [your username] / Library / Application Support / Adobe / Lightroom /

Each type of preset has its own folder, for example 'Develop Presets', 'Filename Templates' and 'Metadata Presets'. Presets are cross-platform

Also check...

"How can I speed up browsing in Develop module? And what are these Cache*.dat files?" on page 265

The default location of the Camera Raw Cache is...

Windows XP—C: \ Documents and Settings \ [your username] \ Application Data \ Adobe \ CameraRaw \ Cache \

Windows Vista or 7—C: \ Users \ [your username] \ AppData \ Local \ Adobe \ CameraRaw \ Cache \

Mac—Macintosh HD / Users / [your username] / Library / Caches / Adobe Camera Raw /

The default locations of the Adobe Camera Raw & Lens Profiles are...

Windows XP—C: \ Documents and Settings \ All Users \ Local Settings \ Application Data \ Adobe \ CameraRaw \ CameraProfiles \

Windows Vista or 7—C: \ ProgramData \ Adobe \ CameraRaw \ CameraProfiles \

Mac—Macintosh HD / Library / Application Support / Adobe / CameraRaw / CameraProfiles /

For the lens profiles, substitute the LensProfiles folder for the CameraProfiles folder.

Your custom Camera Raw & Lens Profiles can also be installed to the User folders...

Windows XP—C: \ Documents and Settings \ [your username] \ Application Data \ Adobe \ CameraRaw \ CameraProfiles \

Windows Vista or 7—C: \ Users \ [your username] \ AppData \ Local \ Adobe \ CameraRaw \ CameraProfiles \

Mac—Macintosh HD / Users / [your username] / Library / Application Support / Adobe / CameraRaw / CameraProfiles /

For the lens profiles, substitute the LensProfiles folder for the CameraProfiles folder.

Also check...

"DNG Profile Editor" section on page 330

64-BIT

The terms 32-bit and 64-bit refer to the way a computer handles information. In practical terms, it means that 64-bit software running in a 64-bit operating system can take advantage of more of your computer's RAM than a 32-bit system, which brings performance improvements. If you're running the 64-bit version of Lightroom with more than 4GB of RAM, you should see an improvement in Develop module response speeds, moving back and forth between photos, or other tasks where Lightroom is loading large amounts of data into memory. It won't make a significant difference in building previews or running large imports or exports are those are mainly tied to disc I/O speeds.

How do I install the 64-bit version?

For Windows, the installation package will automatically install the 32-bit version, unless you're running Windows Vista or Windows 7 64-bit which will default to the 64-bit installation. Windows XP 64-bit's not officially supported, but if you want to try it, both installers are available in the same download.

For the Mac OS, find the Adobe Lightroom 3 application in the Applications folder, select it, and choose Get Info from the right-

click menu. Uncheck the 'Open in 32 Bit Mode' checkbox to open the application as 64-bit.

Lightroom isn't certified for XP x64—does that meant it won't run?

The 64-bit version of Lightroom isn't officially supported on XP x64, so the installer will only install the 32-bit version by default. That just means that the 64-bit version of Lightroom isn't fully tested on XP x64, but it's still possible to run. If you want to install the 64-bit version onto XP x64, start the installer, but select 'Open the Specified Folder', find the Setup64.exe file and double click to install that.

My Mac version doesn't have an 'Open as 32-bit' checkbox. Why not?

If your Mac doesn't have a 64-bit processor, which is true of some of the first Intel Macs, then the checkbox won't appear in the Get Info dialog. If you have a recent Intel Mac, make sure you're checking the Get Info window from Finder rather than a Finder-alternative. Some, such as Path Finder, don't show the checkbox even on machines where 64-bit is available.

How can I check whether I'm running the 32-bit or 64-bit version?

To check which version you're running, go to Help menu> System Info, and you'll find a line titled 'Application Architecture.' x64 shows that you're running 64-bit. If you're running the 64-bit version, it'll also show in the splash screen when you start Lightroom.

INITIAL INSTALLATION

If you're reading this book, you've probably already purchased and installed Lightroom 3, but just in case you're running the trial version, or you need to install on another computer, we'll cover a few basics.

Should I buy the download or the boxed version?

The download is exactly the same as the boxed version—it just doesn't come in a box. Choose whichever is most convenient, and whichever you select, don't forget to store your serial number safely. If you register your software with Adobe, or you buy the download, then Adobe will also keep a record of your serial number, and you can retrieve it at any time by logging into your Adobe account.

Do I have to install the 3.0 version from my CD before installing updates?

Lightroom's trial and update downloads are all the full version of the software, rather than a small update package. If you need to install some months after Lightroom 3.0's release, check Adobe's website to see if a newer 3.x release is available. If so, you can just download the latest version and enter your serial number, without first installing from the CD.

Why won't Lightroom 3 install on my Mac?

Lightroom 3 has new system specifications and, following Apple's lead, the Mac version requires an Intel processor and 10.5.6 (Leopard) or later. That means it won't install on PowerPC machines, or those still running 10.4 (Tiger). If you're running 10.5 (Leopard), ensure your system has the current operating system software updates.

UPGRADING FROM LIGHTROOM 1, 2, OR VERSION 3 BETA

If you're upgrading from a previous version, such as Lightroom 2, you'll need to upgrade your catalogs in addition to upgrading the program.

How do I upgrade Lightroom?

Full releases (1.0, 2.0, 3.0, etc) are always paid upgrades, whereas dot releases (1.3, 2.5, 3.2, etc.) are free updates.

If you haven't already bought Lightroom 3, you can buy a boxed copy from many computer retailers, and Adobe also offer a download version from their own online store. If you already own Lightroom 1 or 2, there's discounted upgrade pricing available.

Do I have to install Lightroom 1 or 2 if I purchased an upgrade version?

If you're installing Lightroom on a new machine, you don't need to install the earlier versions of Lightroom before installing an upgrade version, but you will need to enter the serial number from the previous release.

If I install Lightroom 3, will it overwrite my current 1.x or 2.x version?

Installing Lightroom 3 doesn't affect your existing installations, and you can choose to uninstall those when you're ready. Lightroom 3 will share presets and plug-ins with earlier versions of Lightroom, and will offer to upgrade your older catalogs to the Lightroom 3 format.

Which catalog versions will upgrade to 3.0?

Catalogs from versions 1.x and 2.x, and from the public beta of 3.0, will upgrade to the final 3.0 release. Older beta catalogs, such as those from
the Lightroom 2 beta, will not upgrade without first going through the earlier version.

How do I upgrade my catalog from version 2 to version 3?

If you're ready to upgrade, first make sure you have a current catalog backup, just in case something goes wrong. Proper measures have been put in place to avoid disasters, but you can never be too careful.

When you open Lightroom 3 for the first time, it should follow any existing Lightroom 2 preferences, and either prompt you for a catalog to open, or try to open your default catalog. If you've never run Lightroom on this machine, it should create a clean catalog at the default location.

When you try to open any version 1 or version 2 catalogs, Lightroom 3 will show the following dialog, asking to upgrade your catalog.

You can select a different folder name or location for the upgraded catalog if you wish. The new version 3 catalog will be an upgraded copy—your original version 1, version 2 or version 3 beta catalog shouldn't be affected, other than a record added showing that the catalog has an upgraded version. Once the upgrade has completed, Lightroom will open the newly upgraded catalog as a normal catalog.

The upgrade process will also upgrade your existing previews, however because the entire preview mechanism has been totally rewritten for Lightroom 3, there is more potential for preview bugs. If all of your original photos are available, I would recommend rebuilding the preview

cache for Lightroom 3. It'll take some time to rebuild those previews, depending on the number of photos and the speed of the computer, but in my opinion, it's time well spent. To do so, close Lightroom after the upgrade and find the catalog on the hard drive. Delete or move the *.Irdata previews folder, making sure that you don't touch the *.Ircat catalog file. When you re-open Lightroom, there will be lots of grey thumbnails, so select all of the photos in Grid view and go to Library menu > Previews > Render Standard-Sized Previews and leave it to work, perhaps overnight. If you don't have time to wait, you can rebuild those previews in smaller chunks when it suits you.

If I upgrade, can I go back to version 2?

Once you've upgraded your catalog, you won't be able to open the upgraded catalog in version 1 or 2. You'll still have your earlier catalog untouched, however if you work on the upgraded copy in version 3, for example, using a trial version of Lightroom 3, and then decide to go back to version 1 or 2, the changes you've made to your photos in version 3

will not show up in your version 1 or 2 catalog. You won't want to go back anyway! This is the dialog you'll see if you try to

open a version 3 catalog in version 2:

"How does Import from Catalog work?" on page 236

Do I have to upgrade a catalog before I can import it into version 3 using Import from Catalog?

If you select a version 1 or 2 catalog in the Import from Catalog dialog, it'll warn you that it needs to upgrade the catalog before importing. You'll be given a choice of saving that upgraded catalog, as if you had

opened the catalog normally and run the upgrade, or discarding the upgraded catalog if it's not needed. Either way, the original catalog is untouched, other than a note left to say it's been previously upgraded.

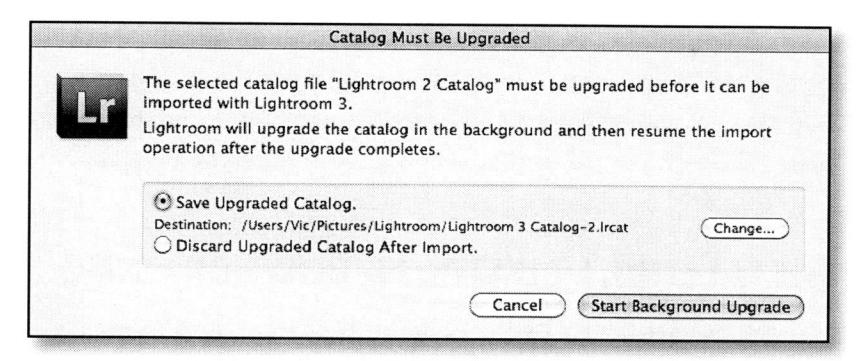

What happens if I try to upgrade a catalog that I've already upgraded?

Lightroom keeps track of which catalogs you've already upgraded, so if you try to upgrade the same catalog again, it'll warn you and give you the choice of either re-upgrading the catalog or opening the previously upgraded catalog.

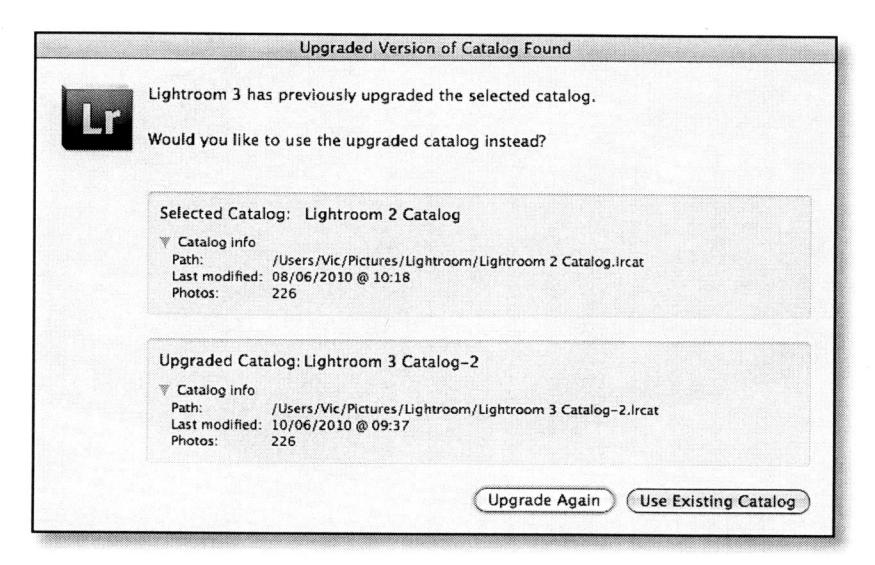

Can I delete my previous installations?

If you have older Lightroom installations on your computer, for example, Lightroom 2 or the recent beta, you can uninstall them without affecting your current installation. Your catalog, preferences and presets shouldn't be affected by the uninstall, but it's always sensible to keep solid backups regardless. If you do have a problem with running the current version after uninstalling an old version, simply reinstall the current version.

INSTALLING, UPDATING & DOWNGRADING

Lightroom's updated on a 3-4 monthly basis and, as well as new camera releases, there are often bug fixes, particularly in the early dot releases such as 3.1, so it's worth staying current with those updates.

How do I check which update I'm currently running?

Go to the Help menu and select System Info and the first line will confirm the version and build number, or the splash screen will also tell you your current version number when you start Lightroom.

How do I find out whether my new camera is supported yet?

Each time a new camera is released, Adobe have to update Lightroom and ACR to be able to read and convert the raw files. Those updates are usually released at 3-4 monthly intervals and there's a list of currently supported cameras at:

http://www.adobe.com/products/photoshop/cameraraw.html

How do I update Lightroom with the latest version of ACR?

Although ACR updates are usually released at the same time as Lightroom updates, they're only for use in Photoshop Elements or the Creative Suite. Lightroom has the ACR engine built in to its main program files, so if you install a Lightroom update, you're done. If you use Photoshop, you will also need to install the ACR updates for Edit in Photoshop compatibility, but Lightroom itself will work correctly without it. Turn back to the Adobe Camera Raw Compatibility section to find additional information.

How do I update to a newer Lightroom dot release?

To update to a new dot release, go to Help menu > Check for Updates, or visit Adobe's website to download the latest update, and install it like any other program. The links are also usually cited on the release blog posts.

How do I downgrade to an earlier Lightroom dot release in the case of problems?

On a Mac, you should be able to download and reinstall without any problems, and on Windows, a full uninstall using Add/Remove Programs should allow you to download and reinstall again.

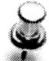

Also check...

"It says: 'Some import operations were not performed. The file is from a camera which isn't recognized by the raw format support in Lightroom.'" on page 106 and "Adobe Camera Raw Compatibility for Photoshop" section on page 359

LANGUAGES

Lightroom's not just limited to English—it's also available in Chinese Simplified, Chinese Traditional, Dutch, French, German, Italian, Japanese, Korean, Portuguese, Spanish, or Swedish.

How do I switch language?

Windows, it's switch easy to of the to one other supported languages. Just go to Edit menu Preferences General tab, select the language you want to use and restart Lightroom.

On a Mac, Lightroom follows

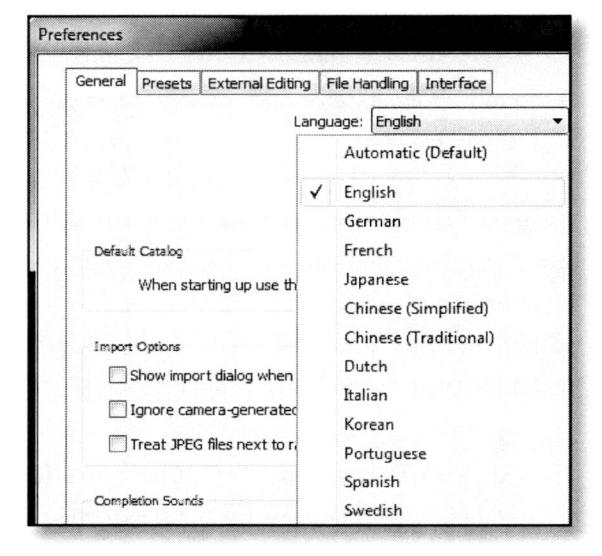

the system language preference at the time of opening, like other multilanguage Mac applications. To change your operating system language, visit the System Preferences and drag your language to the top of the list before restarting Lightroom.

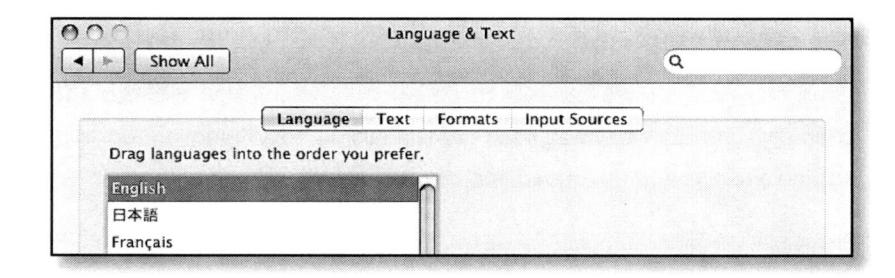

Some Mac users prefer to have the operating system in their native language and Lightroom in English, which isn't quite so simple. There are a couple of unofficial undocumented tricks you can try:

Option 1—go to System preferences > Language and change English to the main language, open LR, and then immediately change it back to your native language ready for opening other software in that language. The language setting is set at the time of opening a program, so it'll stick until the next time you open Lightroom. For those who prefer an easier option, there's a small donationware application which can do that automatically. I have no affiliation with the company, but it appears to do the job nicely. http://www.tj-hd.co.uk/en-gb/languageswitcher/

Option 2—go to the application, right click and choose Show Package Contents, and navigate through Contents > Resources to find the .lproj folder for your language and delete or rename it. That will force Lightroom to open in English until you next install a Lightroom update.

Some of the shortcuts don't work with my language version or non-English keyboard—can I fix it?

If you're using the English version of Lightroom with another language's keyboard, some of the keyboard shortcuts might not work. You can change those shortcuts using the same TranslatedStrings.txt file that we used in the Import chapter to create custom dated folder templates.

The TranslatedStrings.txt file contains all of the translations for its language—and also includes the shortcuts. This isn't officially supported by Adobe, but you can edit the file to reassign the shortcuts, and many users have done so without issue.

If you're using another language, the TranslatedStrings.txt file will already be in your language's project folder, for example 'fr.lproj' for French, and you'll need to edit that file. If you're editing an existing file, obviously back it up first! The locations of the language project files are:

Windows—C: \ Program Files \ Adobe \ Adobe Photoshop Lightroom 3 \ Resources \

Mac—Macintosh HD / Applications / Adobe Lightroom 3.app / Contents / Resources /

If you're using the English version of Lightroom, the file probably doesn't exist, so you can just create a plain text file called TranslatedStrings.txt inside the 'en' or 'en.lproj' folder. You'll then need to search your own language version to find the strings you need to copy into your new English version.

The file is long, so you'll probably need to use your text editor's search function to find the shortcut that you need to change. For example, to change the Decrease Rating shortcut from [to ; you'd find the line that says "\$\$\$/LibraryMenus/MenuShortcut/DecreaseRating=[" and change it to "\$\$\$/LibraryMenus/MenuShortcut/DecreaseRating=;". It comes into effect next time you start Lightroom.

Once you're happy with the result, don't forget to back up your new TranslatedStrings.txt file, as it will be replaced each time you update Lightroom. If you have any problems, delete the file if you're using the English version, or restore the backup of the other language version.

LICENSING INFORMATION

You can download the full license agreement from: http://www.adobe.com/products/eulas/

Lightroom is listed under its full name of Adobe Photoshop Lightroom.

I'm switching from PC to Mac—how do I switch my Lightroom license?

If you're switching from Windows to Mac, or vice versa, you'll be pleased to know that, unlike Photoshop, the Lightroom license is cross-platform

and the same license key and program CD work on both Windows and Mac. There are separate downloads for the Windows and Mac versions.

How many machines can I install Lightroom on?

You can install Lightroom on up to 2 machines for your own personal use, for example, your desktop and your laptop, as long as you're not using Lightroom on both machines simultaneously. Unlike Photoshop, they don't have to both be the same operating system, so you can have 1 Mac and 1 Windows if you wish.

The applicable part of the license agreement says:

"2.4 Portable or Home Computer Use. Subject to the important restrictions set forth in Section 2.5 below, the primary user of the Computer on which the Software is installed ("Primary User") may install a second copy of the Software for his or her exclusive use on either a portable Computer or a Computer located at his or her home, provided that the Software on the portable or home Computer isn't used at the same time as the Software on the primary Computer. You may be required to contact Adobe in order to make a second copy."

How do I deactivate Lightroom to move it to another machine?

There is currently no activation on Lightroom, so moving to a new computer is just a case of uninstalling and reinstalling. They trust you!

FINAL WORDS...

Ok, not quite the final words, as we still have keyboard shortcuts and an index to cover, but you might appreciate contact details for Adobe, while we're talking about useful information.

Where else can I go to find solutions to my problems that aren't covered here?

Adobe Support Pages for Lightroom:

http://www.adobe.com/support/photoshoplightroom/

Adobe User to User forums are the official Adobe-sponsored forums

http://forums.adobe.com/community/lightroom/

Lightroom Forums is a friendlier independent forum

http://www.lightroomforums.net/

I've got a great idea, or I've found a repeatable bug—how do I tell Adobe?

The Lightroom team have welcomed customer feedback since the early betas, and they're still listening now. You can submit feature requests and bug reports using the Official Feature Request / Bug Report Form at: http://www.adobe.com/support/feature.html

You're unlikely to receive a personal reply, due to the volume of the requests they receive, however all of the reports and requests are read by the Lightroom team themselves. It's a great way of supporting future development.

Finally, enjoy it!

Keyboard Shortcuts

On the following pages are all of the known keyboard shortcuts for Adobe Lightroom, both Windows and Mac versions. They're also available in printable format from the Lightroom Queen website: http://www.lightroomqueen.com/lrqshortcuts.php

Many of the shortcuts work in more than one module, so those modules are marked in the last column.

L=Library, D=Develop, S=Slideshow, P=Print, W=Web.

		Windows Shortcuts	Mac Shortcuts	Works In
Import				
Import Photos		Ctrl Shift I	Cmd Shift I	LDSPW
Tethered Capture	Hide Tethered Capture Window	Ctrl T	Cmd T	LDSPW
- No. 10 Carlot Carlot Carlot	New Shot	Ctrl Shift T	Cmd Shift T	LDSPW
Workspace				
Grid View	Go to Grid view	G	G	LDSPW
	Increase Grid Size	=	=	L
	Decrease Grid Size	-	-	L
	Show/Hide Extras	Ctrl Shift H	Cmd Shift H	L
	Show/Hide Badges	Ctrl Alt Shift H	Cmd Opt Shift H	L
	Cycle Grid View Style	1	J	L
Loupe View	Go to Loupe view	E	E	LDSPW

		Windows Shortcuts	Mac Shortcuts	Works In.
	Show Info Overlay	Ctrl I	Cmd I	LD
	Cycle Info Display	1	1	LDP
Compare View	Go to Compare view	C	C	LDSPW
	Switch Select and Candidate	Up arrow	Up arrow	L
	Make next photos Select and Candidate	Down arrow	Down arrow	L
Survey View	Go to Survey view	N	N	LDSPW
Zoom	Toggle Zoom View	Z	Z	LD
	Zoom In	Ctrl =	Cmd =	LD
	(Zoom In Some)	Ctrl Alt =	Cmd Opt =	LD
	Zoom Out	Ctrl -	Cmd -	LD
	(Zoom Out Some)	Ctrl Alt -	Cmd Opt -	LD
	Open in Loupe	Return	Return	L
View Options		Ctrl J	Cmd J	LD
	Show / Hide Toolbar	T		LDSPW
Moving between Modules	Library Module	G/E/C/S or Ctrl Alt 1	G/E/C/S or Cmd Opt 1	LDSPW
	Develop Module	D or Ctrl Alt 2	D or Cmd Opt 2	LDSPW
	Slideshow Module	Ctrl Alt 3	Cmd Opt 3	LDSPW
	Print Module	Ctrl Alt 4	Cmd Opt 4	LDSPW
	Web Module	Ctrl Alt 5	Cmd Opt 5	LDSPW
	Go Back to Previous Module	Ctrl Alt up arrow	Cmd Opt up arrow	LDSPW
	Go Back	Ctrl Alt left arrow	Cmd Opt left arrow	LDSPW
	Go Forward	Ctrl Alt right arrow	Cmd Opt right arrow	LDSPW
Panels	Expand / Collapse Left Panels	Ctrl Shift 0 - 9 (panel number)	Cmd Ctrl 0 - 9 (panel number)	L
	Expand / Collapse Right Panels	Ctrl 0-9 (panel number)	Cmd 0-9 (panel number)	L
	Open/Close All Panels	Ctrl-click on panel header	Cmd-click on panel header	LDSPW
	Toggle Solo Mode	Alt-click on panel header	Opt-click on panel header	LDSPW
	Open Additional Panel in Solo Mode	Shift-click on panel header	Shift-click on panel header	LDSPW
	Show / Hide Side Panels	Tab	Tab	L
	Show / Hide All Panels	Shift Tab	Shift Tab	L
	Show / Hide Module Picker	F5	F5	L
	Show / Hide Filmstrip	F6	F6	L
	Show Left Panels	F7	F7	L
	Show Right Panels	F8	F8	L

		Windows Shortcuts	Mac Shortcuts	Works In.
Selections	Select All	Ctrl A	Cmd A	LDSPW
	Select None	Ctrl D or Ctrl Shift A	Cmd D or Cmd Shift A	LDSPW
	Select Only Active Photo	Ctrl Shift D	Cmd Shift D	LDSPW
	Deselect Active Photo	1	1	LDSPW
	Select Multiple Contiguous Photos	Shift-click on photos	Shift-click on photos	LDSPW
	Select Multiple Non-Contiguous Photos	Ctrl-click on photos	Cmd-click on photos	LDSPW
	Add previous/next photo to selection	Shift left/right arrow	Shift left/right arrow	LDSPW
	Select Flagged Photos	Ctrl Alt A	Cmd Opt A	LDSPW
	Deselect Unflagged Photos	Ctrl Alt Shift D	Cmd Opt Shift D	LDSPW
	Select Rated/Labelled Photo	Ctrl-click on symbol in Filter bar	Cmd-click on symbol in Filter bar	LDSPW
Moving between photos	Previous Selected Photo	Ctrl left arrow	Cmd left arrow	L
	Next Selected Photo	Ctrl right arrow	Cmd right arrow	L
Screen Mode	Normal	Ctrl Alt F	Cmd Opt F	L
	Full Screen and Hide Panels	Ctrl Shift G	Cmd Shift G	L
	Next Screen Mode	F	F	L
	Previous Screen Mode	Shift F	Shift F	L
Lights Out	Lights Dim	Ctrl Shift L	Cmd Shift L	L
	Next Light Mode	L	L	L
	Previous Light Mode	Shift L	Shift L	L
Secondary Display	Show Secondary Display	F11	F11	L
	Full Screen	Ctrl Shift F11	Cmd Shift F11	L
	Show Second Monitor Preview	Ctrl Shift Alt F11	Cmd Shift Opt F11	L
	Grid	Shift G	Shift G	L
	Loupe - Normal	Shift E	Shift E	L
	Loupe - Locked	Ctrl Shift Return	Cmd Shift Return	L
	Compare	Shift C	Shift C	L
	Survey	Shift N	Shift N	L
	Slideshow	Ctrl Alt Shift Return	Cmd Opt Shift Return	L
	Show Filter View	Shift \	Shift \	L
	Zoom In	Ctrl Shift =	Cmd Shift =	L
	(Zoom In Some)	Ctrl Shift Alt =	Cmd Shift Opt =	L
	Zoom Out	Ctrl Shift -	Cmd Shift -	L
	Zoom Out Some	Ctrl Shift Alt -	Cmd Shift Opt -	L
	Increase Thumbnail Size	Shift =	Shift =	L

		Windows Shortcuts	Mac Shortcuts	Works In
	Decrease Thumbnail Size	Shift -	Shift -	L
Hide Lightroom			Cmd H	LDSPW
Hide Others			Cmd Opt H	LDSPW
	Close Window		Cmd W	L
	(Close All)		Cmd Opt W	L
	Minimize		Cmd M	L
	(Minimize All)		Cmd Opt M	L
Lightroom Help		F1	F11	L
Current Module Help		Ctrl Alt /	Cmd Opt /	L
Current Module Shortcuts		Ctrl /	Cmd /	L
Plug in Manager		Ctrl Alt Shift,	Cmd Opt Shift ,	LDSPW
Preferences		Ctrl,	Cmd,	LDSPW
Catalog Settings		Ctrl Alt ,	Cmd Opt ,	LDSPW
Quit Lightroom		Ctrl Q	Cmd Q	LDSPW
Library Module				
Undo/Redo	Undo	Ctrl Z	Cmd Z	LDSPW
	Redo	Ctrl Y	Cmd Shift Z	LDSPW
Quick Collection	Add to Quick Collection	В	В	SPW
	(Add to Quick Collection and Next)	Shift B	Shift B	SPW
	Show Quick Collection	Ctrl B	Cmd B	LDSPW
	Save Quick Collection	Ctrl Alt B	Cmd Opt B	LDSPW
	Clear Quick Collection	Ctrl Shift B	Cmd Shift B	LDSPW
	Set Quick Collection as Target	Ctrl Alt Shift B	Cmd Opt Shift B	LDSPW
Folders / Collections	New Collection	Ctrl N	Cmd N	L
	New Folder	Ctrl Shift N	Cmd Shift N	L
	Expand all subfolders	Alt-click on folder dis- closure triangle	Opt-click on folder dis- closure triangle	LDSPW
	Show in Finder	Ctrl R	Cmd R	L
Stacking	Group into Stack	Ctrl G	Cmd G	L
	Unstack	Ctrl Shift G	Cmd Shift G	L
	Collapse/Expand Stack	S	S	L
	Move to Top of Stack	Shift S	Shift S	L
	Move Up in Stack	Shift [Shift [L
	Move Down in Stack	Shift]	Shift]	L
Toggle Flag	Flagged	P	P	L

		Windows Shortcuts	Mac Shortcuts	Works In.
	Unflagged	U	U	L
	Rejected	X	Χ	L
	Toggle Flag	`	•	L
	Increase Flag Status	Ctrl up arrow	Cmd up arrow	L
	Decrease Flag Status	Ctrl down arrow	Cmd down arrow	L
	Auto Advance	Hold shift while using P, U, X or turn on Caps Lock	Hold shift while using P, U, X or turn on Caps Lock	L D
Toggle Rating	0 - 5 stars	0, 1, 2, 3, 4, 5	0, 1, 2, 3, 4, 5	L
	Decrease Rating]	I	L
	Increase Rating]]	L
	Auto Advance	Hold shift while using 0-5 or turn on Caps Lock	Hold shift while using 0-5 or turn on Caps Lock	L
Toggle Color Label	Red, Yellow, Green, Blue Label	6-9	6-9	L
	Auto Advance	Hold shift while using 6-9 or turn on Caps Lock	Hold shift while using 6-9 or turn on Caps Lock	L
Painter Tool	Enable Painting	Ctrl Alt K	Cmd Opt K	L
Rename	Rename Photo	F2	F2	L
Rotation	Rotate Left (CCW)	Ctrl [Cmd [L
	Rotate Right (CW)	Ctrl]	Cmd]	L
Delete	Delete Photo	Delete	Delete	L
	Remove Photo from Catalog	Alt Delete	Opt Delete	L
	(Remove and Trash Photo)	Ctrl Alt Shift Delete	Cmd Opt Shift Delete	L
Metadata	Copy Metadata	Ctrl Alt Shift C	Cmd Opt Shift C	L
	Paste Metadata	Ctrl Alt Shift V	Cmd Opt Shift V	L
	Enable Metadata AutoSync	Ctrl Alt Shift A	Cmd Opt Shift A	L
	Save Metadata to File	Ctrl S	Cmd S	L
	Show Spelling and Grammar	Mac only	Cmd:	LDSPW
	Check Spelling	Mac only	Cmd;	LDSPW
OS Copy/Paste (within text fields)	Cut	Ctrl X	Cmd X	LDSPW
	Сору	Ctrl C	Cmd C	LDSPW
	Paste	Ctrl V	Cmd V	LDSPW
Keywording	Go to Add Keywords field	Ctrl K	Cmd K	L
	(Change Keywords)	Ctrl Shift K	Cmd Shift K	L
	Set Keyword Shortcut	Ctrl Alt Shift K	Cmd Opt Shift K	L
	Toggle Keyword Shortcut	Shift K	Shift K	L
	Next Keyword Set	Alt 0	Opt 0	L

		Windows Shortcuts	Mac Shortcuts	Works In
	Previous Keyword Set	Alt Shift 0	Opt Shift 0	L
	Apply Keyword	(Alt numberpad for 1 9)	(Opt numberpad for 1 9)	L
Filtering	Enable/Disable Filters	Ctrl L	Cmd L	LDSPW
	Show Filter Bar	\	\	L
	Refine Photos	Ctrl Alt R	Cmd Opt R	L
Text Filters	Select Text Filter	Ctrl F	Cmd F	L
	Starts with	+ at beginning of word	+ at beginning of word	L
	Ends with	+ at end of word	+ at end of word	L
	Doesn't Contain	! at beginning of word	! at beginning of word	L
	Delete Rejected Photos	Ctrl Delete	Cmd Delete	L
Working with Catalogs		S. L.O.	C. ISHIFO	1000
Open Catalog		Ctrl O	Cmd Shift O	LDSPW
Open Specific Catalog when opening Lightroom		Hold down Ctrl while opening Lightroom	Hold down Opt while opening Lightroom	
Develop Module				
	Go to Develop	D	D	LDSPW
Copying, Pasting & Syncing	Copy Settings	Ctrl Shift C	Cmd Shift C	LD
	Paste Settings	Ctrl Shift V	Cmd Shift V	LD
	Paste Settings from Previous	Ctrl Alt V	Cmd Opt V	LD
	Sync Settings	Ctrl Shift S	Cmd Shift S	LD
	Sync Settings - no dialog	Ctrl Alt S	Cmd Opt S	D
	Enable Develop Auto Sync	Ctrl Alt Shift A	Cmd Opt Shift A	D
	Match Total Exposures	Ctrl Alt Shift M	Cmd Opt Shift M	LD
Sliders	Select next Basic panel slider			D
	Select previous Basic panel slider	,	,	D
	Increase slider value	=	=	D
	Decrease slider value	=		D
	Move slider value by larger increment	Shift while using = or -	Shift while using = or -	D
	Move slider value by smaller increment	Alt while using = or -	Opt while using = or -	D
Auto	Go to White Balance Tool	W	W	LDSPW
	Auto White Balance	Ctrl Shift U	Cmd Shift U	LD

Chapter 16 - Keyboard Shortcuts

		Windows Shortcuts	Mac Shortcuts	Works In
Black & White	Toggle Black & White	V	V	LD
Snapshots & Virtual Copies	Create Snapshot	Ctrl N	Cmd N	D
	Create Virtual Copy	Ctrl '	Cmd '	LDSPW
Presets	New Preset	Ctrl Shift N	Cmd Shift N	D
	New Preset Folder	Ctrl Alt N	Cmd Opt N	D
Before / After Previews	Toggle Before/After	1	1	D
	Left / Right	Υ	Y	D
	Top / Bottom	AltY	Opt Y	D
	Split Screen	Shift Y	Shift Y	D
	Copy After's Settings to Before	Ctrl Alt Shift left arrow	Cmd Opt Shift left arrow	D
	Copy Before's Settings to After	Ctrl Alt Shift right arrow	Cmd Opt Shift right arrow	D
	Swap Before and After Settings	Ctrl Alt Shift up arrow	Cmd Opt Shift up arrow	D
Targeted Adjustment Tool	Deselect TAT	Ctrl Alt Shift N	Cmd Opt Shift N	D
	Tone Curve	Ctrl Alt Shift T	Cmd Opt Shift T	D
	Hue	Ctrl Alt Shift H	Cmd Opt Shift H	D
	Saturation	Ctrl Alt Shift S	Cmd Opt Shift S	D
	Luminance	Ctrl Alt Shift L	Cmd Opt Shift L	D
	Black & White Mix	Ctrl Alt Shift G	Cmd Opt Shift G	D
Clipping Indicators	Show Clipping	J	J	D
	Temporarily Show Clipping	Hold Alt while moving slider	Hold Opt while moving slider	D
Reset	Reset Slider	Double-click on slider label	Double-click on slider label	LD
	Reset Group of Sliders	Double-click on group name	Double-click on group name	D
	Reset All Settings	Ctrl Shift R	Cmd Shift R	LD
Cropping	Go to Crop Tool	R	R	LDSPW
	Reset Crop	Ctrl Alt R	Cmd Opt R	D
	Constrain Aspect Ratio	A	A	D
	Crop to Same Aspect Ratio	Shift A	Shift A	D
	Rotate Crop Aspect	X	X	D
	Crop from Center of Photo	Alt while dragging	Opt while dragging	D
	Rotation Angle Ruler	Ctrl-click on start and end points	Cmd-click on start and end points	D
	Cycle Grid Overlay	0	0	D
	Cycle Grid Overlay Orientation	Shift O	Shift O	D
Spot Removal	Go to Spot Removal	Q	Q	LD

		Windows Shortcuts	Mac Shortcuts	Works In
	Increase spot size	1	1	D
	Decrease spot size	[[D
	Hide Pins or Spots	Н	Н	D
	Delete Pin or Spot	Select Spot then Delete	Select Spot then Delete	D
Local Adjustments	Go to Adjustment Brush	K	K	LDSPW
	Go to Graduated Filter	M	M	L
	Show Overlay	0	0	D
	Cycle Overlay Colour	Shift O	Shift O	D
	Switch brush A / B	1	1	D
	Temporary Eraser	Hold Alt	Hold Opt	D
	Increase brush size]	1	D
	Decrease brush size	[[D
	Increase brush feathering	Shift]	Shift]	D
	Decrease brush feathering	Shift {	Shift {	D
	Set Flow value	0-9	0-9	D
	Constrain Brush to Straight Line	Shift while dragging	Shift while dragging	D
	Constrain Gradient to 90 degrees	Shift while dragging	Shift while dragging	D
	Invert Gradient	' (apostrophe)	' (apostrophe)	D
	Hide Pins or Spots	Н	H	D
	Confirm brush stroke	Return	Return	D
	Delete Pin or Spot	Select pin then Delete	Select pin then Delete	D
	Increase or decrease Amount slider	Click and drag horizontally on pin	Click and drag horizontally on pin	D
Edit in Photoshop & Othe	y Programs			
Edit in	Edit in Photoshop	Ctrl E	Cmd E	L
	Edit in Other Application	Ctrl Alt E	Cmd Opt E	L
Export				
Export		Ctrl Shift E	Cmd Shift E	LDSPW
Export with Previous		Ctrl Alt Shift E	Cmd Opt Shift E	LDSPW
Slideshow Module				
Impromptu Slideshow		Ctrl Return	Cmd Return	LDSPW

		Windows Shortcuts	Mac Shortcuts	Works In
New Template		Ctrl N	Cmd N	SPW
New Template Folder		Ctrl Shift N	Cmd Shift N	SPW
Save Slideshow Settings		Ctrl S	Cmd S	S
Go to Next Slide		Right arrow	Right arrow	S
Go to Previous Slide		Left arrow	Left arrow	S
Show / Hide Guides		Ctrl Shift H	Cmd Shift H	SP
Run Slideshow		Return	Return	S
Pause Slideshow		Space	Space	S
End Slideshow		Escape	Escape	S
Export PDF Slideshow		Ctrl J	Cmd J	S
Export JPEG Slideshow		Ctrl Shift J	Cmd Shift J	S
Export Video Slideshow		Ctrl Alt J	Cmd Opt J	S
Print Module				
New Template		Ctrl N	Cmd N	SPW
New Template Folder		Ctrl Shift N	Cmd Shift N	SPW
Save Print Module Settings		Ctrl S	Cmd S	Р
Go to First Page		Ctrl Shift left arrow	Cmd Shift left arrow	Р
Go to Previous Page		Ctrl left arrow	Cmd left arrow	Р
Go to Next Page		Ctrl right arrow	Cmd right arrow	Р
Go to Last Page		Ctrl Shift right arrow	Cmd Shift right arrow	Р
Show / Hide Guides		Ctrl Shift H	Cmd Shift H	SP
Guides	Page Bleed	Ctrl Shift J	Cmd Shift J	Р
	Margins and Gutters	Ctrl Shift M	Cmd Shift M	Р
	Image Cells	Ctrl Shift K	Cmd Shift K	Р
	Dimensions	Ctrl Shift U	Cmd Shift U	Р
Show/Hide Rulers		Ctrl R	Cmd R	Р
Page Setup		Ctrl Shift P	Cmd Shift P	LDSPW
Print Settings		Ctrl Alt Shift P	Cmd Opt Shift P	Р
Print		Ctrl P	Cmd P	LDSPW
Print One		Ctrl Alt P	Cmd Opt P	Р
Web Module				
New Template		Ctrl N	Cmd N	SPW
New Template Folder		Ctrl Shift N	Cmd Shift N	SPW

	Windows Shortcuts	Mac Shortcuts	Works In
Save Web Gallery Settings	Ctrl S	Cmd S	w
Reload	Ctrl R	Cmd R	W
Use Advanced Settings	Ctrl Alt Shift /	Cmd Opt Shift /	W
Preview in Browser	Ctrl Alt P	Cmd Opt P	W
Export Web Photo Gallery	Ctrl J	Cmd J	W

Standard Modifier Keys

On both platforms, in addition to keyboard shortcuts, the standard modifier keys are used in combination with mouse clicks to perform various tasks.

Ctrl (Windows) / Cmd (Mac) selects or deselects multiple items that are not necessarily consecutive. For example, hold down Ctrl (Windows) / Cmd (Mac) to select multiple photos, select multiple folders, select multiple keywords, etc.

Shift selects or deselects multiple consecutive items. For example, hold down Shift while clicking to select multiple photos, select multiple folders, select multiple keywords etc.

Alt (Windows) / Opt (Mac)—Changes the use of some controls. For example, in Quick Develop, it swaps the 'Clarity' and 'Vibrance' buttons for 'Sharpening' and 'Saturation.' In Develop panels, it changes the panel label to a panel 'Reset' button, and holding it down while moving some sliders shows masks or clipping warnings.

To switch catalogs when opening, hold down Ctrl (Windows) / Opt (Mac).

Index

#

0-255 scale 300, 372-374

1:1 previews 253–257 *See also Previews*

8-bit vs. 16-bit editing 300, 372–375

16-bit printing 442

32-bit vs. 64-bit computing 270, 465

Α

ACR

See Adobe Camera Raw

Activating of Lightroom 477

Active D-Lighting (Nikon) 64

See also Camera settings

Active photo 131–133, 292–294

Activity Viewer 118–120

Add Parent Folder 150-151

Adjustment Brush tool 343–352

Adobe Camera Raw (ACR) 359-366, 473

Adobe Camera Raw cache

See Camera Raw cache

AdobeRGB 376-377, 375-381

Adobe Standard profiles 329–330

All Photographs collection 187

Archiving offline 251–252

Attribute filters 189–190, 191–192 *See also Filtering photos*

Audio annotations 105, 172

Audio files

See Audio annotations; See also Music

Auto Advance 162-163

Auto Hide & Show Panels 121-122

Auto Import 111-116

Auto Lighting Optimizer (Canon) 64

See also Camera settings

Auto Mask 268, 347

Auto settings 284–285

Auto-Stack by Capture Time 159–160

AutoSync Develop settings 268,

291-294

AutoSync Metadata settings 132–133

В

Backup 221-227

See also Restoring backups

Badges 130, 144

Basic panel (Develop) 279-283

Batch adjustments 132-133, 291-295

Before/After views 295-296

Bit Depth

See 8-bit vs. 16-bit

Blacks 280-281

Black & White panel 290-291

Blank thumbnails

See Grey thumbnails

Borderless print 431–432

Borders 399, 438–439

Breadcrumb bar 123

Bridge 164–165, 181, 366

Brightness 280-281

Brush size 341–342

Bug report form 478

Burning

See Adjustment Brush tool

C

Cache*.dat files 265-267

Calibration of camera

See DNG Profile Editor

Calibration of monitor

See Monitor calibration

Camera Calibration panel 329–330

Camera preview 272-274

Camera profiles

See Profiles

Camera Raw cache 265-267, 464

Camera settings 63-64, 273, 329

Camera Style profiles 329–330

Candidate photo when using

Compare 134-135

Captions 421-422

Capture Time

See Edit Capture Time

Catalog corruption

See Corruption of catalogs

Catalogs 205-252, 462

Catalog Settings 217, 461

CD/DVD 252, 369-370

Cell Border 128

Choosing favorite photos 160–166

Chromatic Aberration 321, 325

Clarity 280, 282

Clipping warnings 298–300

Clone tool

See Spot Removal tools

CMYK 105

Collections 154–157, 412–413, 427, 440–441

Collection Sets 155–156

ColorChecker Chart 333-335

Color Labels

See Labels

Color Management 259–260, 375–381,

442-443

Color panel 290

Colors look wrong 109–111, 258–259,

377-381

Color space 375–381

Color Temperature

See White Balance

Comments panel 417–418

Compare view 134–135

Contact Sheet 431–436

Contour Shuttle Pro 283-284

Contrast 280-282

Copy Develop settings 291-294

Copying photos

See Duplicating photos

Copyright 76, 389–393

See also Watermarking

Corrupted monitor profile 258–260

Corruption of catalogs 212-214

Corruption of photos 93, 108-109,

460-461

Crop Overlays 338

Cropping photos 324, 336–340, 386

Cross-processed style 290-291

Curves

See Tone Curves

Custom Package 431–436

Custom Sort

See User Order

D

Deactivating of Lightroom 477

Default catalog 209–210

Default file locations 461-464

Default settings 306–308, 321–322

Deleting photos 168–170, 265

Deleting preferences file 459

Demosaic 274–276, 361–362

Deselecting photos 132

Destination panel 82–90

Detachable panels

See Solo Mode

Detail panel 314-318

Develop module 260–262, 265–267,

271-352

Develop presets 75–76, 300–306

See also Presets

Dialogs 138-139, 146

Digital Negative (DNG) format 91–102

Disclosure Triangles 137

Display calibration

See Monitor calibration

DNG 244

DNG Converter 97–100

DNG Profile Editor 279, 330-336, 464

Dock Folder 68-69

Dodging

See Adjustment Brush tool

Dot Releases 472-473

Downgrading Lightroom 472-473

DPI

See Resolution

Draft Mode Printing 442

Drive Letters 202

Droplets 394-398

Dual Monitors 146, 425

See also Secondary Display

Duplicating photos 167–168

E

Edit Capture Time 182–186

Edit in Other Programs

See External Editors

Edit in Photoshop

See External Editors

Edit in Photoshop diagrams 364-365

Effects panel 327–328

Emailing photos 394–395

Embedded & Sidecar previews 253-254

Exclamation Mark icon 145, 274-276

EXIF data 170, 319

ExifTool 173

Export as Catalog 218, 234-235

Exporting photos 367–406

Exporting slideshows 426-429

Export presets 403-404

See also Presets

Exposure 280-281

External Editors 353-366

Eyedropper 276-279

F

Favorite folders 69, 123

File Corruption

See Corruption of photos

File Information 128, 131, 145, 170–173

File naming

See Renaming photos

File permissions

See Permissions

File synchronization software 222, 231,

240

Fill Light 274-275, 280-281

Filmstrip 122-123, 144

Filter bar 124 Н Filtering photos 187–196 Hardware 268-270 Filter Lock icon 189 HDR photos 108, 359, 399 Finding missing photos **Heal tool** See Missing files See Spot Removal tools Finding specific photos Hierarchy See Filtering photos See Folder hierarchy; See also Keywords Flags 128, 160-166 Highlight Tone Priority (Canon) 64 See also Camera settings Flash galleries 447–451 Histogram 296-300 Flickr 407 History panel 312-314 Floating panels See Solo Mode Hot pixels 274 Folder hierarchy 149–151, 201–202 HSL panel 289 Folders panel 147–154 HTML galleries 447-451 Folder structure 82-90 ı **FTP Server** 403, 453–456 ICC profiles 331–333, 381, 442–443, Full Screen mode 118 445-446 Identity Plate 118-120, 420-421, 438-440 Image# renaming 79-80 Gamut 298-299 **Image Size** General maintenance 210-211 See Resizing photos **Graduated Filter tool** 343–352 Import from Catalog 219, 236–237 Grain 328 Importing photos 61–116, 263 Graphics card 268-270 Import presets 90-91 See also Presets Graphics Pen/Tablet 283-284, 347 Import# renaming 79-80 Grey thumbnails 103-104, 257-258 **Index Number** 128 Grid view 133-134

G

	Info Overlay 124–125	Lightroom opens automatically 10
	Installing Lightroom 467	Lights Out mode 135-136
	Interface See Workspace Interpolation 387	Limits See Maximum image size; See also Maximum number of photos
	IPTC data 170	Linear DNG format 94 Loading Overlay 144, 263–267
J	iTunes 90, 426	Local Adjustment tools 343–352 Lock icon
	JPEG format 62-63, 370-372, 374-375, 444-445 See also Raw vs. JPEG formats	Lossless compression 93 Loupe view 124–125, 135
K	JPEG quality 371	Ircat file 207
	Kelvin values 278–279	Ircat.lock file 207, 212
	Keyboard shortcuts 306, 475–476, 479–488	Irdata folder/file 207
L	Keywords 173–182	Masks 281, 316, 343-352 Match Total Exposure 294
	Labels 160–166 Languages 474–476	Maximize Compatibility 107–108 Maximum image size 209
	Lens Blur 348 Lens Corrections panel 319–326	Maximum number of photos 208
	Lens Profile Creator 326, 464	Megapixels 209 MelissaRGB 298
	Library module 147–204, 260–262, 263–264	Memory usage See RAM
	License Agreement 476-477	Menu bar 118

Merging catalogs 219, 239

See also Import from Catalog

Metadata 170-173

Metadata filters 189-190, 194-196

See also Filtering photos

Metadata presets 75–76, 171–172

See also Presets

Metadata Status 129

See also XMP

Minimal previews 253-254

Minimize Embedded Metadata

404-405

Mismatch of ACR versions 359-366

Mismatch of Color Settings 377–380

Missing files 200-204, 406

Module Picker 118

Monitor calibration 258-260, 444

Mosaic DNG format 94-95

Most-selected photo

See Active photo

Movie files

See Video files

Moving catalogs 209

Moving Lightroom on the same

computer 229–232

Moving Lightroom to a new computer

232-234

Moving photos between catalogs

See Transferring between catalogs

Moving photos on the hard drive

167-168, 230, 264

MP3 format 172, 425

Multiple Catalogs 180–181, 215–221

Multiple Computers 234-241

See also Network use

Multiple Monitors

See Dual Monitors

Multiple Users 247–251

Music 425-426, 451

N

Navigator panel 125-126

Network Accessible Storage (NAS) 248

Network use 247-251

See also Multiple Computers; See also Multiple Users

Nikon D2x profiles 330

Noise reduction 274-275, 314-318

Noise Reduction 260-262

Nondestructive editing 62, 369, 381

nVidia graphics card 268-270

0

Offline files 235

See also Archiving offline; See also Missing files

Open Anyway (Edit in PS) 362–363

Optical Media

See CD/DVD

Optimize Catalog 210-211

Organizing photos

See Folder structure; See also Folders panel

Overwrite original file 369

P

Painter tool 163, 179

Panels 120-122

Panel Switches 137

Panoramic photos 106, 359, 423

Parametric Curve 287-288

Paste Develop settings 291–294

PDF format 370-371, 429

Performance

See Speed

Permissions 105, 227, 406

Photosets 412–413

Photoshop

See External Editors

Photoshop Actions

See Droplets

Photoshop Elements 359

Picks

See Flags

Picture Package 431–436

Picture Styles

See Camera settings

Pins 349

Plug-ins 399-403

Point Curve 288

Pop-up Menus 138

Post-processing actions 394–398

PPI

See Resolution

Preferences file 459, 461

Presets 463

Preview area 123

Preview Problems 257–262

Previews 74, 253-270, 430

Previous settings 291–294

Printer profile 445–446

Print module 431-446

Process Version 145, 260-262, 274-276,

361-362

Profiles 272–273, 329–330, 464

Promote Subfolders 151

ProPhotoRGB 298–299, 375–381

Proprietary Raw format 91–102

PSD format 107–108, 354, 357, 374–375

Publish Services 407

Q

Question Mark icon 200-204

Quick Collection 130, 156-157

Quick Develop panel 198-200, 295

R

RAM 270

Ratings 160-166

Ratio

See Cropping photos

Raw converter 272-274

Raw file rendering 271-274

Raw Files diagram (Edit in PS) 365

Raw+JPEG in camera 110-111, 173, 273

Raw vs. JPEG formats 61-65, 278,

305-306

Recovering deleted photos 169-170

Recovery 280–281

Red Eye Reduction tool 342–343

Relative Develop adjustments 198-200,

295

Renaming catalogs 209

Renaming photos 77–82, 166–167,

310-311, 370

Rendered Files diagram (Edit in PS)

364

Render Previews

See Previews

Render Using Lightroom (Edit in PS)

362-363

Resetting sliders 137, 312–314

Resizing photos 381-387

Resolution 381–387

Restoring backups 227-229

RGB values 296-300

Rotation 130

See also Straighten

S

Saturation 280, 283

Saving photos

See Exporting photos

Saving print layouts 440-441

Saving slideshows

See Exporting slideshows

Saving web galleries 449

Scale 324

Screen Modes 118

Scrubby sliders 136

Secondary Display 139-142

Second Copy 75, 223-224

Selections 131–133

Select photo when using Compare

134-135

Sepia style 291

Sequence# renaming 79-82

Sharpening 260–262, 274–275, 314–318,

348, 388-389, 441

Show Photos in Subfolders 149, 188

Size of photos

See Resizing photos

Sliders 136–138, 283–287, 312

Slideshow module 419-430

Smart Collections 196–198

Snapshots 308–312

Solo Mode 120-121, 143

Sort Order 187-196

Sound files

See Audio annotations

Source panel 67-74

Specular highlights 277

Speed 263–270

Splitting catalogs 218, 239 See also Export as Catalog

Split Tone panel 290-291

Spot Removal tools 340–342

Spray Can icon

See Painter tool

SQLite database format 211, 247

sRAW format 61–65, 101, 274

sRGB 298-299, 375-381

Stacking 158-160, 369

Standard-sized previews 253-255

Star Ratings

See Ratings

Status Overlay 124–125

Store Presets with Catalog 304-305

Straighten 323, 339–340

See also Rotation

Subfolders

See Folders panel; See also Show Photos

in Subfolders

Survey view 135

Suspected Duplicates 74–75

Sync Develop settings 291–294, 312, 342

Synchronize Folder 152-154

Sync Metadata 170-171

System Requirements 268–270

T

Target Collection 156–157

Targeted Adjustment tool (TAT)

286-287

Temperature

See White Balance

Template Browser panel 419–420, 427,

440-441, 447-449

Test Integrity 225

Tethered Capture 111–116

Text filters 189-190, 192

See also Filtering photos

Thumbnails 126-131

Thumbnail size 133-134

TIFF format 354, 357, 374-375 Video files 105, 130, 186, 428 Time Machine 226 Viewing photos 133–136 Time stamp **Vignette** 324, 327–328 See Capture Time **Virtual Copies** 160, 308–312 Title bar 118 Volume Bars 148-149 **Toggle Switches** See Panel Switches W Tokens 139 Wacom See Graphics Pen/Tablet Tone Curves 287–288 **Warning Dialogs Toolbar** 123-124 See Dialogs **Total# renaming** 79-80 Watermarking 389-393, 437 **Transferring between catalogs** 219 WAV format 172 TranslatedStrings.txt 88-89, 475-476 **Web module** 447–456 Trashing preferences file White Balance 276-279, 294 See Deleting preferences file Workflow 57-58 **Triangles** See Disclosure Triangles Workspace 117–146 Troubleshooting 457-461 X U **XMP** 92, 129, 220–221, 241–246, 248–251 **UI (User Interface)** See Workspace Υ **Updating Lightroom** 472–473 YouTube 428 **Upgrading Lightroom** 468–472 Z User Order 188 **Zooming in/out** 125–126, 260–262, 337 Versioned backups 221–222

Vibrance 280, 283